MILOSEVIC

Publisher's Preface

Milosevic: A People's Tyrant is not so much a history as a historical document. Less analysis than testimony, it tells the story of Slobodan Milosevic's inexorable rise to power and the turmoil he brought with him. Vidosav Stevanovic, its author, is not a dispassionate, academic observer; he is a Serbian novelist and a liberal who, until Milosevic forced him into exile, was heavily implicated in the politics of his country.

Stevanovic wrote his book in Paris. He used his diaries and his conversations with the exiled members of his circle to whom he had access, to piece together a study of the explosion of ultra-nationalism on the Balkans. In this too the book serves as a historical document of what was and what could be known about the atrocities committed across the region in the 1990s.

But perhaps most importantly Stevanovic's work stands, like Solzhenitzyn's, as a conscience call. Its impressionism is rhetorical; Stevanovic the novelist has turned his pen to politics. In its denunciations of the corruption, both moral and social, of Serbia, *Milosevic: A People's Tyrant* is a manifesto – subjective, impassioned, desperate and political. It is these very qualities that merit its publication in English.

MILOSEVIC

The People's Tyrant

Vidosav Stevanovic

Edited by Trude Johansson
Translated by Zlata Filipovic

I.B. TAURIS

LONDON · NEW YORK

Published in 2004 by I.B.Tauris
6 Salem Road, London W2 4BU

In the United States and in Canada
distributed by St Martin's Press
175 Fifth Avenue, New York NY 10010

ISBN 1–86064–842–8
EAN 978–1–86064–842–7

A full CIP record for this book is available from the British Library
A full CIP record for this book is available from the Library of Congress

Library of Congress Catalog card: available

Typeset in Berkeley Oldstyle by Oxford Publishing Services, Oxford
Printed and bound in Great Britain by TJ International Ltd, Padstow, Cornwall

Contents

Map of the former Yugoslavia

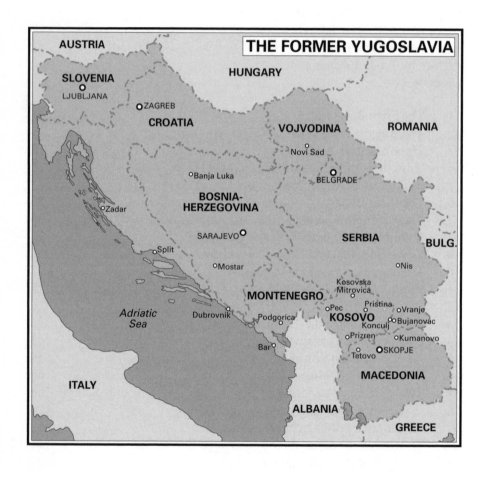

Acronyms and Abbreviations

AIDS auto immune deficiency syndrome
CIA Central Intelligence Agency (of the USA)
CNN Cable News Network
DEPOS Democratic Movement (*pockret*) of Serbia
DOS Democratic Opposition of Serbia
DPS Democratic Party of Serbia
EC European Community
EU European Union
HDZ *Hrvatska Demokratska Zajednica*
 (Croat Democratic Party)
ICDSM International Committee to Defend Slobodan Milosevic
ICTY International Criminal Tribunal for Former Yugoslavia
IMRO Internal Macedonian Revolutionary Organization
JA *Jugoslovenska Armija*
 (former Yugoslav Army, or JNA)
JAT Yugoslav airline
JNA Yugoslav National Army
JUL *Jugoslovenska Udruzena Levica*
 (United Left Wing of Yugoslavia)
KGB *Komitet Gosudarstvennoi Bezopasnosti*
 (Russian Committee of State Security)
KLA Kosovo Liberation Army
NATO North American Treaty Organization
NGO non-governmental organization
OVK *Oslobodilacka Vojska Kosova*
 (Kosovo Liberation Army)
OZN *Odeljenje Zastite Naroda*
 (Popular Defence Division)
SANU Serbian Academy of Arts and Sciences
SAO *Srpska Autonomna Oblast*
 (Serb Autonomous Region)

Acronyms and Abbreviations

SDA	*Stranka Demokratske Akcije* (Party for Democratic Action)
SDG/SSJ	Arkan's groups. SDG – Serb Volunteer Guard or 'Tigers'/SSJ – *Stranka Serpskog Yedintsva* or United Serbian Party
SDS	*Srpska Demokratska Stranka* (Serbian Democratic Party)
SFRJ	Socialist Federal Republic of Yugoslavia
SKJ	*Savez Komunista Jogoslavije* Communist League of Yugoslavia
SPO	*Srpski Pokret Obnove* (led by Draskovic) (Movement for Serbian Renewal)
SPS	*Socijalisticka Partija Srbije* (Socialist Party of Serbia)
SRJ	*Savezna Republika Jugoslavija* (Federal Republic of Yugoslavia)
SRS	*Srpska Radikalna Stranka* (led by Seselj) (Serbian Radical Party)
SS	*Srpski Sabor* (Serbian Assembly)
TANJUG	Telegraphic Agency of New Yugoslavia
UCK	*Ushtria Clirimtare E Kosova* (Kosovo Liberation Army)
UDB	*Unutrasnja Drzavna Bezbednost* (Internal State Security)
UNPROFOR	United Nations Protection Force
USSR	Union of Soviet Socialist Republics
VMA	*Vojno Medicinska Akademija* (Military Medical Academy)

Foreword by Zlata Filipovic

When Slobodan Milosevic went on trial, I felt I might finally be able to draw a line under a part of my life I wish I had never lived. I felt I might be able to bring some sort of closure to a trauma that has lasted over a decade, a trauma that began as war rolled into my native Sarajevo. I am still waiting.

The story of the war in former Yugoslavia is slowly being forgotten. We have forgotten the buses filled with orphaned babies, tied to their seats leaving Sarajevo, rushing through sniper fire and falling shells. We have forgotten the old people's homes where the elderly died quietly of cold. We have forgotten the hospitals filled with bodies; we have forgotten the Market Place massacre, and the shelling of starving civilians as they queued for bread and water. Images of football fields turned into cemeteries, of broken glass, of devastated buildings, of the barely living, the wounded and the dead have merged with other images of suffering elsewhere in the world, and these in turn are being forgotten too.

Only the numbers remain – 13 years since the start of the madness, over 250,000 dead, five million displaced, thousands missing, wounded, scarred, widowed or orphaned. For those of us who lived and survived, the war will always be present. It took away my childhood, destroyed my parents' lives and poured suffering into my grandparents' final years. Its legacy – shattered countries, cultures and peoples, and shattered individual lives – lives on and will mark generations to come.

Vidosav Stevanovic describes Milosevic as a little man of no particular greatness who rose from the greyness of bureaucracy and anonymity at a moment in which no one in the world was prepared to stop him. That makes him the product of us all. Circumstance made him the face of former Yugoslavia in the last decade, and for me, he represented a whole era of horror that defined my life, that of my parents and so many others.

Today, something seems to be changing. As time passes and Milosevic's trial drags on, he is paling out of the immediate memory too. The trial will end, whatever the outcome. But can that really be the end for

us all? My pain, the pain of Vidosav Stevanovic, and that of so many people scattered across the Balkans and those forced to become refugees and exiles will of course never heal. Milosevic's end – if it ever comes – will never be enough. He remains not only in our memory but also in the daily facts of life of millions of those whose lives were forever changed by that period of barbarism he headed and symbolized. Returned to the greyness from which he emerged, he remains a livid scar in all our lives.

Zlata Filipovic

Preface by Trude Johansson

T his book is about a man no one really seems to know. Its author tries to piece together the jigsaw of his fractured character. It is about Milosevic the boy, Milosevic the politician, Milosevic the family man, Milosevic the loner and, ultimately, Milosevic the failure. The story of Milosevic, his family and his compatriots is a story of pitiless brutality and suffering. Every single member of the Milosevic family has taken part in crimes against others, more often than not with murderous conclusions. Slobodan Milosevic is on trial at the International Criminal Tribunal for the former Yugoslavia (ICTY) in The Hague; his wife, Mira Markovic is expected to join him, having been indicted for the murder of former president Ivan Stambolic who disappeared in August 2000.

Slobodan Milosevic first appeared before the ICTY on 3 July 2001 where he pleaded 'not-guilty' to all charges laid against him for crimes committed in Kosovo. On 29 October 2001 he subsequently pleaded 'not-guilty' to all counts of crimes committed in Croatia. On 11 December 2001 he pleaded 'not guilty' to charges concerning crimes in Bosnia. The Kosovo indictment has seen him charged with four counts of crimes against humanity and one count of violations of the laws or customs of war. For crimes in Croatia he has been charged with nine grave breaches of the 1949 Geneva Convention, thirteen counts of violations of the laws and the customs of war and ten counts of crimes against humanity. For crimes in Bosnia, he has been charged with two counts of genocide, ten counts of crimes against humanity, eight counts of grave breaches of the Geneva Convention and nine counts of violations of the laws or customs of war. All these charges are based on both individual and superior criminal responsibility. On 12 February 2002 his trial for crimes committed in Kosovo began, with the trial for crimes in Croatia and Bosnia-Herzegovina commencing a few months later on 26 September 2002. Milosevic does not recognize the international court.

Throughout the whole trial Milosevic has chosen to defend himself. He rejected the prosecutor's demands that the tribunal appoint a lawyer for him

in November 2002, stating 'The prosecution is trying to prevent me from speaking and also trying to impose on me a puppet lawyer, which they have absolutely no right to do.'[1]

At the start of the judiciary process, it was estimated that the prosecution would tie up its case within 14 months, by April 2003. But Milosevic's frequent bouts of illness made that impossible. The case for the prosecution ended in February 2004. All told, that is almost two years. According to the rules of the tribunal, Milosevic will have the same amount of time at his disposal. Milosevic, who has refused to enter a plea in his ongoing trial and still refuses to recognize the validity of the court trying him, will open his defence on 8 June. The 1600 witnesses he has so far called include Tony Blair and ex-President Bill Clinton.

So far, the trial has been suspended nine times due to Milosevic's ill health – he suffers from high blood pressure, which shows no signs of abating. The trial is expected to continue until 2006. It will have been the longest and most expensive trial in the history of the tribunal.

Since his imprisonment, Slobodan Milosevic's nationalist dreams for Serbia and Yugoslavia have disintegrated. With the signing of the new constitution in February 2003, the Federal Republic of Yugoslavia has become Serbia and Montenegro. But if Milosevic's ideals no longer taunt his country, his legacy very much lives on, as do his methods. Democracy, modernization, development and economic growth have been slow in coming. They may yet again grind completely to a halt.

On 12 March 2003, Serbian Prime Minister Zoran Djindjic was assassinated in Belgrade. With him died many of the hopes of the new Serbia. Djindjic was one of the foremost spokesmen for democracy in Serbia and the man on whom the rest of Europe counted to lead Serbia into a new era. Just two weeks later, on 27 March 2003, the body of Ivan Stambolic, former president of Serbia was also found. Stambolic disappeared in August 2000: prime suspects for the abduction and murder were Milosevic's special police forces. Both Milosevic and his wife have been charged along with former special police chief Milorad Lukovic. Lukovic is also a chief suspect in the assassination of Djindjic, as is former Serbian state security chief Radomir Markovic.

Several of the Milosevic regime's most prominent members are still on the loose. Although Arkan, the notorious Serb paramilitary leader responsible for some of the worst outrages in Bosnia, was assassinated in 2000, in

what might have been a Milosevic-ordered attack, his Tigers still operate in parts of Serbia. Several other paramilitary organizations are still at large. Radovan Karadzic is still alive, and is avoiding Interpol. He was indicted by The Hague at the same time as Milosevic, but has so far escaped capture. It is suspected that he is somewhere in Republika Srpska, though his whereabouts remain uncertain. Ratko Mladic is also still at large. There have been several attempts to capture him, among others by storming his late mother's house on the day she died, the most recent being on 26 August 2003. The Hague tribunal indicted Mladic at the same time as Milosevic and Karadzic.

In politics, most of Milosevic's cronies remain active in the new country. In the parliamentary elections of December 2003, the ultra-nationalist Serbian Radical Party headed by Vojislav Selselj, currently also detained in The Hague on charges of genocide and war crimes, won over a third of the seats, more than any other party. If Vojislav Kostunica were able to stay in power, he could only do so by relying on the backing of the Serbian Socialist Party (SPS), still nominally headed by Milosevic (who has vowed to return to politics after his trial). The clear favourite for presidential elections in June 2004 is the nationalist extremist Tomislav Nikolic, the former gravedigger of Stevanovic's hometown of Kraguyevac, who runs the Serbian Radical Party in Seselj's absence.

There is an International Committee to Defend Slobodan Milosevic (ICDSM) that believes that the allegations against him are fabricated by the anti-Serb world. The leader of their American branch claims that:

1. The Hague is a tool the UN Security Council created illegally under orders from Washington; violating all legal standards it demonizes and brutalizes Serbian leaders and Serbian people.
2. NATO and its proxy forces are guilty of war crimes. Covering this up is a key function of the Tribunal.
3. The media have systematically lied, slandering the Serbian people, in coordination with NATO and its solely owned subsidiary, the Tribunal.[2]

Milosevic's story is far from over. The long shadows of the Milosevic regime still darken Serbia's future.

Norway, 2004

Chronology

1986: (*May*) Milosevic becomes Serbian regional Communist Party president.

1987: (*March/April*) Milosevic intervenes on behalf of Kosovo Serbs who allege persecution by Albanian majority.

1988: (*January*) Milosevic's supporters oust Serbian state president Ivan Stambolic.

1989: (*June*) Milosevic addresses one million Serbs at Kosovo Polje on 600th anniversary of Turks' defeat of mediaeval Serb kingdom. (*November*) Milosevic elected president of Serbia.

1990: (*January*) SKJ dissolves. (*December*) Milosevic re-elected as president of Serbia in multiparty elections.

1991: (*June*) Croatia and Slovenia declare their independence of Yugoslavia. Yugoslav military fails to crush Slovenian independence. Fighting breaks out in Croatia between Croats and minority Serbs. (*December*) EU agrees to recognize independence of any former Yugoslav republic that is democratic, respects human rights and protects ethnic minorities. Serbs declare their independence in Krajina province of Croatia. Bosnian Serbs declare an independent republic within Bosnia.

1992: (*January*) EU recognizes Croatia and Slovenia. (*February/March*) Bosnia's Muslims and Croats vote in referendum for independence; Serbs boycott polls. (*April*) EU and USA recognize Bosnia-Herzegovina. Civil war starts between Bosnian government and Bosnian Serbs. Bosnian Serb forces initiate siege of Sarajevo. SRJ created. (*May*) UN imposes sanctions on Serbia for supporting Serbs in Bosnia and Croatia.

1993: (*January*) War breaks out between Bosnian Croats and Muslims. (*October*) Milosevic dissolves Serbian parliament and calls new elections.

1995: (*August*) NATO launches air strikes against Bosnian Serb targets. (*November*) Dayton peace agreement to end the Bosnian civil war. (*December*) Peace agreement signed in Paris.

1996: (*April*) KLA starts attacking Serbian targets in Kosovo. (*November*)

Serbian opposition tries to oust Milosevic following allegations of electoral fraud.

1997: (*July*) Milosevic becomes president of Yugoslavia.

1998: (*February*) Serbian security forces begin offensive against KLA. (*June/July*) Serb forces take back positions lost to KLA in Kosovo. (*September*) NATO issues ultimatum to Milosevic to end violence in Kosovo. (*October*) Serbs scale down military and security presence in Kosovo.

1999: (*6 February*) Rambouillet talks begin, but Kosovo Albanians reject peace plan. (*March*) Talks continue and Kosovo Albanians accept peace plan. Yugoslav representative rejects peace plan. Start of NATO military action in Kosovo. (*May*) UN war crimes tribunal indicts Milosevic as war criminal. (*June*) Milosevic capitulates and Serb forces withdraw from Kosovo.

2000: (*April*) In anti-Milosevic demonstrations in Belgrade 100,000 mass to demand early elections. (*May*) Opposition unites when 18 Serbian political parties form DOS. Government increases repression and blames all unrest on fifth columnists working for NATO countries. (*July*) Milosevic sets presidential, parliamentary and local elections. (*August*) Opposition launches anti-Milosevic campaign under slogan, 'He's Finished!' (*September*) Large turnout at national elections. Vojislav Kostunica wins presidential election; Milosevic rejects result. Opposition calls for general strike. (*October*) European leaders call for Milosevic to step down. Hundreds of thousands of anti-Milosevic protestors peacefully parade in Belgrade. Strikes paralyse country. Milosevic resigns.

2001: (*January*) UN war crimes prosecutor demands Milosevic's extradition. (*April*) Belgrade authorities arrest Milosevic. (*June*) Serbian PM Zoran Djindjic agrees to his extradition. Milosevic transferred to ICTY in The Hague. Kostunica and Djindjic at odds over the extradition; Zoran Zizic resigns in protest over it. (*July*) Milosevic makes first appearance at UN war crimes tribunal and pleads not guilty to all counts. (*August*) As political differences with Djindjic grow, Kostunica's DPS pulls out of Serbian government in protest over alleged corruption. (*September*) UN lifts arms embargo against Yugoslavia. (*October*) Milosevic pleads not guilty to all counts on Croatia indictment. (*December*) Also pleads not guilty on Bosnia indictment.

2002: (*February*) Prosecution open case against Milosevic. Ibrahim Rugova elected president by Kosovan parliament. (*March*) Yugoslav, Serbian and Montenegrin leaders sign a EU sponsored agreement to set up a new state to

be called Serbia and Montenegro in place of Yugoslavia. (*April*) Montenegrin government collapses over differences on new union of Serbia and Montenegro. (*May*) Milosevic faces President Ibrahim Rugova of Kosovo in court. (*October*) Run-off Serbian presidential elections, in which Vojislav Kostunica wins majority, are declared invalid because not enough people turn out to vote. Montenegrin elections result in a vote of confidence in the new union of Serbia and Montenegro. (*November*) President Djukanovic resigns to take on more powerful position of PM of Montenegro. (*December*) Low turnout invalidates Serbian presidential elections. Parliament speaker Natasa Micic becomes acting president. Low turnout also invalidates Montenegrin presidential election.

2003: (*January*) Serbian president Milan Milutinovic surrenders to The Hague tribunal where he pleads not guilty to charges of crimes against humanity. Serbian and Montenegrin parliaments approve constitutional charter for new union of Serbia and Montenegro. (*March*) Parliament elects Svetozvar Marovic president of Serbia and Montenegro. (*May*) Prosecutors win 100 extra trial days for Milosevic case. Filip Vujanovic elected Montenegrin president in third round of voting. Milosevic questions Slovene ex-president Milan Kucan. (*June*) Yugoslav ex-president says Mr Milosevic had nothing to do with Srebrenica massacre. (*October*) First direct talks between Serbian and Kosovan leaders since 1999. (*November*) Another attempt to elect a Serbian president fails because of low election turnout. David Owen testifies against Milosevic. (*December*) Serbian parliamentary elections are inconclusive leading to extensive coalition talks between various political parties. US general Wesley Clark testifies against Milosevic. UN sets out conditions for final status talks in 2005.

2004: (*February*) Prosecutors rest their case against Milosevic. (*March*) Former Yugoslav president Vojislav Kostunica becomes PM of Serbia in centre-right coalition government that relies on support of Milosevic's Socialist Party. Serbia's first major war crimes trial opens in Belgrade when several Serbs face trial for 1991 murder of Croatian civilians in town of Vukovar. Worst ethnic clashes between Serbs and Albanians in Kosovo since 1999 after violence erupts in divided town of Mitrovica. (*June*) Milosevic to begin his defence. Presidential elections in Serbia.

Chapter 1

The Friendless Orphan

T he male name Slobodan derives from the Serbian word *sloboda*, which means freedom. It denotes a free individual; Slobodan Jovanovic, a nineteenth-century scientist, writer and politician who died in exile was the first to bear it. Over time, the popularity of the name grew and spread across the region. Given the Serbian habit of replacing names with nicknames, Slobodan was reduced to Sloba, or indeed *mali Sloba* ('little Sloba') by family and friends. Thousands of such 'little Slobas' exist throughout Serbian towns and villages.

One particular Slobodan became known as 'Sloba-Sloboda' to Serbs at home and abroad; this version was a noun instead of a name, representing a concept rather than a mere individual. 'Sloba-Sloboda' represented the notion of freedom at a time when it was eagerly anticipated in the whole of Eastern Europe. As it turned out, he turned away from freedom, instead leading his people into the quicksand of nationalism. Paradoxically for Serbs and Europeans alike, by generally embodying so many of the different facets of freedom while specifically embodying its denial, this figure has made himself unique in the history of the modern Serbian state.

This is the story of Slobodan Milosevic, a lawyer by education, a politician, an anti-democrat, a semi-dictator, the president of Serbia elected at its first open elections, the president of the newly created Socialist Republic of Yugoslavia, the defeated candidate in the 2000 elections, the leader overthrown by his nation's revolt and, most recently, the prisoner in the Scheveningen gaol and in the dock facing The Hague tribunal. Over the years the Western media have called him the strong man of Belgrade, a great tactician and even the butcher of the Balkans. But today the Serbs themselves have finally begun to understand the duality of his nature, so long concealed. On the one hand he was our Sloba, the new Saint Sava, the most talented Serbian politician of the twentieth century, a lamb among wolves, and on the other he was the 'Devil from Dedinje'. His enemies and

opponents secretly respected him, and his admirers and associates feared his unpredictability. No one was indifferent to him: he provoked extreme and conflicting reactions in people. It was this polarizing duality that lay behind the countless mistakes and tragic misunderstandings that shattered what was once Yugoslavia.

The legend of Milosevic has overshadowed that of Tito. The more we discover about him, the less we understand of him. What do we really know? Almost nothing. Indeed, as a politician and as a human being he may yet turn out to have been exactly that – almost nothing.

He was born at the beginning of the Second World War in the Balkans, in August 1941, five months after the disintegration of the first Yugoslavia.[1] On the day of fascism's defeat he was four years old. But we know very little about his childhood – no official biographical portrait tells us about the child, the boy, about Sloba the young man.

Milosevic excised his own past, leaving only a shadow. No family photographs have been found, and no explanation has been offered as to why. There are no pictures of little Sloba and his parents out on a picnic, there are no pictures of the boy sitting at a Sunday lunch or among classmates. No school records or old identity cards have surfaced. Researching him is like chasing an illegal activist who had destroyed all incriminating evidence. A profound inextinguishable neurosis drove him to obliterate his past.

Alfred Adler wrote that the neurotic personality is driven by a desire for power. Milosevic's whole being has been dominated by the will to power and he has never grown out of the wounds of his childhood. Communism had taught him early that the end justifies the means. In a time of peace, the consequences of his neurotic ambition might have been unimportant, but in the context of civil war they proved devastating.

The Milosevic family is of Montenegrin origin, from a region of Lijeva Rijeka – a remote, sparsely inhabited place that has never been fully subdued by any central power. In the past these highlanders would sweep down to the valleys on lightning raids, then return to the mountains with their plunder. The mountain population was very small and grindingly poor; its only cultural asset consisted of the epic songs that glorified these

people's thefts and raids, accompanied by the wail of the *gusle*, the traditional stringed instrument of those parts.

Slobodan's father Svetozar began his working life as an Orthodox priest. After the Second World War he was expelled from the clergy for denouncing his colleagues to the new authorities. He divorced and his former wife kept their young son, little Sloba; the elder son Borislav went with his father.[2] The reasons for the divorce are unknown. For a few years Svetozar taught history at a secondary school in Montenegro, where his pupils nicknamed him *Saint Horror*. A lonely, friendless, rancorous figure, he was apt to pick fights with the other teachers. He was known to deliver loud sermons in a field outside the town to an audience of upright stones that resembled walking men. In 1962 he was found dead in this place. He had shot himself through the head. The reasons for his suicide are unknown.[3]

Slobodan's mother was a Communist Party worker and headmistress of a school in Pozarevac, east Serbia. Former students described Comrade Stanislava as a strict, just person with no personal connections to people of her milieu. When she was not busy with party duties, she was raising little Sloba. He neither played football nor knew how to swim and neighbours remember how he hated getting his shoes dirty in the muddy streets of Pozarevac. He was the best pupil in his school and was known to dread his mother's wrath if he let his standards slip. Due to his fragile health, little Sloba was regularly exempted from physical education classes.

Just as her son was beginning his secondary education, Stanislava met her future daughter-in-law, Mirjana Markovic, an orphan. Mirjana had been raised in an old house without a bathroom by her widowed maternal grandmother, who wore black every day of her life. The pair saw very few people; they avoided what family they had, and their neighbours avoided them. But Slobodan and Mirjana were inseparable from the moment they met in December 1958. Together they went on to university in Belgrade after they had completed their secondary education.[4] Both won state scholarships, which were awarded only to a very select few. After this, their visits to Pozarevac grew more and more infrequent, no doubt because both their childhood memories of the place were so bitter.

In 1972, Sloba's lonely mother followed the example of her ex-husband and killed herself. Few memories of her, either good or bad, remain. Her son, now a young official of the Law Faculty Party Organization, paid

punctiliously regular visits to his mother's grave but never in the presence of Mirjana, who had by then become his wife.[5] 'Comrade Mirjana' hated cemeteries. She had been born in prison during the war to Vera Markovic Miletic, an illegal activist, whose execution (so one version goes) was delayed only by her pregnancy. As the developing baby neared birth, so the mother neared the date of her execution. There is no official record of Vera's execution, but what is certain is that Mirjana was abandoned immediately after her birth and never met her mother.

Mirjana had grown up to be a somewhat plain girl with lank hair and a penchant for heavy make-up. Her first encounter with Little Sloba probably took place in the schoolyard. No doubt the passionate drive for power they recognized in one another sprang from the same source – a terror of death, which had blighted both their childhoods, and a need to overcome it. It was this that gave their relationship its immense strength. No one could separate them because they were only interested in each other. They cut themselves off from the rest of the world and surrendered to the similarity that united them. Communism supplied the screen that insulated them from the world: inevitably, because dogmatic Marxism had ready-made answers to all their questions. They had both joined communist youth organizations very young and had since become unshakeable supporters of totalitarianism.

Each represented for the other a substitute for society. Mirjana filled the void left by little Sloba's mother, shielded him from his fear of women and protected him from the friends whose trust he suspected and despised. In return, he replaced her absent father. Motherless, she mothered him. Fatherless, he fathered her.

Mirjana's mother Vera and her aunt Davorjanka Paunovic were two beautiful sisters from Pozarevac who led dramatic lives. During the war, Davorjanka, nicknamed Zdenka, became the mistress and indispensable confidante of Josip Broz, by then already known as Tito, following him through all his campaigns as a partisan commander.[6] Tito's associates and subordinates bitterly resented Zdenka: they were willing to be ruled by Josip Broz, but the fact that his mistress had such an ascendancy over the leader made her very dangerous. The affair continued after the war, even more passionately than before. The lovers adored each other, at times with a passion that bordered on violence. The affair ended with the beautiful Zdenka's untimely death from tuberculosis.[7] Tito, heartbroken, ordered that she be buried in the garden of the White Castle at Dedinje in Belgrade.

Vera also played a prominent part in Yugoslav-Serb history. During the war, she was a member of an important underground movement and the mistress of several high-ranking officials in the party. It is still rumoured that Tito was among these lovers and that she had carried his child. While carrying out an undercover mission, Vera was caught and tortured by the Gestapo.[8] She denounced the entire Belgrade resistance network in what was recorded as the worst calamity in the wartime history of the party. Remarkably, one of the Gestapo officers present took pity on her and saved her life. One story claims that he fell in love with the beautiful partisan and looked after the baby girl she had later in gaol. At this point the accounts of Vera's life become vague. Some say she was executed by the resistance at the liberation of Belgrade, others that she escaped to Germany with her Gestapo lover, where she still lives today under an assumed name.[9] Apart from the certain fact that she gave birth to a daughter who was sent to Serbia to be brought up by her grandmother, there exists no verifiable account of Vera's postwar career.

The child was named Mirjana, a derivative of the word *Mir* (peace). She took her surname, Markovic, from a party executive who acknowledged her as his daughter some ten years after her birth. When she grew up she decided to call herself Mira, a name her mother had once used as an alias. She clung so hard to her fragile identity that when she married Milosevic she refused to take his name. This, however, was all she wished to preserve of her past, since she immediately severed all relations with her half-sisters and nominal father. Slobodan was the only person with whom she communed; constantly together, they gradually merged into a single unit capable of confronting the world. Those outside their charmed circle existed only as faceless shadows, with value only insofar as they could be manipulated to advantage.

Yugoslavia was comprised of six republics, two autonomous provinces[10] and 20 national minorities. Its critics viewed it as a conceptual madness created from the fallen remains of two great empires: the Ottoman and the Austro-Hungarian. Its apologists praised it for being the perfect model of an ethnically diverse and integrated society. This Babel-like compound of languages, cultures, customs and histories was held together not by a gov-

ernment, constitution and legal system but by the cult of Tito's personality and what was perceived as a specifically Yugoslav form of socialism. Tito embodied both power and unity. Yugoslav socialism was felt to be unique in its capacity to maintain a balance between the capitalist West and the Stalinist East. The unity of Yugoslavia was complex and fragile: it existed both as a Marxist single entity and as a collection of separate national factions. Censuses used two categories to record Yugoslavia's population: citizenship (Yugoslav) and nationality (any on the list). Every Yugoslav had a dual identity. He or she could be a Yugoslav and a Serb, a Yugoslav and a Croat, a Yugoslav and an Albanian. It was not possible, however, to be a Serb first and a Yugoslav second. Nationality could never take precedence over citizenship. Only nationalists and intellectuals who deliberately defined their identity according to different criteria perceived this system as contradictory and thereby prepared the ground for what would later be known as a 'national identity'.

At the end of the Second World War, the communists took power in Yugoslavia. At the time the country was overwhelmingly rural, with only a few industrialized cities and regions. Workers were scarce. The dictatorship of the people, backed by Soviet tanks, was proclaimed but it was really only the dictatorship of a small circle of party leaders. Before long, power had become concentrated in the hands of one man, Tito. The growth of his personality cult ran parallel to the growth of the working class, the one absent but essential element for sustaining the credibility of the new ideology. More and more people migrated from the countryside to the cities to find work in the newly built factories. The villages were drained of their youth while the towns, brimming with newcomers, began to lose their identities and succumb to village superstitions and suburban fantasies.

The new ideology was bent on creating a new class system. Yugoslavia did not consider itself a nation-state like Germany, nor a state-nation like France, but something altogether different and unique. The issue of nationality still had to be confronted, associated as it was with memories of slaughter and savage conflict. The communists concluded that the best way of facing this issue was to keep the promise that they had made during the war to ensure the support of the majority: all peoples would be guaranteed the right to exercise their specific culture and speak their own language.

To avert a revival of past conflicts – and to establish a base for certain

party structures – a set of new 'nations' was created. The national question was pronounced solved, and was briskly swept under the carpet.

Montenegro was one. It had previously had its own state and ruling dynasty.[11] The Montenegrins' request to form an independent nation was quickly granted. However, there was a strong current of dualism in Montenegrin opinion. Some considered themselves super-Serbs, pure specimens of a greater nation that was destined to lead them. Others preferred Montenegrin to Serbo-Croat as their national language, denied all connection with the Serbs and even claimed Celtic origins.

Then there were Bosnian Slavs, who had adopted Islam but kept their language during the long Ottoman occupation of their region. In Serbia, these were referred to as 'Turkish converts'. Since they were living side by side with Serbs and Croats, their national position needed to be redefined. By party decision they were pronounced Muslims, with Serbo-Croat as their official language.[12]

In the eyes of the single party known as the Communist League (sub-divided into nine parties, also called Communist Leagues),[13] regional nationalism was considered a mortal sin, the greater nation being absolutely paramount. Notions of nationality were not only contrary to Marxist notions of class identity, they were also perceived as a blatant device for career advancement. In addition to having a republic, a province and rights guaranteed under the law, each nation and national minority had its own list of cadres who occupied positions in the republic and the federation. Interminable conflicts arose among the various parties about whose names should appear on these lists. At times, these party conflicts swelled into small-scale national conflicts, which Tito solved by conferring privileges on certain individuals and by removing them from others, or else by abolishing them altogether. Punishment for deviants who did not follow the party line was not severe, since the party did not consider prison and political murder appropriate deterrents. Even the camp at Goli Otok lost its original function as a centre of penal and correctional punishment. People were simply sent into retirement and that was often the last that was heard of them.

A comrade, once he had been thrown out of the party, lost the right to exercise his profession. He was condemned to accept a pension and expected to socialize only with those who had shared a similar fate. The various arms of the secret police (the number of which has never been fully

established – there were perhaps six, seven or more different branches) closely supervised this 'retirement process'.

When Slobodan had completed his studies at the Law Faculty, he embarked on his career. As a 'Serb of Montenegrin origin' he succeeded in securing a place for himself on the Serbian list of cadres. His elder brother, Borislav, the future 'Montenegrin of Serbian origin' appeared on the Montenegrin list. Having the same parents was no guarantee that you belonged to the same nation: 'nationality' was dictated much more by the relationship between the individual in question and the party.

No particularly strong bond seems to have existed between the brothers. They saw each other as members of the same party and seldom met in private. Slobodan's wife Mirjana was always reluctant to spend time with other women, including her sister-in-law, but this was not the only reason. The elder Milosevic was a successful diplomat: having served as the Yugoslavian ambassador to Algeria, he was appointed police chief in the Ministry of Foreign Affairs. His success was not due to any special expertise but stemmed instead from the power held by the different republics' cadre lists. The cadre list that represented just half a million Montenegrins was the same size as the one that represented ten million Serbs, and the influence Montenegrins exerted on the creation of the Serbian lists was disproportionately heavy. Contrary to their Serbian counterparts, the Slovenians, Croats, Bosnians, Macedonians, Albanians and Voivodins maintained very tight control over their lists and refused to allow any manipulation from outside.

The motto of the internationalists under Tito was 'end nationalism, promote the nation'. Tito ruled during a period of mild communism, or 'social-ism with a human face' (terminologically distinct from 'real socialism'), and at this time nationalism was considered a cardinal sin. The struggle against nationalism was an integral and compulsory part of party pro-grammes, congresses and assemblies. All reports began and ended with attacks on nationalism. Party executives each maintained his or her own nationality, lived in state-owned 'socialized' apartments, spent holidays at special resorts, received medical treatment at the Military Medical Academy (exclusively reserved for senior executive members), all the while tirelessly and mechanically repeating slogans against nationalism and private ownership.

The republics were no more than the constituent elements of a feder-

ation. Nevertheless they were referred to as states – since that was what they strove to be. At the federal level, the republics defended their own interests, meaning that they gave away as little as possible themselves and took as much as they could from other republics. Withdrawals were made at all levels from the federal reserves, which in turn needed constant refilling. The resultant confusion created a yawning gap between the developed and underdeveloped republics. The northwest of the country (Slovenia and Croatia) was developing faster than the lagging south (Bosnia, Montenegro, Kosovo, South Serbia and Macedonia). The party attempted to solve this problem of polarization by applying a policy of 'democratic centralism', whereby the more developed republics would have to hand over their surpluses to various 'Funds for the Underdeveloped'. Municipalities, communities, regions and provinces all over Yugoslavia joined in an unseemly rush to prove their underdeveloped status. Those on the giving end were understandably outraged by this arrangement – especially since the money they disgorged would never be reimbursed. Instead, the money received for development was swallowed up by gigantic projects hatched by ambitious local cadres.

This was most pronounced in the overpopulated and poverty-stricken republic of Kosovo. Given that Kosovo quite clearly merited the status of 'underdeveloped republic', the Kosovo-Albanian leaders were given money, which they invested in the infrastructure of their capital, Pristina. They built a huge oriental-style library, university buildings, a modern hospital, a cultural centre, buildings to house various political organizations and a luxury residential area for the leaders. Everything was bigger, more expensive and more ostentatious by comparison with Tirana, the capital of neighbouring Albania, the poorest country in Europe and 'the first atheistic state in the world'. The Albanian dictator Enver Hoxha was much more concerned about building thousands of bunkers to resist 'imperialist attacks' than about his country's economic prosperity.

The career of the younger Milosevic began slowly, and to start with he was heavily dependent on his old friend and guardian, Ivan Stambolic, whose own career had been promoted by a powerful cousin, Petar Stambolic, a high communist official. Petar had somehow been able to convince Tito that he was devoid of ambition; though he himself was the very

embodiment of iron-fisted leadership, Tito never ceased to claim that nothing was more corrosive than the hunger for power.

In the early years it looked as if Milosevic was destined to be a subordinate, to listen attentively and carry out orders without hesitation, just like his predecessor Ivan. It was Ivan who patronizingly dubbed him the 'Little One'. He trusted Milosevic, supported him and generally treated him as a younger brother. He was convinced that he had never had a more loyal and compliant co-worker, or indeed a more modest one. At this juncture, greater advancement seemed unlikely; Milosevic was a 'Little Man'. His rules were simple. He was merciless to subordinates. He only kept promises made to superiors.

Milosevic eventually replaced Ivan Stambolic as vice-director and later director of 'Technogas' (1968–78), where his performance seems to have been undistinguished at best and divisive at worst. But the logic of the time dictated that his incompetence would be rewarded by promotion. For three months he was a *chef de cabinet* for Belgrade's Mayor Pesic. Pesic grumbled, 'What am I to do with Ivan's Little One? He is ignorant of everything, including his own ignorance. He's useless.' The next mayor, Zivorad Kovacevic, later ambassador to Washington in the 1980s, refused point blank to take him on.

The unwanted young executive needed to find another job. At this point his gift for backroom manoeuvring began to bear spectacular fruit: somehow he won the position of director of the Bank of Belgrade (1978–82), despite his ignorance in matters of economics and management. His inexperience was no real obstacle to promotion, since the socialist vision of economics valued above all the cadre's loyalty to the party. Any expert could be found, even one who was not a member of the party but willing to remain in the shadows, to carry out Milosevic's work for him. If the party cadre were to be promoted, the non-member expert might follow him, but only for as long as the superior member's lack of qualifications could remain unnoticed. A non-party expert, for example, could never become a minister.

Milosevic now went to the USA for several months as part of a specialization process to teach him how to conduct business. When he returned he was fairly proficient in spoken English. Overnight he seemed to have become a respectable banker, a man with potential who had finally discovered his true vocation. Next, in accordance with the socialist

principle of role rotation, Milosevic was appointed president of the Belgrade Chamber of Commerce. It was another significant step forward in his political career – one that came just at the right moment because his successor at the Bank of Belgrade was sacked over problems arising from a multimillion-dollar loan that Milosevic had negotiated in the USA.[14] Somebody had to take the blame for this debacle, particularly as it had been leaked to the public. For such eventualities, every communist cadre naturally had his 'double', a shadow that would take the blame quietly and be punished with the loss of his or her job. The incident was quickly hidden from the public eye.

There was, however, one sin that was unforgivable: this was the political sin and the ambitious Milosevic went to great lengths to avoid committing it. He dutifully intoned the communist mantras, never missed a meeting and carried out his party duties with clockwork precision. At the same time he took meticulous care that no senior party members should ever see him as a rival. Milosevic kept out of the limelight, a baby-faced *apparatchik* unknown outside party circles. Following the patterns of his childhood, he remained invisible to the rest of the world. Only in the eyes of his wife was he a human being, a man, a lover and a future politician. He was her political project.

The relationship between Slobodan and Mirjana that had begun in their adolescence had continued through their university years and into marriage. They were never apart. They thought and spoke exactly alike. Among friends, he would sit quietly while she spoke. She had opinions on everything. She saw anyone who opposed her as an enemy, and was swift to accuse them of political deviancy. But Slobodan did not take part in discussions. He did not demonstrate his powers of persuasion among his family or friends, but in party meetings and, perhaps more significantly, in the secret battles that took place behind closed doors. Theoretical considerations of Marxism did not interest him – the business of politics did.

At that time the Yugoslav press was bursting with a wide variety of colourful new magazines and newspapers, none of which differed in its content. The front page was always concerned with Tito's international successes, describing how he had hosted foreign statesmen, philosophers, writers, actors, famous sportsmen and kings. His every word was noted and transmitted to readers. His fellow soldiers and associates rarely appeared on the front page, except on the day of their funeral. The inside pages

reviewed international and domestic affairs (without much regard for fact), local news, culture and leisure. Eventually, one would reach the most important and popular page – the sports page. Footballers were much better known than other public figures, including politicians, and football took up far more space than any other daily news.

The appearance of generalized television in the 1970s threatened the hegemony of the written press. Yugoslavs very soon became addicted to their television screens, just as they had fallen victim to the allure of private cars. Ownership of a TV became an important symbol of status. Eventually, three main television channels emerged. The first broadcast local and international sporting events, but it was the second that soon acquired a cult following. This was the Second News, broadcast every night at half past seven in the evening. The majority of people never missed it. Even though it was filled with propaganda, we all trusted it – communists as much as non-communists. The third channel consisted of American soap operas.

The Milosevic family was in no way exceptional. Slobodan and Mirjana resembled many other couples; having been granted a 'socialized' apartment they were now ready to have children. Their first baby was a daughter, Marija (1966). When Mirjana was pregnant for the second time, doctors suggested that she needed to rest for several months. As an ambitious 'comrade' herself (Mirjana had by then completed her undergraduate studies and her masters in sociology), and wife to an even more ambitious comrade, she did not take kindly to the enforced absence from party life. At least the devoted Slobodan was ever-present, nursing her and passionately looking forward to the birth of her child. A son was born in 1974. They named him after the hero of epic folk poems, King Marko. Nevertheless there was a slight rift between the parents: while the father loved the daughter most, the mother favoured her son.

Chapter 2

The Biggest Funeral in the World

J osip Broz emerged from the Second World War as Tito, as the commander of a large army, as the Marshal, as the most successful anti-Nazi guerrilla fighter, as victor, as secretary-general of the Communist Party, as leader of the popular liberation movement and as the father of the second Yugoslavia. He was a strong and good-looking 53-year-old, decisive and often stern, experience having taught him pragmatism. None of his comrades-in-arms dared to entertain the idea that they might one day take his place. Nobody on the Yugoslav political scene, or in exile, could measure up to him. In power, he proved himself to be sharp, skilful and ruthless, with much personal charm and a flair for demagoguery that compensated for his lack of rhetorical skill.

Tito was courageous and discerning enough – though perhaps he had no choice – to stand up to Stalin in 1948 and emerge from this confrontation undefeated. Because of him, Yugoslavia avoided the fate of other Eastern European countries and the descent into 'real socialism' that their 'people's democracies' imposed. Tito's legend began during the war, even before people knew who he was or what he looked like. Young partisans believed he was Russian and Stalin's closest associate. He was on the 'wanted' list of Nazi occupiers and their collaborators. There were persistent rumours that he was a woman. Anti-communists believed his name was an acronym of one of the Comintern terrorist organizations. Only with the publication of Vladimir Dedijer's *Supplement to Josip Broz: Tito's Biography* did the true facts about his previous life emerge. He was of Croatian origin with a Slovenian mother.[1]

Josip Broz was born in the village of Kumrovec, in the Zagorje region near Zagreb on 7 May 1892. He had to retake his first year at school. He left for the city intending to become a waiter – he later explained this by saying he liked smart clothes – but found work as a mechanic and electrician before joining the Austro-Hungarian army, in which he progressed

to the highest rank of non-commissioned officer. Although there is nothing to prove his involvement in the Bolshevik revolution, it is known that having been captured on the Russian front during the First World War, he was living in a Russian village in 1919, married to a Russian woman with whom he had three children. His wife died, as did two of their offspring.[2]

At the end of the 1920s, he reappeared in the Kingdom of the Serbs, Croats and Slovenes. As the secretary of an illegal political party, he was arrested in Zagreb and given a five-year prison sentence. His response was the standard one: 'I do not accept the jurisdiction of this court.' During Stalin's purges in the 1930s he lived in the 'Lux' hotel as a Comintern cadre. How he managed to survive this perilous period is not known.

His later reluctance to talk about it suggests that there were issues he was keen to hide. In 1937 he became secretary general of the small Communist Party of Yugoslavia and completely transformed it. He surrounded himself with young capable people who called him *Stari* (Old Man) and had great respect for him. The police never captured him ('they were looking for a worker but all the time I was in front of their noses wearing smart suits and walking a poodle'). He remarried just before the war in 1940 (an Austrian called Herta Haas) and each winter he withdrew from his illegal activities for a few weeks to his countryside retreat.

Following the German attack on the Soviet Union, Tito led an uprising in the heart of Serbia, which had seen so many uprisings in the nineteenth century. The majority of his partisans were always Serbs of Croatian and Bosnian origin. Even after the war, Serbs formed the majority in the party, police and army, and at every level of the bureaucracy. Serb praetorians believed this great Croatian communist to be the living heart of their ideal of 'a multiethnic state with all national questions resolved'.

The split with Stalin did not signify a departure from Soviet ideology. Yugoslav dissidents remained staunchly communist and Marxist. The rift did, however, result in a Soviet economic blockade and led to the collectivization of agriculture, which confirmed the fact that Yugoslavia had not strayed from the true path. Activists from the cities infiltrated rural communities and attempted to modernize them, clashing bitterly with the tough conservatism of the countryside. Armed incidents and bloodletting were not uncommon. Agricultural cooperatives were set up and farmers were compelled to join them; but they were resentful and worked little. The programme was not working. It was then that the pragmatic spirit of the

Yugoslav communists was revealed – the 'agricultural cooperatives' were shut down three years after their foundation. The system of small private landholdings, farmed by men who were content to endure a life of poverty, had won the battle against the Soviet monster.

The results of the five-year industrialization plan for this war-torn and poverty-stricken country were little better. Much effort and energy was invested in the building of factories, hydroelectric plants, railways and modern roads. For the 'workers, farmers and honest intelligentsia', mere enthusiasm was not enough to carry out the tasks prescribed by ideology. The party realized it needed to soften its politics and make its plans more realistic if it were to negotiate a middle path between the Soviet Union and the capitalist West. Here the Yugoslav communists showed their skill by opting for something new and different. The majority of the land was left to the farmers and agriculture again satisfied the elementary needs of the population. The growing working class was introduced to the new concept of 'workers' self-management', the effects of which were eventually felt around the world. The law consigned the management of factories to workers and workers' councils, and control was established. The state, namely the party, remained the highest governing institution, with the last word in every decision. The project seemed to be a success. Progress was visible everywhere. The seeds of a consumer society were sown and growing behind the stern mask of Marxism. Bourgeois egoism, once despised, now drove people to work harder and better. Those in charge boasted a higher rate of growth than that of Japan. In ten years, Yugoslavia managed to do what the Western states had taken centuries to achieve.

However, funds for further investments were not derived from profits but from a different unexpected source. Tito and his associates understood very well that Yugoslavia could not be fully self-sufficient, given its position between East and West. The cold war had created two rival empires. So far the Yugoslav communists had managed to avoid taking sides by finding their own third way. To them, Stalinism and imperialism were two sides of the same coin. Their best option was to support both sides on condition they were respected and assisted by both. Tito's secret diplomacy soon bore fruit: open-ended loans poured in from the West. To this day, the amount of money that was diverted into socialist Yugoslavia remains unknown. Some economists claim that propping up the Yugoslav economy must have cost over $100 billion.

Exactly how much of this money was spent on the army and police is still one of Titoism's great secrets. The Yugoslav Army was the fourth most powerful in Europe. The first tourists who trickled into the country found that Yugoslavia was a safe country, with Belgrade the safest capital on the old continent. The streets at midnight were as secure as they were in broad daylight. Crime had been virtually eradicated and the criminal class had emigrated elsewhere. One man – Aleksandar Rankovic, Tito's deputy and the most likely candidate to succeed him – had instigated this pacification of society. Besides occupying numerous state and party posts, he unofficially headed both the official and the secret police forces.

He was at the helm of OZN (*Odeljenje Zastite Naroda* – Popular Defence Division), which later became UDB (*Unutrasnja Drzavna Bezbednost* – Internal State Security); both were honoured in the popular couplet 'OZN knows everything. UDB cannot be escaped.' The walls of public institutions, offices and schools were all adorned with two pictures: those of Tito and Rankovic. A city in Serbia, previously called Kraljevo, became Rankovicevo. His nicknames – Marko and Leka – were pronounced with a potent combination of dread and respect. Among other things Rankovic was the mastermind behind the Goli Otok camp, which was used for the re-education of communists who had expressed their support for the Soviet model of socialism.

Under Rankovic, the police developed mythical characteristics – they were viewed as the most powerful, all-present, all-seeing, all-knowing force in society. Rankovic, as the police chief, was perceived as an individual of cosmic proportions, a multi-talented figure who was Tito's right-hand man, the keeper of Yugoslav unity, the protector of the Serbs, the patron of scientists and writers, an authentic communist and a good nationalist. But there were deep contradictions in this propaganda-fed legend. Formerly a tailor in a small town, Rankovic was personally in charge of the proper functioning of the country, using his networks of policemen, informers and good-willed citizens. Numerous intellectuals, among them the official state author, Dobrica Cosic, Rankovic's favourite, maintained the legend of his superhuman gifts. A writer of epic poetry, Cosic acted as the government's literary mouthpiece. He was granted the right to visit the camps and prisons, and to use his conversations with the imprisoned ideological enemies of the regime as material for his books.

Then something unusual took place within the leadership. At the 1965

party plenary session, held at Brioni (an Adriatic island appropriated by Tito for his own use), Rankovic, the paragon of decorum and orthodoxy, was accused of misusing the police for political purposes. He was found guilty of un-communist supervision of society and the wiretapping of his comrades; he had even gone so far as to conceal microphones in Tito's bedroom. He was summarily dismissed together with all his assistants and forced to undergo a period of 'self-criticism'. Thousands of policemen were forced to retire prematurely. The city honouring Rankovic was renamed Kraljevo.[3] Rankovic then moved into complete anonymity, leading a quiet life in his villa in the residential area of Dedinje in Belgrade. He was a free man, and still nobody, not even his victims, dared to confront him in the street. He made no further public appearances until his death some twenty years later, and left no written records. His associates also kept their counsel.

What had happened was effectively a conflict between centralism and decentralization, a shadowy struggle between the warrior-communists who continued to believe in their myths and the technocratic communists who dealt in the real world. The incoming flood of Western money had begun to infect the country with the germs of consumerism. Young people wore jeans, drank Coca-Cola, listened to rock-and-roll and grew their hair long like the Beatles. The number of private cars was growing. Beauty contests had become popular and Belgrade studios were making co-production films. The newspapers introduced fashion columns, young women wore mini-skirts, the beaches were bright with bikinis, abortion was legalized, and condoms were easily available. Yet, though open to economic growth, Yugoslavia was still deeply suspicious of change and Tito himself was particularly hesitant. After all, he had accepted Khrushchev's visit of reconciliation and had made his peace with his former ally, the Soviet Union, knowing that he could not survive without its help.

Meanwhile, economic reforms were voted for at party summits and companies began to discharge surplus staff. This process was in direct conflict with the government's policy of permanent employment. Given Yugoslavia's proud boast of full employment, something had to be done with these newly jobless people. At the same time, state authority was dwindling and the country as a whole was beginning to claim the right to a more prosperous future. An escape valve had to be found.

Previously, the rest of the world had only been open to high-ranking

officials and to those who had made the decision to leave Yugoslavia for good. The communists now decided to open the borders to all citizens, and accordingly hundreds of thousands of Yugoslavs joined the rush to find work abroad. This had a double advantage for Yugoslavia. On the one hand the unemployed, for whom the state and party were responsible, ceased to exist by the very fact that they had left the country and, on the other, money was being sent into the country to family and friends, thus stabilizing the economy. But the new tilt towards capitalism did not banish socialism. A system of embassies, cultural centres, workers' clubs and patriotic associations were established abroad in an effort to maintain the purity of Yugoslav identity amid the corrupt perils of the Western world. During the holidays the emigrants came home to parade their big cars, colour television sets and bright new clothes. A generation of revolutionaries had become conservatives.

Every model of socialism periodically adopts reform to improve 'the functioning of the system', but these particular reforms had the effect of seriously threatening central authority. It became clear that the state needed to tighten its grip if it were to maintain power. The Yugoslav economy of the 1960s was thriving and looked set for long-term prosperity; at the same time new political factions were appearing across the country. One such faction emerged in Serbia, led by Marko Knezevic whose members quickly became known as 'liberals'. The liberals were quietly engaged on two fronts against the sclerotic views of the orthodox Marxists and against the Serbian nationalism encouraged by Rankovic's followers. A similar group of young and talented militants also emerged in Croatia, led by Mika Tripalo.[4] They demanded economic and social reform, and a move towards liberalism; they relied on Croatian nationalism to gain the support of the people. Their movement came to be known as *maspokovci* (an abbreviation of *masovni pokret* – mass movement). Tito, who saw every new political trend as a threat, reacted by removing the Croatian liberals from their official posts on the charge of fomenting Croatian nationalism, 'anarcho-liberalism' and 'techno-management'. Their Serbian counterparts were similarly purged. In hindsight, this was a heavy blow to the development of the two biggest republics of Yugoslavia.

Following the elimination of the younger groups, Tito had to rely on the cadres left over from the revolution. Not surprisingly, this rump of old-fashioned administrators proved incapable of preserving the 'functioning of

the system'. Unable either to advance or reverse the economic process that was underway, they opted to do nothing and rely on tried and tested mechanisms. The only effective leverage left to them was Tito's cult. And so, one last time, Tito was forced to face Yugoslavia's most intractable issue – the national question. The first step towards tackling this issue was the constitution the ailing communist bureaucracy imposed in 1974. In its attempt to reconcile state unity and national diversity, the constitution unwittingly created new problems. Republics resembling semi-states were allowed to exist alongside Yugoslavia, which was supposed to be representing their united federation. The central committee of each republic was both the guardian of this unity and the guarantor of its eventual dissolution. Each republic had one leader, one army, one police force, one form of diplomacy and one ideology; but each had very different goals. Nevertheless, very few rebels risked imprisonment by speaking out against this new constitution.

To prevent the majority of ethnic Serbs dominating the new status quo, two autonomous provinces were established in the Republic of Serbia – Vojvodina and the province of Kosovo, and Metohija (also called Kosmet). For the next two decades these provinces were under the supervision of Belgrade. Under the new constitution, which recognized them as 'constitutive elements in a federation', these provinces were given expanded rights. The majority – represented by the Belgrade Central Committee – could not force its will on them. They had their own independent lists of cadres. Their capitals of Novi Sad and Pristina had their own academies of arts and science, their own artistic associations, sports federations, banks, independent bureaux for preserving their cultural heritage, universities, newspapers and magazines in all languages, and their own television centres. Administrative bureaucracies were installed for each institution and, as a result, the actual mechanics of governing became slower and more complicated. For example, 'Narrow Serbia' (a term now given administrative value) could not settle its budget without the consent of the provinces, which in contrast *could* reach such a settlement without the consent of the republic. With each passing year this tangled state of affairs created more tension and raised greater obstacles to economic progress. Budgets were routinely voted on far too late, after acrimonious discussions and bilateral threats.

These tensions, however, offered the nationalist and extremist followers

of Aleksandar Rankovic, the former chief of police, a perfect opportunity to reconsider the option of central rule. For them it was clear that this centre should be in Belgrade, in Serbia, which had been humiliated and stripped of power. The idea of a renewed central rule from Belgrade came from a group of intellectuals (communists who had become nationalists) within the academy. No one, including the police, paid much heed to these old men or to their accounts of a victimized Serbian nation and its inalienable rights over other members of the federation.

The public's attention was once again engrossed by a propaganda exercise that brought Tito back into the limelight, emphasizing his heroism and his essential standing as the sole unifying force in Yugoslavia. The 'cult of Tito' was still potent enough to distract the masses from the real tensions within their federation. The fairytale of Yugoslavia's grandeur was maintained with the help of this constitutional sedative, but the Tito cult with its many factions was to have devastating consequences for future generations. Outsiders were intrigued by the phenomenon; Yugoslavs were hypnotized by it. The country seemed stronger and richer than before. State nationalism proved successful as a substitute and mask for minority nationalisms. The Yugoslavian passport was respected worldwide and even had a certain value on the black market. People lived well; they did not need to work too hard, and their jobs were secure. Corruption was concealed, prostitution did not officially exist, the unemployed were leaving the country and foreign loans were flooding in. People were not involved in politics (with the exception of those in power), and the idea of self-rule was progressing, despite the serious economic damage it was causing to corporations throughout the infrastructure – a fact that was never mentioned in public.

Abroad, Tito made the most of his position between the global power blocs, skilfully capitalizing on his reputation as of one of the founders of the non-aligned nations movement. Both East and West saw him as a guarantor of the balance of power. In effect, he had iron curtains on either side of him, and he used them to his own advantage. Within Yugoslavia he was untouchable. He was a three-time recipient of the National Hero title and the holder of an unlimited mandate: he was president for life, immovable, Pharaonic. Several cities were named after him, as were innumerable institutions, factories and faculties. The capital of Montenegro changed its name to Titograd. People sang 'Comrade Tito, receive our

dewy flowers, all the country is following you'. His manner combined the charm of a roguish *bon vivant* with the kitsch of a parvenu. Before the television cameras he played the sage.

Still, age was catching up with Tito. He dyed his white hair a hilarious red. Forgetfully, like an actor playing a role of his youth, he publicly licked his finger as he slowly turned the pages of reports. His dress grew more and more pompous and ridiculous; he would appear in public wearing a different army uniform every time, irrespective of rank. He began to forget the names of his associates and guests. A single whisky was enough to muddle his wits. Meanwhile, his entourage tried to protect him from everything. Finally, his wife Jovanka (married in 1959) was ejected from his life. The comrades decided that her meddling in politics had gone too far and accused her of favouring generals of Serb origin. Tito sadly accepted this; Jovanka quietly left his chambers and retired in solitude.[5] She remained loyal to the last, never uttering a word against him.

Jovanka's departure dealt a massive blow to Tito's health. Doctors now slept in the room next to his. A colonel was present to watch his every step and a rumour spread that the great son of the nation now walked with a limp. An unhealthy blend of age and obsequious flattery had blunted the keen wit of this once pragmatic politician. In the end, like so many dictators before him, Tito began to believe his own propaganda. When he was declared president for life (1971), the text released to the public made no reference to the end of his life. He was simply given an unlimited mandate. He had no serious opponents, there was no obvious candidate for his succession and the law was powerless to remove him from office. His old age advanced apace until the news broke that Comrade President had been admitted to hospital for preventive reasons. Thereafter, for several months there were regular reports that he was on the mend, while statements of loyalty poured in from every corner of the nation. In one famous instance, a *Book of Love* arrived from a city in Serbia, containing more signatures than the place had inhabitants. To no avail; Josip Broz Tito was as mortal as anyone else and he died in Brdo castle above Kranj, in Slovenia, at four minutes past three o'clock on the afternoon of 4 May 1980. The news set off a cacophony of sirens the length and breadth of Yugoslavia.

Most people grieved sincerely. Hundreds of thousands of telegrams arrived at the Yugoslav presidency building, all carrying the same message. The president's blue train carried his body slowly down the line from

Ljubljana to Belgrade, as vast crowds gathered to pay their last respects.[6] Tito's funeral was the greatest spectacle of its kind in Balkan history. More than a hundred state and party delegations from around the world were present – representatives from East and West, North and South, and the Third World. The foreigners were seated on a massive podium positioned on the way to the House of Flowers, Tito's final resting place. Side by side stood presidents, generals, dictators, kings, putschists, powerful bureaucrats, self-proclaimed emperors, sultans, popular leaders, revolutionaries, terrorist leaders and conservatives, all honouring the great dictator. The pathos of his dotage was forgotten, along with the crimes of his career.

Tito was buried under a clean white slab of marble; significantly, no five-pointed star (the symbol of communism) had been engraved on the stone. He had transcended even his own ideology, which could not exist without him. Neither Tito's admirers nor his opponents could have predicted what would happen in the wake of his death. People avoided speculation, perhaps more out of genuine fear and uncertainty than from dread of the repressive police. A slogan caught the mood: 'After Tito – Tito.' No one dared contest this in public. Tito's villas and resorts were empty and deserted: nevertheless, photographs, paintings, banners and slogans of him were omnipresent in ministries, institutes, schools, hospitals, barracks, universities and private homes. His presence and the cult surrounding him had to be maintained. Those passing through the hills and mountains could still see his name carved in stone, set in concrete and even planted in rows of trees.

Every spring the cities, towns and villages of Yugoslavia were reunited for what was known as 'Tito's relay', just as they had been during his presidency. A carved wooden baton would arrive in Belgrade a day before the ceremony and would be left overnight in the youth hall. Talks were given, plays acted, poetry read, music played and political speeches delivered around it. The next day, an official ceremony was held at the JNA (army) stadium, where the current year's president of Yugoslavia received the baton on behalf of the dead leader. Choirs sang 'Comrade Tito, we pledge ourselves to you.'[7] Yet not everyone sang because the ugly reality of Tito's legacy was rapidly becoming apparent.

Chapter 3

The Unsmiling Politician

T he uneasy silence that followed Tito's death was finally broken by the muffled voice of revolt. Inevitably, nationalism was at the root of it. One year into this period of post-Tito uncertainty, student-led demonstrations took place in Pristina, the capital of Kosovo. The overt cause was discontent over poor education and university facilities; in fact, Kosovo's elite of Albanian academics and writers, who felt discriminated against in the job market, instigated the movement. Given this reality their options were either to go abroad or face a precarious existence in Enver Hoxha's Albania.

Kosovars and their prompters in Tirana believed poverty was rife in their region because Yugoslavia was bleeding Kosovo dry. 'Trepca is producing but Belgrade is prospering,' they said, referring to the rich mining area of Trepca in northern Kosovo. No mention was made of the vast sums this overpopulated province received in 'funds for underdeveloped areas', probably because they had been squandered. Nevertheless, yawning gaps existed between the richer and poorer areas of Yugoslavia, which was at once the wealthiest and the most poverty-stricken of all the socialist countries. In the course of the Pristina demonstrations, many of the banners the 'Marxist-Leninist' marchers carried also bore the words 'Kosovo Republic'. The police intervened and street clashes followed, leading to a number of deaths and arrests. Many of the young demonstrators sent to prison for their part in these early disturbances hardened into the leaders of future rebellion.

Media reporting of these events began at a strict minimum and soon petered out altogether. The communists were unwilling to admit what had happened either to themselves or to the people. However, the question of the state's survival and the need to choose between change and self-destruction had been well and truly raised. At the same time, another problem loomed – how were Serbs to survive in Kosovo in the future?

Nobody was eager to confront this spectre. The propagandist Dusan Mitevic[1] airily dismissed the issue, 'Nothing happened, only a few windows broken. It's a job for glaziers.'

Slobodan Milosevic was among those to condemn 'Albanian nationalism and separatism', but his voice was no louder than anyone else's. By now a professional politician, he knew that if he failed to support his superiors' opinions and statements he would be swept from the scene like the Albanian leaders, sacked for failing to 'self-criticize' in time. In the event they were replaced by a group of pro-Yugoslav Albanian politicians – essentially informers – who stepped in to do their critique for them.

As I have said before, Belgrade wielded disproportionate authority in Yugoslavia. It was a rich power base that felt ethnically superior to the rest of Serbia and indeed the whole federation. As the headquarters for all state institutions, it regarded itself as the national capital and the gateway to Europe, neatly balanced between East and West. Yet Belgrade was a small-town metropolis where everyone knew everyone else. An oligarchy of powerful men made the political decisions there and summarily dictated them to the rest of the country. This caused deep and continual resentment.

In 1982, following in the footsteps of his protector Stambolic, Milosevic was elected president of the Belgrade Urban Committee of the Communist League, an antechamber to the real power of the Central Committee. Individuals from the Urban Committee would either end up in the Central Committee or disappear from political life altogether. The Belgrade Urban Committee had the largest party membership in Yugoslavia (larger than that of the Communist League of the whole of Slovenia or Macedonia). For Milosevic, being promoted to this position inevitably meant the beginning of a career of much greater significance.[2]

For the first time his name was heard in Belgrade. He was a man of action. He attacked Serbian nationalism, rooting it out wherever it was to be found. He banned the publication of the collected works of Slobodan Jovanovic, an anti-communist who had been condemned to death for high treason in the distant year of 1947, then publicly attacked the liberals concealed in the party and among the staff of the university. He insisted that Marxism should remain a special subject in schools, not just as a part

of the philosophy course but also as the philosophy behind education itself. When Belgrade's younger generation pointedly stayed away from the relay ceremony, Milosevic won plaudits by condemning their absence as an insult to Tito's work. The revolution was sacred and should be respected. The rejected and forgotten older party cadres, deeply troubled by incomprehensible developments in Moscow, began to see Milosevic as the man to restore true communism, free from the excesses and compromises of modern times. Milosevic's method was simple: attack, deceive, provoke. The Belgrade intelligentsia, comfortable in its tepid communism, did not see him as an adversary and he was able to gain their confidence through strategy and manipulation. At dinners and meetings the word went out that 'there is something about this man'. His hard-nosed tactics were blamed on the behaviour of his opponents. Although he was feared and mistrusted, he remained more popular than the comrades of the party's liberal wing.

Most important decisions were made within the party euphemistically called the Communist League. Here the merry-go-round principle applied. When a cadre completed a term at a particular level of authority he would be promoted to the next level. Eventually, the only position left would be the highest level of all. The only trouble was that no one was elected twice and the mandates were absurdly brief. It was a dictatorship without a dictator. It presupposed a dictator. It needed one but nowhere in the top ranks of the leadership could such a man be found.

The president of the Yugoslav presidency's mandate lasted for one year. This was followed by retirement – a cabinet without visitors, an aged secretary, dead phone lines and a driver-supervisor. Presidents had no power whatever. Little was done; it was assumed that Tito's lingering cult was still sufficiently powerful to maintain order. The army operated on the same basis, as did the police. Even the Communist League's reports were reproductions of old ones, and the Second News continued to come on the air at half past seven every evening.

In Tito's time the power structure had resembled a pyramid with Tito at the top and everyone else below, organized in a party–bureaucracy–army–police hierarchy. The pyramid protected those who were part of it. After Tito's death, only a skeleton of the pyramid remained. Power had spread to the republics and provinces and to party forums where cadres were trained to exercise more permanent and decentralized roles. No one was in any great hurry, no one was particularly afraid of anyone else. Cadres

understood the central fact that they exerted more power in their republics than they could hope to do at a federal level. After all, even if they reached the presidency they could only remain in office for a year.

Theoreticians and practical politicians were convinced that a new Tito was impossible. Given the country's fragmentation and decentralization of control no single individual could hold power and sustain Yugoslav unity. The comrades expected the monotonous wheel of collective rule to keep turning indefinitely and without incident. Each individual among them could acquire a part of that power for a while, but no one could have all of it all the time. An unlimited mandate was out of the question.

Caught as he was in the merry-go-round, Ivan Stambolic left his position as president of the Serb party and took over the Serbian presidency. His protégé Milosevic, following loyally in his footsteps, now put himself forward as a candidate for the Central Committee of the Serbian Communist League, whose membership was the largest in Yugoslavia.

Party elections were a formality with everything decided beforehand among the candidates to such a degree that predictions of the vote could be made several years in advance. On this occasion, however, something unusual happened. The majority of the Serb Central Committee was found to oppose Milosevic, a man who spent time with a small group of orthodox Marxists (friends of his wife) whom the higher echelons frowned upon. Ivan Stambolic stepped in to save his protégé. He laboured manfully for three successive nights to convince his comrades of Milosevic's merits. 'Comrades, this is his last chance. If he is not elected, he will have to leave politics. What should we do with him then?' This was a turning point for him; had he not been levered into power on this occasion Milosevic would have disappeared from political life. Without the support of the nepotistic system he would have been unable to progress. In the end, with the comradeship and help of Albanian and Vojvodina representatives (who did not see him as a potential enemy or executioner), Milosevic won by the smallest majority in the history of the Serbian Communist Party. Countless forced votes made the advancement of his career possible, beginning a process that would end in tragedy.

In the Soviet Union, events were unfolding in a way that ran directly counter to Marxist theory. Mikhail Sergeyevich Gorbachev, the protégé and disciple of the brilliant KGB master Yuri Andropov, was turning his back on communism in favour of *perestroika* (restructuring) and *glasnost*

(openness). Communism was losing its ideological grip. Marxism, which had been trusted for so long as a universal alternative to reality and the vagaries of the human imagination, was in terminal decline.

The future for East Germans, Poles, Czechs, Hungarians, Romanians, Bulgarians and Albanians was uncertain, to say the least. However, the communists of Serbia, who had been politically independent of Moscow for decades but had preserved close ties of friendship with the Soviet Union, desperately hoped that the tide would again turn in favour of the old ways. For these reactionaries Slobodan Milosevic's arrival on the scene was providential. He was perceived as broadly anti-Gorbachev, with a version of *glasnost* that might yield different results and would, it was hoped, prevent too much *perestroika*.

Some of the older communists still clearly remembered the soviets issuing orders to the Communist Party of Yugoslavia in the 1930s to destroy the collective state and carry out national revolutions in Croatia, Slovenia, Bosnia, Montenegro and Macedonia. No such revolution was proposed for Serbia, for it was the power base of the great hegemony and in any case Belgrade's pre-eminent status stood in direct contradiction to the Soviet model. According to the peculiar logic of the Comintern, the Communist Party of Serbia did not officially exist before or during the war. Instead, it was secretly established in 1945 in Belgrade, a city it already controlled. Despite being the most recently established of all the Yugoslav communist parties, the Serbian party had by far the largest membership in the Yugoslav federation. By the end of the 1980s the party had ceased to exist in any meaningful way everywhere but in Serbia, where secrecy was its defining characteristic. There it behaved conspiratorially, even in times of peace. With the coming of *glasnost* illegal activists finally had another chance to work in the shadows, hidden within their closed circles.

The Serb Academy of Arts and Sciences[3] was a public institution and a cauldron of political intrigue. Its membership consisted largely of dis-illusioned communists and hardline nationalists. They were paid by the government, did not declare their incomes, took sabbaticals, used public transport for free and viewed themselves as a potent threat to the regime. They were careful to leave no written trace of their activities. Among themselves they reasoned that a Croat had ruled Yugoslavia for 40 years and there was no reason why a Serb should not do the same for the next 40. What was more, the defenders of the system as well their opponents took it

for granted that dictatorship was the only possible form of government in Yugoslavia.

Where was the Serb who could follow in the famous Croat's footsteps? Most experts expected Dobrica Cosic to be the man. This nationalist writer (once a party writer, even a contributor to one of the Communist League programmes) responded to the rumours with extreme caution, for he both welcomed and suspected the proposal. He made it clear publicly that he always had and always would serve his people. He also stated that the creation of a new Yugoslavian state led by Serbs was a task for a younger, stronger and healthier man than he.

For nearly twenty years a text had been under preparation to spell out the essential 'directives' for the 'Serb national question'. Some people claimed that the text did not exist but that it might one day be written; others suggested that it did exist but had already been banned, while still others thought that it was in the process of being written or that it had never been mooted at all. This much-discussed work finally appeared in the form of a memorandum,[4] extracts of which appeared in the major national newspapers in late 1986.[5] Academics would have nothing to do with it; they pronounced it a work-in-progress and therefore, officially speaking, non-existent. The document approached Yugoslavia's wretched economic condition from a hardline Serb nationalist viewpoint. It was a mixture of nineteenth-century ideals of state formation, historical fantasy, distorted facts, historical anachronisms and wildly ambitious nationalist aspirations. Despite the vehement eccentricity of its style and hypothesis, the memorandum greatly impressed the Belgrade intelligentsia. The 'Serb national question' had finally been raised. This fact in itself was sufficient to encourage its authors, who concluded that the search for a politician who could 'carry out the work' could now begin.

By December 1986 the memorandum (which had by now acquired mythical status) was already provoking political conflicts, both in public and behind closed doors. The communists were deeply concerned that some shadowy power was demanding a 'partnership' with them in order to 'create a new centre of power'. Ivan Stambolic proclaimed that, 'The Memorandum is an *in memoriam* for Yugoslavia,' but he offered no suggestions on how it might be thwarted by democratic means. Democratization needed to be stepped up in Belgrade and throughout Serbia; it was crucial for the survival of the shared state. Other communists made

their criticisms heard just as clearly as Stambolic, though by naming nobody in particular they did so with just enough ambiguity to protect themselves. Milosevic remained outwardly non-committal, but it was rumoured in Belgrade that serious differences of opinion regarding the 'national question'[6] had arisen within the Serb party.

Other rumours were also spreading. Pressured by the Albanians, the Serbs were beginning to leave Kosovo, selling their houses and land at prices determined for them. Serb women were raped, cemeteries demolished and monasteries set on fire. Reports of these events soon started to appear in the media. Serbs were being threatened in the very heartland of Serb culture and tradition. Who would take charge of the new democracy now? Serbs in Kosovo had organized themselves into a group led by former officers and policemen and accompanied by smaller groups of mixed ethnicity. They signed petitions and asked for protection, but Serb politicians in Belgrade paid no attention to them. When they arrived in the capital they were given empty promises and sent home. A delegation of leaders was sent to the southern province to resolve the situation.

On 27 March 1987 Milosevic attended a rally in Kosovo Polje, a suburb of Pristina inhabited by Serbs. During the rally, the mostly Albanian police attacked the Serb demonstrators with truncheons. Milosevic shouted: 'No one has the right to beat these people! [They] ... will never beat you again.' As luck would have it, at that particular moment the state TV network's cameras were trained on Milosevic's angry figure. A far larger audience heard the voice of a leader echoing the frustration of the masses and was impressed. A month later, the magazine of the Serb Literary Association published some verses by a Serb poet from Kosovo: 'A beautiful young speaker appeared/The setting sun shining on his hair/Saying, "I will speak to my people come rain or shine".'[7]

Milosevic had been thrust forward, almost inadvertently, as a candidate for the post of national leader. On the same night he was delivering his speech to the Serbs of Kosovo Polje,[8] Stambolic was attending a concert of old-town songs in Belgrade's famous Skadarlija. That summer he took his family holidays in peace: he had effectively withdrawn from the fray. In the meantime Milosevic was gathering support. Thousands of provincial cadres passed through his office. They came in as communists and left as nationalist communists. The details of Milosevic's programme were unimportant; what really mattered was the arrival of a leader.

By the autumn everything was in place for the removal of everyone who had shown support for a multi-party system, economic liberalism and the surrender of power by the party. Knowing that the conservatives represented an overwhelming majority in most forums and party bodies, Milosevic established himself as their leader and launched his first open attack. The first target was Dragisa Pavlovic,[9] Milosevic's successor as the president of the Urban Committee of Belgrade, a liberal with modern ideas who was struggling to restore order in the fractured organization left behind by Milosevic. Pavlovic disagreed with Milosevic's statements to the Serbs in Kosovo and referred to them as *Quick Change, Easily Promised*,[10] the title of his book. These four words enraged Milosevic, who identified both a pretext for action in Pavlovic's critique and a potential scapegoat in Pavlovic himself.

Yet the real target of Milosevic's attack was Stambolic, the sitting president and the final obstacle between him and the acquisition of full power. Stambolic, convinced that his protégé would never dare to under-mine him, seemed not to notice. The eighth conference of the Central Committee of the Communist League of Serbia was pending (summer 1987) and was expected to be yet another monotonous party ritual.

However, this particular conference proved different – it was held in public. Belgrade television covered all three days of the meeting, which continued late into the night and metamorphosed the conference into a real political process. Such indictments as, 'Pavlovic supports the desecration of Tito's name and image and opposes a resolution of the conflict in Kosovo' emerged from the session. Except for eight members who refused to compromise their opinion, all members of the party voted against Pavlovic, who was summarily removed from his post. More importantly, Stambolic was humiliated by the public display of his powerlessness. The party still controlled the state. A few days after the conference party activists asked for Stambolic's resignation as president of the republic, claiming that he had 'lost the trust of the people'.

There was nothing for Stambolic to do but to abandon the post to which he had been legally elected. He did not attempt to fight back. Over the next few months a retired general, Gracanin, who had been a butcher's assistant before the revolution, acted as caretaker president of Serbia. He was replaced at the next elections by Slobodan Milosevic (1989), the man who had finally made Serbia 'leader-free' in the words of one of his supporters.

Milosevic was the last leader of an exhausted party and the first leader of a new nationalist regime.

Career politicians in Yugoslavia were stupefied. Slobodan Milosevic's victory had been astonishingly fast and easy. There had been no resistance. Prior to the conference the liberal faction in the Serb party had looked strong enough to win power, or at least to balance the hardline communists. Now it was clear that there were in fact very few true liberals and that they had no support, either inside or outside the party. Tito's purges in the 1970s had eradicated most of them and those who remained were of mediocre quality – men who did not believe in communism but could see no viable alternative. Now these too disappeared from the political scene and Milosevic was free to concentrate on the 'Serb national question'.

Milosevic owed his rise to power not to chance but to careful work behind the scenes. He was chosen and recommended to the party, the army and the police by someone else; that someone was his older brother Borislav, a professional policeman and amateur diplomat. Borislav had spent a year in Moscow undergoing secret police training and was almost certainly connected with the KGB. Many people in Yugoslavia had been through training like this and shared similar Stalinist, Slavophile and orthodox convictions. While academics had been writing the memorandum, these conspirators were being trained to carry out its dictates. Borislav had introduced his younger brother to the endangered men in power and had vouched for him. The secret circles understood that Slobodan had the potential to help them keep their power. Slobodan understood that by winning the trust of these men he could gain access to the power so coveted by his wife and himself. Soon it would be the younger brother's turn to take the leading role.

Throughout this time, Mirjana Markovic, as an ordinary member of the university committee, remained unknown and almost invisible to the general public. She had completed her anthropology doctorate in the faculty of Nis, a plain woman who wore no jewellery but liked to decorate her hair and shoes with plastic flowers. Her name had only once appeared in the newspapers over a debate on Marxism as a special subject in schools. Professor Markovic's argument was that Marxism was the 'brightest hope for the future', whereas many others were of the mind that the subject should form no more than one topic in part of a philosophy course.

'Comrade Markovic' made no effort to conceal the interests that distin-

guished her from other politicians' wives. She did not stay at home. While her husband waited in other people's anterooms she gathered supporters around her, mostly members of university party organizations, anonymous professors or students. They included Slobodan Unkovic with his freshly dyed hair, Zeljko Simic, a handsome man who had divorced after his first marital night, Zoran Todorovic and dozens of others. It was only after the victory at the eighth conference that these people came into the public eye. Scandalous rumours were spreading throughout Belgrade – Slobodan's wife had countless lovers, a male harem. She was hailed as the Messalina of the small committees. In reality, the truth was much simpler. Mirjana had indeed surrounded herself with younger men but her only relationship was with her husband. Her retinue were Marxists, ready to follow their leader and support her husband. They gathered round her like iron filings around a magnet. Her attraction lay in her household's power.

The Milosevic–Markovic family revealed nothing of themselves to the outside world. At home they lived and worked behind a veil of secrecy. Formerly, in a careful attempt to preserve the impression of collective rule, decisions had been reached after long deliberations among the party luminaries. With Milosevic's accession, a new system was put in place. Party and state forums lost their significance. Power was suddenly in the hands of the president alone and he carried it home after work to place it at his wife's disposal. Representatives or members of government no longer needed to ratify decisions; they were all made in the privacy of the Milosevic household. Those interested in advancing their careers, protecting themselves and destroying their enemies needed above all to secure a personal relationship with the mother, the father or the now grown-up children of this household. Gaining access to 'Sloba and Mira' was not difficult. Directors, ministers, ambassadors, editors-in-chief, heads of secret agencies and football club trainers all passed through the family living room, for advice, promotion or chastisement.

The Milosevic–Markovic couple refused no one. Anything that served their purpose was good. Unlike their predecessors, they did not condemn nepotism. On the contrary, the way to success ran through this newly famous family's front hall and was won by private talks with Mirjana or Marija, or by visits to clubs and car races with Marko. Slobodan accepted anyone his wife and children recommended, even those who had (or might have had) a compromising dossier with the police.

Several months after Milosevic assumed power, his car spun off the road and flipped over. No one was hurt. Though unharmed, his wife became hysterical and claimed there had been an attempted assassination. This was not reported in the media; the police who examined the scene found nothing suspicious and concluded that the tyre had accidentally exploded. Nevertheless, Markovic demanded an inquiry and the swift punishment of those responsible.

Not long after, in 1990, Ivan Stambolic's daughter died in a car accident on the coast of Montenegro. The circumstances were never made clear and media reports were brief. At the funeral, Stambolic's wife refused to accept Slobodan Milosevic's condolences and responded to his outstretched hand by saying, 'Have you no shame?' No one reacted among those present. Not a single line moved on the new leader's rigid face. He already wore the famous mask that revealed nothing; and again the incident went unreported in the media. Markovic did not attend the funeral, despite having known the girl well. She was too preoccupied with the move from the Milosevic apartment near the Kalenic market into their new villa at Dedinje. For security reasons, the old wall surrounding the villa was strengthened and a new one was built. The family needed to be hidden from curious onlookers and neighbours – from admirers as much as from enemies.

Meanwhile, corrupted by an elaborate web of privileges great and small, Belgrade's intelligentsia found ways of tacitly cooperating with the power base. Its members enjoyed the advantages of a political elite and moved in exclusive cliques, safe among their peers though resentful of their minimal role in government. Their ranks contained no authentic dissidents, revolutionaries or heretics, or indeed any real liberals or democrats. Their tameness ensured that Milosevic's system would remain unchallenged. Their cooperation with the new government was natural and inevitable.

And yet, though perhaps unaware of it, the backing of the intellectuals was vital for Milosevic. They supplied him with the same powerful image that had been the foundation of Tito's cult; the only difference was the identity of the icon. Their very presence and support helped to market him successfully, just as they had marketed Tito's irresistibly seductive image.

Once Slobodan Milosevic's grooming was complete, he was ready to be presented to the masses. The response was immediate. He was the answer to their prayers – a saviour they could follow blindly.

Chapter 4

'Kosovo is the Equator of the Serbian Planet'

There was no significant opposition – by proclaiming the need to preserve the dictates of the old regime Milosevic reassured everyone with a stake in the bureaucracy, including the intellectual class. The next target was the passive bulk of the nation, which could be reached through the media. Whoever controlled the media ruled the conscience and will of media consumers; Milosevic aggressively set out to do so, replacing editors-in-chief and journalists who failed to declare their support with others willing to toe the line. No single media institution in Belgrade was spared and not one single editor. All information was controlled from the Milosevic family villa in Dedinje, whence all media directives emanated.

Dusan Mitevic, a friend of the Milosevic family and the journalist who described the 1981 demonstrations in Pristina as 'a job for the glaziers', was appointed director of Serbian radio and television. In his hands, propaganda and the manipulation of information found a new lease of life. All the skills learnt from communism were now at the disposal of a post-communist leader who was prepared to make full use of them.

Mirjana's dream had come true. Her husband was head of the biggest Yugoslav republic. He had no specific programme, either economic or political, other than to preserve power for himself. His knowledge of economics was limited, but oil had been found in east Serbia, the home of their childhood. Serbia had previously been dependent on other countries for its oil needs. Milosevic made a stirring televised speech at the opening ceremony for the first well, proclaiming that there would be sufficient reserves not only for Serbia's domestic needs but also for export. 'Modern Serbia', he added, 'will provide the equivalent of $10,000 income for each one of our citizens'. He was cheered wildly.

Milosevic's strategy offered Belgrade and the world an anti-bureaucratic revolution in the name of the people. It resembled Mao's Cultural Revolution – and Mira ensured the perpetration of this illusion. Milosevic's revolution was personal, not ideological. Anti-bureaucratic revolutionaries would replace the bureaucrats who opposed Serbia's new leader. All the country's newspapers, with the exception of the federal newspaper *Borba* (The Struggle)[1] supported Milosevic's attacks and condemnations. Although these were often contradictory, they were always successful. A hunt for dissidents began, unlike any seen since the postwar party purges. Three-man teams moved around Belgrade and other cities in Serbia interrogating and judging the accused. Their victims did not complain. Even those who opposed the regime were conditioned to accept that a party decision was irrevocable. There was no appeal.

Despite the vagueness of his politics, Milosevic exerted a wide and magnetic attraction. Friends and foes, from the citizens of Belgrade to the immigrant Serbs of Chicago, rallied to the call of Serb unity. Throughout this period, Milosevic kept mostly to himself at home, letting the propaganda machine do his work. High walls surrounded his villa and the public rarely saw him.[2] He preferred to be above the fray.

To anyone remotely interested in politics, Milosevic was the new saviour. Old communists believed that he would perpetuate socialism and restore it to its original, ascetic beginnings. Hard and soft nationalists alike, ranging from academics and artists to patriotic groups and workers' clubs abroad, insisted that he was first and foremost a Serb, whose ideology was subordinate to his identity. The Orthodox Church saw him as a secret believer who would return their nationalized assets and give them a leading role in the state of the future. Former dissidents claimed that he would liberalize public life. Anti-communists and other members of the middle class were convinced that he would eventually show his true colours and represent their cause. Monarchists hoped that he would reinstate the monarchy and return the Karadjordjevic[3] dynasty to the throne. The central committees of the other republics believed that they were finally free of Serb nationalism because Milosevic had removed all Serb nationalists from power. In short, each group believed what it wanted to believe of him, whatever the contradictions.

As the media propagated the Milosevic myth, he himself remained in his villa, where he continued to receive visitors. By taking advantage of other

people's ambitions, Milosevic promoted his own. He extended his hospitality to anyone except the liberals, anti-nationalists and pro-Westerners who wanted his support as little as he did theirs. This small minority viewed Milosevic as an arrogant manipulator and incompetent leader who would destroy everything that had been created in Yugoslavia and in Serbia. For his own part, Milosevic feared their capacity to see through and understand him, and he did his best to degrade, humiliate and restrict them. One of his most prominent characteristics was his abhorrence of other people's success. Successful individuals aroused his resentment and fury and would often find themselves approached by one of the many three-man 'working groups' whose enquiries would inevitably lead to a forced retirement or a dismissal. Strikes might even be strategically supported by the new regime with a view to provoking the resignation of successful executives.

Behind the smokescreen of nationalist and revolutionary rhetoric he was preparing the 'theft of the century' – the privatization of state property with him as sole proprietor. He had positioned his loyal executors at all levels of the infrastructure, in banks, firms, ministries, police departments and law courts, and they were now poised to act.

The Republic of Serbia's economy had suffered much in consequence of socialist policies. By remaining faithful to the land-ownership laws installed by the 'Serb Revolution'[4] of the nineteenth century, the country had shackled itself to an economy of rural agriculture and industry. It was predominantly a peasant society, lacking an aristocracy with large estates, libraries and art collections. Under Tito, Serbia's industrialization had a single ideological goal: to provide employment for the masses by building large factories. The working class, caught between its rural origins and its metropolitan aspirations, was seduced by the prospect of a consumer society. The managers of the new factories demanded more and more state funding as productivity dwindled. For the state to maintain power and social stability, it had to pump money into industry. But where could the necessary loans be found? Former creditors no longer trusted the new government. The only place left to look for capital was among the people themselves. However, instead of keeping their money in banks, the great majority kept it at home as a provision for the future.

Milosevic had several associates at the Bank of Belgrade who now began to play a more prominent public role. M. Zecevic, a French citizen

and the director of the Yugoslav–French bank in Paris,[5] proposed a 'Loan for Serbia' nationally and abroad with the hope of raising about four billion dollars. If this loan proved successful it would start a 'new production cycle' to improve the prospects of industry. Serbia would become the richest republic in Yugoslavia, the most powerful Balkan nation and a major European player exporting its own anti-bureaucratic revolution to other continents.

The media set about persuading people to deposit funds in the national banks as a gesture of support for the economy. Countless long-term social and financial rewards were promised, and features appeared in magazines about investors who had made huge profits. The campaign was so successful that old ladies started taking their jewellery to the bank. Rich Serbs from abroad were thanked on television for their donations to the domestic cause. Artists offered their works to be sold at fund-raising auctions. Musicians composed songs to herald the new era of prosperity and poets wrote of a new dawn, as they had done under Tito. Groups of delegates left the country to collect contributions from Serbs abroad. As the sums collected were never recorded officially, it will never be known how much of the money went into the agents' pockets. What is certain is that by the end of this fund-raising process, very little of note had been achieved and the media dropped the subject. The focus was then shifted towards attacking the federal government.

Meanwhile, the new Serbian president's first economic action was kept hidden from the public eye. Large sums had been raised, but they remained unaccounted for. Investors did not try to find out what had happened for fear of discovering the truth, and those who were simply curious found that no one dared answer them truthfully. In short, the 'Loan for Serbia' was a complete failure and proved that Milosevic was not a leader who might be relied on to deliver economic stability. He himself was unconcerned. His priority was to rule, not to govern. If he could solve historical and national issues he would keep his popularity and distract the people from economic concerns.

Between the two world wars, the Serbian Orthodox Church began to build what was hoped would be the greatest Orthodox place of worship in the world – the Saint Sava temple at Vracar where the Turks burnt the remains of the last Serbian saint in the sixteenth century – but the building was never completed. Once Milosevic had 'restored the dignity of the

Serbs', it was decided that work on it should resume. Milosevic had formed close relations with church militants and the clergy were encouraged to raise money for the project at home and abroad. To assist in this process, the term 'Serb diaspora' was redefined as 'dispersed Serbs' to include anyone with even the remotest Serbian descent. But events unfolded in much the same way as they had with the Loan for Serbia. An increasing number of intellectuals with religious tendencies travelled to wherever there were 'dispersed Serbs' to read poems, sing songs and generally help the cause by selling books and collecting cash donations for the Belgrade temple. Once again no receipts were given for these donations and individual patriots, as before, pocketed much of the money. Nevertheless, the project went forward apace; priests came to bless the site of the great church and construction work resumed.

In 1389, the last remaining obstacle to the Ottoman advance on the Balkans was removed when Prince Lazar Hrebljanovic and his allies lost a decisive battle against the Turks in Kosovo. Within 60 years the Turks had gained complete control of the area, which they dominated for the next five centuries. The grandeur of the old Serb state lived only in people's memories, in folk songs and in traditional liturgy. Prince Lazar became a mythical figure, the righteous prince who had chosen the celestial over the terrestrial kingdom. During the formation of the state in the nineteenth century, the legend of Prince Lazar was evoked to demonstrate the virtue of Serb people willing to sacrifice their lives for the higher ideal of a celestial kingdom. Without the slightest hint of irony Milosevic later referred to the Serbs as 'the celestial people'.[6]

At the beginning of the twentieth century Kosovo was once again in the hands of the army. Having been displaced for centuries, Serbs now found themselves in a minority to the Kosovo-Albanians who considered themselves native to the Balkans and the descendants of Illyrian tribesmen. The pendulum of Serbian–Albanian relations alternated between periods of peace and periods of war. The cause of conflict was always the same: an aggressive unwillingness to coexist, fed by nationalist propaganda from both sides. No government ever came close to resolving this issue. The idea of a Greater Serbia was just as current as that of a Greater Albania.[7] Serbs

and Albanians were regularly displaced to different countries, creating much resentment. Eventually, it became clear that the only solution was to create not one but two enlarged states, but the trouble with this was that both sides considered Kosovo to be their sacred homeland. Tito tried to solve the problem but was hampered by the identity of his own power. He could not yield land to the Albanians because it would threaten the very foundations of his own status as all-powerful ruler of the Yugoslav people. In his time, democratization was a strictly controlled process guided by him alone. Despite its pragmatism and flexibility, Titoism had little use for any genuine openness.

When his time came, Milosevic promised to solve the province's problems overnight. His conditions were that all power was to be assigned to him, that his enemies be removed from power and that no mention of democratization be made on the grounds that it was anathema to the 'Serb national temperament'. In a speech, he proclaimed that:

> *There remain a small number of fanatics who still dream of altering borders, of allowing Kosovo to separate from Yugoslavia and join Albania. I will ensure that these dreams never come true. Serbia will never let Kosovo go; those who hope it will are not only fighting in vain but also exposing themselves to tragic consequences. They will never succeed because Kosovo is Serbia's rightful heart.*[8]

Milosevic's plan was to ride the nationalist wave he had first witnessed on that famous night at Kosovo Polje. Thousands of Serbs from Kosovo demonstrated in the cities of Serbia, mainly led by ex-policemen and retired soldiers. The Socialist Union, an organization that performed certain specific functions for the party, was in charge of organizing these demonstrations in the cities.

The protestors were welcomed by troops of workers who had been given the day off, along with farmers, government employees and students who chanted slogans and brandished posters of Milosevic surrounded by his followers Jovic, Ckerbic and Kertes. People sang, shouted and threatened. The media described these events as taking place amid 'calm and decorum',[9] claiming that the slogans chanted at these demonstrations were all 'spontaneous'. Their message, however, could be summarized in a single slogan: 'We will not let the West introduce democracy in

Yugoslavia.' The biggest demonstration of all was held in Usce (near Belgrade) in November 1988, when approximately one million people turned out to show their support for Milosevic. I was present at Usce, and among the thousands of demonstrators I happened to notice a handsome, well-dressed, middle-aged man with a banner proclaiming: 'Long live me!' I never saw him again and can only guess that, like so many others who dared to differ from Milosevic, he vanished in the ensuing maelstrom.

But there were other issues at stake. Under pressure from the demonstrators, the incompetent leaders of Vojvodina and Montenegro were sacked and replaced by new people.[10] By taking control of Vojvodina and Montenegro, Milosevic had acquired 50 per cent of the votes within the Yugoslav presidency. Previously, no decisions could be made within the collective presidency because voting always reached stalemate with the eight factions split evenly down the middle. This paralysis would finally change as Milosevic now represented Serbia, Montenegro, Vojvodina and Kosovo, thus assuring the greatest percentage of support. The very dysfunctional nature of these federal organs worked to Milosevic's advantage. With three regional presidents under his thumb, Milosevic ensured control and maintained the stalemate. One of these presidents was the Albanian, Sejdo Bajramovic,[11] a retired non-commissioned officer who had once worked as a bingo compere in the café of a small football club. The incompetence and inertia of the collective Yugoslav presidency allowed Milosevic to pursue his nationalist fantasies unchallenged.

With this tactic Milosevic was not attempting to prevent further damage to the federal presidency but rather to give himself time and space to allow the propaganda to present his 'counter reforms' in a positive light. His standard technique was to blame others: if money was lacking, for example, it was because others were stealing from the Serbian people. Milosevic's long-term plan was to rally the fragmented Serbian minorities outside Serbia and turn them into a majority, thus ensuring that non-Serbian minorities all over the country would remain exactly that. There would be no Gorbachevism in Yugoslavia, or any Western-style democracies. Instead, the Marxists who supported the new leader advocated another form of social structure – party-less pluralism.

Serb nationalism was highly aggressive compared with the nationalisms of Croatia and the rest. Nonetheless, the demands it could make were limited, for outright invasion was impossible at this time. 'They are free to

make their own little states once they give back what is ours,' said Dobrica Cosic. He added ominously that 'a price must be paid for independence from Yugoslavia.' The opponents of Serbia were indeed offered certain elementary rights on condition they accepted 'Serbian demands'.

The true face of Serbian nationalism was revealed in the case of the Albanians, who were essentially denied the right to exist within Yugoslavia. Serbs spoke of uncivilized, poverty-stricken *Siptar*s – a pejorative term for Kosovo Albanians – who had too many children, refused to pay their bills and taxes, avoided taking part in censuses and were sworn enemies of the Serbs. They were seen mainly as refugees who should be sent home. '*Siptar*s owe the land on which they live, the name they carry and half the language they speak entirely to the Serbs' was a common Serbian refrain. These prejudices were made worse by ignorance: almost no Serbs spoke the Albanian language and they were generally oblivious of the history, traditions and culture of the Albanian people.

Milosevic's propaganda complicated the Kosovo question. By manifesting the extent of their racism, the Serbs showed that they were uninterested in a peaceful resolution to the problem. Talks ground to a halt and it became clear that the matter would only be resolved by force. Vasa Cubrilovic, a historian and academic, had written in a secret memorandum of 1937[12] that 'the question of Kosovo should offer no cause for concern. If the Germans can expel tens of thousands of Jews from their country, and if Russia can move millions of people from one part of the continent to another, we should be able to transfer a few hundred thousand Albanians without provoking another world war.'[13] Conflict at this stage would have been impossible, so the plan to expel the Albanians from Kosovo was postponed. What had become clear was that the old nationalist fantasies had re-emerged with a vengeance in the Serb psyche, encouraged by the direction that politics were taking under Milosevic.

During this period Milosevic did not express any personal hatred of Albanians. As ever, he was above such things. He merely manipulated feelings that already existed in the collective unconscious to strengthen his own position and, in doing so, embarked on a trail of brutality that could have only one outcome. To supply this new set of 'quick changes easily promised', Serbian military and police departments were established in Kosovo and approved by the collective Yugoslav presidency. The central committees of other republics accepted the argument that this was 'Serbia's

internal problem' in the hope that their approval would placate Milosevic. The right to autonomy for the Albanian national minority (which in Kosovo was a definite majority) was retracted. Only the liberals stopped to consider the grave implications of removing a people's rights in the name of democracy. The majority merely celebrated a 'historic event'[14] without regard for the consequences.

Pro-Yugoslav Albanians were removed from public office; Azem Vlasi, the last communist president of the Autonomous Province of Kosovo, was arrested and, as demonstrators at a Belgrade rally demanded, charged with high treason. An opportunity now arose for an Albanian nationalist leader to confront Milosevic. The man was Ibrahim Rugova, a poet, essayist and apostle of non-violence. Rugova was also an Albanian nationalist who refused to recognize the Serbian government's authority over Kosovo and planned to create a state within a state. At illegal elections, which Belgrade banned but did not prevent, Rugova was elected president of the 'Republic of Kosovo' with 97 per cent of the votes.[15]

Milosevic's propaganda machine may have portrayed him as a wise, far-sighted statesman, but in fact he had no real qualities. Tragically, it must be admitted that most of his official opponents resembled him and imitated his tactics. His *modus operandi* as a politician demanded an equivalent politician to oppose him, so he could present himself as the sole defender of the Serbian people's rights. His position encompassed that of old communists, soldiers, policemen, bureaucrats, pensioners, nationalists and clergymen of the national church. Given the breadth of support he enjoyed, and variety of opinions he sustained, he was not wrong when he proclaimed that, 'Serbia will be whole, or it will not be anything at all – fulfil my wishes or I will destroy everything.'

In 1988/9, 'unified' Serbia resembled a shop window with only one item for sale – a photograph of a grim-looking man with a smooth face, grey hair, blue suit and blue bow tie. In the picture, Milosevic's brow was serenely unfurrowed and his gaze was fixed on the middle distance. The image could be seen everywhere – on cars, trucks, buses, trains and walls of houses, in cafés, pawn shops, schools and universities. Old women kept it next to candles and icons of saints. Younger women carried it in their purses next to their make-up and love letters. Churches sold it together with the icons of Saint Sava. Milosevic had made himself far more than a president in the minds of his supporters. One author and a later member of

the Academy wrote of the 'passionate outcry of the nation's soul: Sloba-Sloboda'. In a frenzy of blind belief, the masses chanted these two words. The real man had vanished overnight to be replaced by a myth. In Montenegro, people sang 'Slobodan, even though you're a communist, I'll love you as I love Jesus Christ.' The singers looked up to heaven to the celestial kingdom that was finally open to them. They genuinely believed that theirs was the oldest civilization in the world.[16]

The use (or misuse) of the word 'people' is intended neither to offer a conception of a people nor to show respect for a given population. The same goes for terms such as 'history' or 'tradition' that are derivatives of the word 'people' in the language of propaganda. The aim is to create a mass of people that is shapeless, apathetic and ready to listen. Once the mass is created anything is possible: the overthrow of one power, the establishment of another, social change, revolution, street revolts, the stagnation of an existing order, the killing of neighbours, rape, theft, violence against children, drunkenness and the entertainment of millions of people.[17]

Elias Canetti attributes four characteristics to 'the mass':

1. The mass continually wants to grow.
2. Equality reigns within the mass.
3. The mass likes to be compact.
4. The mass needs a direction.

All four characteristics are perfectly discernible in Milosevic's rise to power. A fifth characteristic could well be added, namely that 'the mass searches for victims.' It searches for – and requires – victims but it does not choose them. Someone outside the mass must perform that role. Only then does the mass identify its target.

Having prepared the mass, Milosevic's politics consisted mainly in identifying victims. Although the identity of the victims would change, hatred of them would continue to grow, since Milosevic's nationalist ideals could never be realized. The Serbian national question was, and has always been, insoluble. In a sense, this is one of its greatest attributes, for it is

eternal – a quasi-mystical political quest. Generations to come will have to face this issue and suffer its consequences.

On one occasion Milosevic really did descend from the heavens, at the celebration of the 600th anniversary of the fatal defeat at the battle of Kosovo (28 June 1389). Nationalists have always claimed that the battle was actually a victory and that, by sacrificing themselves, the Serbs saved Europe from Turkish invasion. How could Europe repay them? According to official reports, on Vidovdan (the day of the famous battle that began the eternal war, whose name echoes that of the old Slav god, Svantovid), Kosovo Polje was the site of a gathering of two million people, a fifth of the Serb nation. At noon a black dot appeared in the sunny sky. It was a helicopter slowly preparing to land amid the frenzied mass, where entertainers, musicians, actors and a large church choir stood by. Sloba-Sloboda emerged from a cloud of dust, climbed the 18-metre podium and gave a speech that addressed both past and future battles.[18] People sang 'Tsar Laza, you were not lucky enough to have Slobo by your side.' Much like Milosevic, the masses nicknamed Prince Lazar 'Laza' or *Mali Laza* (Little Laza). None of the foreign ambassadors in Belgrade were there to witness the miracle of the leader's descent among the living, not even the American ambassador. The latter was punished for his failure to attend the ceremony by being refused an audience with the president for a full nine months.

Milosevic was sometimes called the 'American', on account of his early training in the USA. Nevertheless he was not slow to defy America and the New World Order. But he was also associated with the old communist world of the East. The Serbian media called him not only the saviour of the Serb people but also the potential saviour of all humanity – a 'Russian and Chinese man' who could play off East and West to the advantage of his own people. The media assigned him several such contradictory roles. In reality, something very different was happening.

Chapter 5

Building a Belgrade Wall

F rom my diary:

It is the beginning of 1990 and an exceptional congress of the Yugo-slav Communist League is currently underway. The Belgrade media are solidly behind Sloba-Sloboda and his clique and their great patriotic aim is to erase all party disagreements and to recentralize poli-tical power. This is to take place under the aegis of the Serb communists, who take great pains to define themselves differently depending on to whom they are talking. Apart from the communists, this renewal of anachronistic centralism will gain the support of senior citizens, war veterans, the army, the police and bureaucrats – the majority of Yugoslavs – and some national minorities and pensioners. I can see no one who will resist the movement in any organized way.

The anti-bureaucratic revolutionaries' noisy attacks have proved fruitless. In fact they have exacerbated the disintegration of the once centralized party that ruled alone here for decades and that is now paying for its errors. The bits of it that have won some independence are refusing to accept the restoration of a single command centre. Meanwhile, the brutality Slobodan's people have shown has set an ominous example to other countries in the federation. The Slovenian delegates have walked out of the parliament, followed by the Croatians. The Macedonians and Bosnians are confused – they do not know where to stand on this shifting ground. Only the Serb and Montenegrin delegates remain in the chamber, exulting in their

triumph. Neither back-room negotiations nor threats can change anything now. The congress has been called off and will only resume after 'views have been reconciled'. Of course it will never resume. It is too late. All this should have been done years before when the old dictator died. The topsy-turvy barricade of nationalism has already blocked the paths to freedom.

After the congress, Federal Prime Minister Ante Markovic tells the cameras: 'Yugoslavia will live on, even without the Communist League.' Markovic shows no regrets but he is not smiling either. It sounds like a statement that will go down in history. But whose history is it? Here, it seems to divide into sub-histories, which will in turn spawn sub-sub-histories. Of course a state may survive without one of its political parties, but only if its citizens agree on the idea and are willing to defend their rights. In this country too many nations have reawakened recently, and too few citizens understand what has happened. The crowds furiously attack Yugoslavia, their own state, for denying them the right to 'express their national feelings'.

Serb leaders agreed with this. Borislav Jovic, a Milosevic man and the incumbent of the Yugoslav presidency, noted in his diary on 26 March 1990: 'A process similar to the disintegration of the SKJ (Communist League of Yugoslavia) is affecting Yugoslavia itself. It seems unstoppable. Serbia will carry out its duty to ensure the survival of federal Yugoslavia while preparing for a future independent of the mother country. If the country does indeed disintegrate, we plan to unite with Montenegro. We will not appeal to Macedonia. If the Macedonians appeal to us they will have to make an apology for the sins they committed against the Serbs during the First World War. Our aim is to avoid a bloodbath and to establish borders within which there will be no fighting. Outside that border war will be unavoidable since Bosnia-Herzegovina will be unable to survive as a state, and a battle for territory in which no blood is spilled is hardly imaginable. Serbia will not accept a confederation.'[1]

The consequences of Gorbachevism were spreading across the entire Eastern Bloc, as defined by the Warsaw Pact. Within the space of 12 years, the Soviet empire disintegrated. 'Marxism has been the biggest and most expensive illusion of the twentieth century,' concluded Lazek Kolakovski. The true cost of this illusion has yet to be reckoned.

The first tremors occurred in Romania. Life-long President Nicolae Ceauşescu (known as the Carpathian Caligula) and his wife Elena were found running for their lives from a demonstration they themselves had organized. They were cornered near the airport, taken to a provincial army barracks, tried by a kangaroo court and shot like small-time smugglers against the wall of a derelict building. There were street battles in Bucharest; demonstrators took over the television building and read out their reform programme before the cameras. The world received these images via Belgrade television, Milosevic's propaganda apparatus having decided to broadcast the entire sequence of events.

Neither Sloba nor his followers saw any similarities between the Ceauşescus and the Milosevics. Borislav Jovic said: 'Serbia is not Romania: here the army, the police and the people are on our side.' As a consequence, counter-Gorbachevism developed in Belgrade and with it came counter-*perestroika* and counter-*glasnost*. The word 'class', central to the whole of Marxist ideology, was replaced by the word 'people'. This simple lexical shift was felt to be sufficient, and it actually became compulsory in Serbia. The people in whose name all these changes were being made would in theory have to lead themselves. In practice, of course, this meant obeying Milosevic.

Dobrica Cosic claimed that 'The Serb national question is primarily a democratic question.' He did not explain why the other national questions were not democratic, or how democracy could be attained by way of nationalism. The explanation lies in a statement he once made to an assembly of academics: 'In peace, the Serbs always lose what they have gained in war.' Instead of a permanent revolution Cosic – a former communist – proposed a perpetual war between Serbia, its neighbours and the whole world.[2] He also named the man he thought should lead this war: 'Milosevic is the most talented Serb politician of the twentieth century.' Beckovic, another academic, adds: 'Milosevic has done more for the Serb people than the Serbian Orthodox Church.'

Politicians, scientists, artists, economists, sportsmen and entertainers came like pilgrims to pay their respects to Milosevic. A ritual developed. The visitor would say: 'Thank you for everything you have done for the Serbian people. Thank you for restoring our dignity.' Milosevic would listen intently and when they had finished would dismiss them with: 'The visit is over.' He considered a smile a sign of weakness and politeness the

first step towards a loss of authority. Apologists of Milosevic later went to great lengths to justify his rudeness.[3]

Perhaps the communists who erected the Berlin wall unconsciously believed that their work (physical as well as ideological) would last forever. One world ended at the end of the Unter den Linden Avenue and another began on the other side of the Brandenburg Gate: two worlds that would remain divided and locked in conflict forever. The cold war gave both sides a chance to say: 'They inhabit the empire of Evil, while we reside in the empire of Good.'

In the end, though, the citizens of Berlin destroyed the wall and the police did not intervene. The Warsaw Pact, which had united millions of people in a single ideological federation, backed by a considerable nuclear arsenal, ceased to exist. The single most powerful opponent to NATO – the iron fist of Western defence, also equipped with nuclear weapons – disintegrated. The hardline communist countries were too exhausted by poverty to resist. Polish, Czech, East German and Hungarian leaders surrendered power – or more precisely, lost it – at the first open elections. The handover took place, in these countries at least, without street fighting, civil war or bloodshed. The abandonment of communism had proved to be much less perilous than entry into it. Divided Germany had reunited, but not, as had been feared for so long, to provoke the division of Europe or a Third World War. Reunited Germany hoped to become the foundation of a united Europe.

The great illusion of Marxism was on its deathbed, having cut short approximately 100 million human lives. It had failed either to create an empire of freedom or to destroy the empire of greed. New illusions would soon follow as the politicians left over from the old order sought to remain afloat in these new times. Drunk with its victory in the cold war, the West failed to appreciate the true threat of the small-time Eastern power mongers. Once these leaders were in power they would be treated as legal presidents, even though they behaved like dictators.

In this new era of confusion the most urgent question in Yugoslavia was: 'How do we depart from socialism?' Yugoslavian socialism differed from that of its Eastern counterparts. It was more liberal; it did not have concentration camps or public repression; self-rule meant (in theory at least) that companies belonged to their employees; communist leagues offered a softer version of *glasnost* and the intelligentsia was allowed to

play a part in politics. The person of Tito was sufficiently absent to allow for superficial ideological change, but his legacy was still present enough to ensure that idleness was tolerated and foreign loans continued to arrive. It seemed that the process of liberation would be easier and faster in Yugoslavia – the biggest and the richest of the Balkan states – than anywhere else. Only a few tactical adjustments needed to be made.

This liberation would probably have taken place had it not been for the strong man from Belgrade. He proposed his agenda in the form of a question, which he initially posed to himself and his followers but later to the rest of the world: 'Would it not be preferable to maintain the status-quo in Yugoslavia?'

Milosevic ensured that the media answered this rhetorical question in the affirmative. He insisted that the great priority was the nation and its people and that the national question had to be dealt with before leaping into democracy. He claimed that Serbia was forced into becoming part of Yugoslavia after the First World War and that it had 'paid for this privilege with the blood of its citizens, only to be plundered and humiliated afterwards'. Latent nationalism began to re-emerge; soon, fed by the authority of the new president – who had meanwhile illegally extended his mandate – it grew to alarming proportions. Milosevic used this nationalist fervour to dispose of all the obstacles that stood in his way, both ideological and individual. 'Sloba will sort them all out,' said his new admirer, the film director Emir Kusturica,[4] and indeed he did. Complete homogenization was assured. A critical mass of nationalists had been created – with Milosevic at its core – to lead Yugoslavia into the new era. Yet, whereas the other aligned eastern European states were heading, at least nominally, towards democratization, Yugoslavia was developing a form of nationalism that would eventually damage the country beyond repair.

The intelligentsia very much encouraged the propaganda of this time, but they were by no means alone in underpinning Milosevic's identity in the post-communist age. A new form of folk music catered to the many Serbs who were caught halfway between their rural origins and their new metropolitan identities. This music described the false idyll of old Serb villages: 'My village is prettier than Paris, both beautiful from afar, delightful from within.' Hundreds of thousands of the recordings of such songs were sold. Artists' associations were formed and popular magazines published lengthy accounts of the new celebrities' private lives, quarrels and

divorces. They participated in propaganda by publicly proclaiming: 'Kosovo, Kosovo, I'm coming home!' and eulogizing Milosevic. A famous and beautiful young singer announced that the only man she would allow into her bed was the president.

Football stadiums became centres for rallying support and reasserting the unity of Serbia. Within these stadiums, people could shout freely, release their energy and openly proclaim their allegiance to their team and their contempt for its opponents. The main slogan at all matches was 'Long Live Serbia' and supporters carried this cry as far as Dresden. The 'Red Star', once a police football club that most people believed to be anti-communist, soon became the symbol of the unified state. Zeljko Raznjatovic Arkan, a criminal and the son of a policeman who had once run a pastry shop near the 'Red Star' stadium, became the self-proclaimed leader of the '*Delije*' (Heroes) supporters. Arkan took on the job of assembling groups of hooligans to travel to Zagreb and support Belgrade teams, causing as much disruption as possible. Those hooligans who proved their loyalty and conviction would then be specially selected and trained. What exactly they were being trained for only became apparent much later.

Optimists believed that not all had been lost. The federal government and its President Ante Markovic announced a new economic plan and made a concerted attempt to carry it out.

Markovic's reforms aimed to build market institutions, open up the country's economy to the rest of the world, to establish a lawful state with a focus on human rights, to democratize political life and to introduce a multi-party system.[5]

Nationalized property, yet another peculiarity of the Yugoslav state, was to be converted into private property according to a procedure that was later successfully implemented in Poland, Hungary and the Czech Republic. It had been predicted that the process would take five years. With these new social and economic changes implemented, Yugoslavia would soon be eligible for entry into the European Union ahead of its Eastern European neighbours. The federal government hoped to prove that Yugoslavia had been the first of all the socialist states to abandon communism of its own free will – without a coup and without bloodshed.

These changes forecast prosperity. Inflation was reduced, the Yugoslav economy was reinvigorated and the per capita national income surpassed

that of Greece and Portugal. The middle classes became obsessed with free trade and were convinced that everyone should share their appetite for consumerism. Thousands of private businesses were established, of which 90 per cent involved trade. Production was more difficult, because the bad habits learned under communism had not been lost. Historically, the Balkans had focused on trade as the source of wealth.

A liberal approach to economics replaced political liberalism. The federal government had opened its gates to a multiparty system that it allowed each individual republic to implement. Ironically, by progressing logically and assertively, the federal government had opened the Pandora's box of Balkan madness. The echoes of the past, muted but not silenced by 50 years of communism – now re-emerged all the louder. The world had changed, but the opinions of the Chetniks, the Ustashe, the Ljoticevists, the Balists, the Vemeroists, the Domobrans[6] and the Belgrade communists had remained the same. Encouraged and manipulated by Milosevic, they found a way of reconciling all their conflicting ideologies into a single potent nationalist compound. This new form of artificial nationalism was made to order by Milosevic's propagandists and dispensed through the media.

Slovenia was the first to carry out multiparty elections and consequently the first to be taken over by the nationalists. Croatia followed suit. The right-wing nationalist HDZ (*Hrvatska Demokratska Zajednica* – Croat Democratic Party), whose supporters included the advocates of this independent state of Croatia, a Nazi satellite that emerged during the Second World War, won the elections. The leader of the party was Franjo Tudjman, a retired general and historian.[7] The *Srpska Demokratska Stranka* (Serb Democratic Party), shortened to SDS, also presented itself at the elections, under the leadership of Jovan Raskovic, a psychiatrist from Sibenik, and the protégé of Dobrica Cosic. Raskovic published a book in which he claimed Serbia to be an 'oral' nation and Croatia an 'anal' one. He meant to suggest that the 'anal' could never rule the 'oral'. As a response to the Serb claim to primacy, the Croats affirmed their own superiority. What had started as a game of Chinese whispers turned into a shouting match between hostile nationalist factions.

Realizing that his reforms were under mortal threat from the inside, Prime Minister Markovic decided that, within a few months, reformist parties had to be established in each of the republics. These parties would set in motion a programme containing all the reforms he was already

carrying out. The whole country had witnessed the success of his programme. The economy was thriving, inflation had been reduced, debt was diminished and foreign currency reserves in Yugoslavia exceeded the ten billion-dollar-mark. All these reforms were made to no avail: the majority was not interested in acknowledging the obvious. Markovic was losing support; he had even lost to the nationalist parties (Muslim, Serb and Croat) in multinational Bosnia, which had seemed the most promising of all republics. The reformists only won in Tuzla.

New leaders entered the scene: Alija Izetbegovic, a religious Muslim of mild temper, and the longhaired poet–psychiatrist Radovan Karadzic, who was Montenegrin by origin. Only in Macedonia did the nationalists lose to reformists, liberals and the renamed communists. The experienced Gligorov began to govern this little republic caught between the four fires of Greek, Albanian, Serb and Bulgarian nationalism.

In Serbia and Montenegro (where Milosevic had placed his disciples Bulatovic and Djukanovic), the communists – who had overnight become nationalists – did not intend to relinquish power. Even anti-communists did not demand this of them.

> *Serbia, just like other former communist countries, had the right to make changes. However, Milosevic was ahead of other European leaders since his people and his opposition had aspirations for a 'Greater Serbia' that went beyond settling accounts with communism. During the 1980s, the hearts of those Serbs known as the 'intellectual elite' were sown with the seeds of the dream of a greater Serbian state.*[8]

Sloba-Sloboda, perceived as a reformer, Titoist, democrat, monarchist, religious man, nationalist, all-Serb and miracle maker, was in reality the same old Milosevic, a former *apparatchik*. He began the process of democratization by postponing the Serbian ballot until the results of elections in other republics were known: he knew from experience in party conferences, plenary sessions and congresses, that the final speaker would formulate the real decisions.

In the summer of 1990, Milosevic formed a new party by combining the old Communist League with its fellow travellers. At a stroke, he managed to appropriate all the party's funds and take possession of everything that

belonged to it. He called his new party the Socialist Party of Serbia (SPS) with a red rose as its symbol; it immediately and formally took over the media. The SPS also seized control of banks, companies, institutions, ministries, industries, the national capital and many luxury villas. The net result was that the same people were still seated in the same places. They would continue to rule until the elections, which could be manipulated even if they could not be avoided.

The Serbian process of democratization was not over. The multiparty system required more parties, indeed as many as possible. That way, any serious opposition could be watered down and inter-party conflicts could be provoked. Opposition parties sprouted like mushrooms after rain, inhibiting each other's progress in the enforcement of their various 'national programmes'. At the same time, Milosevic encouraged the constant hatching of satellite parties. On the left were the Communist League, the Movement for Yugoslavia (a party of generals), the Workers' Party (no workers belonged to it), and the New Communist Party (which believed in following the example of Kim Il Sung's North Korea). Among those on the right were the Chetniks, led by Seselj, a former Marxist, and various radical and royalist groups; there was also the Alliance of All Serbs of the World.

Milosevic invariably dissolved any opposition that became seriously troublesome. The Democratic Party, which might have been a potential rallying point for middle class liberals, now overflowed with Milosevic's own people: local thugs, former Marxists, nationalists and even monarchists.[9]

His real targets were not the fervent nationalists, who were divided into dozens of different parties, but liberals and the reforms that were being promoted by the federal government. The issues of national restoration and expansion were far more pressing than those of economic reform and Western liberalism. By shifting the emphasis to these issues, Milosevic ensured that the reform movement was left without allies either on the inside or on the outside. Everyone was against the reform – both the minority who were threatened by it and the majority who stood to profit by it. The reform was concerned with political and economic changes, whereas the new Serb politicians were concerned with the idea of an 'immutable nation' that could be all things to all men.

In Yugoslavia, beside the main state and its six derivative republics, there were also two other components.

The Yugoslav Army represented the second great metaphorical state; it was considered the fourth largest standing army in the world, and was revered for its anti-fascist credentials and its victories in the Second World War. The army was also a powerful economic and political structure that was inaccessible to outside supervision. After Tito's death, it found itself without a commander. The third metaphorical state was the police, milder than in other communist countries, but still all present and scattered throughout the public through innumerable secret branches. As Yugoslav police archives will never be opened, it will never be known how many people worked directly for it; nor shall we ever understand the size of its network of associates, stool pigeons and voluntary informers After Tito's death, the police structure also lost its leader, ideologist and protector.

Both soldiers and policemen realized that Milosevic offered as much of the past as was feasible; they did not mind his confusion of Serb nationalism and pan-Yugoslavism, the muddling of anti-fascism and proto-Nazism. They understood the ways of politics: everything, as far as they were concerned, needed to be maintained under central control and to serve the same aims. These two states within a state, which for a decade following Tito's death preserved their former leader's cult, now finally had a personality under whom they could erect a new pyramid and create a new cult. Milosevic could replace Tito. They would submit to him. A single individual's magnetism could once again be the driving force behind the entire nation, just as it had been before.

In Serbia, religion had never played a vital role. The old patriarchal Serb village had respected the priest and the teacher (if it had one), but the greatest respect was always reserved for the local police chief. In the cities, the Church had always been present to conduct christenings, marriages and funerals, charging money for each of these favours. Historically, the government had always sought to curb the influence of the church, and the church had struggled to maintain good relations with the government. It was only under the communists that the Serb Orthodox Church found itself in real trouble, being subjected to persecution. Its land was confiscated, its authority limited and religious studies were prohibited in schools. Atheism became the official worldview, propagated from podiums and throughout the media. Churches were now half-empty, visited only by the elderly, by hard-core believers and by informers on assignment. The church elders, as ever, chose to avoid conflict. Nothing was said or done against the atheist

state, and religious extremists were confined to remote monasteries,[10] to keep them away from politics. Government recommendations were usually followed when there were elections of church dignitaries.

This peaceful coexistence was maintained until Milosevic's arrival on the scene, when the balance tilted toward the church. Previously, it had not been present in public life and in the media. Suddenly it was everywhere.

As the future standard bearer of the 'national programme' and 'the basis of real, evangelical and organic nationalism', the church was a useful ally for Milosevic. Orthodox priests and bishops were present wherever the nation and the 'Serb national question' were discussed, standing alongside academics and writers. New believers appeared all over the country. Middle-aged former communists were christened in churches amid huge congregations, and officials of Milosevic's party were seen clumsily crossing themselves at church services. Some of the new political parties introduced orthodoxy into their programmes, making religious devotion a party duty as atheism had been before.

Finally, a Church party, Saint Sava's Party, was established with a theologian as its leader. The bishops neither approved nor opposed it. The bishop Amfilohije Radovic commented that: 'God must want something great from this people, since He has placed them at the centre of world events.'

The relationship between Milosevic and the Church was not religious. During a visit to Athens, Milosevic went missing, reappearing some time later at Mount Athos, the ancient republic of Orthodox monks where no female had ever set foot. His son Marko joined him, though still a minor. The presidential helicopter stopped above the Serb monastery of Hilandar and landed in its garden. The 20 gathered monks were very surprised at this unexpected visit, but they organized an impromptu reception to honour their guest. Milosevic greeted them like communist comrades and shook the prior's hand before visiting the monastery. Several of their number who believed that communists were messengers of the devil had been kept out of sight in their cells, and after Milosevic's departure they washed every corner of the monastery in which he had set foot.

Milosevic neither accepted the traditions of his new ally nor played the religious man. His communist heart despised the Church, but the nationalist he had become obliged him to court it. His aim in power was not that he should serve the nation, the state and the Church. It was that all three should continue to serve him. He was privatizing the state – making it his own.

Chapter 6

The Fight Brews

Milosevic did not involve himself in the endless arguments between the outdated Marxism of his wife and the infantile nationalism represented by academics, writers and the church. He merely exercised his power. It was becoming clear to him that democracy was unavoidable. The idea of a Western-style multiparty system had already seeped into Belgrade consciousness. It needed to be accepted formally and adapted to Milosevic's needs. Once tamed, a multiparty system would prove to be inefficient and ridiculous. Democracy could easily be manipulated. Indeed, democracy offered many opportunities, among them the possibility of not choosing freedom. Slobodan, the leader of this new democracy, would represent the alternative to freedom.

The pre-election frenzy prevented many from taking notice of other elections. German, the old orthodox patriarch, broke his hip and was in hospital for several months. The first news of this was broadcast as follows: 'The synod has released Patriarch German from all his obligations and duties.' The clergy was in a hurry. At the beginning of December, several days before the parliamentary and presidential elections, further news was released. 'Bishop Pavle of the Raska and Prizren region has become the new archbishop of Pec, bishop of Belgrade and of Karlovac region, and the new Serb patriarch.' A spiritual leader had been elected who would follow the political leader.

The Serbian elections of 1990 were officially free, if one disregards the regime's election commissions and the secret counting of votes. The presidential post had 32 candidates, among them a tram conductor and a fugitive from a mental institution. All were allocated an equal amount of time on television. Serious candidates prepared to debate madmen and police pawns. A famous rock singer ran as leader of the 'Party for Regular Drunkards'. Crowds of people surrounded these candidates as they were interviewed for television and questioned by Milosevic's own journalists. The

public enjoyed the craziness of the candidates as much as the regime that organized it all. One aspiring politician said he would solve all problems in a few days: 'Mops, brushes and a bucket of water are enough.' Serbs were amazed at the reality of democracy, for which they had waited so long. 'Our Sloba was right not to appear on television. Anyway, his programme is peace, the preservation of Yugoslavia and the achievement of Swedish living standards for all people within a couple of years. The others just want war.' They sang 'Sloba, you the great Serb, don't let your people die fighting.'

Propaganda confirmed what the people were thinking and the people believed every word they heard and read. It claimed that the opposition was full of people with dangerous intentions. They wanted power, contrary to Milosevic who already had it and therefore needed no more. It was clear for whom they had to vote. In the history of Serbia the opposition only ever won one election, that of 1888. This only happened because the monarch of the time, King Milan Obrenovic, and the opposition leader Nikola Pasic had reached an agreement about handing over power. The agreement was made with the active participation of the police. Pasic's radicals ruled for many years; they waged three wars and one external economic blockade; they expanded Serbia's borders and cut the population by a quarter. They finally accepted the terms of the Treaty of Versailles for a new Yugoslavia because there was no alternative.

The victory of the socialists was nearly as conclusive as in the old one-party elections. Their opponents were powerless. The socialists won 190 of the 250 parliamentary seats. The Albanians boycotted the elections and thus actually succeeded in assisting the socialists. About thirty of their representative places went to the latter and to the man who had deprived them of their autonomy but who had also made it possible for them to have a state within a state.

In the presidential race Milosevic himself was even more convincing than his party. He himself won the elections in Belgrade and in other cities, towns and villages. All the presidential candidates put together won fewer votes than he did. He lost only in Senta, a place of 3000 citizens with a Hungarian majority, where Dr Ivan Djuric[1] beat him.

The elections confirmed that all legislative, executive and judicial power would remain in Milosevic's hands. Enormous power came from his control of the police and the media. Serbia's new constitution, imposed the year before, gave him the right of veto over all parliamentary decisions. In

practice, this meant that only his orders could be carried out. Nevertheless, his propaganda claimed that new Yugoslav democracy improved on the Western model, combining the best of the French and American systems.

The Serb Orthodox Church, whose zealots saw in Milosevic their chosen leader for the pre-apocalyptic task, the destruction of Catholics, schismatics and other religions and sects, was the newly elected president's first victim.[2] The legal charter that called for the return of all land confiscated from the Orthodox Church was voted in parliament but never received the new president's signature. The reason was never explained and the charter never renewed. And the Church did not complain.

The socialists celebrated their victory. Milosevic appeared in public triumphantly but briefly. He was becoming mysterious in a way reminiscent of certain Kremlin politicians. There was too much of him in the media and too little of him in reality. No one knew what he was really doing and no one asked him to produce any reports. It was clear, however, that he was personally in charge of all the instruments of power: he controlled the prime minister, the police, the credulous generals, the leaders of dependent parties and the presidents of the municipalities. Every place in Serbia, whether important or not, had its blind Milosevic loyalists, or at least people whose names were in the police dossiers and who were ready to obey orders unquestioningly.

It was perhaps too much to hope for democracy in an environment that had neither a democratic tradition nor any of the institutions needed to protect and maintain it. Nevertheless, Milosevic's crushing victory took everyone by surprise. The middle class, which was expected to champion democracy and to protect it, was tangled up in its own contradictions. Corrupted by privilege, it had absorbed the worst traits of European consumerism. Villagers remembered only the old patriarchal myths and the national wars that had robbed them of all they had; they wished to preserve an order that maintained at least the semblance of stability. The pensioners wanted to hold on to their pensions. Unity could only be achieved under the banner of a powerful abstraction such as 'the nation', or the idea of a world conspiracy against the motherland. The victor and his family could offer the masses any abstraction they wanted; provided the package was attractively presented it would be perceived as a rallying-call.

Power in Serbia had been secured. Thanks to the media and to political manipulation, the shift to nominal democracy had gone smoothly. But what

was to be done about the parts of Yugoslavia that posed a threat to Belgrade's authority? In Slovenia, power was in the hands of nationalists who were openly refusing to give money to the Yugoslavian treasury and who were preparing a referendum for independence. The situation was similar in Croatia, except that the Croats were already busy creating their own police force and army. In Bosnia, power was divided between Muslim, Serb and Croat nationalists on a percentage basis. Except for the pliable Karadzic, all Milosevic's opponents looked thoroughly aggressive.

In the 1930s Slobodan Jovanovic proclaimed, 'We have made Yugoslavia. Now we need to make Yugoslavians.' It was a long, intermittent process that was ultimately unsuccessful. Those who considered themselves Yugoslavian were left marooned without official origin, citizenship or state; they did not belong to any nation. It was the same for children born of mixed marriages. No one could formally represent their interests any more, even though their numbers exceeded those of all the pure-blooded Slovenes, Macedonians, Albanians and Muslims put together. Other Yugoslavians, having separated into nations and national minorities, replaced their lack of political identity with a political fantasy. To all intents and purposes the reforms the federal government started had been abandoned. The dinar, after a period of relative stability, was volatile. The only way of guaranteeing economic stability for any one country was to ensure that it received a greater portion of the spoils of collective property than its neighbours.

However, someone still cared about the communal state, or so it seemed. A statement by the political department of the Yugoslav National Army (JNA) in the Belgrade media claimed the existence of a world conspiracy against Yugoslavia. A 'New World Order' fronted by America and the CIA had been established. The conspiracy had three phases: to destabilize socialism, to provoke civil war and to divide Yugoslavia. Separatists were 'cooperating with foreign powers' to bring about Yugoslavia's downfall.

The army, however, 'would not allow this to happen'. Its generals began to act as if they were preparing for the defence of a state to which they had sworn allegiance. They made accusations based on concrete evidence: in Croatia, for example, the new government was secretly arming the police and training the army. Film footage was shown that confirmed these allegations.

Trucks full of guns were said to be crossing into Croatia from Hungary. This country – Serbia's ancestral enemy and a former Croatian ally – was assisting Croatia's preparations for an attack.

One piece of footage, filmed by a hidden camera, was broadcast on all television stations across Yugoslavia in March 1991. It showed General Spegelj, the Croatian army minister, drinking wine and speaking to two silent listeners: 'When the time comes, shoot at anybody. Children, women, the elderly, they're all our enemies.' One of the listeners was an informer of the Yugoslav Army's counter-intelligence unit. Was this not conclusive evidence that the Croats were again planning to slaughter the Serbs? Again, the federal army would not allow this to happen. The defence of socialism and the defence of Serbs had become indivisible in the minds of the military.

The federal government realized that the time had come to act when the Republic of Serbia and the Republic of Montenegro (whose government was led by Milosevic's pupil Djukanovic) both removed money from the Yugoslav federal reserves without permission.[3] The sums involved were estimated at between two and three billion dollars and it is unclear what happened to the money. One thing is certain, however. The media immediately accused the federal prime minister, Markovic, of attempting to rob Serbia and Montenegro for the benefit of Croatia and Slovenia. Sloba-Sloboda and Nebojsa Djukanovic had shrewdly prevented this by taking what belonged to them and to the Serbian people. As a 'preventive measure' they had also seized money destined for the other nations in the federation.

In Belgrade, this was celebrated as a national victory. 'Our Sloba took from them what they had taken from us' and the media praised his nimbleness. In reality, this action marked the beginning of an economy of wholesale theft. The procedure was brutally simple: Milosevic stole from his neighbours and then blamed them for thefts perpetrated against the Serb nation. Milosevic's counter-method relied for support on an irrational, paranoid nationalism he knew he could manipulate. Paranoia was also a flaw of his and it nearly cost him his grip on power. His fear of opponents and his terror of losing control were what provoked trouble.

On 9 March 1991 the United Opposition of Serbia (two months later it became the United Serbian Opposition) organized a demonstration on Republic Square. The protestors met between the National Museum and the

National Theatre at the monument to Duke Mihajlo Obrenovic, the first victim of a political assassination in recent Serbian history, but Milosevic banned the demonstration, despite his habitual claim that 'truth lies with the people'.

That morning, there were clashes between protestors and the armed police. The police were brought in from the countryside and from Kosovo, where they had been training to put the politics of the iron fist into effect. Despite them, tens of thousands of people managed to get through the blockades and meet in the square.

Opposition speakers harangued the crowd from the balcony of the National Theatre while demonstrators clashed with the police that had surrounded the city centre. Little by little, a real struggle emerged as water cannons and tear gas were sent in. Leading opposition figure Vuk Draskovic commanded a counter-attack. Half-blinded by tear gas, these young people bore steadily down on the police. The rebels marched down the main street, still named after Marshal Tito,[4] but then moved towards the Serbian parliament opposite the unprotected presidential building. The building was empty apart from a few confused guards. Heavily armed police squads protected the street leading to Milosevic's villa in Dedinje. The opposition merely entered the Serbian parliament building where the protest fizzled out. They had neither a programme nor any clear demands. They knew neither what to do next nor whom to oppose. They received no support from the outside; 1.5 million Belgrade citizens had stayed at home.

The people of Belgrade had no intention of rebelling against the invisible wall that was rising around them. The city was waiting. Belgrado-centralism had now become a silent political struggle for all those intent on preserving the social status quo.

'Studio B', the first independent city television station, broadcast the street clashes, showing policemen in helmets beating the same people that Milosevic had famously described in *Kosovo Polje* as untouchable. At midnight policemen without helmets entered the television studio, which was inevitably called *Beogradjanka* (Belgrade girl), and stopped the programme. The people were only to hear and see the regime's propaganda against the opposition 'led from abroad and financed by Zagreb and Ljubljana'. That evening Borislav Jovic, the president of the Yugoslav federation, appeared on television to inveigh against the 'enemies of Serbia' and the next morning –10 March 1991 – Belgrade awoke to find

tanks in its streets for the first time since the Second World War. This time, the occupier had come from within.

The tanks were there to guard the main bastions of propaganda – namely the offices of the *Politika* newspaper, the Serbian radio and television building and, at the heart of it all, Milosevic's villa in Dedinje. All roads leading to Milosevic's luxurious residential area were blocked.

On that day Sloba-Sloboda voluntarily entered the prison that would ensure his security. He rarely left, remaining sealed up in his villa, safe from any contact with reality. He received news via carefully chosen intermediaries who were selective about what they told him. He had finally closed the door on the world that had created him. For his opponents his personality was irreversibly defined: he was now the 'Devil from Dedinje'. For his supporters he was irreplaceable. Both his admirers and his opponents, caught as they were between love and hate, knew exactly with whom they were dealing: themselves.

For two or three days Belgrade was quiet. It felt like a party that had culminated in a brawl. Shop windows broken by the 'forces of chaos and madness'[5] were repaired. However, one cold night, a long column of students assembled in New Belgrade and moved towards the old city. Having fought their way past the police on the bridge over the River Sava, they broke into the city centre and gathered around the Terazije fountain. This became their open-air forum, Jacobin club and assembly of 'sixty-eighters' (echoes of the 1968 student protests in western Europe had also reverberated through Yugoslavia). Speeches were delivered, poetry was recited and the people sang, cried and laughed. Anyone could speak his or her mind and no one was censored with the exception of one man. That man was Seselj, a nationalist who tried to say that the real enemies were the Croats and the Muslims, not Sloba-Sloboda, but booing drowned his speech.[6] Karadzic, who had already become the leader of the Bosnian Serbs and commanded a small, unofficial army of his own, threatened to come to Belgrade with his mercenaries and remove the 'bad' Serbs. 'The real Serbs live outside Serbia; the ones inside are degenerate,' he thundered.

Milosevic's people now organized a counter-demonstration at the junction of the Sava and Danube rivers. Even on government-controlled television, it was only too clear that the youngest participants were well over the age of sixty. Speaker after speaker exhorted this greying host to march against the students. However, after dancing a few *kolo*s (traditional

dances carried out by people holding hands and dancing in a circle) and chanting some slogans, the demonstrators dispersed. They would rather conduct wars through their children and grandchildren than fight the battles themselves.

The man whose crumpled posters had been left behind in the mud had now to reach a decision. Both the opposition and Milosevic's followers found him unpredictable. The militant energy on the streets had seriously shaken him; with the protestors having nearly reached his protected haven he needed to work fast. He held a meeting with the presidents of the municipalities and told them that the limits of tolerance 'have to be dictated by the strong. It is essential that we be strong. ... If we have to fight, well, we'll fight! Hopefully they will not be stupid enough to challenge us to fight.' It was not specified exactly what kind of war was to be waged, against whom and to what purpose. The enemy was simply any individual – or Yugoslav nation – that refused to obey the orders issued from Dedinje.

If some kind of war were imminent then it was a military secret. It was unclear whether the army's generals were privy to that secret. The eight-member Yugoslav presidency was neatly divided into four votes on each side; it could reach no agreement. Yugoslavia was no longer an administratively functioning organism.

After long negotiations – and the first mediation by the members of the European Community – Stepjan Mesic, a Croat, replaced Jovic, a Serb and hardcore centralist, as the one-year president of Yugoslavia. Mesic immediately announced that he intended to break up the federation.

Events outside Yugoslavia now took a dramatic turn when an alliance of party bureaucrats and disgruntled Red Army generals attempted a putsch in the Soviet Union. Mikhail Gorbachev was arrested in his villa in the Crimea. Earlier, on 13 February 1990, Borislav Jovic had noted in his diary a statement made by the Yugoslav Army chief of staff, General Veljko Kadijevic: 'It is all Gorbachev's fault. He sold the idea of socialism and communism for a pittance. He destroyed the Warsaw Pact, demolished socialism in Eastern Europe, destabilized the USSR; and worst of all for us he disrupted relations with the European powers and thus placed all communists under suspicion. We now have to defend ourselves, or die.'[7]

On the first day after the putsch, Milosevic's people openly celebrated 'the victory of the forces of good'; corks flew off champagne bottles in the offices of the socialist party. Disappointment, however, rapidly followed.

Boris Yeltsin reversed the situation in Moscow; the putschists were arrested and Gorbachev was returned to power. His resolve stiffened by his wife, Milosevic did his best to rally his supporters. The putsch in the Soviet Union might have failed for now, but his Russian allies had all survived, both the communists and the nationalists. Milosevic's elder brother, Borislav, was in constant contact with them as the advisor who dealt with all family business behind the scenes. Foreign affairs were Mirjana's responsibility.

Danilo Z. Markovic, Mirjana's professor from Nis, was made ambassador in Moscow. Moreover, the Chinese communist regime was robustly intact and was a trusted ally: only two years before it had made international headlines with the famous massacre at Tiananmen Square. Mirjana's follower Unkovic, a professor of tourism, was appointed ambassador to Beijing.

A secret meeting was now held between Milosevic and the Slovenian president Kucan. Milosevic confirmed the right of Slovenians to their own state.[8] Kucan, in turn, recognized that Serbs had a right to their own state. The consequences of this meeting were unexpected. In the summer of 1991 the federal army entered Slovenia with excuse that it was protecting federal customs on the border.[9] According to Slovenian propaganda, cities were placed under siege, dozens of military squadrons flew over Ljubljana and tanks destroyed all that was in their way. The West was profoundly shaken by these events and the question of intervention, which would be raised on many occasions in years to come, was considered for the first time. But the Slovenian interlude ended quickly; the federal army agreed to retreat.

Milosevic's attempt to impose himself and his politics on Yugoslavia as a whole by taking over all major party positions failed at the last congress of the Communist League. That had been his main strategy. In case the renewal of communism should fail, the alternative plan was to try nationalism and the employment of the 'Serb national programme'. Slovenia had to be left to its destiny. The entire army and police complex had to be focused on the defence of Serbian land – meaning areas inhabited by Serbs. Army minister and chief of staff General Kadijevic, disagreed: they should not have left Slovenia without destroying its economic infrastructure. He believed that the principle of scorched earth should have been applied.

The Serbian president, who had no formal relationship with the federal army, opposed vandalism and destruction and it was his decision that

prevailed. Slovenia receded from Yugoslavia and Milosevic had one opponent fewer. He believed he had only one serious opponent left in Yugoslavia and that was the new Croatian President Tudjman – who talked of an independent Croatia for the next thousand years.

The media soon announced that Milosevic and Tudjman had met at Tito's favourite resort, a hunting estate for diplomats in Karadjordjevo in Vojvodinand. What passed between them? Did they try to tackle the issues that divided their two republics and the 1000-year-old peoples they represented? No one knows. Neither was accountable to a parliament or electors and neither took notes. One published photograph showed the two men sitting at a table with frozen faces, like opponents in a long game of poker.

The events that followed were in keeping with the tension of the moment. The draft versions of future events were being drawn up. Misha Glenny later wrote: 'The conflict could have been avoided had Milosevic stopped pushing for a strong federation and had Tudjman shown some good will to enter into talks with his Serbian minority. Both Presidents showed that they were poor statesmen.'[10]

When the concept of 'balkanization' is used in relation to Balkan peoples it needs to take into account the political elite and the national intelligentsia. These have always ensured that politics in the Balkans were characterized by grandiose pronouncements and a generally utopian ideology. Somehow, this worked. In the nineteenth and early twentieth centuries, the general ideology was the nation, perceived as a unity of territory, language and origin. That abstraction was replaced in the mid-twentieth century by the dictatorship of the people, masking the power of a single political caste. Now, on the eve of the third millennium, it was time for the people to represent this unity and no other.

Politicians who offered simple things such as economic progress, better living conditions, bigger hospitals, larger schools, clean streets and the application of law stood no chance of success; such concerns attracted neither the rich, nor the faceless masses of the poor. Who cared if trains arrived on time and whether companies employed too many workers? A real politician concerned himself with the greater issues of national sovereignty and international status. The masses would only swallow and digest issues that did not concern them – grand pronouncements and monumental abstractions.

Chapter 7

The Defence of Serbian Lives and Serbian Borders

Belgrade propaganda now began to reopen old wounds, this time for new purposes. The Slovenians were described as Austro-Hungarian lickspittles, enemies of the Serbs, ungrateful. A rock singer sang 'The Viennese stable-boys want to leave us.' Serbian propaganda claimed that the Ustasha state had killed over a million Serbs in the Jasenovac camp and that the bodies of Serbs lay in mass graves throughout Bosnia and Herzegovina.

Croatian propaganda claimed that at least half a million Croats had been slaughtered near Bleiburg (Austria) in 1945. Pictures of Drazo Mihajlovic and maps of 'Greater Serbia' were sold in Duke Mihailo Street in Belgrade, and this new model of Greater Serbia included parts of Bosnia and parts of Croatia. On Jelacic Square in Zagreb, one could buy the pictures of Ante Pavelic and maps of 'Greater Croatia'; these maps in turn contained the whole of Bosnia and parts of Serbia. Each propaganda organization strove to prove that its people were the victims of a genocide committed by the other. The intellectuals led the dispute by underlining the differences between Croatians and Serbs. Brana Crncevic wrote, 'Croatian intellectuals are not free. Serb intellectuals are.' On Belgrade television, these free intellectuals, never appearing without a priest in their midst, gravely forecast the number of victims there would be when the next war came. The poet Beckovic gave it as his opinion that, 'The greatness of a people is measured by the number of its innocent victims.' Milorad Ekmedzic, a Belgrade academic living in Sarajevo, was more specific. 'There will be about 250,000 killed on our side, and at least 750,000 on the Croatian side. This is how the Croatian question will be solved.' When Ekmedzic was a boy the Ustashe had killed his whole family and thrown them into a pit. Now

his chance had come to settle accounts, to take vengeance on children who were the same age now as he had been when his own family was butchered.

In an operation organized by the Serb Orthodox Church, the graves of the Ustashe victims of the Second World War were excavated all over Bosnia. Their descendants gathered to pray for their dead ancestors and the priests sang as the new believers clumsily crossed themselves. Dobrica Cosic stood amid an exhibition of bones to sign copies of his trilogy of books *Vreme smrti* (The Times of Death), while Serbian television broadcast the commemoration ceremonies live. The synod concluded: 'We are witnessing thousands of innocent victims finally emerging from the darkness of humiliation, hatred and oblivion; as they are raised from their pits, so they arise in the consciences of their oppressors. This is all to the good; reconciliation with the dead and between the dead is an essential condition for reconciliation among the living.'

The older generations' fears were reawakened and propaganda filled the young with false beliefs and fantasies. Pictures and memories of the war that had ended 40 years before were a convenient introduction to this new war, which would pick up where the last had left off. But before any actual battles could be fought, the 'war between collective memories'[1] needed to be waged and won. Each side despised the 'collective memory' of the other for endlessly magnifying the number of its own victims and calling for revenge.

Yugoslavia, the champion of peace and one of the great stabilizing forces in the region, suddenly found itself in a state of undeclared war. No one, apart perhaps from those directing it behind the scenes, understood quite how this had happened. From the outside, the brewing war resembled a series of minor, meaningless skirmishes. Only later did it become clear that 'everything was going according to plan'.

The constitutional rights the Croatian parliament guaranteed excluded Serbs who had been long-term residents of Krajina on the grounds that they had no claim to the constitution because they were only one among many 'constituent people'.[2] The Serbs' response was to refuse to accept the new Croat police force and they set up road blockades with guards and tree trunks. This was immediately referred to as the 'tree-trunk revolution'. Slavonian Serbs did exactly the same in all the municipalities in which they were in the majority. Several SAOs (*Srpska Autonomna Oblast* – Serb Autonomous Region) were established, many of them municipalities that had broken away from the state. A few in Bosnia and Herzegovina did

likewise. In this way the small town of Trebinje became the capital of an autonomous region. The leaders of these bizarre geographical creations were often complete nonentities and very often gang-leaders – they included Babic a dentist, Hadzic a warehouse clerk and Vucurevic a truck driver. Respected Serbs from the cities were not part of this new brotherhood, but as it happened the words and actions of the gangsters perfectly complemented Belgrade's propaganda, which insisted that in places where Serbs were in the majority they possessed inalienable territorial rights. Where they were in the minority, however, they had *historical* rights. In both cases, the territory was considered Serbian and could not belong to anyone else. The existing borders between the republics were described as a Titoist fabrication the Comintern and Vatican had imposed and that needed to be changed. The small town of Knin, which had only a single railway track and not a single cinema, pronounced itself unified with Serbia. The fact that more than a hundred kilometres stood between Knin and the motherland seemed of no importance. Only two options remained open: peace, with a just solution to the Serbian question, or war to avenge the violation of Serb rights.

The recalcitrant industrial town of Borovo on the border between Serbia and Croatia suddenly became notorious. A bus filled with Croatian police-men who had entered Borovo's suburbs to expel the rebels was ambushed and most of the men in it were killed. Seselj publicly congratulated his men for this act and proclaimed that he himself would like to slit Croatian throats with rusty spoons.[3] Croatia had to be attacked – two army divisions could take Zagreb in a fortnight – 'Chetnik submarines' were standing ready to reach the capital of Croatia by the River Sava. It was unclear what Seselj's submarines would do when they arrived in Zagreb and there was considerable scepticism about the success of his planned offensive.

Only months after winning the elections by promising peace, Milosevic was preparing for war. He had to appear to be condemning the drift towards open conflict and did so by reiterating his point that he would cooperate with his opponents but only on condition 'they accepted a rightful solution to the Serbian question'. What he meant by this was unclear. While Milosevic himself affected to be above the fray, his supporters made threats in his name: Draskovic's statement that 'Serbian territory includes any-where where there are Serbian graves' sounded too epic and too vague; Bishop Atanasije Jeftic was more specific: 'Serbian people have yet again

been crucified, in Kosovo and Metohija, in Dalmatia, Krajina, Slavonia, Banija, Lika, Kordun, Srem and Bosnia and Herzegovina.' But Seselj left no doubts. 'Our last defence is on the line Karlobag–Karlovac–Vinkovci–Virovitica'.[4] This meant that two-thirds of Croatia and almost the whole of the coastline would have to be conquered and the whole of Bosnia besieged. Though he was a member of the nominal opposition, Seselj's statements were always in exact accordance with Milosevic's intentions.

Milosevic made no statements and steered clear of rhetoric. 'There cannot be two truths' or 'there is only one truth' was all he would say. Meanwhile, he refused to negotiate with his colleagues from other republics and accused them of seeking to bring about 'the break-up of Yugoslavia'. He opposed the asymmetrical federation suggested by Tudjman and Kucan (according to this model, Croatia and Slovenia would be reformed to capitalism while the remaining republics would be free to choose between socialism and capitalism). He was also against the polycentric federation proposed by Izetbegovic and Gligorov (which would allow for a mixture of capitalism, socialism and a third way, depending on the wishes of the different republics). Last, he declared his opposition to dividing the countries along existing borders (this would have meant the rejection of both an asymmetrical and a polycentric federation; Serbia refuted this proposal by arguing that Serbs were scattered all over the Yugoslavian land mass and that such a solution would be unjust. Lord Carrington, the EU representative, later tried to impose the same plan). No one could satisfy the Serbs' national demands.

Dobrica Cosic had said: 'We will only gain independence from Yugoslavia at a very high cost.' He was proved right by another popular uprising. The superannuated protestors who had demonstrated against the students a few months previously now gathered again in New Belgrade. They cheered enthusiastically and threw flowers at the same tanks that had besieged the capital in March to save it from 'forces of evil and madness'. This time the target was not the centre of Belgrade but Vukovar, a small quiet town on the Danube. Belgrade propaganda claimed that there had once been a majority of Serbs there and consequently Serbia had a historical right to 'repossess' this town. Zagreb's propaganda claimed that the Croats were now in the majority and that even the communists had agreed that rights to land were based on ethnicity. Belgrade propaganda countered by saying that the borders of the republics were 'unnatural' and

that Tito had forced the Serbian communists to accept them. The upshot was a dramatic massacre at Vukovar, a place where no ethnic conflicts had ever before been recorded.[5] Physical conflict had prevailed as the only way of resolving ideological conflict. Once the conflict was over the survivors would be perfectly clear about which side had been right.

The Yugoslav National Army (JNA), still under the control of a presidency that had not formally ceased to exit, now had a new master – the man who had claimed that peace needed to be preserved at all costs and that talks needed to begin, a man currently waging war. There was no declaration of war, but the siege of Vukovar continued and the bombing spread farther afield. The cornfields were filling with corpses.

The leader of Vukovar's defenders was 'Colonel Jastreb' (Colonel Hawk), a former JNA officer. It was only later that his real name became known – Mile Dedakovic. Tudjman, the president of Croatia and former general of the JNA, did not really know who these defenders were and failed to send them any help. His pragmatic approach was to let the besieged people fend for themselves; their sufferings would make good propaganda. The attackers also faced problems: they were running out of men. Reserve forces from Serbia were called up, pronounced as volunteers and sent to the unofficial front. Many of these young men, horrified by the fighting, disobeyed orders and returned home. Valjevo, Cacak, Kragujevac and other columns returned to their cities, organized demonstrations outside their municipal buildings, turned in their weapons and went home. The government was unsure what its next move should be and the opposition kept silent. Apart from Ivan Djuric, scion of a distinguished family of freedom fighters who had all been pronounced traitors by the media, not a single opposition leader spoke against the war. Vuk Draskovic complained that Milosevic had 'stolen his national programme'.

A young tank operator decided to take on Belgrade single-handed. He stole a tank, drove through all the security checkpoints, entered Belgrade, drove up to the federal parliament and left the armoured vehicle parked there. He was not stopped at any point along his 200-kilometre odyssey. His name was Vladimir Zivkovic. Ten such tanks could have surrounded the Serbian presidency and forced Milosevic to give up his offensives, but there was no one to organize and lead the younger generation of Serbs who now progressively withdrew from politics and ceased to make clear demands.

The army was rapidly dissolving into different nationalist factions. The

Slovenians had broken away, as had the Croatians, and they would soon be followed by the Bosnians and Macedonians. National minorities were reluctant to interfere in the wars between nations. The army was stricken by conflicting affiliations within the ranks; its officers no longer knew what orders to give, and their subordinates no longer wished to obey them. It was well nigh impossible to convince the young people of central Serbia, which did not even share a border with Croatia, that the Croatians were their enemies. The army minister and chief of staff, General Veljko Kadijevic, asked Borislav Jovic, a member of the federal presidency, for 150,000 more soldiers. The answer of the militant Jovic (who had exempted both of his sons from the army) was that no one wanted to join the forces any more; alas, the Serbs were no longer the loyal fighters they had once been. Marko Milosevic was also pronounced unfit for army service as were the children of many other patriots from Belgrade. The sons fell ill and the daughters went to live abroad on government stipends. The media made no mention of this, but rumours spread and the phenomenon became popular. The recruits hid and their parents refused to acknowledge the draft. One father wrote, 'My son cannot join the army. His father will not let him.'

The police now moved in to help their army colleagues. Groups of men, 'paramilitary formations' who had been secretly trained for months, arrived in large trucks. Officially, they belonged neither to the police nor the army; in fact they belonged to both. In Vukovar and other cities units of 'volunteers' appeared, most of them made up of criminals and thugs. Among the various groups that formed were Arkan's 'Tigers',[6] Seselj's 'Chetniks'[7] and Bokan's 'White Eagles'.[8] They filled the gaps left by the deserters and claimed to be there to defend 'centuries-old Serbian homelands and the rights of Serbian Orthodoxy'. In the name of patriotism, they roamed about committing unspeakable crimes of rape and pillage; only occasionally did they fight against their opponents. Croatian paramilitary formations that were formed to complement the Serbian ones did exactly the same. As usual, each country's propaganda laid the blame on the other. Their enemies knew the Serbs as 'Chetniks' and the Croats' enemies referred to them as 'Ustasha'.

The grandchildren, born and raised under socialism, educated in brotherhood and unity, continued the battles their Serbian and Croatian grandfathers had lost during the Second World War. They went into the fight with a hatred that burned just as strongly as if they had been at war all their

71

lives. Neighbour took up arms against neighbour. No one could understand how their neighbours could have changed into such monsters; in fact it was they who were different. Two or three years of propaganda had been enough to wipe away the memory of nearly half a century of peaceful coexistence. The principal instigator of this divisive hatred was Milosevic. In the words of Misha Glenny: 'The start of the war in Yugoslavia would not have been so violent had it not been for the unusual personality of Slobodan Milosevic. ... His success lay in his shameless use of the most efficient tools of Balkan politics: deceit, corruption, blackmail, demagogy and force.'[9]

This is obviously true. Perhaps less obvious is that the tools not only suited his appetite for power and his criminal nature – they also suited the needs of his contemporaries. Serbs submitted to Milosevic because they thought he could realize their fantasies; the other nations and minorities of former Yugoslavia followed their leaders for exactly the same reason.

In November 1991 Vukovar fell and the last survivors came out of their shelters. My own exile began on the very same day: 18 November. The city the conquerors proudly took over was utterly destroyed. Milorad Pavic, 'a great Serbian writer', said that it would be easy to rebuild the city and that this should be done in a 'Serbian–Byzantine style', something previously unheard of in the annals of architecture. No one was ready to say who would replace the people who had been killed or what would happen to the refugees. Milic Stankovic,[10] 'the great Serbian painter' entered the city along with the soldiers; he positioned his easel in the centre of the shattered main square of Vukovar and settled down to 'depict the suffering of his people' in the shape of a young Serbian woman whose child was cut out of her womb by her Croatian husband to prevent her giving birth to a half-breed. This event had allegedly taken place for real during the siege of Vukovar.

Serbian artists seemed unable to depict Croatians as anything other than monsters, beasts and killers. Under Stalin, artists were cherished as 'engineers of the soul', under Tito they were praised as 'the honest intelligentsia'. Now, under the new leadership, they simply glorified crimes, concealed the truth and were richly rewarded in consequence. At that time, phoney patriotism was of considerable value in the market of people's guilty consciences, particularly if those who professed this patriotism would never feel its true effects. The painter Stankovic was straightforward about this, 'The artists must mingle with the people and encourage them. They should go to places where there is no danger of being killed because

the people need encouragement.'[11] Death was a luxury reserved for those who needed to be encouraged.

An obscenity appeared in the media – an enterprising businessman had opened a private crematorium in Vukovar, then a tourist agency began to organize group visits to the 'liberated Serbian Vukovar', which was almost empty of inhabitants. Many came.

The JNA had insufficient troops to take over the cities, but it did have artillery. Osijek in Slavonia was bombarded, and later Zadar and Split in Dalmatia. Finally, the shelling of the beautiful medieval city of Dubrovnik began. The reason given for this was that 'Ustashe' were hiding in it. Since no one really knew where the front lines were or whom the warring factions consisted of, this auxiliary front had been left at the mercy of Bulatovic and Djukanovic. The Montenegrins, who considered themselves super-Serbs, attacked the neighbours with whom, until recently, they had shared profits from tourism and drunk water with from the same supply.

One of the first victims of shelling by the 'Serbian armada' was the poet Milan Milisic, who was of Serbian origin. Konavlje (a region near Dubrovnik) was demolished and pillaged in the name of unknown war objectives, which simply meant plunder. A patriotically inclined journalist interviewed an armed Montenegrin who was leaving Konavlje driving six fat cows. 'I'm going back home. My war objectives have been achieved,' he said. A seventh cow had not been part of his national programme. Vucurevic, a truck driver and *gusle* player who had become the president of the small municipality of Trebinje, located at the rear of the city and living at its expense, was just as cynical. 'So what does it matter if we destroy Dubrovnik? We will rebuild it even more beautiful – and older.' The Serbian academic Samardzic said: 'Dubrovnik is in no danger. It is a degenerate city of hotelkeepers visited by Miami grandmothers, British homosexuals, French idiots and German secretaries.'

<p style="text-align:center">***</p>

Both Zagreb and Belgrade were filling with refugees. A people lost, without roots and with no hope of a future. Somewhere they had left their homes and belongings and abandoned their land, their cattle, their ancestors' graves, their history and everything they had. They could not complain to their former rulers, for they had lost them too. Those who had

once been their leaders were busy with theft and pillage. The new men in power understood that to survive they would have to bargain with their enemies using the spoils taken from their war-torn countries. Had someone wiretapped the telephone conversations between the leaders on each side they would have heard sincere words seasoned with a few friendly insults. The clamour of propaganda could not affect businessmen who traded in misery and death. War plunder was on sale everywhere, in the streets and in the flea markets. Furniture, cars, trucks, television sets and video recorders changed hands freely. The goods belonged to whoever had taken them or to whoever bought them. New rich men appeared everywhere, spending money with abandon.

In the space of only a few months the two greatest Yugoslav republics had been ruined and most of their people were living below the poverty line. Instead of finding themselves in modern Europe they were now living in the Balkans of the Middle Ages. No one knew where the borders between the new republics actually were. Seselj claimed that Croatia stretched as far as the eye could see from Zagreb cathedral. His Croatian counterpart, Paraga, responded by saying that Serbia extended as far as the bridge over the River Sava in Belgrade, and that even Zemun (a municipality of Belgrade) was Croatian.

The two rival presidents were already setting their sights on the third republic that had become a state and that the United Nations had recently recognized: the tri-national Bosnia with its three-headed leadership. Milosevic's propaganda held that Serbia's western border lay at the Una, Bosnia's westernmost river, which shared a border with Croatia. This would imply, of course, that the whole of Bosnia should be under Serbian rule. Tudjman's claimed that Croatia's eastern border lay along the Drina, Bosnia's easternmost river, bordering Serbia. And this meant that the whole of Bosnia should be under Croatian rule.

Had Milosevic and Tudjman reached an agreement during their secret *tête-à-tête* at Karadjordjevo? This would soon become clear to everyone, though neither man's propaganda openly acknowledged that an agreement had been made at all. The only ones who failed to accept the reality of a secret agreement were those Western politicians who persisted in their vain attempts to mediate. No one heard the voices of reason from both Zagreb and Belgrade, which warned about the meeting of the two presidents. Vlado Gotovac, a member of the Croatian opposition, has said: 'The partners in

this scandal remained true to only one thing, that they would respect each other's personal safety. Never did Tudjman attack Milosevic nor Milosevic attack Tudjman. ... The conflicts provoked by their politics never affected their personal relationship.' Their wars were conducted without personal disputes, and according to a strict agreement. The thousands of dead on both sides did not affect their understanding in the least.

Despite their apparent differences, Milosevic and Tudjman were very alike as politicians in the Balkans. They had both suffered suicides in their families (Tudjman's father killed himself after murdering his second wife but this was later blamed on the Ustasha). Since neither of the future presidents had undergone a medical examination before the elections,[12] no one knew the exact state of their physical and mental conditions. They were educated in exactly the same ideology and were its most dedicated supporters. They both cherished Tito's cult and his lifelong rule. Tudjman affected extravagant titles like 'president for life' and Milosevic occasionally smoked Cuban cigars and drank whisky, Tito-style. Neither would tolerate different opinions or opposition. In effect, the similarity of their regimes showed their shared qualities better than any analysis could ever do.

Not everyone in Belgrade agreed with what was happening and groups of intellectuals tried to resist as best they could. Several organizations were formed, such as the 'Belgrade circle',[13] 'the anti-war movement', 'women in black',[14] the 'Helsinki committee' and many others that in Western societies would be called NGOs. They organized events and protests such as carrying a huge black flag of mourning down the main street in Belgrade and lighting candles for the dead; they wrote letters and petitions, and spoke to gatherings of sympathizers.

Altogether they numbered 2000 or 3000 people; they offered no danger to the regime because they were incapable of uniting and producing a statement that could be understood by people outside their circle. Citizens did not join them, while the media alternately ignored and attacked them.

In the language of the time, the word 'peace' either meant nothing or represented treason. The Yugoslav national anthem, written by a Czech and later adopted by Serbia, proclaimed: 'Damned be the traitor who betrays his homeland.' To be called a 'pacifist' was as bad as to be called a 'reformist'.

The Belgrade academics were mostly old-school nationalists. They believed in the programmes of the previous century, in the forgotten plans

of dead politicians, in myths that had been dismantled long before. But these academics' statements were not potent enough to stir up hatred. New programmes needed to be designed for use in propaganda battles that used more modern terms than fascism and national socialism. The academic establishment was too mild for this task so new people were brought in – ambitious but obscure professors and failed artists. They received money for their services; offices were provided for them and their expenses were paid. The regime financially supported the magazines they started and the books they published. Yet this new generation of pro-Milosevic writers were not Marxists. They were very different. Almost to a man they were fascists – racist, anti-Semitic and anti-Muslim.

It was laid down in the Serbian constitution[15] that parties, organizations or media that spread religious, racist or national intolerance would not be permitted. But nothing happened to Belgrade's Black Shirts. Milosevic's brand of democracy consisted in giving the advantage to democracy's opponents, regardless of which faction they belonged to. In the name of democracy, extremists attacked the editorials of the independent media, destroying their machinery, harassing their employees and humiliating anyone who stood up to them. The police invariably arrived late on the scene and never found the perpetrators. Even the children on the streets of Belgrade, the newspaper sellers and waiters knew who they were – everyone knew except the inspectors whose job it was to arrest them.

One among them, Dragoslav Bokan, later became notorious in Bosnia for his appalling crimes as leader of the 'White Eagles' brigade, which competed with Arkan's 'Tigers' during the ethnic cleansing campaign. The society had begun to turn towards fascism and the state towards crime. Milosevic accepted all his political options; his sole purpose was to remain in power; if that meant magnifying the chaos around him, then so be it. Tacitly, he fostered the extremists.

The Second World War had resulted in a divided Germany and, from the Balkan point of view, a newly united Yugoslavia firmly in the camp of the anti-fascist league. In the 1990s the roles were reversed: the two parts of Germany came peacefully together again while Yugoslavia fell apart amid general bloodletting. At the end of 1991 Germany alone recognized the independent status of Slovenia and Croatia; Hans-Dietrich Genscher, the German foreign minister whose diplomacy contributed much to the cause of German reunification, had delivered a mortal administrative blow

to Yugoslavia. After this – much like Yugoslavia – Genscher disappeared from the political scene. Members of the European Community were faced with a *fait accompli* and followed suit only two weeks later.[16] Belgrade and the Milosevic media were furious; the Germans were again working against the Serbs who had defeated them twice before. Zagreb was overcome with gratitude and the quickly composed song *Danke Deutschland* was played on radio and television. On the island of Brac in Dalmatia members of the local HDZ were preparing to erect a monument to the German minister of foreign affairs.

Throughout this period, the bombs kept falling and the paramilitary units continued to wreak havoc. The damage was complete; now it was time for outside forces to intervene. The United Nations sent troops to Croatia, which were intended to separate the warring factions but in fact upheld Milosevic's conquests and confirmed Tudjman's successes. When the Vance Peace Plan, compiled by Cyrus Vance and agreed by all parties at the beginning of 1992 (the 1993 Vance–Owen Plan dealt only with Bosnia), was put into practice, both sides responded in writing. Borislav Jovic wrote 'Dear Mr Vance, the presidency of SFRJ (Socialist Federal Republic of Yugoslavia) has received full support from all relevant subjects, including the authorized representatives of the Serbian regions of Slavonia, Baranja, western Srem and the Serbian autonomous region of western Slavonia to fully implement the plan proposed by the United Nations.' Franjo Tudjman wrote: 'In order to avoid any misunderstanding, I inform you that I fully and unconditionally accept the concept and the plan of the General Secretary of the UN which defines the conditions under which – and the regions in which – the United Nations forces will be stationed.'[17]

Belgrade considered this a victory and Zagreb was satisfied. The foundations of Greater Serbia had been laid. The basis for Greater Croatia[18] had also been established. Roads for fresh conquests on the third front had already been opened. Foreign soldiers would partly carry out the work of local warriors. They would not kill, but they would preserve the effects of the killings. They would not displace people, but nor would they allow those who had been displaced to return. The propaganda on both the Croatian and the Serbian sides contained enough material to declare the war an unqualified triumph and to convince its consumers that a victory had been won.

Chapter 8

'I am Interested in 66 Per Cent of Bosnia'*

Milosevic was partial to the drawing of maps defining new borders, with his own state being the biggest and strongest on the map. To simplify matters, peoples, regions and cities were reduced to different-coloured flags that could be moved at will. Cosic's idea of the humane movement of people went ahead without objections. Tudjman planned to pursue a similar policy.

Milosevic continued his double-dealing. He was president of Serbia, which, his propaganda held, Yugoslavia had humiliated. Nevertheless, he continued to protect his state against the very people Yugoslavia had once harboured and protected. When the other republics decided to break away from Yugoslavia (Slovenia and Croatia in 1991; Bosnia and Macedonia also started to break away in 1991 but only got their final referendums in 1992) Milosevic established a federation of Serbia and Montenegro he called the Federal Republic of Yugoslavia (*Savezna Republika Jugoslavija* or SRJ). A constitution for this new entity was drawn up over several days in the little village of Zabljak. In terms of population, the ratio between the two federal units was eighteen to one, but officially they had equal rights. In addition to their own governments, parliaments and presidents, they had two federal parliament buildings, a federal government and a federal president. As equals, Serbs and Montenegrins saw themselves as the lawful successors of Yugoslavia. They claimed the defunct state's property as well as its positions in international institutions, even though the international community did not recognize the new federation. Milosevic's experts on international law referred to this policy as 'a logical progression from the preceding Yugoslavia'. They were careful to use the word 'preceding' rather than 'former'.

* What Milosevic famously declared to Franjo Tudjman at the start of the war.

This manipulation of facts confused Western diplomats and politicians. Baffled by documents that did not correspond with reality and a reality that did not correspond with any documents, they decided either to recognize or to overlook both. They called the new state (which they did not formally recognize) Yugoslavia and entered into negotiations with Milosevic, the president of Serbia. The mediators were either too naïve or too misinformed to understand that Milosevic would never honour the cease-fire documents he now so willingly signed. Both sides behaved as though they were performing a serious task whose consequences would be immediate and wide-ranging.

The presidents of the states established within the borders of the former socialist republics were all, without exception, former Communist Party members. There was only one anti-communist, Alija Izetbegovic, a pan-Islamist who had twice been gaoled for his unacceptable beliefs. Izetbegovic, along with Adil Zulfikarpasic had established the SDA in 1990 – *Stranka za Demokratsku Akciju* (Party for Democratic Action). This was the first party to be established in Bosnia and Herzegovina. Its initial aims were democratization, national equality and civil liberties. Izetbegovic had no political experience. He was a very different breed of political animal from Milosevic and Tudjman. He was devout, polite, spoke slowly and listened to his interlocutors. It seemed he would be an easy victim for his two robust neighbours. However, contrary to Milosevic and Tudjman's confused assessment of him, his party had been established on two firm principles – the national and the religious. This tranquil president was in fact a strong leader who knew how to act hard and decisively. For him, the nation was an offshoot of religion, and religion was the armour of the nation: 'Our motto is to fight and believe,' he said.

Because Serbia had appropriated the Yugoslav National Army for its own purposes, and taken hold of all its weapons and technology, Izetbegovic was unable to pull together an army of his own. His great mistake was to organize a referendum on independence – despite the Serb and Croat parties' protests and threats of war. He won the referendum; the exact percentage of his own Muslim nation was reflected in the results because the Bosnian Serbs and Croats had abstained from voting. If his own declaration is to be trusted, this marked the creation of the first Muslim state in Europe since the retreat of the Ottoman Empire: 'An Islamic society lacking the authority of Islamic law is powerless and

incomplete; Islamic law imposed on a non-Islamic society represents either a utopia or an aggression.'

Belgrade and Zagreb propaganda, which invariably agreed to anything that related to a third party, instantly claimed that once again Islam was threatening Christianity. Christianity and Europe needed to be defended against these new aggressors. But who would lead the defence? Croatian propagandists declared that for centuries their country had been the *Antemurale Christianitatis*, 'the bulwark of Christianity'. Serb propagandists claimed that their people had defended Europe from a Turkish invasion at the Battle of Kosovo on 28 June 1389, three days after which the bells of Notre Dame in Paris had rung to celebrate the Christian victory. As usual, the supine consumers of the propaganda did not question these assertions.

Under communism the republic of Bosnia and Herzegovina had been especially attached to its Yugoslavian identity, which allowed it to avoid any unwelcome association with Croatia or Serbia.[1] A third of its citizens declared themselves to be Yugoslavs, which although a non-existent nation under the constitution still gave them the same rights as any other nationality. But there was an all-important difference; because it was not an autonomous republic it had no cadre lists and thus no way of electing future leaders. However, it seemed that the people of Bosnia had learnt their lesson from the bloody wars that had decimated so many of their people and were now able to live together. This was more obvious in Sarajevo than anywhere else, where tolerance was a palpable condition of everyday life. There was genuine tolerance.

Now, beneath the calm surface of coexistence something different was stirring. Many intellectuals – historians, linguists and writers – were starting to subscribe to a Copernican theory that challenged the Bosnian *modus vivendi*; they believed that life together was impossible. It had only been possible until now because there had been no freedom and therefore no choice. The first effect of freedom was to deny the rights of free people to live in harmony with people of different ethnic origins. Serbs, for example, could not live with Croats and Muslims, just as Muslims would not tolerate living with Croats or Serbs. Ironically, the Serb objection to cohabiting with Muslims implicitly disproved a theory the Belgrade media had so authoritatively asserted, namely that Muslims *did not actually exist* in Yugoslavia and that those who called themselves Muslim were none other than Serbs who had converted to Islam, either because they had been

forced to or out of a desire to conform. Biljana Plavsic, a new politician said: 'Muslims are degenerate Slavs. I know this because I am a biologist.'[2] All three sides viewed people who saw themselves as Yugoslavs as traitors, as a common enemy against which they were united.

Feverish, secret preparations for a war in Bosnia were underway. All three national parties were involved in this: out of fear of the other two sides each side armed itself. Paranoia was rife and it spread like a virus. Echoes of the horrific war in Croatia added urgency to the preparations.

All three national parties in power – the Party for Democratic Action, the Serb Democratic Party and the Croatian Democratic Party – worked hard on their underground plans. According to their propaganda, national identity could only be created out of the ashes of war; it would be watered by the blood of the innocent and strengthened by dogmatic loyalty to leaders. Demos had become ethnos. Each side's conception of democracy was in fact a conception of *ethnocracy*. Once established, the three future states would separate into three religious factions: Orthodox, Muslim and Catholic. Izetbegovic wrote: 'Muslim identity generally asserts itself in its relation to the group, rather than through the individual.' The leaders of the other two sides could have made exactly the same claim. Individuals no longer existed in public. Those who did not wish to align themselves did not belong anywhere.

While preparations for mutual destruction continued apace in Bosnia, academics and writers in Belgrade made preparations of their own. They established the SS (*Srpski Sabor*, Serbian Assembly), which was an association of independent scientists, writers, artists and intellectuals whose task it was to 'promote and protect Serbian national interests'. In this 'independent association' there were of course no ordinary citizens. The assembly, which a certain linguist presided over, soon completed the important task of 'constructing ethnic maps that delineated the future Serbian state'. The maps were ceremonially unveiled at a congress of Serbian intellectuals held in Sarajevo at the end of February 1992. Neither Dobrica Cosic nor Milosevic, who together had instigated this work, attended the congress. Both of them, coming from the same school of politics, had learnt that it was safer to watch from the wings.

A week later at a Serbian wedding the bride's father was gunned down as the procession passed through the streets of Sarajevo. The assassin was a Muslim. That bullet marked the end of contemporary multiethnic Bosnia. It

was the long-awaited spark that would ignite a new war. Each of the nations' intellectuals hoped that the Western powers would get involved and support their individual causes.[3] Serbian nationalists counted on Russia, Croatians counted on Germans and the Muslims counted on the wealth of their Arab coreligionists. And all three sides had turned to the Western democracies to ask for the protection of their rights.

In the parliament, Radovan Karadzic announced that if there were to be a war the Muslims would inevitably perish. He did not mention the Croats. He had received orders from Belgrade to spare the Croats, so they were not sentenced to death. Later, Karadzic and his supporters withdrew from their official positions within the administration, in accordance with a secret plan made a long time before in Belgrade. They then removed to Pale, a picnic area with the best view over Sarajevo. The future capital was neither a village nor a town, but a collection of villas among which was the one that had cost Karadzic and Krajisnik a gaol sentence.[4] The Bosnian Serb colonels who would soon become generals were already holding councils of war there. Among them was Ratko Mladic, who later became famous in Krajina for his ruthless expulsion of the Croats. Karadzic and his parliament (which did not have a single representative from any party other than his own) proclaimed the birth of a Serbian republic that would later become known as Republika Srpska. It was to be ethnically pure, Orthodox and independent. The operation underway was devised by intellectuals and directed by politicians.[5] Tens of thousands of people protested in vain in the streets of Sarajevo and held hands in a 'peace chain'. No attention whatever was paid to them: they were powerless.

In contrast to those who wanted peace, a highly organized, decisive and well-equipped mass knew exactly what they wanted and were preparing for war. The new unwritten law that dominated the Balkans was about to be put into effect: and that law stated unequivocally that life together was impossible for people of different ethnicities. No normal existence was possible until the 'others', whomever they might be, were disposed of. The confused JNA (no one knew who was in command, they only knew whom they served) tried to partition Sarajevo, but failed. Fighting now began in earnest. As the city was not immediately subdued, it needed to be besieged. Since it would not surrender, it needed to be shelled. It did not matter that, as the Pale propaganda claimed, the Muslims were holding tens of thousands of Serbs hostage.

The armament of the Yugoslav Army (which no longer numbered any Slovenians, Croats, Macedonians or Albanians in its ranks) was powerful and efficient, expensively bought from abroad and supplied from the reserves of the new Yugoslavia, which, as Milosevic insisted, was not at war. War had never been declared. 'There is not one Serbian soldier on Bosnian territory,'[6] said Milosevic. 'There is not one paramilitary formation on Serbian territory.'

Milosevic was not a soldier. He avoided danger and dreaded physical conflict, but he seemed to relish organizing the army and the police, to which he gave his full time and attention. The consequences were devastating. The Yugoslav National Army had ceased to exist since almost all those who were not Serbs had abandoned it. It was now called the Yugoslav Army and contained only Serbs. A man who no longer went out into the streets of the capital had presided over this transmutation. Since Serbia was not at war, a rump of the Yugoslavian army remained in Bosnia, together with all its equipment, armament and officers. This force called itself the Army of Republika Srpska.[7]

The shells of the 'new and old' army began to rain down on Sarajevo, which had no defence. People took refuge in their cellars. The new city administration was without water, electricity or gas and lacked even the most basic organizational skills. Prices rose and the new currency became the Deutschmark. International journalists arrived and thus began the longest, best documented and most thoroughly described siege in the history of the modern world. On my television set in Paris I watched the obscenity of war day in and day out, like a continuous soap opera of death. And the details! At times the battle seemed to be between the world's voyeurs and the world's Serbs.

Before long a massacre took place in Vaso Miskin Street[8] among people who were waiting in a bread queue. It caught the world's attention. Foreign television crews arrived on the scene of the attack to broadcast horrifying live images. The French philosopher Jean Baudrillard maintained that the Gulf War 'did not happen' because no footage was ever shown of spilled blood, injured soldiers or dead children. In Sarajevo, the reality of the war was made undeniable by a host of courageous journalists – above all by CNN, which reported live from inside the hell of the siege.

In the long and bloody history of the Balkans this undeclared war will take a special place. It was neither the first nor will it be the last. Its

83

uniqueness springs from the fact that it fused raw imperialism and incurable nationalism. Given the nature of the national leaders in charge, the war on the ground was – unsurprisingly – deeply cruel and senseless. It was visible and present in living rooms worldwide. Voyeurism was part of the equation justifying the enormous media attention it received. Newspaper descriptions of the siege were consistent with standard procedure and the predilections of the readership: a mixture of fact, pathos and unconfirmed claims. All this was blended, as usual, with sports news, fashion, financial reports and the woes of Princess Diana. But television was different: it broadcast and serialized the war live. The participants ensured that nothing happened without cameras at hand, except what needed to be hidden from foreigners and saved for domestic purposes. Originally, it was called a dirty little war. Then it turned into a long disgusting war. Even later it became the war whose instigators needed to be brought to a negotiating table. Finally, it became – and remained – the aimless war. In the history texts that are currently being written in the new states of the Balkans it will probably be called a war of liberation or a civil war. But we can be sure that very few authors will refer to it as what it was, a conflict of nationalisms and a war against civilians.[9]

Milosevic defined the tone, colour and main characteristics of this merry-go-round of horror. He proclaimed that he had always been in favour of peace. He has always tried to exist between light and darkness; one side of his face would be lit while the other was in shadow; then the sides would suddenly change places. The main instigator and director of the war behaved, in fact still behaves, as though he were not present. He did not give interviews, appear on television to explain what was going on or answer questions; he explained none of the moves he made behind the scenes.[10] He remained at home. For him there were two worlds, one outside and one within the family. Every Sunday his wife published sentimental articles that heralded the preparation of a new left-wing party. Their son Marko participated in car races, in which other drivers beat him at the risk of their careers. Their daughter Marija was having boyfriend troubles, despite all the men in her life having received promotions of the sort they could never have dreamed of had they never met her.

While the Belgrade propaganda machine was working overtime to maintain his image, Milosevic hid quietly in the calm of his marital nest. He did not expose himself to the dangerous test of his people's love. Not

once had he appeared in a football stadium; he was never seen in a theatre, at an exhibition or a concert. From his eyrie, Milosevic made constant phone calls to his minions, snaring the country in his web. He asked for nobody's opinions and consulted no advisors. He claimed to know it all. He delivered orders with complete assurance. Those who disobeyed were dismissed by a phone call.

The rise of Ratko Mladic was gradual: he was a communist officer who had slowly climbed the ranks to become a commander in the new totalitarian regime. One of his subordinates said the following in a newspaper interview: 'I was a good communist like all the other comrades. When the order came in, I became a good Serb.' Who gave the order to become a good Serb? What would this officer have become if the order had been different? The training was long, the brainwashing arduous; obedience came first. The young officers were trained to carry out orders in return for privileges. The army neither interacted with society nor shared its problems. When Milosevic emerged, even though not in uniform, the order that had collapsed following Tito's death was re-established. The old ideology held that anyone who was not a communist was an enemy and unworthy of being considered a human being. The new ideology only changed one word – we are all Serbs, anyone who is not is our enemy and unworthy of being considered a human being.[11] A few more details need to be noted about Mladic's rise to power: he was highly ambitious, pathologically cruel and able to wage a war in which there were no rules and to make decisions far beyond his competence. In short, the commander of the Bosnian Serb forces was no better than a street thug.

Milosevic knew how to choose the right associates; he unfailingly selected the worst ones. Not once did he single out a man who would not follow his unintelligible slalom down the icy slopes of Yugoslavian misery. When their tasks were completed, he discarded his people with total indifference. None of them ever complained. The files that listed their crimes, thefts and frauds were safe in Milosevic's hands. A man without a sufficiently disreputable dossier could never find a place in Milosevic's regime, while people with really shocking track records were positioned in high places specifically because they would do as they were told through fear of being exposed. They could be charged with anything: theft, fraud, blackmail, cooperation with the police, police reports against their loved ones, alcoholism, homosexuality, reports claiming their children were drug

addicts, sexual assault against their subordinates. They could all proudly claim that: 'Nothing inhuman is foreign to us.'

During that time Milosevic's regime began to resemble its master more and more: it was aggressive, impudent, irrational and demagogical; it sought neither allies nor supporters, was highly secretive and maintained connections only with those whom the civilized world had rejected. His secret plan, which only a few of his propagandists shared, was for the Serbian people to separate from the rest of the world on the grounds that the rest of the world was against them. Serbia had to be brought into line with its president's psychological state. If there were insufficient evidence to support the idea of a world conspiracy it would have to be invented. Invented evidence was better than real evidence because it could be amended, tailored to the circumstances or even denied.

Serbs have a form of irrefutable evidence they use habitually when everything else fails: 'We saw it on television.' This formula replaced holy texts, popular sayings, the wisdom of saints and scholars; above all it replaced the facts, especially the obvious ones. Every evening at half past seven, the Second News of Radio Television Serbia told its viewers that a world conspiracy was underway. The world was preparing to destroy Serbia and all Serbs, to wipe out Orthodoxy (the only faith that had kept its original purity) and to crush the one national entity that dared to oppose globalization and the New World Order. There was as yet no proof, but television could be trusted. It constantly showed all the wise Serbian heads who endlessly repeated the same message, 'The whole world is against us. Nobody will come to our aid – but we will survive.'

By imposing economic sanctions on Serbia and Montenegro, Western administrations unwittingly managed to convince the Serbian people of the conspiracy theory promoted by their regime's propaganda. The borders were closed from the outside and there were to be no imports of goods or money. Foreign ambassadors left Belgrade, aeroplanes ceased to fly and Yugoslavia's access to international financial and political institutions was barred. Branko Kostic, a former member of the Yugoslavian presidency, said: 'If necessary, we will eat the roots of plants.' He was immediately nicknamed the Root. Seselj added: 'If there is no oil for cars we will ride horses.' However, his opponents still referred to him as 'Governor Pussycat', which was an indictment not of his violent fascism but of his alleged homosexuality. A businessman from Nis started a horse-drawn

carriage service along the empty motorway between Nis and Belgrade, stopping in all major cities along the way.

Serbia became an island with international surveillance around it like that of Dedinje, Milosevic's 'magic hill'. The international community issued a *no pasaran* directive to the Serbs. Milosevic retorted by issuing a similar one to the West. He carefully selected which foreign diplomats would be allowed into the country – the odd minister of foreign affairs, an occasional anonymous 'friend of the Serbian people' and the intermittent 'business partner' who would promise to invest millions of dollars and never did. The regime's propaganda held that all the visitors fully agreed with the views of their host, who reserved the right to change his opinions often and unexpectedly. Nevertheless, Western politicians were taken in by the infantile game Milosevic was playing with them and with his people. When they lost their patience with Milosevic they punished the Serbs who became progressively poorer and more isolated – then they behaved as though this poverty and isolation was not of their making. By the time sanctions were imposed Dobrica Cosic, veteran nationalist writer and Tito's former fellow traveller who had waited many years to acquire political power, had been acting as Milosevic's advisor and self-professed spiritual father for three years. Prior to the war in 1991, *Politika*, the newspaper most loyal to Milosevic, published an interview with Cosic in which he described the national programme, namely the strategy for the coming war, in terms of the 'humane movement of people'. Several months later this idea re-emerged as full-blown ethnic cleansing, carried out by the Serb paramilitary formations, Seselj's forces and others.

Milan Panic, a former cyclist and naturalized US businessman with companies in the Cayman Islands, appeared in Belgrade for the first time after buying a Zemun pharmaceutical factory with Milosevic's approval and the cooperation of those closest to him. He did not invest any money of his own; instead he invested ideas, which according to those with whom he was dealing were worth many millions of dollars. Soon afterwards Belgrade suffered a serious shortage of medicines.

A Serbian called Ostap Bender was the owner of a satellite channel through which the Milosevic regime's propaganda was broadcast to the rest of the world. The sanctions did not apply to propaganda, for some reason. Milosevic had won Bender over with a simple covert threat: 'Your money, my name, are these not enough?'

Both Cosic and Panic were 'unsettled and worried'. The introduction of sanctions had failed to bring about Milosevic's downfall but it had made it more difficult for him to apply his habitual 'counter-methods'. Help was needed. Cosic became the first president of the new Yugoslavia and Panic became prime minister, elected by the socialists and a few members of the opposition.[12] They did this to 'save Serbia from NATO bombardment'. Cosic made soft statements, incomprehensible even to him. Panic was constantly with journalists; he even commandeered a government aeroplane so that he could move them around the country and abroad, which made him easily and instantly popular. In fact, the business of the pair was to convince Western administrations that Yugoslavia was not the aggressor and that Mr Milosevic had no connection with the Yugoslav Army, just as that army had nothing to do with the war in Bosnia. This was no more than anti-Serb propaganda sown by the Vatican and Comintern, and supported by the defeated Yugo-nostalgics. The latter were more dangerous than all Serbia's other enemies put together because they were the last remaining witnesses who knew that life together *was* possible and because they claimed that it could be possible again in the future. Such a future could never be accepted. At least a decade prior to the break-up, Dobrica Cosic had claimed that Yugoslavia was dead; now he suddenly found himself the first president of a ghost country. On the inside, the Cosic and Panic 'duo without a helmsman' and without real power (because Milosevic still held it) proudly declared a war on crime. Crime rates were soaring within Serbia and Montenegro, and this was almost entirely attributable to various Mafia organizations whose ties to the Milosevic family were not difficult to trace. In fact, it is thought that these Mafia organizations regularly paid an informal tax to the residents of the Dedinje villa. Is it possible that Cosic and Panic did not know this?

Cosic and Panic announced their planned assault on organized crime from the podium of the federal parliament. However, neither of them was ready to arrest the main criminals or to dismiss the paramilitary units, even though both were constantly in the media and known to everyone – including the children who played in the streets. The Cosic–Panic resistance to Milosevic was necessarily confined to words alone. Crime spread throughout the country, *assisted* by the emptiness of Cosic and Panic's oath to remedy the problem. It was ironic that the country should declare a war on crimes committed by paramilitary units when it had

claimed that no such units existed at all. For decades the Yugoslav secret police had directed criminals in foreign countries. Abroad they were causing damage to others and occasionally completing patriotic tasks such as bringing about the bankruptcy of those emigrants who dared to tarnish the name of Tito. Since Milosevic had gained power and 'restored the dignity of the Serbs', these internationalists had felt the call of the homeland and returned to Serbia. The secret police recruited them from old lists and allied them to local brutes, maniacs, bullies and drunkards. They became the 'Tigers', 'Wolves', 'Eagles', 'generals and colonels of the people's army' and 'military leaders'. They were useless soldiers but proved willing to follow their instincts and commit crimes that would under other conditions have cost them a prison sentence or a place on the Interpol wanted list. They pillaged, spread terror and slaughtered the unprotected, thus fulfilling Cosic's promise of a humane movement of people.

The introduction of 'unjust and unprovoked sanctions' against Serbia and Montenegro created a climate for black-marketing at state level. This suited the regime, which was ready to seize whatever plunder it could. Official thefts were performed through the agency of legitimate government organs. Criminals back from the front lines joined the politicians in wholesale theft with the benefit of police protection. Helped by increasingly xenophobic propaganda, crime spread over the whole society, finishing off the remains of the old moral code and creating a brand new one – a counter-morality that reflected the needs of Milosevic's counter-method. Deception, theft and summary appropriations brought quick wealth to the new caste, with the added advantage that there was only one compulsory tax to be paid on it, which had to be handed over to the representatives of the state leader.

Milosevic had by now earned a new nickname from the various criminalized politicians and politicized criminals clustered around him: The Boss.[13] The new 'business' conditions, combined with absolute indifference to its victims, underpinned the rapidly growing wealth of Serbia's ruling family. Not one representative of the opposition in parliament had ever questioned the Milosevic family's suspicious sources of revenue. Two years later *The Economist* published figures suggesting that the Milosevic family had amassed sums equivalent to $1.1 billion. Tudjman's gains were comparable. As for Izetbegovic, who had once made the Hajj pilgrimage to Mecca, no reliable estimates exist.

Chapter 9

Crime, Inflation and Other Games

Since power, propaganda and plunder represented the only infrastructure in Serbia, elections needed to be organized as soon as possible to provide the propaganda apparatus with material to confirm the viability and functionality of the power structures. This was crowd entertainment with very little risk for those in power. The regime chose the right moment, forced the conditions, allocated times in the media and named the members on the election commissions. The rest was a technicality.

In autumn 1992 the clamour of applied politics overshadowed all other issues. Milosevic put himself forward as a candidate for a position he already held. His most recent ally Milan Panic changed roles and became the counter-candidate and representative of the united Serbian opposition (DEPOS). He had already bought a large factory without spending a single dollar; why should he not become the president of a people whose language he had forgotten? Dobrica Cosic did not get involved. He said, 'I give my support to the political forces that give me their support.' But the old man was no longer important. His national programme had served its purpose; its creator would soon be sent back into retirement. The vociferous Vojislav Seselj, who had so far been kept in reserve, now entered the game. He was needed to confront the opposition and collect the votes of those who were confused, of those who took his criticism of communism seriously and of the nationalists who still believed in the idea of a Greater Serbia and the 'unification of all Serbian territory'.[1] This project had been brought close to fruition in the killing fields of Bosnia.

Over the coming years sham elections would become the norm, a habit both the government and the opposition adopted. Milosevic defeated the Californian cum Cayman Islands businessman Panic – the opponent with whom he had shared the spoils of the Galenika pharmaceutical factory.[2] The president's and Seselj's party won exactly the same number of seats as

they had two years previously – about 80 per cent. Several opposition parties abstained. More parties joined in and shared the remaining seats among themselves, while muttering complaints about the outrageous ballot conditions and rigging of votes. Markovic's party – the Union of Communists, the Movement for Yugoslavia – failed to get a single representative but never complained of electoral irregularities. Power continued to reside in the family where all were equals. Comrade Markovic once said, 'I have always thought mine the stronger sex;' nevertheless, her husband somehow remained stronger than everyone else. Instead of falling, Milosevic strengthened his power, thanks to the odd chemistry in the minds of Serbian voters and the boycott of Albanian votes.

Serbia's infrastructure had indeed fallen into complete disrepair. The factories had stopped working; there was no medicine; schools had no heating; buses were hours late and aeroplanes no longer flew. Pensions arrived late; old cars fell apart; the ambassadors had left Belgrade; refugees from Croatia and Bosnia's Serb-controlled areas were pouring in – but throughout this period the regime's propaganda mill continued to pump out its message. At the heart of this propaganda was Serbian Television, which charged its licence through electricity bills. Whoever wanted to have light and heating had to pay for a television licence. There were no recorded cases of anyone refusing to pay this imposed charge nor were there any protests. Money was regularly coming in to where the regime needed it most. This media octopus, which employed several thousand people (the disobedient had by now been sacked) stretched its tentacles to every city and to every local office that cooperated with the central office, by confirming whatever came from the capital.

The country's great economic achievements were proclaimed every evening. Any alleged crimes committed during the war were consistently denied. In fact, very often the war itself was said not to be taking place. The Muslims must therefore have been shelling and killing themselves to spite the Serbs. America, (which everyone believed was trying to acquire Siberian oil deposits via the Balkans), was conspiring against the plucky little nation that opposed the New World Order. Islam-friendly France was denouncing its loyal ally from the First World War.

The treacherous British were openly cooperating with the Germans who themselves had cooperated with the fascist Croatians. The Croatians, true to their behaviour in the Second World War, were killing and expelling Serbs

all over again. Luckily, in Russia, the American–Judeo–Masonic–Muslim agent Gorbachev had been removed, but the communists and nationalists, the Serbs' natural allies and brothers, had lost power. As for the Pope – he was Polish, and neither an ascetic nor a saint like the Serbian patriarch. He hated his Slav cousins because they were Orthodox. All in all, Milosevic's media attacked anyone who came to mind and, regardless of how outlandish or incorrect the attacks they always succeeded in gaining the people's support. People trusted them and, in doing so, became unwitting collaborators.

If one trusted Serbian election results it might seem as if Milosevic were popular with the voters, but they did not always please him in return. They gave him power; they did not question his decisions; they did not go on strike; there was no trace of social revolt; they justified his actions despite failing to understand them and they cursed him only to save their consciences or to trick their interlocutors. However, they persisted in hiding the money they had accumulated through years of savings or had acquired from family members working abroad. They loved their home country and despised its dinar; they loathed the Germans but held tight to their Deutschmarks. This could be tolerated. The undeclared war cost as much as the declared one, his clique constantly asked for more money, the police force was not cheap even in places where young men dreamed of becoming policemen above all other careers.

The cost of propaganda abroad was high (an advertisement in the *New York Times* was said to cost around $2 million) and Marko Milosevic had just crashed his seventeenth luxury car.[3] Now Slobodan's inner banker was looking for an opportunity to show his understanding of the essence of finance. Surely banks were meant to make deals not with their own money but with other people's? Surely banking was like politics, just a question of trust? If investors refused to come forward of their own free will they needed to be lured. If they distrusted the state that had already robbed them twice (because it had to) they might trust those in which the state placed its own trust. Therefore, one had to find ideal go-betweens, unsullied individuals to whom trust could not be refused. The rest would flow naturally.

Inflation, which had held steady for a long time in Serbia, began to rise dramatically. Every day, street dealers in the cities (this was a new occupation ex-doctors and university professors sometimes held) would offer ever more federal dinars to the Deutschmark. This money, fresh from the mint, was losing value daily. It was no use even to save marks. The

governor of the National Bank said: 'We have devalued the German mark.' But what could be done with these devalued marks? The question had not even been formulated in the public mind before the answer appeared in all the state media. Save. Invest your foreign currency. You will get the highest interest rate in the world – 10 per cent a month. Of course, only invest in private, not in state, banks. State banks are unpredictable because they are too big; private ones are much more trustworthy because the state watches them closely.

The situation was the same as it had been three years earlier when the party was formed. The doors were open to everyone; there were no conditions. Dozens of private banks emerged, humbly calling themselves 'savings banks', but only three of them gained the absolute trust of the people as well as the government. The first was Braca Karic (Karic Brothers); the Karics were Kosovo Serbs who started out by running a family orchestra that played at weddings and watering holes but later rose to the top of the Serbian business world. Bogoljub Karic, known as Bogi and a personal friend of the president, was the head of the bank. He had a villa in Dedinje located between the Milosevics and the Cosics. Jezdimir Vasiljevic, known as 'Boss Jezda', set up the second bank. Nobody knew anything about him except that he had been very successful in the outside world and had hurried home to help his people. The third was run by Dafina Milanovic, known as 'Mother Dafina', who went straight from gaol to a senior position in a private bank. She had served no fewer than ten gaol sentences, on one occasion for issuing 700 bad cheques. She claimed that 'Serbia was the apple of her eye'. This was sufficient confirmation of her banking abilities and even more persuasive than her gaol record.

The media singled out 'Boss Jezda' and 'Mother Dafina' (other plans were in store for the Karic Brothers), and turned them into mythical figures. They, in return, either believing what was said and written about them or else, simply by following the orders of their creators, acquired mythical appetites and indulged in mythical behaviour. Long queues would form in front of the banks 'Boss Jezda' and 'Mother Dafina' ran.[4] To reach the magic counter you had to wait all night, fight those in front and behind you or buy a numbered ticket. But somehow everyone managed to invest his or her money. Over the next few months these investors basked in the sweet illusion of becoming rich by staying at home and watching television. In Serbia, people still sang the song 'No one can harm us/We are stronger than

destiny/Those who do not love us/Can only hate us.' Meanwhile, the mid-summer night's dream needed to be kept going – the sleepers had to be kept drowsy in case they discovered that they had fallen in love with a donkey.

'Boss Jezda' showed the imagination of a producer using other people's money to put on his own show. He decided to entertain the masses with a high-profile chess match, even though chess was of no interest to the great majority of people. The famous match between Bobby Fischer and Boris Spassky, held several years previously in Reykjavik, had to be reorganized. The prize money was to be five million dollars – even the bankers no longer used the domestic currency. An agreement with Spassky had been reached, but how could a successful arrangement be made with Fischer who had stopped playing and who had retreated from public life? 'Boss Jezda' somehow managed to do this.[5] Fischer not only arrived in Yugo-slavia but, with television cameramen eagerly recording the event, he also spat on a document from the US government forbidding him to violate the UN sanctions. Later, in the luxurious resort of Saint Stefan in Montenegro, the 'match of the century' was played again with the same result as the previous one. The American chess dissident, who denounced the American way of life and thinking, had to defeat the former Soviet dissident who submitted to it. The Serbs, and Montenegrins who regarded themselves as Serbs, thus sent a message to President Clinton and to all other nations suffering under American occupation.

Milosevic had to have a part in this media event. He received Fischer and had a 'long and sincere talk' with him. The photographs clearly show their similarities: the stiffness, the mask-like expression, the awkward movements, the detachment from ordinary life and the autistic behaviour. 'The unhappy little child who is orphaned early in life grows up to be a big unhappy man,' Fischer once said. Both men, having been hurt in childhood, became all-powerful when they grew up. Fisher commanded the pieces in a game that imitated war; and Milosevic commanded the living in a real conflict. Both men's dream had come true, yet the games they played reflected the eternal stalemate between black and white.

The frenzy of greed that had spread through the population subsided as quickly as it had arisen. The private banks were swiftly ruined and as they disappeared so too did the money they contained. Via private go-betweens the money had been transferred from people's pockets into the vaults of state banks. The state banks then had it flown from Serbia to Cyprus under

names selected from telephone directories and obituary columns. The Milosevic family bank (nostalgically called the Bank of Belgrade) and several offshore companies received it in Cyprus under the auspices of the elderly Mrs Vucic, Milosevic's associate from his banking period. From there it was redirected to banks in the West where it was deposited in the private accounts of numerous patriots living abroad who gladly agreed to guard the money until its real owner needed it. It was the least they could do for their beloved homeland. Two or three of these expatriates who had started collecting expensive pictures by Serbian painters, buying Rolls-Royces and frequenting casinos were later murdered. The hand that robbed the Serbs had long and merciless fingers. The Western police never found their killers because the trail invariably went cold in Yugoslavia. The Yugoslav police at that time were unwilling to pursue any kind of criminal.

By the end of 1993, inflation in the country of Serbs and Montenegrins had reached record-breaking levels. In January of the following year it became the highest in the history of humanity. 'The rise in prices amounts to a fantastic 313,563,558 per cent. On average, the prices rise 62 per cent a day, 2 per cent an hour and 0.029 per cent a minute.'[6] A note inscribed with the number five followed by eleven noughts (in writing, it is five hundred billion dinars) was printed, and on that very same day, one could buy no more than a box of matches with it.

One could also wipe one's shoes with it without any sense of waste or regret, or make a family collection for future generations. It still bore the legend 'Falsification is punishable by law,' as well as the image of the national poet Jovan Jovanovic Zmaj and a picture of the National Library in Belgrade. It was worthless paper, printed with a symbol of culture that had lost its value. 'At the end of 1993 the dinar has been completely removed from practical use. Thus the government, though run by men who purported to be uncompromising defenders of the Serbian national interest, allowed the Deutschmark to become the national currency. Hyperinflation finally invalidated the reason that had provoked it in the first place.'[7] At the time, the academic Kosta Mihajlovic, who was Milosevic's economic advisor and one of the authors of the memorandum, claimed: 'What represents one of the biggest long-term advantages of the Yugoslavian economy is the determination of the people to endure hardship.' This, of course, was matched by the iron determination of the elite not to share in any part of that hardship.

There were numerous suicides of dinar multi-billionaires. One desperate man, who spent his entire monthly pension on a sausage and piece of bread, wrote in his suicide note, 'I don't want to die hungry,' then hanged himself. Another woman who could not bring herself to end her own life said:

> *I am afraid to die because I will burden my children with funeral costs. They also have nothing to eat. I have forgotten the taste of fruit, meat and even milk. I do not eat breakfast or supper, I no longer drink coffee and I no longer smoke. ... And my last pension was eight billion dinars – just enough for a roll of toilet paper.*

While Milosevic was still playing the role of Sloba-Sloboda, he promised his people Swedish living standards as soon as he could stop the Slovene and Croatian plundering of the Serbian economy. Typical of his famous counter-method, the opposite occurred. He claimed that the Serbs had failed to achieve the highest living standards in the world because of 'unjust and unprovoked UN sanctions'. Still, neither he nor his people in any way held him responsible for either the inflation or the sudden abject poverty that had struck the majority of the population. Nor was he seen to have had anything to do with the criminals and fraudulent bankers,[8] the misery of everyday life or even the war. He was above and outside it all and could not be held responsible. Milosevic was a great illusionist because, despite his hands always being empty when he took them out of the hat, his audience remained convinced that they saw the results that his propaganda machine had promised. Now, having understood the suffering of the people, he decided to solve all their problems at a stroke, just as he had once done with the Albanian question in Kosovo.

One of his chosen pensioners, Dragoslav Avramovic, a former employee of the United Nations whom the crowds and media were soon to know as 'Grandfather Avram' or 'Super Grandpa', announced an anti-inflation programme.[9] He looked like an old man who had just come back from the market, but he handled the economic situation like a village witch doctor and, to a large extent, copied the model the disgraced former prime minister Markovic had proposed (obviously omitting notions of privatiz-ation or of a free market). Nevertheless, he too was turned into a mythical personality. This time they were dealing with the antithesis of hyper-criminals such as 'Boss Jezda' and 'Mother Dafina' (who needed to be

forgotten). Avramovic was presented as an impeccably honest man; the regime's propaganda machinery once again successfully persuaded the masses to place their trust and confidence in him. Once he had completed his role to the satisfaction of the Milosevic family he would be returned to retirement.

Inflation was brought under control; the terrible shortages ceased and there was enough money to live on. Poverty was still on the increase and there were no new jobs, but no one was particularly dissatisfied, neither the impoverished population nor the new caste of criminals and war profiteers. The 'just social policy of Slobodan Milosevic' continued to impoverish the people, yet there were no strikes or demonstrations. Milosevic proclaimed, 'We cannot be blockaded. Perhaps a thousand years of sanctions might have an effect on us, but otherwise they can neither harm nor threaten us.'

While Milosevic could calm the domestic situation with talk, circumstances on the international front had become highly precarious for both Serbia and Montenegro. Domestic and international policies were under the sole direction of the strong man of Belgrade. Now it was a question of manipulating the European Union's political uncertainty and its disagreements with the United States, which could be used to Serbia's advantage. Dobrica Cosic wrote:

We have reason to expect friction within the Euro–American alliance. With luck this will change our situation and give us room to affirm our national rights and interests. ... We can also expect Russia to reconfirm its strong presence in the Balkans. The reappearance of Russia will certainly challenge the stability of the alliance and upset the current balance of relations between Germany and America in the Balkans. They will no longer be able to operate here with the support of the European Union and the Islamic countries of the Near and Middle East.

The 'father of the nation' did not entertain the possibility that Serbs might actually welcome the Euro–American alliance.

Milosevic had rejected his 'spiritual father' – he even let Seselj publicly humiliate Cosic – but, as he could think of no alternative political option, he continued along the same path. As a politician without politics he depended on a negative system of judgements that reflected his own

understanding of the world around him as well as the way he thought it perceived him. The damage done so far to Serbia and Montenegro was unimportant. The priority now was to make misery and disaster look like the result of a highly sophisticated foreign policy thwarted by the vengeful Western powers. The Western administrations were incapable of finding a solution – they were used to respecting certain rules and could find no way of dealing with a man who constantly broke them. Over the following two years Milosevic drew out his stalemate with the international community, interrupted only occasionally by what became known in Serbia as *ghali-ghali*[10] pacts and resolutions.

By stalling the United Nations, Milosevic gave himself enough time to complete his conquest and finally present the *ghali-ghalist*s with a *fait accompli*, which actually suited them better than a more vague result. Henceforth, the conqueror was now chiefly concerned with his own camp. During the process of deceiving the opposition, Milosevic's men had inevitably started to believe their own propaganda and had begun to deceive themselves.

Karadzic and Mladic, Milosevic's subordinates in Bosnia, were convinced that they were untouchable; they made one mistake after another and always in public. They shelled Sarajevo in front of the cameras and bragged about their cruelty to the world media. This inevitably reflected badly on Milosevic. He was their real commander, paymaster and supplier and it was under his orders that crimes were committed and their programme was carried out. Milosevic's counter-method did not allow for his subordinates to take the upper hand.

Karadzic, using the patriots from Bosnia who were living in Belgrade as intermediaries, had promoted the idea that he was the true leader of the Serbs, a true Orthodox, a monarchist and a man who hated not only the Turks but also Bolshevism. He said: 'We are dealing here with the end of the First World War. It can only end now, as we progress towards the establishment of our own state. ... Bolshevism was a foreign conspiracy, fomented not only by Russia, but also by Paris, Berlin, Ljubljana and Zagreb.'[11] Stories were circulating that Duke Tomislav Karadjordjevic, the last living son of King Alexander, was due to be crowned king of Bosnia and to marry the biologist Biljana Plavsic.

Dobrica Cosic said of Karadzic, as he had said of Milosevic four years before, that he was the 'most gifted Serbian politician of the century'.

However, the Dedinje master would not tolerate his local chiefs trying to reduce his power or take his place. Denying any connection with the perpetrators of the war in Bosnia, Milosevic imposed his own sanctions on Republika Srpska, which had hitherto been unaffected by the sanctions of the international community. He also closed the border crossing on the Drina River, which was the most important trade channel between Republika Srpska and Serbia.[12]

The regime's propaganda had to justify this abrupt change of policy towards people who had been 'victims of unjust and unprovoked sanctions'. The more contradictory the information the better it was. In the prevailing political chaos only invented fact could pass as truth, for the truth itself was too horrific and absurd to fathom. These new truths were tailored to the level of sophistication and self-deceit of the average recipient of the news. The people also needed heroes to distract them from the misery of their everyday lives.

The state, which still denied that it was at war, needed exemplars to act simultaneously as warriors and peaceful politicians. Milosevic, seated on the sofa in his villa where he received foreign visitors, was both the frontline commander and the innocent bystander who had no connection whatsoever with the war. He relied on state propaganda to manufacture front men for him so that he could play both roles with impunity.

During the battles in Croatia, the first of many heroes to be cloned was Kapetan Dragan (Captain Dragan). His real name was concealed from the media.[13] Dragan was a Serb by origin, although it is not known where he was born or who his parents were. He had fought in several wars and was living in Australia when the 'great threat' to the Serbian people first manifested itself. He immediately returned to the fatherland and placed his skills at its disposal, training units of thugs for special missions. Former JNA officers envied and hated him, but could do little about him.

Following his first successes, he went to Belgrade, where the media could always have him on call. His small, tough face became a feature of the front pages. In his interviews he praised Milosevic unstintingly. It seemed that in addition to his practical fighting skills he was also knowledgeable about serious military strategy, apparently more so than the generals. He was seen in the streets and restaurants, at concerts and fashion shows, always in his camouflage uniform and without weapons. Cartoon books written with him as the central character were on sale in all the

newsagents. His face lent itself to caricature. But all this was only an introduction to his great humanitarian mission, the Fund for Veterans and War Orphans.

Advertisements for his fund appeared constantly on television: 'Help those who defended you'.[14] But Dragan's star soon faded and he disappeared from the public eye. It was never known how much money went into this fund or for what purpose it was used.

There were some immutable stars in the firmament of Serbian public life. Arkan's rise was slower than Dragan's and he became a well-known fixture of Milosevic's regime. He had spent several years robbing banks in Europe and was rumoured to have liquidated various political enemies along the way. He was expelled from several European states and was on Interpol's wanted list. This did not prevent him from opening up a pastry shop in Belgrade and becoming the leader of the Red Star football team's supporters, known as the Heroes. His units wore red berets and their members were chosen from among the Heroes. They soon became known as the Tigers and were among the first to arrive on Bosnian territory in Slavonia and Baranja. After Arkan had cleansed Bijeljina of Muslims, Biljana Plavsic kissed him in front of cameras. His only comment on this occasion was that he wanted to open up a chain of modern pastry shops 'across the liberated Serbian territories'.[15]

Arkan had been married three times and had seven children. People said he was a good husband and a loving father, a loyal friend to those who did not cross him and a good Serb. He also respected Mr Milosevic as much as he respected Patriarch Pavle. Then suddenly, from one day to the next, the media were aflame with news of Arkan's new love: Ceca Velickovic, a famous singer of turbo-folk music. He divorced his wife and Ceca became the fourth Mrs Raznjatovic. Their wedding was a spectacular show.

Accompanied by the Belgrade jet set, Arkan went to collect his bride from her village in traditional style. The wedding took place in a packed church and was conducted by select members of the clergy. The celebrations continued in the ceremonial hall of Belgrade's Sava Centre. The groom threw thousands of Deutschmarks to the orchestra and musicians and the cameras filmed the entire event for a special feature that was broadcast all over the country.

These celebrations allowed an entire nation to forget its misery, to forget the war and above all to forget Sarajevo. The video of Arkan's wedding

became a valuable commodity all over Serbia and among the many 'dispersed Serbs' around the world. The reality of Milosevic's ailing country was obscured in a whirl of colourful images, loud music and patriotic phrases.

Meanwhile, Karadzic was also establishing himself as a great Serbian patriot and warrior, and his appetite for publicity ensured him regular appearances in the world media.[16] This was the man who had threatened to bomb Rome, Paris, London and, if necessary, New York and Washington.

He enjoyed the reputation he gained from his public statements, but to him and his caste of war profiteers a reputation was not enough. The world needed to acknowledge the exceptional nature of his deeds. Karadzic's soldiers captured UNPROFOR representatives and tied them to electric pylons, ensuring that images of these actions were made available to the whole world. Karadzic's men wore hoods over their heads and posed for the camera saying: 'No one can harm us. We are stronger than destiny.'

The fourth patriot was General Mladic. In the spring of 1995 Mladic was unhappy about the breadth of his front lines, the slow movement of his soldiers, their lack of motivation and his opponents' resilience. His solution was to start a widespread campaign of ethnic cleansing in eastern Bosnia. He personally commanded his artillery to wipe out Muslims and any other non-Serbs at any cost and using all necessary means. No attempt was made to prevent this new offensive. The United Nations forces sat quietly in their camps and the Muslims took no counter military action. Unofficial Bosnian sources later claimed that Izetbegovic had made an agreement with Mladic and traded Srebrenica for Tuzla. Encouraged by the silence of the world, the ambitious general expelled the whole population of Srebrenica and, in the process, killed all its male inhabitants. International commissions later established the number of victims to be around 8000. Serbs who had been expelled from other parts of Bosnia repopulated the deserted city.[17]

After the massacre at the Markale market,[18] the Western public finally reacted strongly enough for the NATO pact to be put into action. Air attacks were directed on the sites where the army was stationed. The commanders, both those on the ground who were in the process of completing 'the humane movement of people' and their leader in Belgrade retreated in the face of superior force. But by that stage their campaign of ethnic cleansing was essentially complete.

It was now time for the Croatians to get involved. President Tudjman

had brought a group of retired American generals to Croatia to train his units for forthcoming assaults. These units now carried out two actions, with the deceptively picturesque names of *Blesak* (Flash) and *Oluja* (Storm), in areas that Milosevic's unskilled commanders had controlled for the previous four years. These actions went ahead without incident. No one on the Serbian side opposed the Croatian troops as they advanced through the deserted territory. There were no military clashes or cases of individual resistance. In Belgrade, Patriarch Pavle asked Milosevic what was going on and whether Serbia should assist its brothers. Milosevic retorted that everything was going according to plan.

There was no real fighting, even around the former capital of Knin, 'the Serbian people's invincible fortress'. The generals who had been sent from Belgrade (including the new commander, General Mile Mrksic, who had won fame at Vukovar) were among the first to flee from the area. The leaders of the Republic of Srpska Krajina, led by the former policeman Milan Martic,[19] were the quickest of all, escaping a full day before everyone else. Later, from their hiding places in Bosnia, these men declared 'a permanent guerrilla war for the liberation of all Serbian land'. Nothing has been heard of them since.

The roads were filled with columns of refugees desperately trying to catch up with the army that had abandoned them. Encouraged by the considerable ease of their advance, the Croatian troops approached the undefended city of Banja Luka from which numerous Serb patriots were preparing to escape. The American chief of staff, General Shalikasvili, now halted the advance with a warning from Sarajevo, but by then the Croatian war objectives had been reached; they had regained their territory and taken possession of Herzegovina. Although the Serbs now controlled three-quarters of Bosnia, the Muslims had managed to cling to a few cities and enclaves, which were enough to preserve the existence of their state.

Two of the great warlords' ambitions had been satisfied while the third simply made feeble complaints to appease his supporters. It was time for the great powers, known as the 'Contact Group', to enter the Serb–Croat–Bosnian theatre and assess the results of the war.

Chapter 10

Trilateral Encounter at OK Dayton

T he trucks and old cars that lined the roads of Serbia were filled with women, children and the elderly. The families of the Serbs from Krajina and Slavonia who had turned so many others into refugees were now refugees themselves.[1] They were now in the homeland that had promised them independence, that had armed them and pushed them into a war with their neighbours and that had now finally abandoned them.

As these families had lived for centuries outside Serbia, hardly any of them had relatives or contacts there. Most made their way towards Vojvodina, which Tito had repopulated with the families of his partisans after expelling the long-term German residents known as *Volksdeutsche*. Only very few refugees actually reached their intended destinations because the local authorities, acting on orders from Belgrade, diverted them southwards to Kosovo. Once there, they would fill the ethnic gaps left by the long-term Serb, Montenegrin and Herzegovinian residents who had been planted there in the 1920s after the expulsion of the Turks. The academics then proposed a scheme to those in power: 400,000 Albanians could be expelled and replaced by the same number of Serbs from 'Western Serbian countries'. The next task was to reduce Albanian fertility rates 'by means of state policies' and then to increase the Serbian birth rate.

However, like all previous attempts at 're-Serbifying de-Serbified Kosovo' (this time with displaced Serbs from Croatia) and reintroducing Christianity to the region, this project was a failure. The majority of the refugees refused to venture into new battles, preferring to stay in camps established in provincial Serbian towns. Life in these camps was hard; there was little food and less hope. Many realized that life in Serbia was much worse than it had been in their previous homeland, especially by comparison with the rosy picture painted by Milosevic's propaganda.[2]

'Boss Jezda', the vanished banker and financial wizard, was once quoted as saying, 'Wars continue as long as they are profitable.' And now

there was no more profit. Towns and cities had been pillaged; the economy was ruined and all lines of communication had been cut. Even agriculture had come to a complete standstill. Milosevic had to act quickly. He appeared on the media and made lofty statements about peace, about the need to put an end to violence and hunger, and about the importance of realizing that what had been achieved was an agreement, not a victory. No one had been defeated. In reality, there were obvious winners and losers; perhaps as many as 200,000 people had died.[3] The armed had attacked the unarmed, and the unarmed, hypnotized by their tormentors' cruelty and the civilized world's indifference, were incapable of defending themselves. It was a war of armies and para-armies against civilian populations.

About one-third of the three million refugees from the war were Serbs in whose name the senseless fight was started in the first place. Today, though in line for possible EU membership in 2007, Croatia is still struggling, Bosnia is destroyed and Serbia is economically ruined and morally humiliated. Entire populations have been wasted and crushed, even if their representative regimes can claim to have won.[4]

As if enough damage had not been done already, those in power began to confiscate humanitarian aid given to refugees in order to pay loyal supporters and patriots. Although these patriots publicly manifested their objections to Western civilization and to the 'New World Order' they were perfectly happy to use Western aid to enrich themselves and use Western bank accounts to assure the safety of their capital. The humanitarian aid arrived in the Balkans through non-governmental organizations. To reach those for whom it was intended, unarmed volunteer drivers had to transport the convoys through improvised customs barriers and endless ambushes. Only around 10 per cent of the supplies made it through to the hungry, sick and wounded. The rest, once it had been stolen and 'privatized', was sold to them in the markets and shops run by the patriots of all three camps.

Those who sent the aid claimed that, although most of it was stolen, what did successfully reach its destination was playing a vital role in keeping people alive. This was obviously true, but the aid was also enriching those who had caused the hunger and misery in the first place. The traffic in humanitarian aid ultimately went towards enriching a single individual – Karadzic – and his group. He became rich overnight and, but for his gambling tendencies, he might have been even richer. During the war, grant-seeking organizations were established that claimed to be con-

ducting research into how best to bring about democratic change in each of the three conflicting factions. These organizations were supposed to operate independently of the governments. They required funds and, much like the socialist companies of old, had huge numbers of employees. Documents were drawn up and distributed to the hierarchies of different commissions and subcommissions. People at each level of the hierarchy and on each rung of the bureaucratic ladder needed to be paid. At the end of the year, extensive reports were published that sought to justify expenditure and explain the successes achieved in this new process of 'democratization'. In this way a business structure was established that enriched the bureaucrats and appeased the West by giving them a sense that progress was underway in war-torn former Yugoslavia.

In Serbia a rift quickly opened between Milosevic's regime, which preyed on its own people, and the organizations that were swallowing international aid money. This new *status quo* actually suited neither side. The lack of cohesiveness between them meant that both lost credibility. The regime criticized all organizations it did not directly control and the organizations retaliated by criticizing the regime in the popular press. Milosevic had to find a solution. Since nothing in Serbia threatened his power, there was no formal need for a dictatorship. A false parliamentary system served him better than a one-party system. Milosevic realized that the intolerance of differences of opinion that characterize formal dictatorships would not actually help his cause. When the press attacked him he made no effort to respond aggressively; he did not arrest his opponents; he did not organize camps; he did not instigate pogroms; he did not proclaim states of emergency in the country; and he did not make himself the commander in chief of the army and the police.

In the past, by nurturing a harmless opposition, Milosevic had retained all the power and shared it only with those at the top of his party and at the top of other close parties, such as Seselj's and his wife's. He controlled everything, was responsible for all business and allowed no one to challenge his decisions. Milosevic's sole interest was power and the endless games it involved. The government obediently executed whatever order he issued to Prime Minister Mirko Marjanovic, while the opposition leaders behaved as they saw fit. Their authority was easily controlled and confined.

The media placated the masses by presenting them with what seemed to be a true democracy. Western politicians treated Milosevic (and mistakenly

so) as a rather unintelligent underdog with whom they could play around. Unfortunately, they failed to recognize either his intelligence or his underlying strategy. For Milosevic and his family's business, everything was going according to plan.

The war in Bosnia, however, was an organizational shambles. There was enough armament for several wars,[5] but every day the number of available soldiers diminished and those who remained were mostly untrained and desperate villagers. The trained patriots were sitting comfortably in the cities proclaiming their hatred of the enemies with whom they were secretly trading. Desertion was endemic in Serbia. There were not enough prisons willing to take in the deserters and, faced with the growing numbers, the regime gave up on the process; 12,000 young men were accused but not prosecuted and the rest were forgotten.[6] Paramilitary units refused to fight in areas where they could not pillage safely and where their opponents were not just women and children. This worried the patriots who had sent their children abroad and whose only battles had been against the 'traitors' in their neighbouring buildings or apartments. The regime's lack of consistency was soon to be imitated by its subordinates who began to interpret the orders received from above as they saw fit.

Vojislav Seselj was the only one at work on a more substantial project of expelling Croats from Vojvodina, taking possession of their homes and giving them to his boy scouts. In the meantime, he attacked journalists who dared to write articles against Milosevic, his creator and alleged opponent. If he personally attacked or assaulted somebody (which he often did), the courts did not accept the charges the victim brought against him. There was no law stronger than 'Duke Voja' and his protector Milosevic, who publicly proclaimed Seselj to be his favourite opponent – for 'his consistency in the expression of his opinions' and for his refusal of help from abroad. Later, when they had a disagreement (Seselj did not want to accept the peacemaking rhetoric publicly), Milosevic took him to court and the rotund duke asked for the following to be taken down for the records: 'I state that Slobodan Milosevic is the greatest criminal in Serbia.' The judge and public prosecutor did not react; neither did the president nor his followers. The statement sounded so natural and obvious that to confirm or contest it seemed superfluous.

Despite Milosevic's great concern for the wellbeing of his celestial people, a brain drain now seriously affected Serbia. The healthy and the

angry, scientists, artists, the young and those with any kind of perspective on events were leaving in droves. They were the people who should have stayed to fight the regime and work on stabilizing the economy; their departure ensured that Serbia would remain sunk in the quagmire of its misery. The process worked to Milosevic's advantage, both psychologically and politically. With the departure of Serbia's best minds, his opposition became weaker and his dull majority grew. Milosevic cared little if this damaged the state, provided it did not diminish his power.

In the nineteenth century, Serbia, although sparsely populated and poor, had been a country that attracted immigrants. It was a country where people could live well, enjoy a certain degree of personal freedom and generally prosper. Only in the twentieth century did Serbia endure three waves of emigration. The first one took place after the Second World War, when the Nazi collaborators and anti-communists fled. The second wave was in the 1970s and was mainly due to adverse economic conditions. The third and most dramatic emigration took place in the 1990s when Milosevic's opponents, enemies and victims fled to preserve their lives. This third wave of emigration was sufficiently massive to have serious consequences for the man who had destroyed the country.

The Serb paradox functioned abroad much as it did at home. Members of the first two emigration waves, who in the meantime had become Europeans, Americans, Canadians and Australians, were no less Serb because of their departure – on the contrary they featured prominently in Milosevic's nationalist rhetoric. The propaganda maintained its influence over the emigrants via the Serbian TV satellite channel. This was broadcast all over the world and featured reports of the great pressures weighing on Milosevic and Serbia. Even from afar, this propaganda was taken as absolute truth. Members of the first two waves of emigration gladly accepted the illusions sent via satellite television, but they did not return to the homeland, they did not invest in the Serbian economy and they did not volunteer to fight in the war. Their sole response to Serbia's hardship was to send messages of support and, occasionally, to take part in demonstrations outside their national embassies and cultural centres, shouting, 'Down with the New World Order! Down with Clinton!' But they never shouted 'Down with Milosevic!'

The third wave of emigrants, once abroad, had to take the most degrading and unrewarding jobs just to survive. Their compatriots did not

extend a helping hand, concluding that they had left their homeland at its most difficult time and could sink or swim. The majority could not get the necessary documents and work permits to remain in the countries to which they had fled. They queued for days outside embassies and consulates, only to be refused the status that would allow them to work legally and live adequately. They were amazed to see that Milosevic's friends and allies had no such trouble with the foreign administrations that had punished them with sanctions. They all had passports; borders were open to them; they had money in banks and apartments in which to live. Slobodan's elder brother Borislav roamed Europe as he pleased, but neither his presence there nor his activities ever attracted any publicity.

Time and again, Milosevic appeared to have plunged himself into impossible situations with no apparent forethought. This was deceptive; in fact he was as cunning a strategist as his wife and, contrary to her, he possessed a real instinct for knowing when a situation was turning sour. He realized that he was militarily defeated even before the nationalists and the generals; he realized that the Muslim army had not been defeated but had simply halted its offensive for lack of heavy armament. It was only a matter of months before 'the borders of the Serbian territory' would begin to crumble. Sadly, his allies had failed. Greece was slowly distancing itself from Belgrade; China had abandoned him and Russia was overrun with poverty and chaos. But Milosevic's inevitable counter-method, however, offered a solution. *He would rely on his opponents.* Not on the European Community – which was little more than a trade and customs union whose companies gladly laundered their money in Serbia – but on America. As Russia and China were no longer willing supporters, Milosevic, the American man, while maintaining his ideological abhorrence of the New World Order, put out feelers for a US connection. Talks now began, not with the American minister for foreign affairs but with his special envoy, Richard Holbrooke.

Capitalizing on the Clinton administration's desire to deal with the Yugoslav problem before the presidential election, Milosevic managed to create a brand new role for himself: he became the guarantor of peace. He secured this role by stating that, 'All the world's diplomats know that, regarding the war in former Yugoslavia I always supported a peaceful solution to the conflict between the warring factions.' This statement was intended to emphasize that he had not taken part in the war and could in no

way be held accountable for the horrors that were perpetrated. Milosevic's reasoning seemed so logical and persuasive that his justifications were accepted without argument. He had prepared the terrain; all he needed now was to convince Tudjman and Izetbegovic to join him. They worked best as a trio: one long-time believer, one new one and one atheist. Although they now spoke three different languages,[7] they did not require translators. Tudjman made a statement calling Milosevic 'a partner who can be trusted', and thus confirmed the long-held suspicion that they had held 'partnership talks'. According to the chief officer of Tudjman's cabinet, the two men had met 18 times during the war, which the omniscient Western intelligence agencies appear to have overlooked.

A delegate of representatives from Republika Srpska paid Milosevic a visit before leaving for the scheduled negotiations with the Americans in Dayton, Ohio. They were convinced that behind his negotiator's mask he was still 'their Sloba'. But when they met Milosevic, he addressed them angrily: 'Never has such a small group of people caused such extensive damage ... your stupid nationalism is to blame for everything.' He took care to blame their nationalism and not to breathe a word about his own; as far as he was concerned his nationalism was seasonal while theirs was endemic. Karadzic's men were so shocked that they reported what had happened to the media. If Milosevic was not a nationalist then he was no longer 'their Sloba'. Perhaps he was not even a Serb. He would betray them to the New World Order and to the globalizers who were working for the Americans. Worst of all, he was probably a collaborator in the new evil that so far had only been revealed to Serb politicians in Bosnia – the 'Judeo–Muslim conspiracy'. This time, Milosevic's associates and partners were appalled to witness how unscrupulously he sacrificed his principles, promises and people to necessity. They had obviously learned nothing in all the years they had watched him rule. As far as he was concerned, his personal power had to be preserved at any cost.

Before the delegations left for Dayton several things were decided: the Serbian president would represent the unrecognized SRJ, which actually had its own president (the powerless and invisible Zoran Lilic), a government and a parliament. He would also represent the unrecognized Republika Srpska, which controlled all the necessary state organs and which the Church supported. Finally, Milosevic would also represent the Republic of Montenegro – even though the constitution recognized it as a

separate state in the federation. This trinity could only be combined in the persona of Slobodan Milosevic who knew exactly how to present the national interest and could be trusted to promote Serbia's best interests too. These decisions were made with the full accord of the patriarch of the Serbian Orthodox Church, who was one of the signatories of the agreement.

Since the Republic of Srpska Krajina was no longer in existence – its president, state bureaucrats, army and police force had moved to a safer place, leaving their refugee population to fend for itself – it would be represented by the one who had created it by force and who eventually dismantled it with such tragic consequences.[8]

The talks took place in the US military base in Dayton, Ohio. The three negotiators were held in unofficial custody and were to be released only once an agreement had been reached. Richard Holbrooke, an adept of 'bull-dozer diplomacy', walked tirelessly between the partners who were seated at different tables. For the first time all three Balkan politicians were forced to reach an agreement without deferral, without consulting their par-liaments and governments, and without agreements with their cousins, followers or advisors.

Even in this subordinate position, Milosevic still maintained the upper hand. His one condition was that if Kosovo were mentioned he would stop the talks. He peacefully surrendered the Serb part of Sarajevo that had been the cause of so much fighting and with which he had managed to retain power in the region and to undermine Karadzic's ambition of becoming a national leader. His only other request was that he be permitted to phone his wife every evening. In those moments, the strong man of Belgrade was again little Sloba. The power of his personality proportionally diminished with his distance from Belgrade, as did his charisma. Only Mirjana could restore his self-confidence. His wish was granted. After several days of painful vacillation, news broke that an agreement had been reached. The three uncompromising defenders of three conflicting national programmes had achieved peace. Their power had not been contested. They had not been accused of crimes. Nothing had been publicly held against them.

Each of the leaders would easily be able to explain to their people why they had not yet achieved equality. The national renewal would soon be completed and, when it was, only those who belonged to the ruling nation would have equal rights. Maximum ethnic purity was understood to be complete, having been achieved by means of terror, force and poverty.

The signing of the Dayton agreement took place in Paris so that the European powers could at least share in its success as a consolation for their endless mistakes during the conflict. Bosnia was made an independent state comprised of three separate entities. The Serbian entity was separate and represented 49 per cent of Bosnian territory. The Muslim and Croatian entities were combined, despite the objections of both Tudjman and Izetbegovic, and consisted of 51 per cent of Bosnia. Every entity was given the right to 'special relations' with their home countries, excluding the Bosnians because they had none. Bosnia was divided by the very agreement that claimed to unite it. The success of ethnic cleansing, war against civilians, crime and lies was thus publicly confirmed.

Television cameras recorded this historic moment and the ceremonies that followed. First there was a reception in the Palais d'Elysée, at which President Chirac shook hands with Tudjman and Izetbegovic. He did not, however, extend his hand to Milosevic, who brushed aside the affront by waving his right hand as if at someone in the audience. The three instigators of war, now the signatories of peace, were seated at the same table, like students retaking their exams. Slobodan Milosevic, Franjo Tudjman, Alija Izetbegovic. Six members of an examining commission stood behind them, wearing the kind of expressions one might expect at an orphanage party. They included the five solemn members of the all-powerful Contact Group and the current president of the European Union. Gonzales, Clinton, Chirac, Kohl, Major and Chernomyrdin seemed distant and uninterested. They all looked very uncomfortable. The culprits signed the document and shook hands. They too wore funereal expressions. Clinton started the formal applause that the rest of those present accepted. Then the signatories shook the hands of the members of the commission, who thus confirmed their political blindness and irresponsibility. Clinton briefly extended his hand to Milosevic, while barely glancing at him. Clinton's reluctant handshake saved Milosevic. By allowing himself to be defeated, he had won; by becoming a peacemaker he hoped to ensure that his war crimes would be forgotten.

It was time to celebrate what Milosevic considered a victory. Serbia had been saved and its national interests defended. The Belgrade media continued to maintain that Milosevic had taken no part in the war and that an agreement had finally been reached between the warring factions 'thanks to the consistently peaceful politics of Slobodan Milosevic'. The

Serbian ambassador in Stockholm began to spread rumours of his boss's candidature for the Nobel Peace Prize; if Mr Arafat, a world-renowned terrorist, was worthy of such an honour, why not Milosevic? He stated that he was 'simply against war. In places under my supervision, wherever I make decisions, there will be no war.' Bearing in mind Milosevic's tendency to apply the counter-method, this statement might have been taken as conclusive proof that a new war was imminent.

Chapter 11

Peace Explodes in the Balkans

A
t the end of 1995, after four years of bloody conflict and three
pointless wars, peace finally returned to the Balkans. Anywhere
else in the world this would have meant a change of leadership,
presidents, political teams and strategies. There had been so many victims,
such suffering, such damage and so many social and political mistakes that
dismissals, resignations and election defeats should have poured down like
rain. But nothing like this could happen in this land of myths and miracles,
where everything was either incomprehensible or totally irrational.

The American policy of proclaiming no victor and no vanquished
allowed each nation to declare the triumph of its leaders. They were kept in
power, even if this meant new uncertainties, mistakes and defeats.
Suffering and poverty were always someone else's fault. No president
dedicated to the welfare of his nation could have any connection with the
poverty, crime or corruption in his own country. Unbelievably, the
presidents and their castes – in Serbia they were called businessmen, in
Croatia tycoons and in Bosnia they remained nameless – *were never held
responsible* for the endless misery and degradation. Their people forgave
them in advance for everything they had done and gave them free rein to do
whatever they wanted in the future.

The national intelligentsias of all three sides once again took up the task
of interpreting reality for the masses. The media continued to ignore the
truth of the warmongers' behaviour and the opposition consistently
defended the regime it claimed to be challenging.

No one was called to account, and the few individuals who did raise
objections were rapidly silenced and ignored.[1] Given the strength of his
propaganda support, it was a foregone conclusion that Milosevic would be
proclaimed a 'permanent' president. Although he was never awarded an
unlimited mandate, he behaved as though this were the case. His opponents
behaved accordingly. The majority of the Serbian people, even those who

considered themselves to be members of the opposition, sincerely believed that Milosevic was irreplaceable. He was certainly not ideal, but the alternatives were even worse; he made mistakes, but others would make worse ones. It was widely known that he had become rich by unlawful means, but so had all the other eligible candidates. I asked many different people whom they would like to see in the place of their current president. The answers were all depressingly similar: none of the opposition leaders, who were too likely to change their views from one day to the next; no one from public life and no one young. For every one of the possible candidates there was an insurmountable objection. One man had abandoned his illegitimate child, another was too close to the communists, a third had been in hiding abroad while 'we were waiting here to be bombed' – no one was suitable. The idea of electing a candidate who enjoyed Western support was suggested and rapidly rejected. Everyone said the same thing: 'we will change Milosevic ourselves when the time comes.' No one even pretended to know when that time would come.

The Western administrations were actively looking for an acceptable replacement for Milosevic. The trouble was that no such man existed in the entire political spectrum of former Yugoslavia.

No one seemed to realize that finding a replacement was irrelevant and that what was really essential was to introduce the idea of change and to begin the healing process. The Western administrations were convinced that the wrong successor might provoke a crisis in Serbia, which might destabilize the whole of the Balkans. Stability was an obsession for them, as much as it was an excuse. Thus Milosevic was kept in power as the guarantor of stability. Was it possible that these great Western powers perceived Milosevic's hideous deeds as a form of coherent order?

It was one thing that the West could not work out – whether Milosevic was a nationalist or a communist, or indeed if he was either; but what they really failed to appreciate was that he was impossible to pin down, specifically because his politics were so unclear. All he was interested in was power, at any cost. Since Milosevic was neither a nationalist nor a communist, negotiations over power were possible. The Western administrations were convinced that they could achieve the results they wanted by threatening him, by putting pressure on him, by pushing him to give up his post and by forcing him to retreat. Yet Milosevic's great talent for saying one thing to mean another rendered all talks with his Western

supervisors redundant. Milosevic did make personal concessions; he also betrayed Serbia's interests on numerous occasions; but in general he deftly outwitted his interlocutors and maintained his firm grasp on power.

Milosevic's domestic policy was unconcerned to justify the war adventure that had almost ended in universal catastrophe. Only traitors asked for justifications. The economy was on a steady decline as usual and, as usual, Milosevic continued to promise a better future. If there were ever any unrest, the theory of a world conspiracy would be revived and blamed for the hardship suffered by the masses. Milosevic considered this system to be a far more efficient way of calming the masses than – for example – finding a way to raise their salaries. At that time the average monthly salary was around 100 Deutschmarks and inflation continued to render this money almost worthless. Serbian foreign policy was also foundering: Serbia had been humiliated, had lost its former allies and had used up the credit accrued over more than two centuries in a matter of a few years. The Serbs became the pariahs of Europe; even their red passports – which still had the letters S(ocialist) F(ederal) R(epublic) of Y(ugoslavia) – aroused the deep suspicion of immigration officials.[2]

As far as Milosevic was concerned, Serbia's unpopularity was a mere detail and not worthy of concern. The masses were too blind and dull to see the reality. Deception, blackmail and plunder had to continue. As long as there were misunderstandings Milosevic still had a role to play – his method was to create problems in order to solve them publicly and thereby regain the confidence of his people. If everything ran smoothly, the peacemaker would become insignificant.

In peacetime just as in war, Milosevic single-mindedly pursued his one priority – and that was to remain the most powerful man in the region. So far, he was proving successful; his power was under no threat and he was able to exert it freely at the expense of those he ruled.

In Dayton, everything had been quickly and easily completed. Milosevic had willingly agreed to divide countries and cities and to sacrifice 'centuries-old Serbian territories'. He forgot about his plan for a great and unified Serbia, did not raise his chin in defiance and made no threats. He surrendered even what was not asked of him. He raised his glass and made toasts to both friends and enemies. Whatever the true outcome of the agreements, Milosevic himself was out of danger and his power had been preserved. He almost cried in front of the US secretary of state, saying:

'Thank you Sir. Your picture will be all over Serbia.' He had been eager to return home as soon as possible, to his devoted wife and to the gaol-like security of his villa-bunker in Dedinje. After signing the agreement and his triumphant return, the humble negotiator, back in his own surroundings, regained his arrogance and began to make plans to ensure that not one of the agreements came true. Even the smallest detail would not be solved without dragging it out and endlessly debating its validity. The Dayton agreements were now out of Western diplomats' hands and under Milosevic's own control. It seemed that the only way of ensuring they be adhered to was to threaten Milosevic with air strikes. When this happened, he would retreat briefly and apologize before advancing again when the situation had cooled off.

This game continued for years. In the end, the Western diplomats understood Milosevic's irresistible need for power, but they also knew that, *in extremis*, he would always yield to pressure from the West. This relationship allowed the Western powers to feel that they dominated the situation, while Milosevic continued to pursue his fantasies behind their backs.

Not every Western policy towards Yugoslavia was so negligent. The forces of international justice would not be so easily thwarted. The international tribunal in The Hague had spent two years drawing up a list of war crime suspects and suspects for crimes against humanity on the territory of former Yugoslavia. The first two on the list were Karadzic and Mladic. The third man was Milan Martic, the policeman who had become a president. Then followed innumerable anonymous criminals.[3] On the list were small dealers, maniacs, criminals, bullies and killers – of whom all were the great criminals' minions. Generally, people were either truly surprised or pathologically proud to feature on that list.

With the excuse of desiring peace, Milosevic refused to hand over the accused. He considered the accusations an indictment of the whole Serbian nation.

Tudjman, whose soldiers also appeared on the extensive list, refused to accept the preponderance of blame established by the pro-Serbian international community. As far as he was concerned, only the Serbs, not the Croats, had committed war crimes. Izetbegovic, the third signatory of the Dayton agreement in Paris, was also displeased that several of his men had been added to the list of suspects. He considered the Muslims to have been innocent victims, without exception.

The three negotiators all agreed that the guilt of any one of their soldiers or subordinates reflected the guilt of their whole nation and should therefore not be investigated, particularly by foreigners from abroad. The domestic tribunals in the new states could not – and would not – try the very people who had established those states. The reason was that the tribunals had been designed specifically *to judge each regime's opponents*: meaning the pacifists, human rights activists and democrats who had been pronounced traitors.

On the black market in Serbia, which was larger and economically more significant than the official and legal one, clashes between the Mafia and its bosses' interests were becoming frequent. There were at least three major Mafia networks: the Serbian, the Montenegrin and the Albanian. These Mafias were never a prey to nationalism or narrow-mindedness; they cooperated in a businesslike way and each group knew that its survival depended on its collaborators. The politicians supervised these dealings from afar. While one group was in charge of oil, another controlled drug traffic, cigarettes, alcohol and prostitution. Each sector was strictly under one group's control, deviations were not tolerated and Milosevic at the top made sure that ruthless punishment was meted out to transgressors. The Serbian, Montenegrin and Albanian Mafiosi were not men of honour and they often broke the unspoken rules of their underground guild. This unavoidably led to clashes. Ambushes were set up, drive-by killings and machine gun shoot-outs were frequent, and scores of petty criminals were killed every year in the underworld. Poor Serbian towns began to resemble Chicago of the 1930s. The police never came near the killers. Even today, not a single case among these spectacular murders has been solved. No trial could be conducted for fear of shedding light on the *éminence grise* who oversaw all the activities of the underground.

Zoran Todorovic, known as 'Kundak' (Rifle-Butt), once said that he thought himself a greater 'threat to society than AIDS'. In his gentler moments he wrote poetry under the pseudonym 'Teodor A'. Like all those surrounding Milosevic's wife, he became rich. No one knows how. Once something was 'privatized', or rather once something was taken without being paid for, it passed into the hands of family members. Companies were divided over dinner. Friendships with Comrade Markovic brought great wealth, despite her declared Marxist abhorrence of capital. Todorovic lived on an ancient 3500-hectare estate in Vojvodina. As a member of the

new caste he could buy anything he liked at whatever price he chose. His business methods were never questioned. One day, some time after he had privatized Beopetrol (by seizing 200 petrol stations from the Croatian JNA), he was gunned down in the square in front of his company's building.

The assassin shot him in the head. No one saw the killer. He approached his victim in leisurely fashion, shot him and then walked off peacefully. He wore no hood; he might just as well have had no face for all that the witnesses would say about him.

Kundak's funeral furnished an opportunity for a gathering of all the president's men. A letter from Comrade Markovic was read over the open grave, since business commitments had prevented her from attending (she was abroad promoting her books).

Dear Zoran,

I have never been farther away from you and yet I have never been closer to you. From Madras in south India, I am not able to come to Belgrade and greet you one last time. … But I do send you a message across all the mountains and seas – I will never part from you. … I will miss you for the rest of my life. I would like to know that as you are leaving, you are not leaving me. Please, remember all of those you have left behind, as we remember you. …
Goodbye,
Mira.[4]

The manner of the murder and the kind of funeral held for Teodor A. Kundak later became a privilege of the higher caste. The new rich people and patriots were often murdered with a shot to the head. The killers were never found. High society funerals continued to take place on a regular basis and those who attended them were definitely becoming a dying breed. Journalists who wrote about the funerals would try to guess who in the congregation would be the next target. This was the fate of the new caste and its inevitability was accepted without compunction.

Comrade Markovic no longer answered the phone calls announcing the latest death, for she was too busy writing articles and new books. 'I am always writing several books at a time.' She had what may be described as a split personality. While she felt for the victims' families she did not have

time to get too involved in their grief, probably because she knew only too well who had done the killing and why.

Proximity to Milosevic and his wife brought many privileges but there were many who paid for them with their lives. The causes of these numerous murders remained unknown, either to the police or to the public.[5] No doubt those who survived this process of 'primary accumulation of capital' have fascinating stories to tell.

Given the new circumstances, the propaganda apparatus had to modernize. Comrade Markovic set a new tone with statements such as the following: 'During the war in Bosnia I was one of those rare citizens who never managed to remember which army was occupying or freeing which part of the territory. Of course I knew that this was my helpless way of protesting against a reality I did not condone and over which I had no influence.' Wilful ignorance was the new truth; denying all knowledge and coming across as an innocent lamb was the best way of ensuring clemency.

The old propaganda had claimed that the whole world – excluding Libya, Cuba, North Korea and China – was against the Serbs. Serbia had only a few true friends, such as the Russian Zhirinovsky, or France's Le Pen. The new propaganda instead promoted the idea that Serbia had been unjustly demonized. 'The truth about Serbia' inexorably spread across the globe and Serbia acquired more and more supporters to defend it. Only the pacifists rejected the idea of 'Slobodan Milosevic's consistently peaceful politics', claiming on the contrary that he had caused the war that had just ended. Serbia's former apologists were no longer in vogue; they had to be replaced by European intellectuals who had 'seen through the lies about the Serbs' and now backed their cause. The European intellectuals who might have seen through this fraudulent propaganda were busy lamenting other crises across the globe; their intellects and consciences were like migratory birds that flew from place to place according to the impulse of the season. Ethnic cleansing was now underway in Rwanda.

The first new supporter of the Serbs was Peter Handke. He had been appalled by footage of Karadzic's Serbs leaving the suburbs of Sarajevo, digging up the bones of their ancestors and setting houses on fire. Kusturica told him: 'Serbs set their houses on fire because they love them.' The Austrian writer subsequently took a fortnight's trip through Serbia. His special escort was 'Mr Pavic, a friendly, elderly gentleman' who quietly won him over with regime propaganda. Handke did not witness the poverty

and suffering of a people who had been cut off from the rest of the world, nor did he notice the corruption and violence around him. What he did discover in this unknown country were monasteries from the Middle Ages, a beautiful countryside, friendly writers and remarkably civilized natives. Handke's visit provoked him to write a powerful attack on the anti-Serb camp. Across Europe, Yugoslavian (Serbian) embassies organized literary evenings at which the writer was guest speaker. Serbs in the audience, who had been made into pariahs across the world by the autistic politics of their leader, listened carefully to Handke's defence of the ideas put out by the Belgrade propaganda machine, then bought his book.

Occasionally people spoke out against Handke's position. One poet from Belgrade, a member of the opposition, sent him a message in a satirical poem entitled 'Danke, Handke'. Handke failed to appreciate the irony and publicly thanked the Serbian people for showing their loyalty in their poems. Milosevic and his supporters not only paid Handke but also invited him to speak at numerous events and praised him as the 'greatest writer in the German speaking world' and the 'literary and moral conscience of Europe'. This Austrian writer of half-Slovenian origin was even invited to open the International Book Fair in Belgrade. The fact that practically no foreign publishing houses were represented and that there were no copies at all of the works of his more critical colleagues, did not seem to bother him.

The end of the war in Bosnia and the termination of economic sanctions had not shown the 'comparative advantages of the Serbian economy' as announced by the regime. Poverty had not diminished, factories were still in ruins, the villages were still sleeping and cities were sinking into lethargy. The young and the competent were rapidly leaving the country. The only part of the economy that was still functioning was the illegal plunder that enriched the presidential family and its supporters. The fight against crime – announced by the president in two or three of his speeches – was really a fight between the criminals and the rest of society. Serbia had too many weapons, too many former warriors, too many refugees from Croatia residing in camps, and a large number of patriots from the other side of the Drina River who had somehow got hold of money and who did not want to live in the new Bosnia established at Dayton. Nevertheless, no changes were made in the government. Prime Minister Marjanovic was an optimist despite the obvious reality and Milosevic was pleased with his

contribution to the slow collapse of the economy and to the enrichment of his family. General poverty still allowed for individual wealth.

At this juncture a new political party appeared on the Serbian scene, claiming to represent a new force in Serbia. Specifically, it condemned corruption and unlawful wealth. This was the *Jugoslovenska Udruzena Levica* (United Left Wing of Yugoslavia), shortened to JUL. It had been established in 1994 through the unification of 23 small parties, but only now appeared in its full splendour. Its president was Ljubisa Ristic, an experimental theatre director, a sixty-eighter and the son of an army general. He always appeared in public tie-less and wearing military boots.[6] The ideologist, founder, director and spokesperson of this new party was none other than Comrade Markovic. She had spent some time in hospital suffering from depression and had not left her house for months. Now that she had recovered she let it be known that in her view Serbia, Yugoslavia and the Balkans were in urgent need of essential left-wing ideas expressed by a well-funded party that could properly represent the poor.

A few newly wealthy people, war profiteers and private businessmen with Milosevic connections joined this party. 'The twenty-first century will be a century of left-wing politics, of science and of women,' wrote Comrade Markovic, unabashed. The media agreed with her and for the whole of the spring that followed the end of the war newspapers and television features were filled with reports of the JUL's founding meetings, promotions, celebrations and award ceremonies. Comrade Markovic's interviews and speeches were ubiquitous; her regular Sunday articles grew longer and less comprehensible, and were increasingly translated into Russian and other languages for diffusion abroad. She became an honorary member of the Ukrainian Academy and of the Lomonosov Institute in Moscow. She travelled widely, promoting the idea that Yugoslavia was ready to change and develop:

It is time for new elections, but also for new hospitals, roads, schools, kindergartens, and buildings. It is time for a new law on information, for new history and literature books in schools, for the essential fight against crime, for the great settling of economy and education and for affirming our right to enjoy the simple civic pleasure of sleeping peacefully after the evening news.

The idyll began. Or rather, according to Comrade Markovic, the idyll continued from where it had been interrupted by the forces of the outside world when they decided to break up Yugoslavia. 'How could they have done such a thing? Were they not afraid of God? They are believers, do they not know that evil returns to haunt sinners?' As far as she was concerned the greatest affront was that they had dared accuse her and her husband. 'My husband did not play a crucial role in the events of 1990.'[7]

In the Milosevic family, birthdays occurred more often than in other families and their house was always adorned with flowers. Comrade Markovic wrote:

I have flowers everywhere – on the carpets, on chandeliers and lamps, on my skirts and shoes, in my hair, in the garden, on cigarettes. ... I see flowers as being beyond time, I have never thought of them as dying in the autumn, or ever dying, in fact. Perhaps flowers just drift off to sleep. ... My house is quiet and peaceful. I have an undefined sense of waiting for something.[8]

In the Milosevic family, in that quiet and peaceful house, in that 'sense of waiting for something', birthdays were repeated several times a year. The children – 30-year-old Marija and 20-year-old Marko – often received presents from family friends and rich left-wing supporters who wanted to show their loyalty to Comrade Markovic.

Marija's passing boyfriends all had good careers. They became the owners and directors of companies; they were given positions in the government and were appointed to diplomatic posts. Marija herself was presented with the radio station 'Kosava' (Wind), a floor in the former building of the central committee, the most modern equipment, a team of professionals, a list of programmes and a host of listeners. She was also given the right to do whatever she wanted. Not long after, she started her own television station. She repeated her intention never to marry or have children as a warning to her numerous suitors.

As for Marko Milosevic, a job was invented that would bring him money and fun. In the city of Pozarevac, a vast discotheque was built, equipped with ultra modern equipment. It was called 'Madonna'. Those who appeared for the opening included the new leftists, Belgrade's jet-set, chiefs of police, a crowd of faces from Interpol's most wanted list,

journalists, and the Milosevic–Markovic couple. The rhythm of the 'turbo-folk' music and the bright lights marked a moment in which all was forgotten – the wars, the dead, the bombardments, the refugees, and, most importantly, individuals' own feelings of guilt.

A few years previously Belgrade and Serbia had been bursting with enthusiasm; there was tension in the air, big projects were underway and miracles were expected. A leader had been invented to answer the needs of the restless masses and to make all their wishes come true. Thereafter, events took place that the majority did not understand and that the media represented as a string of victories. However, once the 'war in which Serbia did not participate' was over, the true emptiness of everyday life struck the nation. The majority subconsciously realized that stupidity and wilful ignorance were the best defences against reality. Since there was no money for leisure (there was barely enough for food), television offered the only available entertainment. The programmes on television included fashion shows, turbo folk, American shows, expensive JUL promotions, clair-voyants and astrologists.

These clairvoyants and mediums began to replace the priests who had hitherto featured regularly in the regime's propaganda, particularly on television. The celestial and spiritual forces were expected to perform feats of which ordinary mortals were incapable.[9]

Comrade Markovic was deeply superstitious; she believed in the occult, despite her claims that politics and sociology were the only disciplines that would allow society to understand itself and to progress.

Both my children and I have long been interested in astrology. ... Astrology is a part of our lives. ... Marko knows a lot about Cancer, his own sign and Marija knows a lot about Virgo, which is hers. ... I often say, with a little sadness and some irony, that what a government or ministry cannot solve, maybe the stars can.

The fact that Milosevic's own wife believed in these cosmic forces encouraged many others to follow suit.

In any family unit in patriarchal Serbia, the father was the supreme authority. Regardless of what kind of man he was, the father knew everything and did whatever he liked. In the absence of a father (and many had been killed in the endless wars), the widowed mother would take on the

patriarchal role. Since she filled the role of both parents, her authority was absolute.

In the Milosevic–Markovic family, the roles were sometimes confused. Mira sometimes played Slobodan's role and the children took every opportunity to replace their mother and father. The authoritarian leader of the people had no authority at all within his own family and made up for it by the rigour with which he governed his greater family. In front of his real family he had to remove his mask. Sometimes, in that 'quiet and peaceful house', he would have to walk on tiptoe with his head down. He was not allowed to interrupt his wife during her ritual hair-combing sessions because during that time she mystically 'delved into the depths of her being'. Her tears frightened him more than any of his enemies and foreign statesmen ever could. Once Mira's eyes, having left the 'depths of her being', turned to look at him, the boy who was again forgiven for his deceit and treachery would raise a glass and say, 'Pussycat, this is to your new book – and may you always love me.'[10]

No questions relating to the war were asked in postwar Serbia. There simply was no war. There had been no sequel to the processing of the 'Serb national programme'; there had been no intellectual or moral cleansing through the admission of crimes and the judging of criminals. There had been no concentration camps in Bosnia. Western propaganda had fabricated the concept of 'ethnic cleansing'. The Serb artillery did not shell Sarajevo. The defeated Muslims invented the pits filled with corpses near Srebrenica. Serbian volunteers did not rape Muslim women. In Banja Luka, 15 mosques were not levelled to the ground. The lies went on and on. The media focused on different issues of minute significance and the intelligentsia kept quiet.

The regime's unofficial writers busied themselves investigating world conspiracies against the Serbian people – and found them everywhere; 'independent authors' wrote dry academic books about James Joyce's life in Trieste at the turn of the century or indulgent autobiographies about 'what life looks like from the window of my apartment in New Belgrade'.

Several of my friends warned me not to talk about the war. They said 'It is not polite. People have had enough of talking about the war.' That one could not even mention the war suggested that harbouring even the faintest hope that justice might one day be done on behalf of the nation by trying the war criminals, or at least questioning their guilt, was utterly futile.

Silence suited the regime and its supporters as well as it suited those who opposed it. If Milosevic is innocent – and people who signed agreements with him still claim that he is – then those who executed his orders or miraculously deduced his wishes are also innocent, as are those who, obeying the law of the masses, turned aside from reality.

No one fully appreciated the terrible implications of this silence. As long as Milosevic and his executors were not accused of their crimes, the Serbian nation itself would be blamed for the war by the whole world and eventually the Serbs would blame themselves utterly for the horrifying mistake they had made in placing their trust in Slobodan Milosevic.

Chapter 12

'I Love You Too'

Milosevic was brilliant at creating problems for himself and brilliant at riding them out. In March 1991, having convincingly won the elections, he banned demonstrations and almost provoked a revolt. To prevent any future revolts, he provoked a war in Croatia that seriously threatened his power. With the war in Bosnia, he provoked sanctions that instead of destroying him somehow helped him to survive. He was officially defeated in the Bosnian war but claimed the victory as his and took full credit for the peace settlement that ensued.

To maintain his grip on power Milosevic called an election in autumn 1996. The blockade of the media was complete. As the peace puppet of the West, Milosevic felt safe and unpunishable. His European and American partners cancelled the economic sanctions against Yugoslavia precisely at the most propitious moment for him. Certain Western papers wrote 'that the international community has voted for Milosevic'. With a coalition that included his wife's fledgling party, he won the elections with an over-whelming majority.[1] His voters, however, managed to do something he neither liked nor expected: at the municipal elections that took place at the same time they voted for the opposition's coalition known as *Zajedno* (Together). The same people, at the same time and in the same place voted for two different sides. A schizophrenic perception of reality had caused schizophrenic decisions. Through his courts and judges Milosevic annulled the electoral results that benefited the opposition, claiming the elections had been rigged. Milosevic made no attempt to hide this brazen deceit and his lies and arrogance betrayed the full extent of his contempt for the intelligence of ordinary people in Serbia. The people seemed to be even greater masochists than Milosevic was a sadist.

Outraged once again by the way the election had been manipulated, the opposition called for demonstrations that the regime had banned. It was a routine confrontation between opponents that knew each other all too well.

They made no effort to act out a convincing fight; they knew that even bothering to pretend was a waste of energy because no one would ever have the courage or stupidity to denounce them.[2]

Then something unexpected happened on its own, apparently without provocation or explanation. Thousands of Belgrade citizens of all ages took to the streets – there were more of them than there had ever been before. They did not stop at outpourings of discontent, some noise and some broken windows, but came back the next day. Then they began turning out every day; they walked the streets of the capital, without incidents, without outbursts, peacefully as though they were doing their usual job, protesting and laughing. The students started a parallel protest. In dozens of Serbian cities, the same infectious phenomenon was repeated. Entirely different social groups found themselves walking in the same columns. They forgot their differences and joined together to ask for the same things: a change of regime, Milosevic's departure, democracy and entry to the European Union. The government and the opposition struggled to control the situation but they were facing a tidal wave. Milosevic tried in vain to organize dozens of counter-demonstrations across Serbia, just as in 1989, and put an end to this dangerous and uncontrollable phenomenon. The same participants – unemployed workers, poor peasants, miners on vacations that had gone on for years, drunkards and street riff-raff – were taken in buses, trucks and trains from city to city under the guidance of local socialists to represent the forces that defended order, work and the nation. Everywhere they were greeted with contempt but there were no incidents. No one joined these unfortunate individuals, not even Seselj's local supporters. After a few speeches and chanted slogans, they moved on to another city. Their protests were passionless and tiresome.

The final counter-protest, widely announced in the media and held in the centre of Belgrade near the Terazije fountain, a symbol of student resistance, was a public humiliation. Speaker after speaker, standing beside Comrade Markovic, railed against the foreign lackeys, mercenaries and traitors among the Serbian people. The crowd, which had been assembled with great difficulty, showed virtually no response. Coming to his wife's rescue, Milosevic took the microphone at the last minute. For the first time he had nothing to say and no one was listening. The supporters who had been hired for the day were chanting 'Sloba, we love you.'

He stopped to listen; then, scornfully waving his hand, said 'I love you

too.' Within ten minutes the Milosevic rally had broken up and his counter-protestors were running for their lives. Lines of fully armed police were blocking the entrance to Kolarceva Street, where a mass meeting against the regime was underway, and were moving towards Knez Mihajlova Street, where the students were protesting. The same thing happened virtually simultaneously in cities all over Serbia. The protests went on day after day. It snowed every night and it was as though the snow had come to bury Milosevic's regime.

Milosevic had fallen into a trap of his own making. For the first time he had reached the brink of defeat. His authority was seriously endangered and opposition was growing by the hour. People had managed to overcome the fear on which the regime had relied for so long. Milosevic's sister parties – those of Seselj and of his wife – were becoming an embarrassment and a liability. Worse, his associates began preparing their departure: they were selling their apartments, withdrawing the last remaining available money from banks, seeking friends in the opposition and becoming more polite, agreeable and democratic. It was clear that they would change sides within seconds of their leader's overthrow. It seemed that the recluse from Dedinje had no more answers for the desperate people in the streets, which his propaganda referred to as the 'forces of chaos and madness'.

The propaganda apparatus was itself no longer functioning as before. While the evening TV news was being aired, hundreds of thousands of people banged on pots and pans across the cities of Serbia, drowning out the boring lies that dripped from their television sets.[3] This was far more dangerous than anything that had happened before. If the veil were to be stripped from everyone's eyes, the people would see that the king was naked and shaking with cold. If someone were to harness this tide of indignation and direct it towards Belgrade and the hill in Dedinje, the police and the army, both of which were now uncertain, would stand aside. These would truly be the last demonstrations to mark the downfall of the man who had started them in the first place. Time was running out.

Milosevic countered. Things needed to be turned upside down. If the allies were not working properly why not try the enemies who were organizing the tired people in the streets and causing all the mayhem. The leaders of the demonstrators, themselves frightened by the sheer energy of the revolt that they had accidentally awoken, wanted nothing more than a little power in the cities where they had legitimately won elections. They

had not increased their demands; they made no attempt to articulate the people's discontent in broader political terms. They were neither contesting the greater power nor repudiating the legitimacy of the regime. In fact, their lack of an agenda could be understood as an offer to cooperate, so the offer should be accepted. Milosevic was pragmatic when he had to be and ready to cooperate when forced to. He only needed the approval of Western administrations, but they had accepted all his earlier proposals and he had no reason to suspect that he would be denied this time.

It is not known who brought the two sides together or where the negotiations took place. Things merely changed in the first few days of February 1997, naturally and smoothly as though the scenario had been arranged beforehand. Milosevic had graduated as a lawyer and now his training came in useful. He proclaimed, under his name, an act known as *Lex specialis*. This was a decree issued by the president of the republic that acknowledged the united opposition's electoral gains and directed the government and Prime Minister Marjanovic to relinquish power. According to the *Lex specialis*, a prime example of Milosevic's manipulative writing skills, no one was held responsible for the rigged elections that had led to three months of revolts. National reconciliation was considered to be far more important than the investigation of minor errors. The opposition accepted this agreement and called off the demonstrations. The exhausted people came off the streets. In their cold rooms the warm televisions were waiting for them: fashion shows, Venezuelan love soaps and football matches would again replace everything else.

I described my experiences of this unusual period in a diary entitled *Kradljivci sopstvene slobode* (Thieves of their own freedom).[4] The new people in Kragujevac contacted me and I returned from my exile in France to join them. We besieged Radio Television Kragujevac (at the time still part of Serbian Television) and managed to take it over, even though armed police defended it. The TV images of this event were shown all over the world. We broadcast freely for 144 days without money, with minimal equipment and without professional journalists. Our motto was, 'We are an open television station. Anyone can express their opinion provided they do not spread national, racial or religious hatred.' Anyone from Kragujevac and any guest could appear on our programmes. A municipal official answered viewers' questions daily. We broadcast the programmes of scores of other radio and television stations; we were the first to broadcast

television bridges with Croatia and Bosnia and interviews with people from all over former Yugoslavia. The regime was furious. Seselj personally attacked me everywhere as a 'traitor and foreign mercenary, whose only claim to being Serbian is his name'. He also sentenced me to death. He accused me of 'selling Kosovo to the Albanians'. Soon everyone was against us, primarily because of me – both the reigning power and its opposition. The aid promised from abroad never arrived. When I finally understood that this could no longer continue I retreated. I managed for six months, just as I had promised at the start. Radio Television Kragujevac overnight became the voice of one party only, that of Vuk Draskovic. It no longer troubled the regime and rejoined the conformist mainstream of TV stations available in Serbia. I returned to France.

Two factors contributed to the demonstrations ending and to Milosevic's comeback. The first was the covert influence of opposition leaders who cooperated with their alleged opponent. The second was the lip service the representatives of Western democracy paid to the demonstrators while secretly supporting their partner, Milosevic, the 'guarantor of stability in the region'. In any event, the last chance to avert a fresh catastrophe was lost. The liberated cities received no financial or professional aid from abroad and were left to their own devices, confused and exhausted; once again, having spent all their energy in vain, they sank into the lethargy of despair. The revolt had seemed as bright as a rainbow in the desert. After it faded the desert was even more arid and desolate than it had been before.

My diary:

Last winter, the demonstrators shouted at the representatives of the old government, at times aimlessly, at times with the joy of new hope in their voices: 'Thieves, thieves'. They were right. That power really did take everything from them: freedom, potential, history, money, the right to be human, the possibility of entering the modern world, as well as the possibility of elections. Today, several months later, what should they shout at the representatives of a new government who have deeply disappointed them and betrayed their hopes? They have not even the strength to admit that there is nothing they can do, that they are weak and incapable, that they are sitting around and waiting for something to happen, having already resigned themselves

to defeat and to looking for holes to climb through in the wall that separates us from the rest of humanity.

Today, in the light of what has happened, the demonstrators can only say one thing, sadly and without anger, something like an epitaph for their leaders: they stole their own freedom.

But they have no voice left to say anything. They are caught in a trap of their own making, and now they can only be quiet and wait.

Following the brief sojourn and sudden departure of freedom from this area, it is certain that the death of Milosevic's regime will take a lot longer than even he expected. He will no doubt feature in the Guinness Book of Records, *in the encyclopaedias of abnormality and the schoolbooks of madness as the bogeyman of children's stories. He will go down in the jumble of memories, facts and hopes that we call history, as a paragon of cruelty and a master of manipulation.*

The recovery was illusory and short-lived; gathered around the deathbed of Milosevic's regime the demonstrators had celebrated and swaggered in vain; but the disease, instead of killing its instigator and dying away, had reinfected the people and was raging again.

A rumour spread that students in Montenegro had begun to organize demonstrations. People wondered if the students had grown up and become independent. Alas, they had not. Their demonstrations were not an attack on the Milosevic counter-method but simply a demand for a safer way of applying it. They were a modern variant of those they claimed to oppose. They had the same manners and appetite. Their phoney liberalism and patriotism were tools for legalizing their thefts. Milosevic, for his part, wanted to prolong the period of 'primary accumulation of capital' and to keep his new class in suspense for a while longer. Who would survive? Who would hang on to what they had stolen? Who would avoid featuring on the list of the accused? When would the accusations against tired war profiteers, frightened killers and chatterbox thieves begin? Because no one knew the answer to these questions the members of the new caste were compelled to remain loyal to their leader.

Djukanovic, the Montenegrin president, had had great success achieving the dual job he had begun. Western administrations accepted and supported him; he was useful because he allowed them to show the world that they were against Milosevic and that they were useful to him because their sup-

port guaranteed he would never be tried for the crimes he had committed during the war, or for Montenegro's part in the destruction of Dubrovnik. For Western diplomats and the Western media, a single claim to moderation was enough for them to see a democrat in a former totalitarian.

During the war, Biljana Plavsic became famous for two reasons. She was the only woman in the Pale fellowship and was considered 'a model of Serbian beauty'. She was also the most hardline and radical of them all. She told the wounded men in the hospitals: 'I am pleased to see you in such large numbers,' and expressed the essence of her philosophy concisely: 'If six million Serbs die, six million more will live in happiness and prosperity.' With the first signs of peace, Plavsic began to look to her own survival; she became more moderate in her pronouncements, either out of choice or because she was forced to do so by her war comrades.

She moved to Banja Luka, took Karadzic's place as president of the 'Serbian entity' and placed herself under the protection of the international forces that under different conditions would have clapped her in gaol.

Plavsic's behaviour exemplified the prevailing attitude: those who had provoked the war needed to implement and monitor the Dayton agreement. Mladic and Karadzic were the only people who could not fulfil this role because they had so unwisely and explicitly boasted of their crimes to the world's media. Had they not done this in the presence of journalists they would probably be 'implementing' the Dayton agreement at this moment and quarrelling with representatives of the Muslim–Croat entity.[5]

A game of hide-and-seek now began in the media, which hugely entertained journalists, audiences and diplomats. Karadzic and Mladic were removed from the public eye. Karadzic was no longer the president and Mladic no longer the commander of the army. They could not enter these new times in the same roles. Everybody wanted to know where they were hiding, if they were healthy and what they were doing. The news was mainly positive. Karadzic was in Pale surrounded by his loyal guard who were all 'ready to die for him'.

The international peace-keeping troops walked by his villa every morning and kept good neighbourly relations with him: '*Bonjour, monsieur Karadzic*' '*Salut, les mecs*.'[6] He occasionally returned to his first love – poetry – to describe the suffering of his people in an asymmetric, decasyllabic verse form.

With false tears, Allah's children
Got the keys to Serbian cities
From the Dayton jury,
This brotherhood of discord and its demonic force.
Pushes us, Christ's guardians, away from Christ's land,
Into nowhere, into oblivion.
After winning all our wars so justly
The punishment of the green tables had caught up with us.[7]

The 'green tables' are an allusion to his gambling losses – the gamble of cars and the gamble of war. A group of academics and 'non-party individuals' in Belgrade organized a board for the protection of war heroes who had been proclaimed criminals. The main rationale behind it was that 'the fate of Dr Radovan Karadzic is the fate of the whole Serbian people.' The persecution of a longhaired poet who had received Russian literary prizes symbolized yet another genocide of a people who had already endured centuries of the same thing.

General Mladic was not mentioned in the board's statutes. Little was said or known about his whereabouts. He was in hiding in a secret location and only occasionally appeared in front of the cameras. He was seen in Belgrade attending the funeral of a war colleague, then in Bosnia participating in building a house. The implication was that he was not only a tank and cannon operator but also a builder who could repair what had been destroyed by those whose lives and livelihoods he had himself destroyed.

Following the imposition of sanctions on Serbia and Montenegro many factories ceased to operate, while others drastically reduced production or worked part time. The workers were on paid leave and the poisoned rivers began to run clear again. The water again looked like it did before the beginning of the 'great leap' in industrialization – indeed it looked like water. Fish reappeared, there were crabs in the whirlpools and people went swimming again. People joked that Milosevic, the anti-Gorbachev, anti-democratic, anti-European Serb, had turned out to be the greatest ecologist on the old continent.

Milosevic's response to the sanctions was swift: in the autumn of 1997 he prepared elections that would legitimate the rebels, but more importantly legitimate him. He did not stand for election himself; instead he was made president of Yugoslavia under the authority of the federal government. Having replaced Lilic, he followed in the footsteps of his spiritual father Dobrica Cosic, who had gone back into retirement and was almost 80 years old. While playing the role of his new opponents, nevertheless, just as before, the Montenegrins voted for Milosevic in the federal parliament. They would probably vote against him once he was no longer their opponent. Meanwhile, elections took place for the seats surrounding the Serbian presidency and for benches in the republican parliament.

A number of prominent figures were removed from office to make party procedure simpler and clearer. Life was made easier for voters too who no longer had to face the uncertainty of choosing between different candidates. The result would be the same whoever they voted for. Seselj said: 'As long as there are fools I will have voters.' Indeed, the number of his voters was growing considerably; most of them believed he was a medical doctor and philanthropist who treated the poor for free. In voting for him they were convinced they were voting for the opposition.[8] Tomislav Nikolic, called *Grobar* (the Gravedigger), Seselj's deputy, wrote: 'Serbia has entered the era of Serb radicalism.' The candidates for president of Serbia were Lilic, Seselj and Draskovic. Djindjic and his Democratic Party abstained, depriving the elections of any legitimacy – seven years too late.[9] Half the population did not vote; 50 per cent would have to suffice as a reflection of the nation's opinions and desires.

The results of the first round were as follows: Seselj, Lilic, Draskovic. With Draskovic out of the running the impersonal Milutinovic replaced the equally impersonal Lilic, who had been ambassador in Athens during the Mitsotakis administration[10] and later the (nominal) minister of foreign affairs. That ministry deserves particular mention because of its redundancy: the versatile president was entirely and personally in charge of all foreign policy. The results of the second round of elections were ambiguous, particularly in relation to the number of voters. Milutinovic won under questionable circumstances and he made no show of celebrating his victory, while the garrulous Seselj accepted his defeat. It later became public knowledge that victory had been bought from the rotund duke; in the vernacular of the time, it had been 'privatized'. The Western adminis-

trations turned a blind eye. As long as Dayton was nominally respected, those who had signed it were free to do what they wanted back home, although of course the less publicly the better. Milosevic gladly obliged. What had not been seen had not happened.

A year earlier the representatives of democracy had attacked him for rigging the elections. Now those same people were asking for special treatment and support in new elections. No one was consistent: and it became very clear that Milosevic's method was indeed the best for retaining power, even if it was not quite legal.

Chapter 13

The State against the Terrorists

These elections, much like those described in Domanovic's book *Stradija*,[1] was the political swansong of many opposition leaders. Their organizations in the provinces existed only on paper, and even in the capital they were only a front. There were no more demonstrations, protests, street clashes or petitions. The anti-regime *Zajedno* coalition failed to coalesce, and so did all the others. The opposition parties were threatened by extinction. 'We have a major problem,' Milosevic said to his followers. 'We face a complete collapse of the opposition'. It was now his strategy, using the counter-method, to keep the former opposition alive as long as possible. It did exactly what was asked of it, which was next to nothing. It released the occasional strong political statement and continued to indulge in petty corruption in the cities it still controlled, which had been won with such difficulty during the demonstrations. It settled back to wait until the regime destroyed itself. The opposition had ceased to exist politically – it had transformed itself into a passive majority that no longer had any representatives.

In the Western states and in other former Yugoslav republics, there was not much happening either. The new countries had divided the property of the old country between them, not with the respect and care of successors but with the callous greed and destructiveness of brigands. Culture was divided in the most cruel and absurd way of all, since it was intangible and hence could not be protected. Everyone took or proclaimed as theirs whatever they could lay their hands on, according to the right of the strongest. Artists who had once considered themselves Yugoslavian were utterly rejected and forgotten, having no ostensible practical use. Yugoslav culture, as it was called for so long, ceased to exist. It destroyed itself and now must be rebuilt from scratch within the context of each separate nation.

In early 1998 there was intense media speculation about the composition of the new government. Would Milosevic's socialists and his wife's JUL

party establish a coalition government with Draskovic's SPO? They would, if Draskovic became minister of foreign affairs and his associates got enough ambassadorial posts. Those interested had caught the diplomatic fever. The first prize, for example, was the Prague embassy: there was not much to do, there was no Serb national minority, it was a beautiful city and for these petty politicians, Czech women conjured up images of erotic excess and debauchery. However, news was released one day that turned everything on its head. The JUL (extreme left), the socialists (centre left according to their propaganda) and Seselj's party (extreme right and undisguised fascists) had together established a government of national unity. Seselj himself was this government's first vice-president, the former gravedigger Nikolic[2] was the second, and their fascist followers had several other spheres of activity. The red-and-black coalition, which had secretly and successfully cooperated for years, had finally admitted its relationship in public. Its (official) ideological opponents agreed whole-heartedly with this new arrangement. There would be no misunderstandings, no arguments and, above all, no competition.[3]

It was difficult at first to fathom why Milosevic – whose deceit in the past had always been so relentlessly rational – had finally decided to reveal the other side of his power. Then it became clear that he was preparing to perform another illusionist trick, more complicated and risky than any he had attempted before. He had already won the hearts of his compatriots by promising to solve the Kosovo question, or more precisely the question of the Albanians in Kosovo. He cancelled their autonomy and imposed a military and police administration. The forcefully-united Kosovar state and its regime had made it possible for Albanian nationalists to make a parallel state, every bit as undemocratic as the one they had inhabited to date. According to Albanian sources, at a secret ballot in 1990, 99 per cent of the electorate voted for independence – complete independence, followed by union with their motherland Albania. 'We are all illegal citizens back there. … I am a president of two million illegal citizens,' said Rugova, president of the Kosovar republic, who lived in his own home and travelled freely. By abstaining in elections, the Albanians had made it possible for Milosevic to manipulate their non-existent votes and obtain the majority he needed. For strategists of the 'Albanian national question', Milosevic's harshness and his public violence were the only opportunities they had for raising international awareness.

To arm himself with good excuses and to provoke his enemies, Milosevic employed his double, Seselj, who considered himself 'the ugliest Serbian politician'. Seselj did what he was told – threatened, insulted and attacked – in order to provoke the opponents, above all the extremists among the Albanians in Kosovo. In turn, this provided Milosevic with an excuse to do what he had been preparing for a long time.

For almost a decade, Milosevic, Bulatovic and Djukanovic enjoyed a domestic idyll. They were like a father and his twin sons who understood each other without saying a word and who functioned harmoniously without agreeing. Then, as in a comedy, they publicly argued: the father acted strictly, one son was disobedient and the other loyal. While the audience watched the story unfold, the old associates peacefully robbed them and made off with the money.

In the Balkans, a car is more than a means of transport or a status symbol: it is proof of virility. A family's last pennies are used to ensure that the father can drive his car to his local watering hole. In order to protect a factory that manufactured passenger cars in Kragujevac, *Crvena Zastava* (Red Flag),[4] a law was passed that imposed very high duties on the import of foreign cars.

However, Djukanovic – who in the meantime had become president of the Republic of Montenegro – wanted to help his people: every Montenegrin received a right of import with minimal duty. For months, a strange trade took place: the Montenegrins bought cars abroad and sold them in Serbia. The federal government – Bulatovic had become its prime minister, having lost the elections in his own country – did not react to this. When the number of imported cars suddenly rocketed to 200,000, the federal government woke up and ordered every owner of an imported car to pay duty; otherwise their cars would be confiscated. The new owners paid, knowing that most of the cars in question had been stolen in Europe.

The plunder from this venture was divided in the same way as when the Yugoslavian federal reserves were broken into. Each participant took several hundred million marks. The stolen car scam was child's play by comparison with the schemes being developed in and around Kosovo at this time. For nine years Milosevic's propaganda had been repeating that the Kosovo question had been solved and that the Serbs there were protected. Borislav Jovic declared that 'today the Serbian people in Kosovo are no longer used as pawns in the preservation of any individual's power; they

now have the freedom and the power in their own hands – definitely and completely.' Milosevic's people now claimed that the situation in Kosovo was chaotic and dangerous and used this as an excuse to launch a new campaign there. The armed liberation army (OVK and UCK),[5] an organization without headquarters, commanders or official leaders, immediately went into action.

The OVK and UCK leadership consisted of 'Marxist-Leninists' from Tito's prisons and officers of Tito's former army, who had united for a joint offensive. The Belgrade headquarters passed these guerrilla fighters the order to take possession of territory and besiege cities, inflicting maximum damage.

Azem Demaci, once known as the Balkan Mandela, was the only Albanian politician who joined them. Rugova, known as the Balkan Gandhi, kept quiet and waited for his moment. He was not aggressive and he was not a revolutionary. He was the president of an unrecognized state within a state whose government was abroad. He wanted nothing but peace. At the same time he spoke of his compatriots' war without weapons and was angered that the Serbian side had weapons they were ready to use. He was for the independence of Kosovo and for the realization of the far-reaching targets of Albanian nationalism. For him, the significant issue was to make Kosovo a neutral state with Albanian and Serbian affiliations, but open also to Macedonia and Montenegro. He did not explain how this could be made possible without another Balkan war and he was not asked.

Each side abdicated responsibility for what was happening. It was easy for them to convince their own populations, who were convinced of their own innocence and the guilt of others, but it was a different matter with the international arbitrators. Still, it was worth trying. Both sides had their lobbies and admirers around the world. The lobbies were well paid and the admirers were naïve and biased.

Rugova and his people had two advantages. First, to the Western public they played the role of victims and patrons of peace; sometimes they even claimed to be the only pro-Europeans in the Balkans. No one asked them why they exposed their people to unnecessary trouble and constant poverty. Second, their opponent's fondness for military games in which he did not directly participate was well known. Milosevic had never visited the front, the military camps, the cemeteries or the wounded in the hospital. He inhaled the reek of blood through intermediaries, while refusing to admit

that anything unpleasant was happening. These were lies spread by the mercenaries of foreign powers. Finally, he denied he had anything to do with the fighting, which in practical terms was true. He had made no declaration of war and had issued no direct orders. Since he had no war objectives, he could not be considered the instigator of war – yet in the future he would sign a cease-fire in the name of some unknown and invisible entity that was responsible for the attacks.

As in Croatia and Bosnia before, the destruction of houses, the burning of villages and the expulsion of populations began in Kosovo. Special units of strong and well-trained young men attacked and occupied villages. To any impartial observer the whole offensive looked like a well-rehearsed manoeuvre: the participants of both previous wars had been waiting for a long time to return to the battlefield. As soon as they arrived they showed a fanatical determination to attack women, children and the elderly. The suffering of the unprotected was the rule; the killing of a soldier was a rare occurrence. And, as always, the commanders and presidents were responsible for nothing.

The contention that the Serbs had committed all the crimes was opposed by the contention that the Albanians were the worst offenders. The two propaganda messages were complementary: 'ours' tells the truth, 'theirs' shamelessly lies; 'we' defended ourselves, 'they' attacked us. The 'foreign representatives' could support either side and be equally deceived.

But before the 'foreign representatives' were deceived, the 'people' had to be tricked all over again. They had to be persuaded to give their silent approval to the head of the family, his wife and their new caste, and condone the atrocities that would be committed in their name. A referendum was organized[6] that prevented any foreign intervention into the interior affairs of Serbia. The question asked was 'Do you accept the participation of foreign representatives in solving the problems in Kosovo and Metohija?' The nature of the problem and its proportions were not described, therefore the question could be interpreted in any way the participants of the referendum chose. It was not said who the 'foreign representatives' might be, or what they would do. Once again the term 'Kosovo and Metohija' was used, which had long ago gone out of use. For the collective subconscious of the people, the term indicated the future division of the disputed territories that the Belgrade and Pristina nationalists and both national intelligentsias had been discussing for some

time. Kosovo would belong to Albanians, Metohija to Serbs – or vice versa. Both sides thought that they would succeed in securing the lion's share of the spoils.

The referendum was a success. *'Serbia has uttered its historic no.'* Milosevic once again became the only legitimate representative of 'his people' whom he had deceived so many times and had brought time and again to the brink of disaster. The silent majority decided that there would be no 'foreign representatives involved in solving the problems in Kosovo and Metohija'. The affair would be left to domestic repairmen who had so often proved that, however pitiful the situation, they could make it worse.

Kosovo was flooded by hundreds of journalists. The reports and pictures they sent back once again appalled the Western public. The Western politicians needed do something to gain time and conceal the traces of their former mistakes: vague UN resolutions, chaotically ordered, were circulated – some passed, others did not. The formulation of clear and precise conditions for an intervention was vital, but it took an immense amount of time.

European scholars spent months discussing the terms that should be used, while the pragmatic Americans waited for the situation to deteriorate beyond any solution. They would then cut the Gordian knot with their bulldozer diplomacy. In the meantime they engaged in open-ended shuttle diplomacy. The American ambassador in Skopje hurried to and fro between the warring factions while his Belgrade colleague held aloof from all talks. The combatants had to be 'brought to the negotiating table', as if this might have some miraculous effect on the relationship between the representatives of Milosevic and Rugova, both of whom were equally arbitrarily chosen and equally incapable of making their own decisions.

Eventually, Milosevic – by now involved in conflicts with Europe, America, the Council of Europe and NATO – went to Moscow. He negotiated for several hours with the elderly Yeltsin who staggered drunkenly in front of the cameras. Tsar Boris was slowly but surely dying under the weight of his power, while this same power rejuvenated and refreshed Milosevic. After long talks (the translator was Milosevic's elder brother Borislav, who was shortly afterward appointed ambassador to the Kremlin),[7] the two men signed an agreement and released a joint statement. Those better acquainted with the circumstances could have recited it in advance. The signatories of that text were pupils of the same school.

141

The conflict in Kosovo had to be solved by exclusively political means. The partners neither stated what they meant by 'political means' nor said when and how they expected this to happen. The Western governments made no objections. They did not want to be reminded of Chechnya, Russia's own 'internal affair'. As soon as the media had announced this important news and the diplomats had calmed down, Milosevic's forces began an offensive in Kosovo. Had he sworn that there would be no offensive? Indeed he had. But the counter-method relied on contradiction and the unexpected. Milosevic had to show his strength so as to placate his supporters in Belgrade and intimidate any possible opponents.

He lived off other people's belief in his strength, talent and skill, despite the fact that he was constantly defeated. Perhaps everyone else – and not only the Serbs – lived off their faith in him. To those outside Serbia, he was the perfect adversary: he always lost.

The villages and towns in which the UCK kept its units of unknown size and armaments all fell. There was no real fighting. The soldiers fled first and the civilians followed them. Just like the Krajina Serbs during their flight from Croatia, the Albanians did not ask their army to protect them. In the battered Balkan conscience, soldiers always shared the same attribute: they were responsible for nothing. If they were running away, it was to protect their own lives. The people would somehow manage because they were eternal, just, constantly exposed to genocide, indestructible and the oldest civilization in the world. The summer had passed quickly and winter was rapidly setting in; several hundred thousand refugees were trying to survive in the woods and forests of Kosovo. In the chaos of the former Yugoslavia the seasons were the only thing left that functioned regularly. Everyone talked of a humanitarian catastrophe that needed to be prevented. But how long would that take? In Sarajevo and Bosnia three full years. In Kosovo, as with Bosnia, it would only be 'prevented' once the 'humane movement of people' was already complete.

The Dayton agreement had been little more than a stamp that endorsed what had taken place. It was a true pax-Americana, with European sub-guarantors – and it amounted to nothing.

Throughout this time, Milosevic continued vacillations over Kosovo with NATO, the European Union and the United Nations. As always, he protested his own innocence and the guilt of his opposition. He described his offensive in Kosovo as 'a legitimate state taking action against

terrorists'. This view of the events was repudiated. Several resolutions were drawn up condemning the Dayton negotiator and Paris signatory, 'the great politician born in a little nation'. If he did not yield there would be another resolution, and another, each one more decisive than the last.

Official statements from the presidents of Western democracies were followed by sharper ones from their ministers for foreign affairs – and for some reason these statements were always made prior to elections in their countries. The monotonous threats of bombardment were repeated, but instead of frightening the culprit and organizer, they simply frightened the population of Serbia. The psychosis of waiting for judgement day thus began. 'There is no saviour for us but we will not perish' was the word in the streets of Belgrade. Why worry about tomorrow if tomorrow might not come? More and more Milosevic's propaganda disregarded the facts and played solely to emotions. Even the most sensible felt the cold hand of fear.

Fifteen years earlier some terrible news had hit a city in central Serbia. A self-proclaimed prophet had foretold that on a certain day at a certain time an earthquake would destroy the place. The people were in shock. On the day before the predicted catastrophe, nine out of ten people camped in fields around the city. They spent the whole night waiting for the earth-quake. Nothing happened. The next day they calmly returned home. Nobody called the prophet to account. The earthquake simply did not occur and that was it.

At the end of October 1998, while the television was broadcasting pictures of NATO aeroplanes taking off, the earth in Serbia started to shake. The walls trembled, the chandeliers swung, windows shattered. Western democracy was attacking the unarmed Serbian people. Some time later, the people slowly realized what had happened: it was an earthquake whose epicentre was very near the city that had been spared several years previously.

A friend of mine who was there claims that during that crazy night there was not a single person in the city who did not feel deep hatred for the West, the European Union and America,[8] particularly those who had vainly trusted them for so long.

It was only a false alert, provoked by natural elements and immediately used by the regime. Propaganda could not relent. The regime's media still spoke of the danger of bombing, claiming that it would begin on the following Wednesday, then that it would actually be on the Friday; there

were statements that 180 targets had been selected in Serbia, then that there were more. All the cities and villages were in danger. Even the dogs and cats would not survive. The Americans had placed an atomic bomb under the Adriatic Sea that would move underground and arrive just under Serbia where it would explode.

Serbs in the diaspora made constant phone calls home, expecting at any minute to lose their homeland and their loved ones. The NATO planes went out onto the runways and took off as for a parade. They were filmed from all angles. The generals serenely inspected their weapons; the plans were ready; the attack could begin. Rugova still supported the intervention, provided it was limited to Kosovo. Were the Albanians unafraid of bombs or was it simply that their peace-loving president had already calculated how many of his compatriots were expendable?

As the events reached a climax, all eyes – both Serbian and international – were on Milosevic. He was alone on stage, deep in thought, as Holbrooke worked in the wings. Finally, he made an announcement. He agreed to withdraw the troops he himself had sent into the pointless Kosovo adventure. The decision was interpreted in two ways: the Serbs believed he had not flinched in the confrontation with the pro-Albanian West, and the Western allies believed that the great tactician had convinced the Serbs to withdraw.

Everyone could relax: there would be no bombing. The president of the Federal Republic of Yugoslavia had once again saved Serbia. 'Our Sloba sorted them all out.' There would be no bombing, thanks to his consistently peaceful politics, which periodically caused wars. I do not know of a single voice that was raised to denounce the priceless propaganda success that the world had conspired to offer Milosevic.

Chapter 14

Between Two Earthquakes

S o far, the Kosovo Albanians had suffered considerably from the conflict. Their reluctant guerrilla force had been defeated, hundreds of thousands of people had been displaced and turned into refugees, a doubtful promise of autonomy had been made, the misery of the Albanian people had been prolonged and increased, and the extremist political factions had become even more firmly rooted in their determination to fight the oppressors. For the Serbs, the results were equally ominous. They had again been humiliated in the eyes of the world; they had secured a fragile victory; they had incurred the wrath of the Western powers; they had increased their political isolation; and extremism was on the rise among them, just as it was among their Albanian counterparts.

Both sides had effectively lost the conflict. Serbs from Kosovo were refugees in Serbia, and the Albanians were refugees in an area of Kosovo that still belonged to Serbia. The option of living together had been removed indefinitely. The propaganda of both sides encouraged hatred; indeed, not to hate former neighbours and fellow townsmen was considered dangerous. The only remaining option was the 'humane movement of people', on both sides. Nothing had been solved, and only after more violence, more referendums and more peace talks would another fragile solution be proposed.

Milosevic and Rugova sat at separate tables, each surrounded by their own political advisors.[1] These two figures were perhaps the only victors because both of them had retained their own power, as well as de facto mandates from their humiliated peoples to persist with the politics of destruction. Their people, although deeper in poverty and with even less perspective for the future, still did not reject such politics. There was no resistance to the incompetence and ruthlessness of the two leaders, neither among the elite nor among the general population. The Western administrations again supported their politics, and in their attempt to support the

abstract concept of peace they made no effort to highlight the true causes of the conflict.

The moderate nationalism of small Balkan nations, which in the nineteenth century had been a safeguard against the excesses of the greater regional powers, had turned into aggressive, violent and auto-destructive mass movements led by cynical and incapable leaders. The way was left wide open to them. Boxed into their pygmy national cultures, which they supported with false myths, national intelligentsias spread xenophobia and the idea that 'life together is impossible'. The politicians responded immediately; life together would be possible only once the maps had been redrawn.

The national states in the Balkans seemed condemned to permanent conflict; they were unstable, barely capable of scraping a living, and a danger to themselves and others. The only solution was to establish democratic states where all citizens would have equal rights. Such states had to be demilitarized and kept under international control for some time. Once a peaceful cohabitation had been reached, the newly democratized states could be admitted into a greater one. Life together would be possible because it was necessary and unavoidable. This project was cheaper and more plausible than any of the other solutions the Western democracies had come up with. However, none of the Western diplomats had yet formulated such a plan, let alone attempted to implement it.[2]

The best way to describe the situation in Serbia at this point would be to say it felt like a nation that had sustained one earthquake and now awaited another. Somehow the Serbs had survived the last one. Might the next be stronger and more destructive? People were so unsettled that they preferred to leave the situation in the hands of Milosevic, the shaman who would drive away the evil forces as in the old folk tales. They believed that he was stronger than the outside world, just as he was stronger than they were.[3]

The independent press had been almost entirely crushed and its influence, already confined to the literate, persistent and stubborn, was disappearing faster than the territory of the Serbian state.[4] Milosevic was bent on eradicating it completely by manipulating the democratic procedure. Amid accusations of libel and slander the courts obediently tried its editors and fined its journalists.[5] This could not be called outright censorship because both sides knew and respected the rules of the game. As usual, Seselj, acting on Milosevic's orders, was confiscating capital for unlawful reasons and with no justification.

There was no legal or moral relationship between guilt and punishment. If a man was accused it was not because he was guilty or innocent, it was because he was accused. No one was safe and no one was there to stand up and fight. Half the population did not vote, the middle class was despised, workers were out of work, farmers lost everything whenever they did business with the state, and the intelligentsia lived off the pickings of the rich. The army was humiliated and poverty-stricken, national minorities had lost their rights, health care was slowly disappearing, life expectancy was decreasing, roads were falling into disrepair, tourism had ground to a halt and there were no foreign investments. Catastrophe was near at hand.

One might have expected the entire population, excluding the regime and its protégés, to be seeking a way out of this misery, but no effort was made at any level to rectify the situation. What was lacking was either a capable party or an enlightened individual who might formulate a pro-gramme for change on behalf of the majority. The immobility was fascinating and hypnotic. It seemed that the entire population favoured passive pain over the pain of effort. What was certain was that negative energy was gathering beneath the surface that might at any time explode in the shape of new mass demonstrations, provided there was someone to lead them. Alternatively, this energy might manifest itself as a resurgence of support for the Devil from Dedinje. As ever, it was up to him.

No longer obliged to grapple with the opposition and relying on the newly created caste of war profiteers, the Belgrade administration now had both the time and the means to prevent dissatisfaction from becoming resistance. This was done by publicly ridiculing those who did protest or by handing them over to Seselj's followers. Seselj had said that 'a traitor is any man who collaborates with foreigners and the foreign. A patriot is one who does not collaborate with them.' Seselj's supporters ensured that any-one who had even considered making their dissatisfaction known would clearly understand that their objections were treasonous and punishable.

The students (who had already rebelled twice) and the young had no perspective for the future of their ruined country and its shattered society. The university had easily been subjugated by a simple decree that took away its autonomy. The deans were now appointed from above and were already wreaking havoc. The dean of the philosophy faculty had dismissed all his professors and abolished the department of world literature because only national literature merited study. Other deans were given respon-

sibility for sorting applicants and offering places to whomever they deemed suitable. If they wanted to survive and have any chance of a future career the young needed to acquire the admiration and support of the regime's academic representatives. They either had to become nationalists or act as though they were. Many who had started out by feigning support were soon won over through habit and necessity. The others sank to the lowest ranks of society or fled to the West to start a new life from scratch.

Serbia was lost in political apathy, desperation and a kind of hopeless frenzy. The old morals had become obsolete: justice had ceased to exist and truth was indefinable. Society had been destroyed on the inside: there was no sign of even the most basic social solidarity. The regime's media continued to churn out the same material. Clashes between nationalists and ultra-nationalists, who called each other traitors and fought for places in parliament, were the only events of any note to occur in the stagnant desperation of Belgrade. The emptiness of the world begins where language stops. Since words had lost their meaning, the few remaining protesters no longer listened to each other – they just spoke in favour of themselves and against all others.

After a brief period of calm the situation in Kosovo began to worsen again. Predictably, Milosevic had broken the promises he made to Holbrooke. Western governments were once again surprised by what had already happened several times before in exactly the same manner. But this time something had to be done, if only to save their public honour. As usual, a peace conference was convened. If it failed another would be organized and then another until the participants got tired and signed an agreement.

It is not known exactly who, in the name of the Contact Group, came up with the idea of a peace conference at Rambouillet. The statutes of this conference were thoroughly ominous and not only to the long defeated opponents of Milosevic's regime. The Serbian side (which the other parties condemned as the guilty occupier before the talks even started) was represented by a delegation without any real authority that included not only the representatives of existing minorities in Kosovo but also a man of Egyptian origin. The Albanian side was also represented by a mixture of parties, movements and individuals, as well as by the military commanders of UCK – whom the Belgrade regime considered to be terrorists and criminals.[6] The two teams of negotiators were on separate floors of the

Chateau de Rambouillet; there was strictly no communication between them; they avoided encounters and even took their walks separately.

Even the diplomats present admitted that the only thing that functioned in the conference was the security apparatus and the Swedish food provided for the Balkan guests. No one attacked them. They ate well, drank little and slept peacefully. Neither side signed the Contact Group's proposal. The conference was disbanded with a pledge to reconvene in March. The diplomats who had led the negotiations in the names of their allies were said to be 'happy with the first results' – meaning that they were pleased with the wording of the unsigned text they had drawn up.[7]

Three weeks of shuttle diplomacy ensued. The mediators seemed genuinely to believe that they could convince both sides to yield to some of their demands. The disbanded conference resumed in March. Given that in reality there had been no 'first results', the second leg of the conference offered no 'additional results'. Both old and new names appeared on the list of participants. There were again no direct talks. The delegations sat in their rooms, had lunch at separate tables and refused to say a word to each other. One of the Albanian representatives belonged to the political wing of the internationally unrecognized UCK – this was the young hardliner Hasim Taci, known as 'Snake'. A few months earlier the American government had declared his organization to be a terrorist one. The Serbian side left the conference to consult Milosevic – and signed nothing.

There was a reason for this. Unknown to anyone else, Milosevic was facing a major conundrum that he himself had created. His propaganda had been much too vocal about Kosovo, to the point where it was now impossible to withdraw without losing face. The damage he would incur by not withdrawing was of no concern to him except insofar as it might affect his own position of power; nevertheless, a choice had to be made.

Since the talks had produced no positive results, a mediator was sent in to unlock the great tactician's secrets. The last meeting between Holbrooke and Milosevic lasted for eight hours. The journalists waited, the diplomats were anxious and the soldiers were ready for combat. Again, nothing was achieved. Neither the special envoy nor Milosevic disclosed a word of what they had discussed. The ambiguous statements from both parties in no way explained why it had become impossible to reach an agreement. Milosevic did not even try to say something new: 'Yugoslavia cannot and will not accept the presence of foreign troops on its territory.'

149

With his habitual cunning, Milosevic had avoided the issues at hand, flattered his hosts, given them a false image of himself and his policies – and made an agreement utterly impossible. He presented himself as a serious conversationalist, a hard negotiator, a man who kept his promises, an intelligent enemy and a polite host, but for all this no results were achieved.[8]

The allies finally resolved to take action. After years of hesitation and prevarication, the strong man of Belgrade had finally left them with no alternative but to launch an attack. The complex mechanisms of democracy had reached the point of no return; they now chose the only form of advance still available. The fighter jets took off from bases in Italy, at first by dozens later by the hundreds. It was the first NATO action since its establishment – and for the first time since the Second World War, German servicemen were involved in military combat.

The bombing of Serbia, Kosovo and certain targets in Montenegro started on the evening of 24 March 1999. Some 58 years earlier – on the morning of 6 April 1941 – the Luftwaffe had bombed the Yugoslavian capital, burying several thousand people under the rubble. The national library, filled with old manuscripts and valuable books, had burned to the ground; 54 years before that, allied planes had dropped bombs on Belgrade and several other Serbian cities under German occupation. History was repeating itself, except this time Serbia was on its own without the support of its traditional ally Russia, or of the European powers that fought side by side with Serbia against the Germans.

The writer Filip David wrote in 1993: 'General indifference is our response to the calamity that is inexorably approaching. The greatest punishment we shall receive is that our shrieks of agony will be greeted by a matching indifference.' This was entirely true – there was neither understanding nor pity for Serbia in the world at large, only contempt and a sense of satisfaction that justice had finally been done.

What I now refer to as the war against Serbia – Montenegro's role in the war was as ambiguous as its former place in Yugoslavia – was the consequence of two mistakes. Milosevic made the first of these and the Western allies the second.

Milosevic was convinced that the allies would bomb for a few days in order to placate their own media and would then give up. He calculated that he would once again emerge unpunished, just as in the wars in Croatia and

Bosnia. He believed in the image of his opponents that he had created for himself. He saw them all as bureaucrats who delayed finding solutions to problems until it was too late, or until after their next elections.

The allies were equally convinced that Milosevic would give in after a few days, as he had done in the past. They too believed in the image that they had created of their opponent. According to their evaluation he was a politician who would only respond to aggression and whose only rationale was to attack the weak and retreat from the strong. No one made an effort to establish Milosevic's true psychological profile or exploit his innate psychological weaknesses; they simply went into battle with his shadow.

Neither side made any provision for the future. It was officially announced that 'this is not a war against the Serbian people but against the criminal regime of Slobodan Milosevic.' Milosevic was the one who had started the war against the *Kosovo*-Albanians (as distinct from the Albanians) by officially claiming that he was fighting terrorism. These mistakes cost innumerable civilian lives and the irrevocable degradation of several states and nations.

Chapter 15

At War with the World

Milosevic declared a state of war and officially took the post of
supreme commander. His army and police, reinforced by para-
military units, attacked all the areas they suspected to be UCK
front lines, from the north to the south and southeast. The operation was
later named *Potkovica* (Horseshoe). Ethnic cleansing now began in earnest
in Kosovo; it had clearly been prepared very carefully and was based on the
experience of Bosnia. The fantasy of destroying or expelling the Albanians
– which the media, nationalists, academics, Seselj and small fascist
organizations had been evoking for years – became a reality, proven
beyond doubt by the wretched columns of refugees quickly massing at the
borders of Albania, Macedonia and Montenegro. There were no indepen-
dent witnesses because all foreign journalists had been expelled and the
international observers had been withdrawn several days earlier. Many
horrific things took place behind that wall of silence that will not be
revealed for many years to come, if ever.

The Yugoslavian and Serbian parliaments declared a state of war on the
whole world, excluding Russia and China. A general mobilization was
decreed throughout Yugoslav territory. The defence council, which
included Montenegrin President Djukanovic, did not meet. The federal
government led by Montenegrin Bulatovic opted for war. The constitu-
tional president Milosevic continued to lead unconstitutionally. Military
courts and military censorship were introduced. The independent media
were confined to releasing the information that TANJUG, the official
government news agency, offered to them. All the newspapers and all the
radio and television stations were to broadcast the same thing. Seselj made
threats to the 'home traitors who were collaborating with the American
fascists', and Comrade Markovic joined him with invective against the
'fifth column'. This did not make the non-existent fifth column any more
real.

The extreme right and the extreme left were awash with patriotism and their militants clung tightly to their places in Belgrade, in other words they hid in the bomb shelters that were reserved for the select few. The population made do with improvised shelters in cellars and were left uninformed and terrified. As always, the regime paid next to no attention at all to those it claimed to represent. Propaganda was becoming more absurd than ever, full of fear and panic. The situation had changed both for the masters of propaganda and for their servants. Previously, their lies had caused bombs to be dropped on other people; now they themselves were being bombed. Their reports became surreal: 'Yugoslavia is defending its independence from fascist attacks,' 'Bill Clinton is Hitler,' 'Madelaine Albright bears a swastika in her heart,' 'Wesley Clark is a traitor.' Never once were Milosevic's actions questioned. Instead, it was claimed that Serbia was the last country in the world to hold out against the Nazism of the 'New World Order', which was to take possession of Siberia's hidden riches via Serbia and Kosovo.

Politicians and the media called for 'all Serbs of the world to unite'. Seselj demanded that all 'dispersed Serbs' make a substantial contribution to the fight 'against the fascist aggressors' by undertaking terrorist actions in the countries in which they lived. All the opposition parties backed Milosevic. He was the president of a country at war. 'If we have to replace him we will do so after the war.' This became the general slogan, repeated by non-governmental organizations, feminists, pacifists, the media (with support from abroad) and the last remaining independent intellectuals.

Throughout the bombing, rumours spread across Serbia like wildfire, most of which had been fabricated and spread by police 'information centres'. It was claimed that someone was trying to poison the water supply, that chemical and biological weapons were being used, that an atomic bomb had been prepared. It was just a question of time before a Serbian city became another Hiroshima. The country's only saviours would be the army – which fiercely responded to all attacks – heroes like Arkan and the cunning Milosevic, and brotherly Russia which would once again enter the war to defend the Serbian cause just as it had done at the beginning of the First World War.

But the former Soviet Union's foreign policy had changed. The former Soviet states were now independent and Soviet unity was a thing of the past. Milosevic could no longer count on his historic ally and protector;

Russia was swamped with economic and political unrest, and struggling to achieve a safe transition from totalitarianism to democracy. The rouble was now almost worthless, poverty was rife, disorder reigned, Yeltsin was ailing and the communists and nationalists again had the majority in the Duma.

When he received the news of the first NATO attacks, Prime Minister Primakov turned his aeroplane around in the middle of the Atlantic and returned to Russia as a sign of protest. Yeltsin was appalled and threatened war. 'I must warn NATO, the USA and Germany against pushing us to engage in military action, as such a venture would inevitably entail a war in Europe if not a world war. We are against such an outcome.' The generals also issued threats. The Duma made strong statements. After a whole decade of waiting the Russians once again held an anti-American card in their hands that had cost them nothing.

Milosevic had never thought or behaved as a Serbian statesman, even when he had signed ceasefires; he had always been interested in his personal gain to the exclusion of all else. Incapable as he was of solving Serbia's problems, he was good at creating trouble for all his Balkan neighbours. He now claimed that Russia would benefit from supporting Serbia.

Reporters, analysts and politicians all spoke of homogenization in relation to Serbia. It seemed that this word offered an explanation for everything that had and had not happened. According to scholars, specialists and speculators, homogenization was complete in Serbia, even more complete than it was in Iraq. It was happening for the second time in the decade that Milosevic and his family (both great and small) had been in power. Comrade Markovic wrote: 'I wish the last decade of the twentieth century had not happened. If only the century had ended in 1988. We really could have done without 1989 and even more so without 1990.' In her way of thinking history was not only useful for manipulating ideology: it could also be denied or erased. Comrade Markovic's opinion was that the Serbian people should forget the war that was being waged all around them and remember the unsullied and everlasting idyll of a united state and people.

Although weather conditions were unsuitable, the NATO air raids continued relentlessly, night after night. Sirens wailed constantly, even when they were unnecessary. For years the regime had used fear as one means of controlling its people; now fear was its only option. Milosevic trumpeted that it was not just his regime under attack, but every man, woman and

child in Serbia. He succeeded in making himself believed yet again in his posture as the only person capable of securing their defence. Domestic anger against him and his crew was diverted to America and the Germans. In the cellars of Serbia, the cowering masses were sure of only one thing: Milosevic was Serbia.

In Belgrade, which was simultaneously the capital of power and the centre of opposition, it was clear what the regime wanted. It wanted to personalize the conflict and make NATO see whom it was killing. In the Square of the Republic, which had once been famous for the anti-regime demonstrations held there, 'spontaneous' concerts were organized. Thousands of young people sang and danced under the open sky, wearing the word 'Target' plastered across their chests in provocation and protest. Various groups were sent to camp under the Sava bridge – the most obvious bombing target – as a sign of defiance, all under the watchful eye of the cameras. Socialists and JULists coordinated resistance everywhere, except of course on the front line.

The foreign journalists who arrived in the capital observed that the shops were all well stocked and their windows clean and shiny. The cafés were filled with people and the theatres offered free performances every evening. The only conclusion that could be reached was that the whole of Serbia was united behind Milosevic. But in the unseen provinces the shops were bare; the cafés had neither music nor customers; there were no concerts or theatrical performances; the drug and foreign currency dealers were walking deserted streets. Most of the men were in hiding and the women were no longer wearing make-up. Everything had stopped – pensions, child supplements, humanitarian aid and repayments of loans the state owed the cities. There were no chemical products for water purification, the electricity kept cutting out, and old refrigerators and freezers filled with food were falling apart. Municipal buildings had been abandoned, particularly in areas where the *Zajedno* coalition had held power. The treasuries were empty, no money at all was coming in, the members of the opposition had either mobilized or escaped, and bombs were falling on the last functioning factories. Serbian refugees from Kosovo – whose numbers were growing rapidly – could not get through to the capital; the police and army redirected them towards places under opposition control. The state had abandoned both sides.

Still bitter about the provinces' earlier anti-Milosevic demonstrations,

Belgrade was wreaking a terrible revenge – in no small measure with the help of the allies who inflicted very severe bombing in the regions. Foreign journalists and analysts acknowledged the outward unity in the capital and identified patches of resistance throughout Serbia that they thought might foster future revolt.

The Serbian villages had still not awoken from the winter dream that had started at the beginning of the great industrialization in the 1950s. But now worker-farmers were out of work both in the city and back home. They could not return to the factories because they no longer existed and they had forgotten how to cultivate the land. No political party had been able to unite them, not even the short-lived Farmers' People's Party. Until Milosevic came to power, modern Serbia had never experienced real hunger. Thankfully, there was enough food in the countryside both to survive and to blackmail the impoverished cities with high prices. Now, city fugitives were hiding from the army in family houses in the countryside. At the same time more and more soldiers (those who were not fighting in Kosovo) left their barracks and scattered across the countryside to hide in the villages.

Still the propaganda machine ploughed on; there were constant reports of aeroplanes being shot down and allied pilots captured. In the villages, hunts for the Wisconsin and Nevada bandits who had dared attack Sumadija were organized. Every night large groups of armed men (most of whom were army fugitives) walked around their own villages looking for healthy boys to go out on search patrols. The searches proved fruitless. There were no pilots but the hunts continued for as long as the regime saw fit to keep its villagers and farmers engaged.

NATO's strategists claimed that they were only bombing military targets. This would 'reduce Milosevic's ability to injure others'. That was the first phase. Airports, electronic command centres, barracks, concentrations of heavy artillery and tanks, headquarter buildings, police buildings and other major symbols of the regime were hit. Later it became known that these attacks had yielded poor results. In the second phase the economy was targeted through attacks on what purported to be military resources: oil refineries, factories, long distance power lines, bridges, roads and railways. There was the occasional mistake that a NATO spokesman would refer to as 'collateral damage'. In Leskovac a building estate was hit and in Grdelica gorge a passenger train was struck. The victims were women,

children and the elderly. In Kosovo a column of Albanian refugees was massacred – these were again women, children and elderly people. Milosevic was as safe as the house into which he had locked himself.

He did not even think of visiting the Kosovo he had so courageously defended or of taking a walk in the Belgrade that loved him so. He did not appear on television, but still the media tirelessly repeated his name and talked of his efforts to 'find a peaceful solution'. The bombs and missiles targeted none of his bomb shelters and residences.[1] As to why Milosevic's residence was spared, scurrilous stories spread of a priceless Rembrandt on the second floor that NATO was loath to destroy.

But Seselj, as ever, had a new plan: 'Serbian radicals, deeply concerned by the seriousness of the NATO aggression, demand a referendum on a possible Yugoslav confederation with Russia and Belarus.' Several days of silence followed. No one joined Seselj's initiative (almost certainly suggested by Milosevic himself) but it did become a daily topic of discussion in the Yugoslav parliament, which unanimously approved federation with Russia and Belarus. State sovereignty, which was being so vigorously defended against the allied forces, was blandly offered to distant Russia at the stroke of a pen. Why? Beyond the hopeless, last ditch call for a saviour, the Serb elite's newfound wealth originated, in large part, with the Russian Mafia: increased cooperation would have served their interests well. The utterly despoiled Serbian people – pariahs of Europe and victims of seemingly endless attacks – made no objection to this criminal fellowship.

The land of revolts had become the land of obedience; the Serbs were resigned to following their worst compatriots and trusting their least skilled commanders. The political elite of Serbia was made up of manipulators and criminals as corrupt as anywhere in the world. They saw themselves as realists who understood the needs of the moment, while the population held them to be a phenomenon against which they were helpless, just like a chronic disease. The 'time of plunder' had come and nothing could be done – either individually or collectively – to prevent it. Paralysis also affected the elite: they neither believed that they could ever overcome America nor that the Western alliance could pursue its offensive to its bloody and inevitable end. Saddam Hussein, still in power after the Gulf War, was brought up as an example in every conversation. A similar scenario needed be repeated in Serbia – neither a victory nor a defeat.

The hope was that the bombing would end and that a new Berlin

congress would be organized in which Serbia, just as it had done 120 years previously, would be granted another section of Kosovo or Bosnia. The congress would ensure that the elite remained in power and would allow it to do business until the next war. Directly or indirectly the Western powers would still have to negotiate with Milosevic. There was no other option. Regardless of what kind of talks were held or how they were conducted, the boss would find a way of securing something for himself, for his family, for the new caste and for his supporters. The only thing to do was wait.

Meanwhile, the bombing was clearly achieving little. Serb forces had not given up. The allied forces claimed that they had achieved their aim of destroying Milosevic's military capabilities, but no reports substantiated this in any depth. Albanian refugees were still crossing the borders and filling improvised camps. In the depths of Kosovo, inconceivable horrors were still taking place. The man from Dedinje had an unconquerable determination to destroy – and this final canvas of destruction was turning into his masterpiece.

Before the start of the bombing two vital details were omitted: no war objectives had been defined and no provisions had been made for what to do with Serbia, its regime and its neighbours once the attacks ceased. When the air attacks failed to yield results, no one seemed to know what to do next. The allies decided to persevere with the offensive but hesitated about sending in ground troops. Plans were ready and logistics calculated, it was known how many soldiers were necessary and where, and the percentages of individual state participation had already been calculated. But Western politicians, sensing the mood at home, were reluctant to risk soldiers' lives. This was occidental civilization's moment of glory – a single human life was worth more than any political objective. In the Balkans, however, after so many years of war, life was worth very little, if anything at all. Balkan politicians and their intelligentsia valued nations, not the individuals that constituted them.

Given the rift between Balkan and European perceptions of the value of an individual's life, a modern hierarchy of death was established. How much more is an American life worth than a Serbian life? How much more is a Serbian life worth than an Albanian one? The numbers of innocent victims would one day provide the answers, if they were ever independently established after the war.

Not one member of the three ruling parties had been drafted into the

army and all their sons had been miraculously spared. Seselj said he would fight to the death but he clearly meant someone else's. Those who had the means to leave Serbia chose one of three destinations: Cyprus was a favourite among the new caste but it was expensive and its authorities created administrative problems, which added to the cost of the stay. The main European destination was Budapest, where visas for Western countries could be obtained. Best of all were the countries that could be attacked publicly – Germany and America. Ironically, no one at all applied for a visa to Serbia's beloved Russia.

For those who had failed to get to the detested West there was a fourth option – Montenegro, where bombing and mobilization were no threat and where the Yugoslav Army remained on the whole in its barracks. Montenegro was also the property of the federal state and as yet there had been no 'collateral damage' there and no shortages.

The extended Milosevic family, however, had not yet abandoned its war duties in the capital or left its safe bomb shelters. Publicly they beamed with patriotism but in private their trust in Milosevic was waning fast. Before the war Milosevic had seldom appeared in public; now he had become totally invisible. His secret telephone numbers had been changed again and even his close supporters had not been given the new ones. Even Comrade Markovic's courtiers, who were always better informed than anyone else, no longer knew where the couple were. Occasionally, Milosevic himself appeared on television to make a brief statement. He looked old, his face was swollen and he avoided facing the camera. The role of commander-in-chief did not seem to suit him.

Chapter 16

Everyone is a Winner

Milosevic had started his career with a putsch – on the pretext of saving Serbia from the 'harmful influence of other republics' and of preserving Yugoslavia as an extended Serbia. He dealt ruthlessly with those who opposed him or offered alternative non-nationalist solutions to the region's problems. He presented himself as the only possible representative of the different political factions in Serbia – whether they claimed to be right wing, left wing, extremist or moderate. He forced himself on atheists and believers – and despised both. He did not respect the constitution, the law or any system of moral values.[1] He preached fantasy, provoked needless conflict and made unsustainable alliances. In Serbia this made him the country's most successful politician. For years he worked carefully to disassociate himself from all the wars he had initiated. In the sea of blood he clung to the most efficient buoyancy device available to him – a peacemaker's rhetoric.

Now he was trapped in a war against an invisible enemy and, as a result, he found himself suddenly transformed into an active and public villain. He could no longer hide behind his subordinates. The allies had denounced him as the cause of the conflict, a dictator and a criminal. They described him as a 'serial ethnic cleanser'. He had always been that, but for years no one had wanted to notice. The Western media attacked him savagely and most politicians described him as a guilty criminal who needed to be disposed of as quickly as possible. Only Henry Kissinger was a little softer on him: 'Slobodan Milosevic is not another Hitler, but a small-time Balkan thug.'[2] No peace treaties could ever be signed with him again. At last the world had understood.

Military experts from Brussels now put another of their plans into action, which 19 non-experts (the heads of NATO's member-countries) had ratified. NATO forces bombed the state television station in the centre of the city, the former building of the central committee in New Belgrade (a

symbol of communism and a bastion of Comrade Markovic's party) and, finally, Milosevic's residence. At first glance, the heart of the regime had been hit. However, the building of the central committee was empty, as was Milosevic's residence – even the antique furniture had been taken out of it. The only place where people were still present was in the television station. After the attacks the dead were pulled from the rubble of the main building, only metres away from the children's theatre. These were the technicians and administrative workers whom no one wanted to move from the danger zone.[3] Not a single member of Milosevic's party was in that part of the building at the time of the attacks.[4]

The regime managed to regain control of the population within a few hours, with programmes broadcast from a secret location. A private station network was used as first aid. The regime knew that without television it could not survive for long and so it did everything in its power to stay on the air with its parallel reality. The allies should have identified that the television stations were Milosevic's true weak point, but they had refrained from striking these targets after strong appeals from Western journalists who objected to their Belgrade colleagues being endangered. Yet these same journalists had spent years endangering and destroying other people's lives with lies and manipulation.

As so often before when he was up to his neck in trouble, Milosevic was given a reprieve by pure chance – in this case it was a mistake committed by his opponent. During one attack on Belgrade, the allies bombed the Hotel Yugoslavia and the new Chinese embassy that was next to it. They later justified their mistake by saying that they had used old maps. Numerous analysts, the allies' counter-intelligence agencies and the all-seeing Ajax aeroplanes failed to pick up on what the whole of Belgrade knew perfectly well – the Chinese had been long gone.[5]

The Chinese hysteria that resulted from this blunder coincided with the anti-Western mood in Serbia. It was hardly surprising that an attack on a member of the Security Council's embassy would be very poorly received. This distraction was exactly what Milosevic needed as he hid in a location that was also unmarked on the allies' maps.

In the past, the Yugoslav Army had constituted an independent state of its own, residing within a greater state. It was responsible only to its chief of staff, who was responsible to no one else. It was in charge of defending the country from outside enemies and maintaining constitutional order. The

formulation 'maintaining constitutional order' could only have meant a war against all those who opposed the regime either in thought or deed. Since there were no outside aggressors, the army was kept on a war footing to fight the internal enemy, which meant its own population. When the 'years of change' took place, the ideological army tried to introduce changes to its own and to its opponents' detriment. In choosing between communism and Yugoslavia, it opted for communism. The multi-party system looked suspicious and the army was against it from the start. The system disregarded the fact that it was supposed to be made up of representatives of all nations; overnight it became ethnically pure, with representatives from only one nation. Later, when forced to choose between its own state and Milosevic, it opted for Milosevic, following him from crime to defeat and from defeat back to crime. It waged war against those members of its own population who did not wish to remain under the power of its chosen leader. It did not refuse cooperation with paramilitary formations and it did not obey the rules of war. It neither punished its criminals nor prosecuted deserters. No officer was stripped of his rank for shelling cities, setting villages on fire or ordering massacres. *Only those who refused to comply were prosecuted.*

The army peacefully accepted the periodic replacement of generals by which its new commander purged the top ranks and removed anyone who was potentially disobedient. At the start of the NATO bombing, the army fled the barracks that were subsequently all destroyed. The soldiers dispersed in cities and villages and used their populations as human shields. The soldiers were protecting themselves – or relying on someone else to do so – in order to be ready for the events that were to follow.

'To reduce Milosevic's ability to injure others', NATO now systematically began to destroy the Serbian energy system. Graphite bombs hit long-distance power lines, not destroying them physically but ensuring that the carriers could no longer function. This resulted in the loss of electricity and a dangerously polluted water supply. Yet again, the population – instead of Milosevic – was exposed to direct pressure. Both malicious and well-intentioned people in the West, politicians, journalists and ordinary people, found it difficult to understand why these endangered and contaminated people did not rebel. They were surprised that the Serbs and other nations of Serbia who were trapped between allied bombs and their regime were incapable of summoning up the courage to take control of their situation. They found this particularly puzzling given the ease and

conviction with which these peoples' commanders, administrations, diplomats and soldiers had responded to the threats directed at them. No one had reproached the Germans for not having a spontaneous mass revolt against Nazism or for not removing Hitler from power, or the French for not having crushed Pétain before the arrival of the allies and de Gaulle.

It seemed that even the Western powers were willing to overlook the significant difference between democracy and dictatorship. In a democracy, resistance is possible because power is limited both legally and temporally. In a dictatorship, resistance is not possible – given that the very introduction of dictatorship precludes any difference of opinion. The dictator cannot be overthrown by elections because they are limited and manipulated – dependent on the whim of the dictator. Demonstrations and street pressure have a limited effect unless brilliant and determined politicians lead them because fatigue eventually replaces the initial euphoria of dissent, and that fatigue is in turn replaced by disappointment. Protest is only possible up to the point at which police intervention and intimidation turn to violence, pain and humiliation.

In the late 1990s Western governments underwent a change of opinion about Milosevic. It is unknown quite where or how this happened, but he ceased to be seen as the guarantor of stability in the Balkans and was rejected as an eligible negotiator; it also emerged that he was not even a legally elected president, but a usurper. He was finally seen for what he really was – a man of criminal tendencies, the leader of an extended Mafia family, a serial criminal and a bully.[6]

Had they wanted to, these democracies could have forgotten or hidden the conclusions they had reached; they did not – they acted on them. There might still be hesitation, but that is one of democracy's privileges as well as one of its disadvantages. Nevertheless, for better or worse the direction had been chosen and the target was visible. The Rubicon had been crossed. At a precise point in time, it had suddenly become unthinkable for any Western politician to consider negotiating with Milosevic, even about his surrender. In their eyes, his active role had ended.

The consequences of this rapid change of heart were unexpected, even for the cynics. At The Hague tribunal Milosevic was accused of war crimes

and crimes against humanity. The public prosecutor was Louise Arbour, a rigorous Canadian. Once again, Milosevic had ensured that he would be remembered in the history of Europe and the world. He was the first head of state still in office to be accused of war crimes and crimes against humanity. He went from being a local politician to becoming one of the world's great villains. He could not leave Serbia; he could not even travel to Montenegro, the 'other apple of his eye'. All the 'Serbian territories' he had seized and then lost had become inaccessible to him. He was in a steadily shrinking prison cell.

He was not alone. With him were other accused criminals Milan Milutinovic, Dragoljub Ojdanic, Vlajko Stojiljkovic and Nikola Sainovic. Those names meant nothing even to the Serbs who had suffered under them – everyone knew they were merely Milosevic's subordinates. This meant that he was alone, with no one behind the scenes to help him except his own personal Lady Macbeth, Comrade Markovic.

The game was up. NATO envoys arrived in Belgrade – Chernomyrdin, a Russian and Ahtisaari, a Finnish diplomat. Chernomyrdin, as he had been at the signing of the Dayton agreement in Paris, seemed uninterested. Ahtisaari had a frozen facial expression, like a judge delivering the harsh verdict that had just been announced to him by the jury in the back room behind the court. Since he was personally stricken and was aware that he was in real danger, Milosevic accepted the NATO demands. He did not even attempt to posture about the interests of the Serbian people with these serious emissaries from faraway empires.

He knew that his decade-long game with the Western politicians had ended – or that a long break announcing the end was about to take place. Those who had negotiated with him for a very long time had faced up to the kind of person he was when their public forced them to do so. They were compelled to see him for what he was – a dictator and criminal – and to demand his removal. Still, Milosevic was not intimidated. Not all had been lost. They had not come to take him to court. They temporized on their real accusations and the appropriate punishment. He needed to invent a new game that would satisfy both his opponents and his followers and that would replace reality until the game could no longer be played. To begin with, conditions that were far severer than those he had been refusing for months needed to be accepted.[7]

According to time-honoured Milosevic tradition, as soon as the

unwanted guests left the scene conditions would be changed and everything agreed upon would be categorically repudiated. The whole question of the crimes perpetrated in Kosovo was transferred to the United Nations, which had previously been deliberately kept out of the conflict – suddenly the UN had become inescapable and indispensable. For Milosevic, this was a new opportunity to present himself as a pillar of justice and a balanced world order – at least in his own media. Russia and China were once again scolding the Americans who had dared start something without them. In the meantime, little was done to relieve the suffering of the Balkan peoples.

The worst-case scenario seemed to have come true: 'Serbia is destroyed, Kosovo deserted, neighbouring countries destabilized – and Milosevic saved.'[8] For Western governments that had participated in the bombing this represented a victory. They had something to report to their public. A war in 'defence of the moral values of our civilization' had been won. However, their opponent Milosevic was also celebrating; that is he was once again refusing to accept the reality of his defeat. He made an address to the nation on television and radio and spoke for eight and a half minutes, as briefly as though he had just returned from a country stroll. He claimed that Serbia had won. He claimed that there were only 600 dead and missing soldiers. Yugoslavia not only managed to 'save its territorial integrity' and defeat the new world order but it had also 'restored the dignity of the United Nations'. In honour of the victory, fireworks were organized in Belgrade. Socialists and JULists celebrated their patriotism and the courage of their historical leader, while Seselj's followers could barely contain their disappointment that the war had not continued until the final victory over the USA.[9]

At the protest in Usce many Novembers before, when he was enthroned as the national leader, Milosevic had said, 'All people have a certain love that eternally warms their hearts. For the Serbs, this love is Kosovo. That is why Kosovo will remain a part of Serbia.' The masses cheered: 'Kosovo is Serbia, Serbia is Kosovo.' On listening to this I was transfixed with dread. They really had no idea what they were saying or in what times they were living. Ten and a half years later, neither the crowd nor Milosevic remembered what had been said that day, any more than they recalled the deep frustrations and overheated sentiments that had since made them monsters in the eyes of the rest of the world, whether they deserved it or not. Yet, these are the Serbian people whose culture I share and in whose language I write.

The Western media tirelessly asked the same question: 'Why has Milosevic given in?' Endless explanations were put forward. To my mind, the motive for Milosevic's surrender lay outside the sphere of politics and beyond any concern for the country he led or for the people who followed him. The explanation lies in his 'unusual personality' and in his adamant determination to act according to his own interests – and the interests of the caste he represented. Seen from that angle it can be concluded that he had not given in. By his own lights he had not even been defeated. He had safeguarded his power and his structures of repression. The property of the Milosevic extended family had been damaged and frozen in certain places but it had not been entirely destroyed. None of his belongings had yet been confiscated in either the East or West and there was no danger of that happening in the near future. He had signed what was asked of him and, together with his entourage and loyal opposition, had retreated to the last line of defence. Now, while preparing to settle with those who might have seen through him and who might have insisted he relinquish power, he would wait. He would also need to convince The Hague tribunal to waive the accusations against him.

Beside the trap his propaganda had led him into – 'Kosovo is the cradle of Serbian history and culture,' 'Kosovo is the most expensive word in the Serbian language' – Milosevic had a private *casus belli* for the conflict in Kosovo. Through a series of transactions via Greek and French middlemen, his family had got hold of the Trepca mines and their hidden reserves of silver. They had to be saved at all costs. The Albanian leaders, too, were dreaming of the fabulous wealth hidden beneath the neglected soil of Kosovo.[10] They also were thinking about the oil that would gush from wells throughout the province and bring joy to anyone who lived to see it; this was all the more reason why Milosevic should ensure that his own and his family's interest would prevail.

But this time the West made it absolutely unambiguous to Serbs that 'as long as Milosevic is in power there will be no economic aid. The Stability Pact for south-eastern Europe will not be applied to Serbia before the removal of its current regime.' The offer was clear. All that had to be done was to remove the unnecessary man, turn away from him or turn against him. Milosevic was doomed and the Serbian people saw no reason why they should share his fate.

They did not, however, attempt to dispose of him immediately after the

defeat. 'History does not repeat itself, it is rather human nature that repeats itself.' Sensible decisions could have been made earlier had they depended on reason and common sense. But they did not; everything was taking place below the threshold of reason, in the darkness of fantasy and frustration. Consciously or not, Milosevic had found a flaw in the collective unconscious that he could exploit again and again – the tendency to resist reality and to admire the victim. Epic pathos was the basis of his criminal pragmatism.

Even in a situation of poverty and semi-famine the majority of Serbs were reluctant to do anything against the politician who had given them the opportunity to do whatever they wanted as long as they did not disturb his power, and who had let them be against the whole world as long as they were not against him. He was their fantasy; they were features in the land-scape of his schizophrenic perception of reality: and by their interaction these two symptoms nurtured and fed each other.

The arrival of foreign troops in deserted Kosovo occurred by stages. The British and French moved in slowly and unhurriedly, while the Germans seemed uncomfortable with the role of conquerors – they had been forced into this by the allies who had taught them the meaning of democracy. An opportunity now arose for the exhausted politics of Yeltsin to do something to the Serbs' advantage and against the others.

Having completed a circular journey from Bosnia through Belgrade and Nis, a battalion of Russian parachutists were the first to enter Pristina and take over the airport. Welcoming ceremonies to greet the Russians had been organized all over Serbia. After years of propaganda even the older generation had forgotten what havoc the Red Army had wrought on its last sweep through Yugoslavia in 1944. The Serbs of Pristina greeted the Russians like an army of liberation; they threw flowers at them, jumped on the tanks and kissed their Eastern brothers – who were in effect in the pay of their future occupier. In other locations around Serbia there were different reactions to the Russians' arrival but they were not shown on the regime's media.

Meanwhile, Serbs from Kosovo joined the Yugoslav Army, which was retreating in an organized fashion. Now they too were leaving the former Serbian province in long columns of overcrowded tractors and trailers, just as the Albanians had done a few weeks earlier. This was a stark defeat, whatever lies had been spoken to describe it. This was abject flight, as seen several times before in Slavonia, Krajina and Bosnia.

Chapter 17

Twelve Years Past Midnight

Before Milosevic's time, one party (the Communist League) had ruled in Serbia and Yugoslavia. It had had no rivals and there had been no alternative to it. From the outside, the party was strong, unified and, as Tito used to say, monolithic. During the Second World War, and before the appearance of republican parties after the war, different factions had emerged – groups that opposed other groups, even a clashing of opinions. There were dissidents like Milovan Djilas. There were whole groups of officials who thought and acted differently and thus went outside the limits of the dominant ideology. Examples include the 'Serb liberals' and 'Croatian *maspokovci*' (see Chapter 2), whom Tito dismissed.[1] Near the end of its existence, the party began to show signs of tolerance. In fact, it had come to resemble a collection of different people who used the same rhetoric for different aims. What remained unsaid in their opinions and on the margins of their arguments left some space for personal freedom, even if it was insecure and short-lived.

When Milosevic accepted that the multi-party system was an inevitable evil, many different parties were formed. In Serbia alone there were around 180 of them. As it operated behind the scenes, the regime channelled chaos through a variety of avenues. In preparing his great project to create an extended Serbia while plundering the nation from behind his smokescreen, Milosevic formed his own party, the SPS.[2] Amid the confusion of Serbian pluralism, the SPS was the wealthiest, best-organized and most efficient group of all. It suffered no internal disputes, though its rhetoric and those responsible for conveying it to the public were occasionally changed. No opinions were voiced on the party's behalf without the express consent of the president, who, being busy with state business, had ensured that he would remain permanently and irremovably in office.[3]

Western politicians were surprised when, after yet another defeat, the parties and politicians failed to rise up against their semi-dictator and his

unstable wife. When their secret services were trying to locate the Milosevic couple, Western leaders expected dissidents to come forward as informers, but Serbia was not a country in which real political parties representing real layers of society actually existed. The family directed and controlled everything, and its executors and subordinates performed their functions in the hierarchy. There were no ideological or political splits in the Mafia, only interests, mutual or personal. Settlements involved sharing plunder, and deaths occurred when people crossed into other people's sectors or if the rule of silence were broken. What was significant was that the members of the Serbian Mafia needed to fight neither the state nor the law because it already controlled both. The police, courts and army never prosecuted them; on the contrary, they supported and protected them. There were no internal enemies, for all other parties were either prepared to cooperate or were already collaborators.

Therefore, the enemy could only come from outside and it became known as the 'enemy of the Serbian people'. A wave of letters demanding Milosevic's removal from the presidency spread across Belgrade. Ironically, they came from Milosevic's former allies, those who had created and maintained his power. Letters were also sent from the Serbian Academy of Arts and Sciences, the Synod of the Serbian Orthodox Church, the Literary Association of Serbia, the retired Dobrica Cosic and from many others. Several years too late, they indicted Milosevic with the same accusations they had previously brought against his opponents – the Western mercenaries, Croatian allies, Muslims, Albanians and globalizers. None of them later admitted that they now agreed with the traitors who 'did not love our Sloba', the people who were still viewed as traitors and still had no rights.[4] Those who had written open letters of dissent once again put themselves forward as candidates for the leadership and hid the reproaches they had made about their political father and former master. They did not reproach him for the crimes he had committed during the humane movement of people, or for the wars he had engendered. They did not mind the violence towards his own and other populations; they could live with his deceptions and thefts. What they did mind very much was that he had not fulfilled their programme. Instead of a Greater Serbia he had made a smaller, rapidly shrinking one. Had he given them power things would have been different. Now they were offering him his last chance to step aside and give them another opportunity to carry his project to full fruition. They believed that

his programme was good but that his execution of it had been wanting.[5] This was not because it had been ruthless and barbaric but because it had been unsuccessful.

Milosevic did not respond. He had believed for years that he need answer to no one in Serbia – not the parliament, not his own party and particularly not his disappointed allies. They had created him but he had kept them alive and saved them from the tide of democracy. But for him they would have been out of the public eye long ago; more talented and competent people would have replaced them. The least they owed him was obedience and silence. Nevertheless, Milosevic still defended himself through his spokesman Seselj, who took over his defence. In the meantime Seselj had left the government 'for capitulating to the aggressors' but had then decided to stay in it 'because of the peril in which the Serbian people find themselves'. Like Milosevic, he was a lawyer and was likely to resort to the law whenever he did not opt for direct violence.

The legally elected president, argued Seselj, was responsible only to his people and could only be replaced legally; he did not specify exactly what he meant by 'legally'. Those who had written letters asking for his dismissal worked for Clinton and the Germans. Those who did not collaborate with these enemies did not write letters to the legitimately elected president. The only patriots above suspicion during this period were illiterate, and Seselj and his men would make sure that more of them were found. The definition was fairly clear: 'A patriot is a person who is against any foreign involvement in our internal affairs. Those persons who invite foreigners to involve themselves in our internal affairs are meddlers and traitors. There will be no mercy.'

Instead of the Europeanization of the Balkans, which had allegedly begun with the NATO bombings, the Saddamization of Serbia began. The Iraqi model had already been applied up to a point – 5 per cent of the population had everything and the rest had nothing. The middle class no longer existed. Both cities and villages faced a barren future. A small number of people took advantage of the general misery, while the rest were desperate – and obedient.

In 1898 the Serb politician Nikola Pasic wrote that, 'Among the Serbian people there are no particular layers, there is no nobility, no clergy with particular class interests, no bourgeoisie, no hired working class. There is not a state in Europe in which the division of land and wealth is as equal as

it is in Serbia.'[6] But 100 years later it was a fact that there was no state in Europe in which the division of land and wealth was as wildly unequal as it was in Serbia. In ten years, a manipulator who seized all the land and wealth for himself, had wasted a whole century of fighting, suffering and effort.

Why did people who remembered their history fail to change or over-throw this appalling figure? The answer is that once a certain level of totalitarianism is reached, individuals become powerless. Layers and class no longer existed in Serbia. The collective memory no longer represented a source of courage and identity; it simply became a vehicle for cheap propa-ganda. Power, like a blind apocalyptic machine, had become the only functional mechanism. Change, for better or worse, did not depend on the dictator himself: he was only an invisible part of a mechanism lumbering towards disaster. Nothing could stop this machine's advance, not even the dictator himself. Were he to attempt it, the machine would simply destroy him too. For Serbia, the time of favourable solutions had passed. Only the worst solutions remained. The same went for Milosevic.

In Great Britain, the opposition had won the elections of 1945, right at the end of a war that had been won by the government in power. In Serbia, the opposition did not try to overthrow the regime even after a war that had been lost and had caused widespread misery and poverty. The reason for this was that Serbia's opposition could not be united – not under the guardianship of the Church and Patriarch Pavle, not at the demand of the Western governments, and not even with the help of the money the Serb diaspora offered. Some 180 parties, of which the majority existed only on paper, sought in vain to realize a common vision that entailed a change of regime and the departure of a dictator. Their leaders hated one another and worked behind each other's backs, but other than that they did nothing of any consequence. The greatest players in this political debacle were the presidents of the two largest parties, Draskovic and Djindjic, who had not spoken to each other since the time of the demonstrations they had called off together. The explanation given to their followers and the voters was that they could not stand each other. Mutual dislike had been transformed into a political stance; intent on their petty rivalry, the two men neglected their far more pressing political responsibilities.

In the meantime, little attention was paid to the conditions of the people in whose name the party leaders had risen to power. The most important

thing was that the leaders themselves should remain unscathed.[7] The people could find their own ways of surviving. Opposition politicians kept repeating Nikola Pasic's slogan: 'There is no saviour for us, but we will not perish.' For whom was there no saviour? And who would perish?

Internal factors, which I have outlined in this book, caused the break-up of Yugoslavia. Everyone knows who was responsible; their guilt is obvious and widely recorded. The end of 1991 was when Western governments first became embroiled in the misfortunes of those small nations, which, convinced that their intelligentsias and politicians could deliver a better life, suddenly demanded their own larger states. The Dayton agreement, incomplete and cynical as it is, was nevertheless an attempt to stop the suffering of the people and the destruction of a whole region. From that day until the end of the bombing of Serbia and Montenegro, the extent of Western responsibility in yielding to or cooperating with Milosevic and the other players of the war games is wide open to anyone who wishes to investigate. The *blame* still lies with the local warlords, with local politicians and with their intelligentsia for persisting with their nationalist programmes. But the *responsibility* has shifted to Western politicians.

The Western powers' guilt began at the moment when yet another cease-fire was signed with Milosevic. That guilt would later be measured in numbers of innocent victims. It cannot be ascribed to everyone – nations or organizations – but only to particular administrations and to certain individuals within them. But who would do the ascribing? The Hague tribunal was not designed to perform that function. The intellectuals who were *de service* forgot the Balkans as soon as they finished their presentations on television and it was time to move on to the other exotic countries that were staggering under the weight of dictatorships and natural disasters. The Balkans would be forgotten until the next flare-up.

Many criminals would never have been caught had they not drawn attention to themselves by flaunting their stolen money. The best thing for the police to do after a bank robbery is to watch for sudden increases in spending at every level of the underworld. The situation is reversed, however, in countries that are vocal about their international rights. Here, the agents of the head of state carry out the thefts under police protection; but the money taken from the victims is not hidden from them thereafter, for they are the ones who need to be shown that they are absolutely powerless to resist. Moreover, it helps them get used to the idea that they will be

robbed again tomorrow. This procedure tends to work very well. Instead of provoking hatred and resistance in the victims, it ensures their silence.

Although confined to Serbia, Marko Milosevic bought a new yacht in Greece that cost over five million marks. This money could have paid for about 50,000 pensions in Serbia for a year – or, to be more precise, this was the number of pensions that would not be paid. Such figures were of no interest to the grown-up father that Mira and Slobodan's son had become.[8]

The real news, however, was that Milosevic himself had decided to pay out some money from his private account to the Russians, to whom his country already owed a great deal. With this they would be able to pay for oil and gas for the coming winter. This small investment from the family money would eventually find its way back into family accounts (through the Russian Mafia and the Serbian state) in countries that had banned its members. The regime would provide some sort of heating for the people, even if not gas or oil, so they could make it through to spring in reasonable health. The summer would go by quickly: people would dream of holidays they could not afford and of the promised Serbian sea that had inexplicably slipped through their fingers. When the long autumn rains returned, the opposition parties would try to prove that they still existed by issuing threats and organizing demonstrations. And life in Serbia would go on.

Although the regime itself had no worries about heating, food and money, it was as worried as the rest of the population about the future and how it would survive the next days, weeks, months and years. Milosevic's strategy had always been to delay the inevitable, allowing the situation to deteriorate very slowly – given enough time, those in power would always be able to find a way of profiting from the collapse. Milosevic, the members of his family and the parties who worked with them behaved like the mad captain and officers of a sinking ship, throwing passengers and sailors overboard. All that mattered to them was to reach the shores of 2001, even if there were very few survivors on board.

They sincerely believed the communists and nationalists would soon take over in Russia and that the renewed Russian empire would take over the central Balkans and replace the Western allies, which had been unable to advance further than Kosovo in the first phase of their construction of Greater Albania.[9] The new Berlin wall would be in Kosovska Mitrovica. That was one side of the coin. The other showed that the Republicans would win in the United States, and Milosevic's regime believed that they

would be more sympathetic to their cause than the Democrats had been. Before the Democrats were elected the Serb media saw them as future allies while dismissing the Republicans as enemies of the Serbian people. They now speculated that the younger President Bush would prove fairer to the Serbs than his father had been. Milosevic's followers were ever relentlessly intolerant of logic. They thought and acted in a way that echoed the old song: 'My white rose/how blue you are/like the green grass.'[10]

Administrations were changing all over the world except in Serbia. The 'most talented Serbian politician of the twentieth century' would not change his politics, for its defining feature was a total lack of direction. Arkan had always been very vocal in the media and had made such statements as: 'We will be sheep no longer! We will be wolves, or even better, we will be "my tigers"! In me flows the blood of the Obilic family and it prevents me from watching the fascist monster devour Serbian villages or allowing Ustasha daggers to slaughter more Serbian children and their mothers.' Having completed many tasks for the boss in the 'liberated Serbian territories', he spent most of his time at his home, which he had turned into a fortress. On the outside it was one of the less sightly buildings in Belgrade, surrounded by shantytowns and overshadowed by the luxurious 'castles' of the new rich. The profitable part of Arkan's work remained invisible. Drug trafficking, which had descended on Serbian cities with the silent approval of the authorities and the police, was carried out exclusively through Arkan and his men. The 'sheep' did not become 'wolves' and they allowed the 'tigers' to do as they pleased. The 'sheep' often went to the matches of the 'Obilic' suburban football club, which Arkan had bought. In the same year the team successfully entered the first division and won the premiership in Milosevic's state. The armed 'tigers' sat in stands among the 'sheep' and the opposing teams played as badly as they could in order to let 'Obilic' win. Arkan's wife Ceca became the director of the club because, unlike her husband, she was not on the so-called fascist monster's most wanted list and could still travel abroad. Arkan himself continued to walk the streets of Belgrade as though the city were his backyard.

The 'Great Tiger' eventually became a lamb. One afternoon two unknown men he had greeted minutes before sprayed him with bullets in the Interkontinental Hotel hallway.[11] After a half-hour delay an ambulance arrived, but he died on his way to hospital. Famous politicians, priests,

artists and criminals attended his huge funeral. Later, to pacify the heavily armed 'Tigers', the police arrested Arkan's alleged killers; all the suspects were former policemen.[12]

In European states a minister is worth more than a criminal. In Milosevic's state a minister was expendable but a criminal a priceless pearl. The leader of the family conducted all business and his ministers merely signed and implemented his decisions. Hundreds of worthless people were its ministers.

Pavle Bulatovic, a Montenegrin employed in Serbia, had been minister of defence for many years and was the most insignificant of the insignificant. He did not make public statements, he only came to work to be seen, and no one knows what he did in his office other than sit in his chair and look out of the window. He was murdered at his favourite watering hole while sitting between two generals who were his regular drinking partners. The killer, who shot him through a window from outside, was not seen and was never found. Beckovic, the academic, presided over Bulatovic's funeral service in his native village in Montenegro. The following words were intoned: 'Pavle, our brother, today Belgrade was adorned with your head.'[13]

Some time after that, Lainovic, a commander of the Serb national guards and the successor of Bozovic Giska (known as the 'Great Growler') was also liquidated. Two previous assassination attempts on Lainovic had failed; a third attempt finally succeeded in disposing of this muscular street fighter, a newly rich man and the financier of numerous opposition parties. The motives were certainly not political – unless we admit that stolen money was at the heart of Serbian politics. Several other criminals died in shootouts, some were even killed on the way back from their friends' funerals. It seemed as if the disorder the invisible boss and his scheming wife were producing had even infected the Mafia.

By disposing of both the significant and insignificant witnesses of atrocities for which he was responsible in Croatia, Bosnia and Kosovo, Milosevic was methodically preparing himself for the future.

Chapter 18

'Save Serbia and Kill Yourself, Slobodan'

The signs of Milosevic's imminent downfall first appeared in Croatia. Politicians, journalists and analysts had given up claiming that, politically, 'Milosevic and Tudjman were Siamese twins'. It was denied that the two men's regimes had been mutually supportive throughout the conflicts and wars. Serbia did its best to assert that this was untrue, as did Croatia.

For a long time it had been rumoured that Tudjman was unwell.[1] He underwent a 'surgical procedure' for which medical explanations were vague. He had won the previous elections as a dual personality – as a gravely ill and a completely healthy man. At the end of the second to last year of the twentieth century, the president of Croatia and of the Croat Democratic Party (HDZ) was in hospital and had severed all contact with the public. To add insult to injury, the presidential and parliamentary elections were very close. The ruling party – unified around Tudjman's name and image – was in a state of panic: its economic objectives and the privatization of Croatia had not yet been achieved and the historian and former general was rapidly losing both his strength and his sense of reality.

The news of his death was announced several days after it happened, but he had still failed to stay alive until the elections were over.[2] Milosevic's Croatian homologue's funeral was a grandiose affair, in keeping with his tastes in life, but the empty spaces at the service could not be disguised – no important statesmen attended, no one from Europe and no one from the Balkans excluding Turkish President Süleyman Demirel. Tudjman's former associates and protectors had renounced him. Milosevic sent a brief telegram in which what was not said was more important that what was said. He was now completely alone on the stage.

It had taken the Western governments ten years to understand what was happening in Croatia. Then, in response to growing public outrage, they applied pressure on the Croatian opposition: they had a common enemy and had to unite against him. The Croatians understood that this was an order rather than a suggestion.

Six opposition parties presented a united front for the electoral battle. They had no other choice. It was no longer possible for these Croatian leaders, who had thus far enjoyed an easy life, to avoid clashes with Milosevic and to circumvent their responsibilities. Their unity proved more successful than the self-interested policies they had pursued to date. The majority of the electorate voted for the coalition of leftists, right wing and centre parties that would please everyone and anger only the dead president, his followers and Milosevic in Belgrade. The Croatian opposition had won the elections for the second time – the first time Tudjman was the victor and the second time the electors rejected everything he represented; now it seemed likely that the Serbian opposition would follow suit. Milosevic was furious.

A man neither the Croatian government nor its opposition expected to win now won the presidential elections: this was Stjepan Mesic,[3] known as Stipe, Tudjman's fellow fighter and the famous nationalist who had announced the death of Yugoslavia after being its 'presiding officer' for only a few months.[4] He later fell out with Tudjman over the war in Bosnia, left the government, changed his rhetoric and became someone else. All he kept of his former self was his short hair, his beard and the popular sincerity of his manner. Milosevic knew Mesic well, so in theory he should not have represented a threat; in practice, however, there was great danger in his readiness to cooperate with The Hague tribunal by revealing Tudjman's secret documents and recordings.[5]

Milosevic had destroyed all the evidence in his own garden, but had been unable to do the same in his neighbour's. On his own, he continued his role as public president and private Mafioso. He did not sign anything, did not note anything, and did not write any reports. He did not even use the telephone to discuss secret plans or actions. Intermediaries carried orders given verbally by the president. It is reported that many of these men then disappeared – dispatched by killers – as soon as they had ceased to be useful. Likewise, in an attempt to reveal as little as possible about their activities, Milosevic's loyal opposition remained quiet. The journalist

Slavko Curuvija, who decided to write about this, was killed in front of his home before the eyes of his wife. This was a stark warning to anyone else who might have been thinking of going public with sensitive information.

Milosevic had made one major mistake. He had conducted secret negotiations with Tudjman, trusting him as a colleague in the essential task of 'privatization'. But Tudjman saw himself as a major statesman and hoped to go down as such in Croatian history. Sloba was convinced that Franjo and he understood each other – the nationalist rhetoric was just a smokescreen for the 'greatest robbery of the century', an indulgence for the naïve and the foolish. What really mattered was eternity; a great politician would live on even after his death provided he left a lot of other people's money to his sons and grandsons, to be laundered and finally respected by the generations to come. It would be up to the descendants subsequently to interpret history and to glorify their ancestors. This would be done all the more successfully if no proof of villainy were left behind.

Now, with Mesic's revelations, Milosevic saw that Tudjman's vanity had uncovered exactly what he would much rather have kept hidden – why the wars in Croatia and Bosnia were started, how they were directed, secret agreements about the division of Bosnia, and long descriptions of the methods, means and intentions used for ethnic cleansing. Sloba did not, however, allow his media to attack Franjo, his dead opponent and former associate, for fear they might acquire an appetite for savaging paramount leaders.

Montenegro, the 'second apple of Sloba's eye', turned a consistently blind eye on events in Serbia and Croatia. Djukanovic abandoned his former master and became the associate and favourite of Western governments. He was an associate by virtue of being against Milosevic and he was a favourite because he was a democrat. He had been Milosevic's follower and henchman for ten years and had been a democrat for only the last three. Unlike most born democrats, Djukanovic could even remember the day he had become one. During the bombing, his property in the small republic was spared from destruction, his business with the Italian Mafia and the tobacco Mafia had grown, he had won public approval and foreign statesmen received him as one of their own.

Taking advantage of Milosevic's weakness, Montenegro had taken a few steps towards independence. Belgrade no longer managed its foreign relations: the Yugoslavian minister of foreign affairs was barely allowed to

cross the border. A Montenegrin police force was established and local customs officials were introduced. A local airline company was launched with a single second-hand passenger plane.

The Duklja[6] Academy was set up alongside the already existing Academy of Arts and Sciences. No country in the world had so many academics per citizen, not even the Serbs. Independent sporting associations were in preparation, as well as associations of pensioners and other parallel institutions. Finally, as proof of what could be achieved when Milosevic was one's opponent, the Montenegrin National Bank changed the currency from the dinar to the Deutschmark. Those on the run from European police hid in Serbia. Those on the run from Serbia and its ruling family hid in Montenegro. In this respect, the two lawless systems complemented each other very well.

The 'Montenegrins of Terazije' – a group of people of Montenegrin origin who had spread Serbianism in Belgrade under the leadership of the poet Matija Beckovic and the philosopher Ljubo Tadic – felt the earth shaking under their feet. They were terrified that the impoverished Serbs would stop buying the only product they had on offer – Serbianism in all shapes and sizes.

In 1995, Milosevic had told his henchman Jovic, 'If we make peace, we will rule for another 20 years.' In the interval he had made one peace, caused another war and signed a capitulation that he had proclaimed a moral victory. And he still believed he could rule for another 20 years. On one occasion he lost his temper with Bogoljub Karic, the man who had financed Comrade Markovic's literary success: 'Bogi' he said, 'what concern is it of yours how long I rule? I will rule as long as I want to.' Milosevic still believed in the 'unlimited mandate'.

The verb 'to be able to' in his mind was always replaced with the verb 'to want'. Not to act according to his own will would mean losing Mirjana, 'the mystical depths of her being', the power to commit violence, and the chance to scorn individuals like Karic. In order to receive an 'unlimited mandate', which was Milosevic's sole interest, the constitution had to be amended, early general and presidential elections had to be held, the president of SRJ had to be made immune from the jurisdiction of the

federal parliament, and the mood of the electorate had to be assessed. There would be a 'dialogue between Milosevic and the people'. Milosevic saw no reason why the citizens of Serbia should betray him in these new elections. He would use certain members of his entourage to account for a third of the votes and could thus ensure a victory on both fronts; almost half the remaining voters would probably abstain out of sheer fatigue. The majority the opposition had on paper would thus be seriously diminished and the participation of Seselj and his followers would further weaken the opposition. If manipulation of votes and the help of Seselj were not enough, then the extra measures would surely ensure a victory for Milosevic.

Defeat seemed impossible: the television of Serbia and the newspaper *Politika* published supplementary editions, state funds were used in the campaign, the election commissions had been paid off, obedient judges were in place, and the army and the police had pledged their support.

Given the economic and political sanctions that had been imposed on Serbia, the strict border controls, the diffidence of the Western governments and the promise of Russian support, Milosevic was sure that the climate was right for him to regain the confidence and loyalty of his people. He believed that, once this victory had been secured, there would be no more defeats, not even theoretical ones.

Having accomplished what he had planned through the intermediaries of his power – the parliament, the courts, the ministries and the media – Milosevic no longer concerned himself with details. He left the responsibility for the elections to his subordinates and propaganda apparatus, counting on the weakness of his opposition. His new ambition was to raise his wife's status in the government. It was time for Mirjana to emerge from his shadow and take the office of president of the federal parliament. Luckily, she was not interested in being president of the government; as she said herself, she did not have the patience required for the job and was anyway far too busy finishing several books.

The Serbian opposition offered several explanations for not once committing itself to a serious fight for power in the ten years it had existed. The real reasons were kept quiet, the false ones constantly repeated. The majority of the opposition's leaders were people with no professional qualifications, who had never held down any other job with any degree of success. Similar players could be found on Milosevic's team; the difference was that they had a captain who was also the referee. As a reward for their

180

endless political and electoral defeats, these leaders had been granted unexpected social promotion.

They became rich; they were given villas and land; they travelled a lot; they spoke on TV; they met ambassadors, negotiated with foreign politicians and had numerous followers and admirers. They had become almost unrecognizable in their new costumes, even to themselves. Now Milosevic believed that it was unlikely even now that they would risk these luxuries and privileges by actively opposing him. No one wanted another Kosovo.

The opposition leaders had always in the past found excuses for not challenging Milosevic. He did not respect the rules of the game; he wiretapped their conversations, placed spies among them, bribed them, scared them and filled police files with details of their lives. They also complained about the lack of fair election conditions. If a new leader were found, these conditions would improve and fair elections would become possible. Another excuse was their lack of money. If only the Western democracies would send them money as they had done for the Poles, the Czechs, the Hungarians and the Bulgarians! Their final excuse was that 'it was still not time', not the 'right moment', the 'fight for power could harm the Serb national interest' and other such claims.

The Serbian opposition leaders persistently blamed the Croatian opposition for injustices perpetrated against their state. They claimed that the Europeans and the Americans, the Vatican and the Comintern, the Protestant anti-Serbian conspiracy and all the Muslims were supporting it – and yet there were no terrible consequences. The unification and victory of the Croatian opposition caused a certain jealousy among the Serbian leaders. They themselves had always found it impossible to cooperate in a fight against the common enemy. Still, they now had before them an example they were obliged to follow.

No one in the world, including their long-suffering voters, could accept excuses anymore. They had to unite or disappear.

Before they united, the leaders had to chose a leader to represent them. They would gladly organize 'collective representation' but they needed a single individual candidate to counter the Devil from Dedinje. They found themselves in a quandary. Djindjic did not trust Draskovic, and Draskovic trusted Djindjic even less. Canak, a man from Novi Sad, was unpredictable and much too obsessed with the autonomy of the Vojvodina region. The leaders of the four social democratic parties – two of whom were generals

the boss had dismissed, the third being Milosevic's former mayor of Belgrade – had parties with no members and no one understood what they meant when they talked about social democracy. Ilic from Cacak had an insurmountable problem: he was not from Belgrade, which meant that he was not under the surveillance of *carsija*.[7] Perhaps Djukanovic could be of use, for he already had a reputation for standing up to Milosevic, even if he had cooperated with him for many years. But the president of Montenegro preferred to remain safely within his own fief rather than take a risk on someone else's territory.

Draskovic refused to negotiate. Because he enjoyed the support of the Serbian people, including General Drazo Mihajlovic, he considered himself above all the other candidates and independent of the squabbling. But Djindjic now took matters into his own hands. Aware of his own unpopularity, he arranged for someone to stand in for him as leader of the future coalition. This was Vojislav Kostunica, his former comrade from the Democratic Party who had in the meantime established the Democratic Party of Serbia (DPS), and who described himself as a 'great democrat and a great Serb'. The party was small, rigid and unpopular, just like its president. At the time when it was being decided who 'among the equals' would assume the leadership of the coalition, Kostunica and his 'Slav nationalists' received just over 2 per cent of the vote.

But Kostunica did have certain major advantages over the others. He was originally from deep Serbia and had become a true citizen of Belgrade. He was not corrupt and lived a modest life. He was religious; he was even related to the militant Metropolitan Amfilohije. The other leaders were not frightened of him, Milosevic even less so. Kostunica's party had made its presence known largely through the patriotic announcements that were regularly broadcast over the regime's television station.

Djindjic and the other leaders believed they had taken the right step. Kostunica would carry the burden of the fight, and the blame in the event of defeat. If he won – and there were some who believed this was possible – there would be insufficient members in his party to fill a single ministry, so other leaders would put their men in those places. No one saw him as a threat – not even Milosevic – or indeed as anything more than a vehicle for the achievement of personal ambitions.

Chapter 19

A Man with a Village Named After Him

The group of Milosevic's opponents, gathered with difficulty, were called the Democratic Opposition of Serbia (DOS). It consisted of 18 parties and was three times bigger than the Zagreb coalition. The parties generally had few members and were without real organization in the field. Kostunica's DPS did not have committees in every city; even the one in the capital was small and inactive. Only Djindjic had an organization that reached everywhere and everyone. For himself he reserved the position of 'director of the pre-election campaign'. He would work behind the scenes, while others faced the danger of challenging Milosevic.

Before, the opposition had merely imitated the regime's actions. Now, the regime imitated the opposition's secondary ranks. Draskovic refused to incorporate his SPO party, which was the mouthpiece of resistance in the provinces, into the united opposition. Since the opposition did not join him, Draskovic also opted to be represented by a stand-in. Vojislav Mihajlovic, the grandson of General Drazo Mihajlovic and a lawyer without visible talent, was put forward as the SPO's presidential candidate. Seselj, Draskovic's close friend from Herzegovina, who was preparing to rid the electoral body of the opposition, adopted the same tactic. He put forward his own vice-president, Tomislav Nikolic, as the Serb radicals' presidential candidate. Milosevic – the only one without a stand-in, since he was 'the greatest, the best and irreplaceable in the battle for freedom and national dignity' – had three doubles challenging him.

Caught between the corrupt regime and the opposition that mimicked it, a group of young men and women organized an association under the simple name of *Otpor* (Resistance). Its symbol was a clenched fist. Deliberately avoiding the centralizing tendency of political parties, their

movement was made up of many cells, but without a hierarchy of administrative and executive committees answerable to a single leader. All the cells were equal, there were no subordinates, no one issued orders, decisions were reached through agreement, there were no leaders and anyone could be a spokesperson. To the surprise of the regime and to the parties of the so-called opposition, *Otpor* cells began to mushroom not only in Belgrade but also in other cities, large and small. For the first time the provinces were not overawed by the capital. Members of *Otpor* organized posters, announcements, demonstrations and happenings. They used irony and humour, ridiculing their opponents and challenging the deadly seriousness of the nationalists. They laughed and had fun, resisted wherever they could and in unexpected ways, and thus succeeded in having an effect not only on the regime, the politicians and the media but also on their parents.

A series of *Otpor* actions and the regime's attempts to put a stop to them punctuated the year 2000. Young men and women who acted as if they supported neither the regime nor the opposition were often taken away for 'informative talks', held under temporary arrest, humiliated and sworn at, and sometimes beaten up. Units of criminals were occasionally sent out to silence them. The regime's media spent more time attacking *Otpor* than the opposition, but this had little effect on these young people because, unlike their parents or previous generations, they were not in the habit of fear. The cells of resistance spread and their actions became increasingly spectacular. The members of the elite – once the levers of the regime, now its listless opponents – started to think about how these young people could be used to prove that they had always been against Milosevic. The perennially shame-less Dobrica Cosic, now 80 and the doyen of Milosevic's former clique, became a member of *Otpor*. Its members could all have been his great grandchildren; they could not remember his crimes and he had forgiven himself a long time before.

There had been only one rule in Serbia's fast-moving history: everything happened suddenly and unexpectedly. Opinion polls in the spring and summer showed the DOS candidate, Kostunica – who had begun the race a long way behind – steadily gaining support. He had overtaken the shy Mihajlovic and the imbecilic Nikolic and was rapidly closing in on Milosevic himself. Draskovic and Seselj complained that the poll results had been rigged, but it was in vain because Vojislav

Kostunica's support continued to grow. 'Voja the Serb'[1] was in the process of overtaking the other 'Voja the Serb',[2] then 'Toma the Serb'[3] and eventually 'Sloba the Serb'.

Serbia has always been a land of small farmers. Both its great dynasties were of peasant stock. The politicians, scientists, writers and generals of recent times all had similar origins, which may explain why they scorned village culture and sometime openly hated it. The 'old bourgeois families' of Belgrade had only been bourgeois for two or three generations. One academic wrote in his autobiography: 'All of us from the Isakovic family are descendants of grandfather Ljuba.' He could not remember a great grandfather who came from the city. Even the prophets of Serbian history were not city frauds but illiterate farmers. Village people paid these prophets in eggs and if their prophecies were wrong they were pelted with excrement.

The most quoted mystical proclamation of the twentieth century was forecast in the nineteenth century near a small town called Kremna in Uzice. A peasant named Mitar Tarabic uttered the prophecy; the village priest wrote it down and newly established city dwellers spread it around by word of mouth. In his text, which seemed fraudulent from the start, Tarabic predicted the suffering of the Serbian people, wars, epidemics, refugees, burnt churches and the prolonged destruction of the people for as long as the survivors did not 'stand under one plum tree'. He – or perhaps his later hagiographers – also announced that the Serbian people would be saved by unity, belief in God, respect for the king and unification with their brothers from across the Drina.

He also described the individual who would save the Serbian people, but his account was so vague that anyone could have been positively identified with it. When the Sloba-Sloboda myth was first created, a significant number of my colleagues and fellow citizens considered Tarabic's description of the saviour to fit Milosevic perfectly,[4] a view for which there was considerable popular support.

The 'director of the pre-election campaign', Djindjic, decided to mount a rather modest campaign for Kostunica's candidacy, without spending too much on television messages, advertisements, bribes for the media and/or big meetings. The DOS candidate visited towns, cities and villages without a procession of expensive cars or huge screens; Kostunica simply walked in the streets and shook hands with the people. At first it looked as if this

'campaign without a campaign' would be only moderately successful, but then everything changed. When Kostunica was visiting a village above Kremna, where the descendants of Mitar Tarabic lived and where the farmers regarded themselves as prophets, the eldest among them saw in Kostunica 'the new president'. Leaflets suddenly appeared everywhere proclaiming that since Tarabic had said that a man who bore the name of the village from which he came would save Serbia and since Kostunica came from Kostunica in deep Serbia, he was therefore that man. The thought of a potential saviour had clearly touched something deep within the subconscious and mythical residues of the Serbian people, for the descendant of the former Damjanovic family (which took on the name 'Kostunica' only once they had come to the city) overtook Milosevic.

The words of a simple farmer had killed what support remained for Sloba-Sloboda. Now he was no more than the Devil from Dedinje who needed to be destroyed, with a bludgeon if necessary.

In the early twentieth century, nationalists had been proud of the article in the Serbian constitution proclaiming that 'Freedom of the press shall prevail in the Kingdom of Serbia,' though there were no special laws to ensure that this happened. In modern times, however, the article has been utterly disregarded, with newspapers being paid off by those who governed the state or by political parties in opposition and anyone who 'criticized the government', namely Nikola Pasic and his ministers, rarely surviving. The writer Radoje Domanovic was a prime victim of the lack of freedom of expression in Serbia at this time and, like so many other Serbian writers, he died in poverty. He could not even earn enough to buy himself bread; he began to drink, contracted tuberculosis and died at his father's house in the countryside a few kilometres from where I was born. This fate, or something akin to it, would have awaited me had I stayed in Serbia under Milosevic's regime: for ten years not a single dinar was deposited in my account in Belgrade. The options offered to me were death or collaboration. I chose neither.

In launching a new election campaign, one of Comrade Markovic's followers tried to revive the legend about the freedom of the press having existed since the start of the twentieth century. Minister of Telecommunications Ivan Markovic claimed that 'the degree of media freedom has reached an incomprehensible level. In the SRJ, freedom of information is so great that we should draft an information law to protect the other

freedoms and rights of citizens.' In other words, the people needed to be protected from the media and the journalists. The barrier separating journalists from the people was Milosevic. Had Domanovic lived through the Milosevic era he would have died of shame to see his bitter prose become a reality.

People working for the media that actively opposed the regime were not the only ones to suffer. Members of the 'independent' press were also harassed with libel and slander suits. The regime's agents pressed numerous charges against anybody in the media they did not personally control; the courts responded with quick verdicts and the 'independents' paid their fines with money received from abroad. Seselj publicly manifested his satisfaction at securing this additional plunder from 'enemies of the Serbian state'. Vucic, the minister of information, oversaw this process.

A certain Greek tragedy begins with a hero being made blind for insulting the gods and ends with the hero acknowledging his mistakes and accepting his punishment. Oedipus tore out his own eyes to be in darkness. The Yugoslavian tragedy also began with general blindness. No one could see; no one could even contemplate what would happen. Yugoslavians thought their social and economic problems would solve themselves. They had managed to avoid the poverty of eastern socialism; they were not afraid of hardship or creeping capitalism. They worked little and concerned themselves with nonsense. I am a witness of the irresponsibility of that time; I took part in it and I am still suffering the consequences. Ivan Stambolic paid more than once for his blindness. With great effort he created Milosevic, who overturned him with a putsch at a crucial moment. His daughter died under strange circumstances. He spent years outside politics and, in his solitude, he settled accounts with himself, with the communist system to which he had once belonged and with the Serbian nationalism he loathed. He joined the first group of Belgrade citizens to visit Sarajevo while it was being bombed. He seemed to be looking for atonement and forgiveness for the political sins he had committed. But those who were present when he spoke – and I saw and heard him speak during his Paris visit – realized they were listening to a mature politician who was laying out serious ideas and was ready to implement them. He had probably decided to return to politics in Serbia but had not yet announced it.

Similar thoughts emerged elsewhere. On 25 August 2000 the former president of Serbia disappeared while jogging near his house. A witness

saw two men drag him into a white van. A formal investigation was carried out, but neither Ivan Stambolic nor his kidnappers were found[5] and there was no comment on his disappearance in the regime-controlled media. In a telephone conversation with Gligorov, the former president of Macedonia, Milosevic denied any connection with the case. After Stambolic's presumed death these two desperate politicians were no longer afraid on his account. Mira had been quoted as saying: 'Opposition is not the real danger. We must beware of the vampires from the eighth conference.'

They had been afraid of their former friend who was still a man of the people and who knew every corner of Serbia. Mira had said, 'To protect the state and the truth, we defended ourselves – politically, through the media and against the NATO air attacks,' but she had other means of defence at hand. Her husband placed all the resources of the state at her disposal.[6]

During his stay in Paris, two months prior to his disappearance, Florence Hartmann (a journalist for *Le Monde*, and now spokesperson for *Carla del Ponte*) had the opportunity to see Ivan Stambolic again. He described our compatriots in the following way:

> *The main problem with the Serbs is Slobodan Milosevic. He is no longer a leader, a saviour of the people or the defender of Serb dignity. To them, he is no longer a Messiah. Serbian people admired him like a god and they believed that if they identified with him they would become gods themselves. But Slobodan Milosevic remains in the clouds while the people sink deeper into the mud by the day. All this time he has mocked the Serbian people, who for him are only an object of manipulation. Slobodan Milosevic and the Serbian people used to be one. This connection no longer exists: Slobodan Milosevic and the Serbian people are now separate. Serbs must face up to this new reality. This will be very hard for them because the only way they can build their future is by admitting defeat. The only way of admitting defeat is to repudiate Slobodan Milosevic and his politics.*

These words correctly described the situation and offered a political way out. But desperation does not choose a way out. It does not even look for one: it has been defined by its previous mistakes and it just repeats them. A new song was sung in Domanovic's *Stradija* – in the streets, the stadiums, across cafés and in the meetings. 'Save Serbia and kill yourself, Slobodan.'

At the same time the people were looking for a new saviour. 'Kostunica, save Serbia from madness.' This song was sung everywhere; it followed the first one but sometimes preceded it. In my fellow citizens' minds there always had to be a saviour, even if they elected one from whom they would one day have to be saved. The best candidates for the position were those of whom nothing was known.

No one knew if the new man would be just as incompetent as the last one. If that turned out to be the case those who had elected him would lay the blame on someone else. Anything would do, so long as admitting defeat could be avoided and condemnation of the politics that had led to defeat could be sidestepped. In truth, no one in Serbia was suitable for this impossible job: the political and cultural elite, which had created both the politics of defeat and Milosevic himself, the agent of defeat, would be condemning itself if it found a replacement for Milosevic. Amid massive security, Milosevic now appeared in public to be greeted by the miserable remains of former crowds. He spoke as always, mechanically chanting words and paying no attention whatever to his audience. They cheered absentmindedly.

The elections of 24 September went ahead without incident. The weather was warm and sunny and there were no clashes. The police did not attack the voters, who did they but know it had suddenly become genuine electors: for the first time in many years they held the future in their own hands. Perhaps it had dawned on some that there was a link between the piece of paper they were filling in and the prices of bread, milk and electricity. Foreign correspondents had little to report except that the turnout had been the highest ever witnessed. Belgrade and the provinces both witnessed the same miracle: only very few people stayed at home waiting for better times to come. Slobodan and Mira voted together in the municipality of Savski Venac. The counter-candidate Kostunica made no attempt to smile for the cameras. The other candidates were unimportant – they had had their moment and would now return to their former existence.

As soon as the polling stations closed silence descended on the streets, squares and cafés, and on the lost towns and deaf villages. The voters sat in front of their televisions. The socialists announced that they were in the lead and that Milosevic was ahead of Kostunica. The JUL said the same. The opposition claimed that Kostunica was far ahead of Milosevic. The debate raged throughout the night. A glimmer of light came from Seselj's party

when the Serb radicals announced that Kostunica was ahead of Milosevic but that the votes of half the electorate had yet to be counted. It looked as if there would be a second round of elections. For the last time Seselj played the role of the boss's spokesperson and, in congratulating the opposition, he made his bid to cross over to the other side. He was not alone.

Over the next few days Serbia was given a chance to become a different country. Milosevic's election commission put off announcing the results and a second round was announced. Milosevic rescinded the elections that had just taken place and postponed them for another year. The regime opted to drag things out the for as long as possible; in the meantime it would prepare the army and the police for a final reckoning with the 'NATO traitors'. The opposition announced its victory in the federal and presidential elections – and once again called for demonstrations. Suddenly, the Federal Republic of Yugoslavia had two presidents and two army commanders. The spectre of civil war loomed over a country that still did not know where its borders were. Milosevic made no appearances and no statements. As in previous crucial moments, he made himself unavailable. His wife also disappeared from the public eye.

The Western governments recognized the new president: they had not recognized the old one for the past two years. A storm was imminent in Serbia, even if it was ten years too late. It broke on 5 October with a demonstration in Belgrade. 'For hours I watched people pouring into the city. Then I left my house and joined them.' These are the words of one of my sons. The police blockades at the entrance to the capital were broken and tens of thousands of people rushed into the city centre. A column from Cacak led by its mayor Ilic was the longest: besides cars and trucks, it also contained bulldozers. The discontented of Sumadija went back to the nineteenth-century model of revolt by attacking the centre of power. On the square in front of the Yugoslavian parliament, a country still ignorant of real democracy was coming into its own with the largest crowd ever seen in the capital. Strong young men pushed their way past the police units and entered the building. Smoke billowed out; Milosevic had his Reichstag but could not exploit it – it was too late. The rebels besieged the Serbian television building, overcame its security guards and poured into the rooms where the disgusting programmes had been prepared for years. The director of television was beaten up and barely escaped being lynched. Filip David wrote to me that same evening saying: 'Everything was over in two hours.'

Police units joined the people in the streets; they were all brothers now. The armoured units on standby did not attack the 'forces of chaos and madness'. People who had never met congratulated and kissed each other. There was singing, dancing and tears of joy. Many shops in the city were looted. The state television continued to transmit, only now it was broadcasting exactly what was happening – the wall between the media and reality had finally collapsed. The opposition leaders kept coming and going – they were negotiating somewhere with someone.

Belgrade was celebrating its first victory over its enemy and over itself. All the other cities across Serbia were also celebrating; the streets were abuzz with people and orchestras were playing. Socialists and JULists were nowhere to be seen – they spent the night in the houses of other like-minded persons and with friends. In Pozarevac, the 'Madonna' discotheque and 'Bambiland' amusement park, both of which belonged to Marko Milosevic, were ravaged. Hundreds of thousands of people were still celebrating the next day.

The old messenger god Hermes had not come to Belgrade. He had been in a bad mood or was simply indifferent. He had seen such things many times before – in the region between the Mediterranean and the Danube only the seasons change; everything else merely repeats itself. History goes around in circles; the centuries resemble each other; regimes intertwine over time; dictators leave and return; wars continue; the same territories are lost and regained over and over again. But one of Hermes's envoys did pay a visit to Belgrade the next day, in the form of Ivanov, Russia's foreign minister, a hardline representative of Putin's new administration. He congratulated Kostunica, the winner of the elections, and promised him Russian support. He was brief with the defeated Milosevic, and made it clear that he no longer had Russian support.

General Nebojsa Pavkovic was nowhere to be found throughout the night. Even Milosevic could not find him. The next day the general contacted Kostunica and suggested a meeting with his predecessor. The former president hosted the meeting in his villa, known as the 'oval house',[7] but Kostunica only stayed for one hour. Both later stated that they had discussed no more than the transfer of power. They did not take any notes, did not call on any witnesses and did not inform the media. Milosevic appeared on television and this time the mask had fallen from his worn-out face. He was an old man through whom someone else was

speaking. 'It has just been announced to me that the opposition has won the elections.' It was as if a ventriloquist were speaking through the mouth of the former president, who was saying that he felt relaxed after freeing himself of a heavy responsibility and that he would now take some time off to spend with his grandson. He was lying as usual, but perhaps for the first time he wished those lies to be true. The ventriloquist fell silent and the lights went off.

No one could feel like a winner. We had all been defeated, except for those who had understood nothing.

The next day, this realization was not evident in the speech of the new president. 'Dear liberated Serbia. Belgrade is Serbia today, and not a condensed Serbia but our great Serbia. This is our great Serbia that exists only if one man leaves – Slobodan Milosevic.'

Kostunica stopped. He had never been very good at exciting the crowds. But people in front of him were yelling like madmen, howling and crying. Someone shouted 'Let's arrest Slobodan.' 'Let's go to Dedinje.' The speaker quickly added, 'We should not arrest him. He was arrested a long time ago when it became impossible for him to come out among the people.' The crowd accepted this.

Kostunica continued. Had the listeners understood what he was saying? The words of a modest speaker could not express their enthusiasm; nevertheless, they were happy just to hear the improvised voice from the podium. It was a different voice, not the one that had for years tried to convince them of the impossible and that had led them into the great unknown. It was enough even to believe in what had not been said. 'I am proud to be a citizen of Serbia and proud to belong to our Church; I am proud that you have placed your trust in me and have voted for me as president of FR Yugoslavia,' Kostunica added. For the first time the Orthodox Church – repressed for decades then over prominent in the politics and mischief of the defeated Milosevic – was cited in second place, right after Serbia and before Yugoslavia. That order was illogical – a 'citizen of Serbia' and 'member of our Church' becomes the Yugoslavian president! It did not sound very promising, but the listeners still heard what they wanted to hear – the song of their joy, the shout of their hope.

The opposition leaders were standing on stage behind their new leader, smiling and applauding. The greying Djindjic with his child-like face, Mihajlovic with his moustache, rigid little Tomo Vucic Perisic, General

Obradovic, stripped of his rank with his schoolteacher glasses, and the nervous Professor Korac. Most of them did not understand what had happened. They had won, although their passports were ready and primed for a quick exit. They had overthrown Milosevic with the same moves they had once used to save him. The crowd saw them as their leaders, under the authority of this grim faced man who was no longer 'one of the equals', but the leader of a crowd that was stirring and swaying. He had become their new idol. Kostunica continued. 'We do not need Moscow or Washington. Serbia is capable of dealing with everything on its own. We are moving towards a new future with France, Greece and Norway. We are asking the world to lift its sanctions. Serbia is today a part of Europe and the rest of the world.' He forgot to mention the neighbours with whom they would have to go into the future. He also omitted the national minorities, people of different religious affiliations, refugees from the western areas and from the south, the first two waves of emigration and half a million young people who had left, who had fled from his predecessor and the unbearable life he had made for them.

But by saying 'Serbia is today a part of Europe and the rest of the world' he had said all that really mattered.

Chapter 20

To Remain the Same We Must Change Everything

S o rang the Kostunica slogan. Serbia – or Yugoslavia, to be more precise – did become part of Europe and the rest of the world, at least officially, with breathtaking speed. The Western governments understood that the first battle for democracy had been won in the elections and on the streets; they also understood that the winners needed both their support and a push ahead. Those who had formerly negotiated with Milosevic understood that at last they were dealing with Serbian politicians who could be made to respect agreements and contracts, and that the best way forward was to accept them into the international community.

Kostunica was immediately invited to meet leaders of the European Union in Biarritz and was greeted as a guest of the French state. President Chirac and Prime Minister Jospin vied for his attention. People saw that he was serious, shy, badly dressed, had great difficulty making promises and was, as a fierce opponent of the NATO bombing, angry with his hosts. He had a discreet meeting with the representatives of the diaspora who were all Milosevic supporters, not one was an opponent.[1]

With all doors open to them, the representatives of the new federal government, comprising members of DOS (the Democratic Opposition of Serbia) and of Milosevic's Montenegrins, were able to assume their tasks without difficulty. Economic sanctions were lifted and FR Yugoslavia was welcomed back into the United Nations, the International Monetary Fund, the World Bank and other organizations. The Belgrade airline company could once again fly over its continent, though not yet to Zagreb and Ljubljana. The Serbs became Europe's favourite children as easily as they had formerly become its pariahs. This provoked complaints from Serbia's neighbours who considered themselves better democrats and, each in their

own way, closer to Europe, or at least with more of a claim to European money.

The reports, commentaries and articles emanating from Serbia at this time were rather like descriptions of travels through a newly discovered country. Politicians, economists, emigrants and tourists made their way to the island that had once again rejoined the continent. Belgrade public opinion (or rather *carsija*), for the first time not part of the power but the power itself, welcomed the visitors as penitents, converts and above all as debtors. These people felt proud of themselves and of the moral victory they had already annexed from the provinces. They spoke the language the foreigners wanted to hear, the language of democracy, human rights, resistance to the regime, old patriotism and various new phenomena. This was the 'democratic nationalism' some interpreted as 'liberal socialism' – exclusive to Belgrade and only possible in that city. Milosevic had been relegated to the past. No one defended him, certainly not the academics, writers, journalists and *nouveaux riches*.

According to this rendering of the fight against a dictatorship, Milosevic's associates were those who had publicly opposed him, the critics of Serbian nationalism and the emigrants. They were later called 'moral Taliban' because they dared to reprimand even the 'perfectly clean Kostunica'.

Milosevic had retreated to the 'oval house'. Security men, who protected him from the people outside the villa and from any idea he might have of slipping away, surrounded him. Still, the surveillance was not that strict. His son Marko, together with his own family and his uncle Borislav, left on a regular JAT flight from Belgrade to Moscow. He tried to get into China, but was turned back from Beijing airport for possessing a fake passport, which the Serbian and Russian immigration authorities had somehow overlooked. Marija Milosevic sold her radio-television station 'Kosava' and bought another gun. Mira found herself unable to publish her articles; at the October Book Fair where only the year before her books had been omnipresent there was no mention of her name. The number of family friends grew smaller by the day. The number of those who knew and cooperated with them was approaching zero.

Kostunica, by contrast, who started the year 2000 with 2 per cent of the votes, was breaking all records for popularity. Tens of thousands of votes turned into millions. The same process was taking place among the

'dispersed Serbs'. Those who had been 'for our Voja all along' exceeded 80 per cent. The wave of admiration changed neither the expression on the new president's face nor his habits; he still lived in his family apartment and did not become wealthy overnight. Most of those who had been 'for him all along' discovered that he was married without children, that his wife was a lawyer and that, instead of the 17 cats Seselj assigned him, he had only three. He did not expand either his official biography or his bibliography; he retained his old political convictions. He believed that the 'Serb national programme' could be achieved by democratic means, that the crimes outside Serbia 'were yet to be investigated' and that The Hague tribunal was illegal and anti-Serbian. He could not care less about it.

Many of the old Milosevic hands harked on the same themes that they had evoked before. Dobrica Cosic wrote that Kostunica was the 'true expression of the national being'. Those close to the national writer warned him not to use the phrase 'the most talented Serbian politician of this century' because he had used it to describe first Milosevic and then Karadzic, and both had ended up on The Hague tribunal's indictment list. Many more or less distinguished minds of the Belgrade *carsija* followed in Cosic's footsteps. They proved their consistency by the very promptness with which they changed sides.

Critics of the Milosevic regime and of Serbian nationalism, the basis of his ideology, joined in the chorus. All of a sudden they concluded that 'among the Serbs' there was no longer any nationalism, any war criminals, or any criminals at all, even Milosevic. Everything was the opposite of what it used to be and it looked nothing like what was visible. The past, indeed, was an invention of the 'NATO humanists'.[2]

There used to be too much Milosevic in the media, now there was none. He had disappeared; not a word was uttered about him on television in Serbia. In his ever-loyal *Politika*, which replaced several editors and kept most of its writers while its former director[3] hid in a monastery, his name was only mentioned in passing. The so-called 'independent' newspapers gave him more coverage than others did, but this was probably due to an unwillingness to confront the real problems of state and society. The new people in power only mentioned Milosevic in relation to themselves; his downfall was the only real proof of their victory.

Dobrica Cosic and the academics turned to the 'fulfilment of national interests through the wise national policy of President Kostunica'. Bogoljub

Karic said: 'I was not accustomed to meeting President Milosevic' Those who once sincerely loved him now sincerely hated him.

The Mafia sought candidates for the vacant position of godfather among the new holders of power. The greatest and the most important product of the Serbian elite, Milosevic, had disappeared as quickly as he had been created. Bodyguard Senta – who had been promoted to a general[4] – had more chance than he did of becoming a president. Only Mira Markovic had less of a chance than Slobodan. 'The comrade of all her comrades', she was the most hated person in Serbia. Had she been a tragic heroine, she would have said, 'Leave my husband alone! Everything is my fault.' The majority would have believed her.

The storm that broke on 5 October settled into an autumn drizzle. The lightning had failed to strike the main culprits, or the smaller ones, or their close and distant associates, or the institutions that they had created and that maintained them. One of Kostunica's pre-election slogans had been 'let us change everything in order not to change anything'. Milosevic's people kept their positions in the army, the police, the ministries, the banks and other institutions, and his ambassadors remained at their posts until the 'end of their mandates'. In the meantime, the new DOS ambassadors were taking crash courses in diplomacy. Events at Djindjic's 'crisis head-quarters', where important issues to do with the economy and monetary flows were being grappled with, occasionally interrupted the idyll.

Everything had been postponed until the early elections for the republican parliament in December. Until then, the fact that the opposition had no economic or political programme to speak of, or any brilliant people to work on them, could be obscured by the excuse that the 'new government had not yet been fully established'. The only visible strategy was postponement.

At the start of 'Kostunica's era', a dead person was yet again used to political advantage. This was the poet Jovan Ducic, who had died in the USA during the Second World War and been buried in Libertyville. In his will he had expressed a wish to be buried in his hometown of Trebinje, which was now ethnically pure. The incumbent mayor of Trebinje, the truck driver and *gusle* player Vucurevic, had expelled all the Muslims, boasting that 'they were perfectly fine and not missing anything' – not a thing, that was, apart from their hometown, their homes, their property, their graves and their right to return. The earthly remains of the poet Ducic

197

– a former career diplomat and nationalist – were brought to the church in his hometown as he had requested. A throng of priests, Republika Srpska politicians, local people and guests from Serbia gathered for the occasion. One of them was Kostunica. The academic Matija Beckovic gave the funeral oration and, once again, he proclaimed the impossibility of living alongside people of other persuasions. The next speaker said 'Let us mention the one whose name is unmentionable'. He was referring to Milosevic: Sloba-Sloboda had lost his mythical worth. When he had finished, another 'Serbian knight' took his place – Radovan Karadzic, the psychiatrist inclined to mass murder and decasyllabic verse.

The representatives of Western administrations minimized the political damage to the image of 'another and different Serbia' wrought by this Kostunica foray. They convinced him that he must visit Sarajevo. When he arrived at Sarajevo airport, Kostunica met two members of the tri-member presidency of post-Dayton Bosnia, uttered a few words and mumbled that 'there is time for apologies and reconciliation'. Karadzic's followers, tired of sabotaging the Dayton agreement and of surveillance by the United Nations high commissioner, were active again. Here was a real politician who considered 'Serbia, FR Yugoslavia and Republika Srpska to be indivisible'.[5] The Belgrade nationalists, who had been severely shaken by the October storm, raised their heads again. Their 'great project' was neither dismissed nor condemned – perhaps the new man would head it by different means in the name of 'different, democratic national politics'.

Even Comrade Markovic praised Kostunica: 'Many of my comrades say that his national-related politics are similar to those advocated by the SPS (the Socialist Party of Serbia, which Milosevic established in 1990).' This unexpected support was not spurned. Mirjana once again took her only political weapon into her hands – her husband would continue where he had left off, this time as the 'president of the strongest opposition party'. The ruined country and general poverty had to be blamed on the new government, the USA and the NATO pact. Slobodan awoke from his whisky-induced daze and appeared at SPS meetings, where again he eerily reminded people of a ventriloquist's dummy. The SPS Congress was duly held, even though this party, by supporting Milosevic, had relinquished all hope of recovery.

Milosevic was elected president of the crumbling SPS, but the dark shadow of The Hague tribunal dominated all the proceedings. Comrade

Markovic, who at this juncture had decided to launch a counter-attack, had come to the following conclusion:

> *I have many times likened The Hague tribunal to a contemporary Gestapo, and its prison to a concentration camp for the Serbs. The odd Croat and Muslim are only there to deceive the world's public. The majority of those present there are Serbs, and it seems as if only Serbs have sent them there. I do not know if we have always been like that. Or have we recently become such people? ... As for my husband's responsibility for the wars outside Serbia, which Serbs waged in Croatia and Bosnia and Herzegovina, I really cannot see any evidence that would satisfy an international or a Yugoslav court.*

Once again the Serbs had to be convinced that, instead of Slobodan and his criminals, The Hague tribunal was prosecuting them, each one of them, and that this was 'selective justice' as opposed to the 'unselective justice' the domestic courts meted out. Many members of the new government, who had links with and relied on the old government, shared her opinion, though they considered it their own. It would be a dangerous precedent to prosecute the culprits. The innocent ones could end up liking it, and it could become a regular activity in the domestic courts. Worse, the interests of the new caste were in real danger.

The family, stripped of its power, was being revived in the 'liberated media'. A new image was being fashioned. Expert hands that were well equipped with money and someone's secret support were drawing the new photo-robot. A couple of journalists from the weekly magazine *Vreme* (*The Times*) were brought from Slovenia to interview Comrade Markovic in her 'calm house with a sense of waiting for something'. They sat on white reclining chairs in a white living room and walked on pale carpets; there were artificial flowers everywhere. The journalists emphasized that their hostess answered their polite questions 'sincerely and openly'. Though not even Milanovic's television journalists could have been more accommodating, nothing could disguise the obvious falsehoods that filled the impromptu text that the 'warm hostess' delivered to her visitors.

The December elections were boring for everyone except the voters. If we disregard the jungle-like din produced by Seselj's and Arkan's followers, there was practically no pre-election campaign. People voted for

lists rather than individuals, thus allowing the leaders to apportion the seats at a later date. The democratic opposition of Serbia, the 'Vojislav Kostunica list', won the majority it needed to rule – and it kept its opposition name, DOS. Drakovic's party did not pass the election threshold, though Arkan's followers, led by the kickboxing champion Pelevic, almost succeeded in doing so. The 'Serb radicals' returned to the modest results of their beginnings, obtaining just enough to ensure Seselj's survival. Milosevic's socialists won around 14 per cent of the vote.

In accordance with a previous agreement, Zoran Djindjic became the prime minister of the republic's government. He could take the credit for organizing Milosevic's fall, but the number of his voters failed to grow. He chose unknown and less unknown ministers and then named seven vice presidents. Only two of these had not previously worked for Milosevic.

The newly appointed government had yet to assume its functions, as the 'Serb radicals' were endlessly slowing down the parliamentary procedures. For Milosevic and the main agents of his regime, Seselj managed to buy another month's grace in which to conceal the evidence and organize secret negotiations. Out of the public eye, the distribution of plunder was continuing apace. This was to be followed by legalization. With luck, the new caste would emerge on safe ground with everything that had been pulled from the wreckage of Serbia. Then, as a new oligarchy, they would rule over what remained.

The masses were offered a few human sacrifices. The 'loyal Kertes' was arrested. He was accused of transferring state funds into the party and private accounts of socialists, JULists and the 'Serb radicals'. Instead of pens and lighters, his gifts to regime patriots – including the 'professional Serb nationalist' Brana Crncevic – were cars. Criminal charges were also brought against Zivadin Jovanovic, the former minister of foreign affairs, who had issued diplomatic passports to Marko Milosevic. Mirjana's son had seven such passports. But investigations into the assassination on the Ibar motorway, into the murder of the journalist Curuvija and into Ivan's Stambolic's disappearance were never started. Their likely organizer, the chief of secret police Radomir Markovic, stayed in his job. The following conclusion was unavoidable – 'We have a former rotten government in opposition and a former rotten opposition in government.'

Chapter 21

A Dry Tree in a Dead Forest

In the Balkans, intellectuals like to say that the winners write the history. By saying this they emphasize two things: 'our history' is true, therefore 'we' are the winners. 'Their history' is false, so 'they' are the defeated ones. They avoid facts in advance – if they do not suit 'us' then they belong in 'their' history. As soon as the same facts are moved to 'our' history, they immediately become different and better because they are 'ours'. Responsibilities and blame are also clear in advance – 'we' are innocent and the victims, 'they' are the killers and guilty. The national historians have the relatively easy task of confirming what everyone knows. As soon as someone contests this, they are branded 'traitors' who work for 'them', and hence for the world conspiracy. Balkan historiography suffers from the children's diseases of pre-modern times. Hundreds of academics – and thousands of those who dream of becoming academics – repeat the same story. Only the names of the winners and the defeated are exchangeable, as are the names of the culprits and the victims. The historian who sticks to the facts ceases to be a historian. A writer who does not repeat what has been said and who does not support the national myths ceases to be a writer. This happened to several of my colleagues and indeed to myself. The opposite happened to Dobrica Cosic, who took a different line – and turned out to be a better writer and a greater man than he really is.[1]

Following Milosevic's fall, Serbian society faced yet another dilemma – whether to examine its conscience and involvement in the wars and crimes or once again to confirm that others were to blame for everything. The first solution would lead to painful recovery, the second to prolongation of the disease and deeper suffering. In this difficult task, the Serbian elite once again decided to side with its people. As survivors of the October revolt who later accepted its results, the old Milosevic elite continued to maintain that the Serbian people were the victims, that all others were criminals and murderers, that the real crimes were carried out mainly against the Serbs

and that the culprits were everywhere but in Belgrade. A choir of like-minded people, well trained to help construct Milosevic's cult and to defend the 'national programme', managed to drown out all other voices, just as it had ten years before. Those who criticized the bases of Milosevic's regime were attacked all over again from different sides. New accusations supplemented the old ones.

Kostunica, who represented the Belgrade *carsija*, established by decree a 'commission for reconciliation and the establishment of truth'. The responsibilities of this imposed commission included an examination of the causes of Yugoslavia's break-up, the crucial role played by Tito and the malicious influence of other republics in this process, the addressing of linguistic questions and a change in the 'terrifying image that had been created about Serbs'. The members of this commission included a few men from Cosic's propaganda apparatus, dozens of second-tier nationalists who were not too embarrassed to collaborate with the regime, and several independent members who heard about it through the newspapers. Professor of international law Vojin Petrovic and historian Latinka Perovic were not prepared to conceal what clearly needed to be uncovered and they immediately resigned.[2] The commission excluded members of other nations or republics, including Montenegro. Those who considered themselves to be the winners eagerly settled down to writing 'their truth'.

The Hague tribunal bears all the hallmarks of its founders – high moral principles, slowness, bureaucracy, hesitant pragmatism and ignorance of the people with whom it must deal. Caught between the humane intentions and murky political games of Western governments, this guinea-pig tribunal arrived late on the scene, but is moving ahead. The cells of the Scheveningen prison are slowly filling with individuals accused of war crimes; underlings who committed atrocities in the field are locked up next door to generals, mayors of 'liberated cities' and chiefs of local police. Among them is Momcilo Krajisnik, a primitive fanatic and Karadzic's prison companion. Both men have made progress. Once they used to be arrested for theft; now they have graduated to charges of genocide.

Biljana Plavsic has joined the prisoners who carried out the crimes committed in the name of a nation; she decided to surrender to 'prove her innocence before the court'. Karadzic and Mladic, however, are still at large years after being indicted; the soldiers of the international corps look the other way when they see them and no one has even attempted to arrest

them. To spare their soldiers, the Western governments are happy to protect people who never spared anyone other than their own.[3] Thousands more remain at large.[4]

The main order-giver was not among the group gathering in The Hague. Milosevic was back in the 'oval house', visiting the headquarters of his party and occasionally giving surreal interviews.[5] He said he had nothing to do with the wars or the crimes, especially not with the army, the police and the paramilitary units. The Americans, who wanted to reactivate NATO, which had outlived its usefulness with the ending of the cold war, had caused the break-up of Yugoslavia. Genocide was only waged against the Serbs. The accusation that he had taken two to three billion dollars out of the country was complete nonsense – he had always lived off his salary. Both villas were bought legally. He did not say whether he paid for them out of his salary or whether he had to borrow some money from Mirjana. He left his defence to the leaders of the new government, to the Belgrade *carsija*, to his followers abroad and to the 'perfectly clean Kostunica'. He would allow them to explain why they were unable to deliver him to their new allies who, only a short time before, had been bombing Serbia. In addition to the poverty, corruption, Mafia connections, nationalism and growing clericalism he had fostered, he sentenced them to political confusion, with himself at the centre of the whirlwind. He no longer held power but he could still inflict damage. They might be sharing power with the people but they still could not harm him.

The chief prosecutor, a determined Swiss lawyer named Carla Del Ponte, became a target for propaganda even before Milosevic's fall. The federal minister of justice, a Seselj supporter, called her a whore in an official letter and there were many other insults for which the government did not apologize. After Milosevic left office the vocabulary was softened, but the object of hatred remained the same. The new government continued in the same style, as did the independent Serbian media. A storm of invective blew up prior to the visit of the chief prosecutor to Belgrade. 'Del Ponte, a mythical monster, flies in the sky and frightens the people,' said Igic, the 'defender of Kosovo' who resided in the capital. Kostunica announced that he was too busy to meet her.[6]

When he did meet her, it was a cool encounter. The president could not bring himself to be polite to an enemy of the Serbian people. The meeting lasted one hour. The statement that followed was short and ambiguous, but

the majority enjoyed everything that 'our Voja said to that anti-Serb creature'. When a journalist asked Carla Del Ponte, 'What was your message to Kostunica?' she replied, 'Nothing. The meeting consisted of his monologue.' Other officials were less talkative, but no more polite.

Only a few 'DOS members' were prepared to cut the umbilical cord that connected them to Milosevic. The machinery of Western democracies ground slowly onward and now had passed the point of no return. The mountains of paper they had already generated obliged them to keep going and produce even more. Their conferences, their conclusions, their diplomatic corps, their media, their voters and their non-governmental organizations swept them forward. Then the Americans, led by their new president George W. Bush, added their weight to the forces demanding that Milosevic be brought to trial.[7]

The US administration slowly formulated what conditions it should impose on the new Belgrade government. If the Serbs wanted financial aid from the USA as well as American help in important international institutions then, in addition to the permanent democratization of their state and institutions and the breaking of ties with the previous regime, they must begin to cooperate with The Hague tribunal. In other words they had to do something about Milosevic. But the avenues leading to Milosevic obviously crossed the paths of the new power holders and their people in the institutions, beginning with the academy and going right down to the associations of musicians. To make his position clear, President Kostunica received Milosevic as the president of the 'strongest opposition party'. Seselj had so far been spurned, as had the kickboxing Pelevic who had taken over from Arkan. The conversation between them was a private tête-à-tête. The statement released after the meeting made it clear that the two men had discussed the 'political situation'. No cameras were present; there were no written records; there was no press conference; President Kostunica did not inform the federal parliament and Milosevic did not report to his party. That evening, Comrade Markovic again knew more about what had passed than anyone else. This, however, was the last time.

Though both were inclined towards promoting a democratic state, President Kostunica and Prime Minister Djindjic took paths that occasionally crossed but mostly moved them further and further apart.

After having initially flirted with the Western governments, the lawyer Kostunica returned to his old convictions and 'traditional values' – the

army, the Church, the academy, the Belgrade *carsija*, the ideas of Dobrica Cosic – and his own innate stubbornness. The philosopher Djindjic opted to gather up the remains of Milosevic's state to create a power base for himself, doing all this behind the president's back and far from the eyes of the public. Since his popularity did not match Kostunica's, he had to rely on the Serb diaspora overseas who could and might be willing to contribute money for his survival.

The West gave the new government three months' grace before insisting it carry out its international commitments, including its responsibility to The Hague tribunal. Kostunica and his advisors, who understood this to mean at least three years, calmly continued to spread the word of 'democratic nationalism', but Djindjic clearly understood that it was a matter of weeks. First of all, Radomir Markovic, former chief of the secret police, was dismissed and arrested. For days, reports circulated that he was refusing to cooperate with the investigative judge and would not accuse his former master. There was no proof of his involvement in the series of murders;[8] therefore there was no crime. In the case of Ivan Stambolic, there was not even a body. What murder? The man simply disappeared. Markovic was the most powerful policeman in a state where people often disappeared without trace, and he openly cited this fact in his defence. The investigative judge was faced with a wall of warped logic. Following Markovic's arrest, several much smaller fry were also brought in – they did not know anything either. All the clues pointed straight to the villa in Dedinje; then suddenly they all disappeared.

For the time being, the one who, with his wife, had ordered so many murders and disappearances felt immune. Pressure from Serbia's creditors and donors was increasing by the day. Kostunica angrily resisted on the grounds that it endangered the democratic process in the FR of Yugoslavia. In his view, holding onto the main anti-democrat in some way aided this process. It was out of the question that a Serb, no matter what he had done, should be tried abroad. He suggested a solution – a 'dialogue between Milosevic and the people'. The ministers in the republic's government, well aware of its empty treasury, understood this slightly differently: one who gives must somehow be paid back. The fact was that Serbia's only potentially lucrative exports at the time were war criminals and their commander, the arch-criminal. Like everyone else, Djindjic believed in the judgement of the Belgrade *carsija* – Milosevic would be more dangerous

appearing before The Hague tribunal than he was in Belgrade. He would become a legend, a martyr, a new saint, when he should be presented to the people as a corrupt criminal.

✳ Suddenly, Milosevic was charged with an unusual offence. He was accused of unlawfully buying a part of a garden in front of his villa. He was also accused of making verbal orders to his subordinates asking them to debit large sums from the state treasury and credit secret accounts overseas.[9] The only things missing were unpaid parking fines. The people of *carsija* were secretly smiling – once again they had outwitted the enemies overseas. They kept smiling until the end of March.

Filip David wrote:

> *The whole story of Milosevic's arrest has a prehistory of its own, almost completely unknown to the wider public and which is only now being revealed. The new President Kostunica allowed Milosevic and his family to remain in the presidential residency, under the protection of the army (which was allegedly only protecting the residency) and the police. Therefore, Milosevic had some sort of guarantee of security from President Kostunica.*

One condition of democracy is to respect one's political opponent and his rights. But to protect a war criminal is to defend his politics and break the rules of democracy. Kostunica opted for the latter option, which was to remain loyal to a project the national elite had set up long ago and placed in the hands of Sloba-Sloboda. Kostunica himself had been a product of Milosevic's politics; coming to power at a time when changes were needed and nationalism was muted, though still strong, he supported his predecessor even to his own detriment. The inner nationalist soundly defeated the inner democrat.

> *Complications occurred when the investigative judge indicted Slobodan Milosevic and issued an order for his arrest, since Milosevic refused to respect his invitation to appear before the court.*
>
> *The problem was therefore reduced to bringing Milosevic, willingly or not, to a hearing of his indictment. This happened after many complications and after two days and two nights of drama that turned into farce.*
>
> *Milosevic was moved to the central prison, where he was placed*

under one-month temporary arrest so the investigation could be carried out in safety. About ten Belgrade television and radio stations followed the events live at Milosevic's residence, where several hundred Milosevic followers and opponents were gathered.

The 'oval house' was a fortress filled with weapons and security equipment.[10] Convinced that the people would defend him, Milosevic was preparing for armed resistance, while his followers outside were hoping to cause a revolt and mount a coup – all in vain. The representative of the republic's government negotiated for hours with the Devil from Dedinje, who became hysterical, threatening to kill his family and commit suicide. 'I have lived upright, and I will die upright,' he said. When the 'giant among dwarfs'[11] finally agreed to go to the investigative prison, Mirjana helped him pack his bags. When he entered the police car, his daughter Marija, having drunk a litre of cognac, ran after him and fired a shot, screaming 'Kill yourself!' .

She at least had a certain warrior instinct, unlike her brother Marko, who was hiding somewhere in Russia and only occasionally calling home. Filip David continued:

As time went by, the temperature rose and it became clear that events might take an unexpected and very dangerous turn. Obvious disagreements between the federal and republic governments had surfaced, as well as disagreements between Kostunica and Djindjic and potential, very dangerous disagreements between the army and the police. President Kostunica's statement after a joint meeting with DOS leaders somehow fixed these, but the bitterness remained. Many things remained unsaid.

Likewise, many things were left unfinished, ambiguous and hidden.

Milosevic's days in prison went by calmly. He was a good prisoner, just as he had been a good student, bureaucrat and party *apparatchik*. The obedience he had formerly shown to his mother and wife was now shown to his gaolers. His favourite was called Macak (Tomcat) and he often took walks with him around the prison yard. The prison warder recorded every meeting with him and later published a book about it. Milosevic did not see or meet other prisoners in the central prison, the ordinary criminals and products of his society whose sentences had been handed down during his

rule. Remembering a legend in which Serbian army commanders ate along with their men from a common cauldron, he praised the beans prepared for the prisoners.

Nevertheless, Mirjana brought him food from home every day. He asked for Tolstoy's *War and Peace*. He did not read the newspapers and did not have a television. Lawyers, party comrades and family members visited him and were not obliged to do so at official hours. Among them was his daughter-in-law Milica, back from Russia; the police never questioned her about her husband Marko's whereabouts. Milosevic was still ruling his broken party, as always from afar.

Milosevic refuted all the points in the indictment. He personally wrote the appeal and gave it to his lawyer, who forwarded it to the prosecutor's office and the public. In this bizarre text, he claimed that the money debited from the state treasury and credited to secret accounts did not end up in his own hands but was used to help Serbs in Croatia and Bosnia, to finance the war, and to pay the wages of Karadzic's officers and men. This, he said, could not be done straight from the budget because it was a national secret. Here he implicitly admitted what he had been denying for years, namely that under his rule the state waged war on other territories. Once again he had placed his own interest above all others. Neglecting the oath of office he had sworn on three occasions, he used this national secret as though it were his own. No one called him to account for it. He was never tortured by moral dilemmas. Soul-searching and remorse were never part of his personality. Several times he said that he saw himself as the moral winner – but over whom? Over NATO of course, but also over the USA and over anyone else who dared to oppose him. He appeared to have given up deception as a tactic.

Nevertheless, a small comedy under his direction and starring him in the lead role took place in a special part of the prison's building called 'Hayat'. The medical board established that the former president was in good health with a minor problem of high blood pressure. Milosevic considered the opinion of the experts to be incorrect – that is, not in his favour. The socialists, JULists and radicals started saying he was ill, badly treated, in danger of losing his life – and that this was all part of a conspiracy between DOS and NATO. Mirjana and Milosevic's daughter Marija joined the chorus, as did brother Borislav from Moscow, one of those guarding the family's hidden wealth. The Medical Board of the Serb Radicals (the party

contained no members of the medical profession more senior than a nurse) issued a statement 'conclusively establishing' that this was a case of medical murder. Milosevic was taken to VMA (*Vojno Medicinska Akademija* or the Military Medical Academy) – the most prestigious medical institution in Belgrade – where he underwent many tests. A group of experts then ruled that none of the Serb Radicals' claims were true. Milosevic returned to prison. Still, the desired effect had been produced – a few people started to view the thug as a victim.

The real victims were elsewhere, and most of them were dead. They were all over the former Yugoslavia, in Croatia, Bosnia and in Kosovo. Thousands of people listed as missing were never found. The new democratic governments in the new national states did not care for the living, let alone the dead. Having committed their crimes, the army, the police and the politicians of those countries considered themselves as beyond punishment – fighting for the nation meant they were free to kill the enemy.

Actions like theirs did not need to be concealed from the domestic judiciary, which did not press charges against the warriors; they had only to be hidden from foreigners who stuck their noses into other people's business instead of concerning themselves with the sins from their own past.

Then, thanks to the perseverance of reporters from small provincial newspapers, it emerged that a refrigerated truck filled with dead bodies had been found in Kladovo after having floated to the surface of the Danube. The government of the republic and the new police minister, formerly Milosevic's vice-president, were forced to take the investigation further; every day the budget reserves were shrinking and Serbia's dependence on the West was increasing. The corpses were removed from the refrigerated truck, taken to the capital and buried in the Batajnica cemetery. Experts established that they were the bodies of Albanian men, women and children.

The news shocked the people who for years had been convinced that all crimes were perpetrated against the Serbs. It had no effect, however, on the elite and the politicians: the wise men of Belgrade had already prepared their excuses and explanations. The socialists, JULists and radicals, once again disgracefully united, said the discovery of the corpses was related to ongoing 'NATO aggression' and the subversion of the Serbian people by propaganda. Some were even angry with the policemen and soldiers – if

they had been killing people in the national interest they should have learned the intricate skill of concealment. There were also some who refused to believe the story of the 'driver Nikola' – the pseudonym of a man hiding somewhere in Europe – who, unable to sleep after realizing what was in the back of his truck, photographed the stacked bodies before running away. Once he had testified in court, he took a false identity and settled somewhere that was a healthy distance from his homeland. The majority of those involved in the operation 'The Depths 2' were never arrested. Other trucks and mass graves began to appear, always in the vicinity of important construction projects. The Serbian minister of police said that at least 800 bodies had been found and that many more probably lay buried under fresh deposits of motorway concrete or in the concrete blocks of bridges.

Milosevic's 'reconstruction and construction', which had been so widely touted after the bombing, did not just make sense as propaganda but it also served to conceal the truth, in the form of Milosevic's victims. The 'cleaning up of terrain', which in army parlance means the routine removal of the dead after a battle, had a deeper purpose. Every trace of crime Milosevic had ordered or allowed had to be removed. Realizing he was losing, he attempted to remove all the traces of that war. After that, he had the monumental effrontery to say that he was not ashamed of anything he had done and was sleeping peacefully at night, unlike 'driver Nikola'. In the moral sense he was as dead as those whose lives he had taken away.

On Vidovdan 2001 – 12 years after the six-hundredth anniversary of the Battle of Kosovo and Milosevic's speech to a million-strong crowd of his compatriots – the police entered his cell and told him to get ready to travel. 'Where am I going?' he asked. Then he understood. It is said that for several minutes he resisted, clung to the bed and refused to move. Then he suddenly changed his behaviour, packed what he could into a suitcase – he took a copy of the Bible that his old ally Metropolitan Amfilohije had given to him as a present – and meekly followed his escort to a police van. Ten months earlier, a similar vehicle had been used to kidnap Ivan Stambolic. The prison warden drove his car behind the van. The operation was named 'The Dove'. They went through the gates of the central prison without problems. Around a hundred of Milosevic's supporters, gathered outside the main entrance, failed to recognize the vehicle with its precious load, and let it through – they were mostly old men and women, the last

defenders of a man who had wrought nothing but misery and destruction in their land.

Some time later an armoured black limousine arrived with Comrade Markovic – she had sensed that something was happening to her husband. She slammed the door in a curious journalist's face. 'Damn you,' she screamed. Then the black limousine raced away.

The van containing Milosevic stopped at a police checkpoint near Belgrade, where he was transferred to a helicopter. Before climbing in, he turned briefly to those present and said: 'Farewell Serbian brothers. You really sold me cheap.' There was no response. The leader of millions, the 'saviour of the Serbian people', the 'man who restored Serbian dignity', Sloba-Sloboda, was seen off on his trip to an international prison by scarcely a dozen of his own people, all of them impatient to be rid of him as soon as possible. The policemen who once shivered with fear and love at the sight of him helped the white-haired, slightly bent figure up the steps into the aircraft. With those last steps Milosevic left Serbian history and entered a different arena, bigger and just as uncertain.

The helicopter took off and floated away westward. A while later it flew over the Drina, the river Serbs still credit with mythical properties – some think it connects two parts of the 'Serbian national being', while others see it as the western border of the Serbian state.

Shortly afterwards Milosevic was delivered to international forces at a base near Tuzla in Bosnia. High military security was in place. Representatives of The Hague tribunal were waiting to explain the reasons for his arrest and where he was going. He listened calmly and did not say a word. The prisoner without a number – he would be given one a few hours later – was then transferred to a British military aircraft, which immediately took off and flew towards Europe, monitored by hundreds of radar transmitters.

Dusk was settling on the old continent. Television and radio stations were broadcasting the news, both true and false. Thousands of specialists, journalists, intellectuals and politicians were discussing the man in the aeroplane headed for The Hague – he was once again a subject of controversy. Some speculated that several other people indicted of war crimes were also on board. Fifteen minutes before midnight the phone rang in my apartment in Paris. 'He has just arrived.' Some time later, the television stations began to show footage that an amateur photographer had shot over the roof of the prison in The Hague. Two policemen accompanied a

handcuffed man. The man was moving with the lumbering gait of one who took little exercise. The ambiguity was producing the reality. The creator of nothingness was returning to nothing.

Milosevic is prisoner number 39, case number IT-99-37i. He celebrated his sixtieth birthday in a cell under the watchful eye of a camera. Scores of lawyers, attracted by the prospect of worldwide publicity and money, offered to defend him.[12] A 'committee for the defence of Slobodan Milosevic' was formed, and the list had 200 names on it. The citizens of Serbia did not seem to care.

The love of the crowds did not turn to hatred, but to indifference. It was a sick, humiliated indifference after all the hysteria and the lies, the violations and crimes, now so very painful to remember.

The socialists, JULists and radicals demanded the immediate release of their president. Kostunica's party comrades, ready to break the coalition that brought them to power, announced that surrendering Milosevic had been 'the last straw'. More Milosevic apologists popped up in unexpected places. In the Western democracies there are many who, for reasons of their own, still claim that Milosevic needs to be tried in Belgrade. They can be answered by the simple, terrible words of an anonymous Bosnian: 'Milosevic is at The Hague? Come to Bosnia, dig up one of our thousands of mass graves and tell the news to the corpses there. Only you will need to shout very loud because their ears are stopped with earth.'

As for the survivors, they are dumb with grief for the dead, with shame for being alive and with desperation at the barbarous clamour that has arisen round the gaol in Scheveningen and is spreading through Europe like a plague. We cannot rule out a verdict of not guilty for Milosevic. The worst is always possible. One missed detail or set of circumstances may give him a chance to show himself again.

The pity of it is that the job that is now engrossing thousands of soldiers, policemen, investigators, judges and politicians could have been done by a couple of lowly Yugoslav policemen thirteen and a half years ago had they been sent to arrest a minor official and putschist named Slobodan Milosevic, residing in Savo Kovacevic Street near Kalenic market in Belgrade. On the following day everyone but his wife would have forgotten him. Perhaps Yugoslavia would have been spared, Croatia preserved, Bosnia saved and Kosovo turned into an autonomous state. Serbia would be intact, the whole area would be about to join the European Union, very few

Americans would know the whereabouts of Sarajevo and no one on earth would have heard of Karadzic.

At least 200,000 people would still be alive, and five million of today's refugees would still be in their homes. The thunder of hatred and the lightning of suffering would never have struck the Balkans. The entire territory would not be immersed in poverty as if by a biblical flood. Milosevic, the 'man without qualities', would long ago have been released from prison; he would be in retirement, spending time with his grandson.

And this book would not have been written. None of us would have found out the truth about ourselves, about others, about human nature, about the civilization in which we live, about hell on earth and the heaven we will never reach. We would not have known that this world has so much suffering and pain in it, that it is lit by such fires of horror and flashes of beauty. Or that we need to save it from ourselves, since it is the only world we have.

An anonymous witness at The Hague trial, whose entire family was slaughtered by Karadzic's soldiers, said: 'I am a dry tree in a dead forest.' If we do not understand his pain, if we do not share it with him, then we are that dead forest. No fire will warm us. Milosevic was our moment of truth, the limit of our being, and the challenge of our conscience. His victims are more than victims; they are us. A part of their suffering was intended for us and they endured it in our place.

Who cannot see this, has not seen anything.

Notes

Preface

1. BBC World Services, 11 November 2002.
2. Jared Israel, editor, vice chairman. ICDSM. www.icdsm.org

Chapter 1: The Friendless Orphan

1. Yugoslavia was known as 'The Kingdom of the Serbs, Slovenes and Croats (Yugoslavia)' from 1918 to 1929. In 1929 the kingdom became the first Yugoslavia under King Alexander I. At this point it was divided into nine *banovina* (provinces).
2. Svetozar went back to Montenegro, but there are conflicting stories on whether Borislav came with him or stayed with Svetlana and Slobodan.
3. Milosevic's political rival, Seselj, wrote in a moment of fury against his opponent (see *Velika Srbija* (The Great Serbia), number 21, January 1995): 'Little Slobodan wanted his father's death, at least unconsciously. When it did take place, he was struck by guilt and depression he was never able to shrug. His depression was interrupted only by occasional manic periods.'
4. Slobodan got a law degree in 1964.
5. They married in 1965.
6. Zdenka was sent to Tito as a courier in 1941; he decided to keep her on as a secretary.
7. 1 May 1948.
8. This was in 1943 while she was party secretary in Belgrade. She goes down in history as allegedly one of the worst traitors of the party.
9. There are also rumours that young communists shot her while she was taking one of her walks outside the prison, and that she was killed in Slovenia in 1945. The most likely story is still that she was killed in Benjica on 7 September 1944.
10. Bosnia-Hercegovina, Croatia, Macedonia, Montenegro, Serbia and Slovenia, plus Kosovo and Vojvodina.
11. This was the Petrovic dynasty (1697–1918). The last king of Montenegro, Nikola Petrovic, enjoyed a long reign (60 years). By reinforcing relationships with old European dynasties – one of his daughters was Jelena of Savoy, the

wife of the last Italian king – he expanded the borders of his small state. In his latter years he spent most of his time writing poetry and eventually died in exile.

12. In 1965, 'Muslim' became an official name, equal to 'Serb' and 'Croat'.

13. In addition to the Communist League in each of the six republics and two autonomies, the Communist League of the Yugoslav National Army was also created. Serbs and Croats were referred to as Yugoslavs under its statutes. Once retired, members of the army would join one of the remaining eight leagues, once again becoming Serbs, Croats and so forth.

14. This was the 'special loan for structural adjustment' the World Bank granted to the Bank of Belgrade via Milosevic. The amount in question was US $275 million. Due to mitigating circumstances, the Bank of Belgrade owed debts of 388 million US dollars. According to my sources, the loan has never been paid off. It will now have passed the billion-dollar mark.

Chapter 2: The Biggest Funeral in the World

1. Among the rumours was the theory that the 'known' Tito was not the real Tito. People talked about him being replaced after a visit to Moscow, by the son of a German duke, supposed to support Stalin but in the end betraying the Soviet president. The background for this theory was the question of how many fingers Tito had (the 'original' was said to have lost a finger working in a metal factory, while the 'impostor' had all five) and the fact that a metal worker could speak four languages fluently and possess amazing diplomatic skills.

2. Tito is said to have had long-term relationships with two Czechoslovakian women, one Austrian-Croatian woman, one Croatian woman and five Russian women, one of whom, Ira Glogorieva, he married, before he met and married Pelagija Belousova. He had children with all of them. Later he continued his affairs, until he met Herta Haas, whom he also married. After Herta, he had an affair with Mirjana Markovic's aunt, Zdenka, before marrying Jovanka, his final wife.

3. Questions of whether the real reason for the removal of Rankovic was his stern opposition to the economic reforms of the period continue to be asked.

4. Mika Tripolo continued his career in politics, was a member of the opposition against Tudjman and also of the coalition establishing the first post-Tudjman Croatian government (editor's addition).

5. Jovanka was put under house arrest, kept there until right before Tito's death, and then placed back under house arrest with all her rights as a president's wife revoked.

6. Not everyone was weeping. Throughout Yugoslavia, between 4 and 8 May 1980 some 4000 citizens were arrested or punished for celebrating the death of

Josip Broz by singing and dancing in public places, despite being fully aware of the consequences of such behaviour. No such cases, however, were recorded in Serbia (Milenko Vucetic, 'Hulje i maroderi' (Rats and Marauders), *Srpska Rijec* (Serbian Word), number 74, 21 June 1993).

7. Here are some of the verses of that song: 'Centuries of suffering have passed/Dying silently for freedom/With a song instead of a cry/Comrade Tito, we pledge ourselves to you'. It is clear that, as a symbol, Tito's legend had even challenged perceptions of the past: before Tito – Tito.

Chapter 3: The Unsmiling Politician

1. Dusan Mitevic, later head of Belgrade TV, was one of the minds behind the Milosevic coup in 1987.
2. In 1984 he was appointed chief of the Belgrade Communist Party and in 1987 he was named leader of the Serbian Communist Party.
3. SANU was founded in 1886 as the Serbian Royal Academy. It has been accused of being the hardliners behind both the Bosnian and the Kosovar wars.
4. The memorandum of the Serbian Academy of Arts and Sciences (SANU), released in 1986, is a well-organized list of complaints and criticisms against the Yugoslav system, as it existed at the time. The main theme of the argument in the memorandum is that Serbia was wrongfully taken advantage of and weakened under the 1974 constitution of Yugoslavia and that as a result Serbians are the victims of genocide (in Kosovo) among other things.
5. Also sent to the Helsinki Committee in 1987 as a part of the charter.
6. Bogdan Bogdanovic (the only academic to have left the Academy), an architect and a former mayor of Belgrade, later wrote, 'The intelligentsia played a clear and decisive role in the cloning of a new nationalism. In the previous period, nationalist dissidents had been harshly criticized, but this proved futile. Analytical criticism was not permitted. The tumult only enhanced the reputation of those who were being criticized, thus increasing the value of their work. However, it is an open secret that many champions of nationalism were directly related to central and national committees. When necessary, they were sent from there into circulation. ... The towers of national fantasy grew and cast their shadows. The anachronous academies of arts and sciences (there were eight of them in Yugoslavia!), like laboratories in Bacon's *New Atlantis*, prepared in vitro the virus of a new disease. Later, as we know, the arguments and Molotov cocktails exploded, the ghosts emerged and the epidemic spread' (*Intelektualci i rat* (The Intellectual and the war), Belgrade circle, Centre for Anti-war Action, Belgrade, 1993).
7. Much has been made of this moment and it is seen as the foundation stone of Milosevic's rise to ultimate power. However, in a private communication,

Vidosav Stevanovic explained his reasons for giving such a short rendition of this episode: he believed that this was not a crucial moment in Milosevic's career, but rather an opportune piece of media propaganda. Acquaintances of Stevanovic who were present that day with Milosevic testified to his obvious shaking and fear and his lack of oratory skills and appeal (translator's addition).

8. 'First I wish to tell you, comrades, that you must remain here. This is your land; these are your houses, your fields and gardens, your memories. You will not leave your land because of the challenges of the present, because you have been struck by injustice and humiliation. Never has it been in the spirit of the Serb and Montenegrin people to shrink in the face of obstacles, to demobilize when it is time to fight, to weaken when it is time to be strong. It is for your ancestors and your descendants that you must remain here. Your ancestors would be disgraced and your descendants disappointed. ... Yugoslavia does not exist without Kosovo! Yugoslavia will disintegrate without Kosovo! Yugoslavia and Serbia will not fail Kosovo!'

9. Following several years of political and human isolation, Dragisa Pavlovic died quietly in 1996, aged 53, in the middle of a conversation with his youngest son. He had refused to undergo a crucial heart operation. During his life he had published a book entitled *Olako obecana brzina* (Quick Change, Easily Promised) (published by Globus, Zagreb, 1989) in which he analysed with precision the appearance of Slobodan Milosevic and predicted his future moves. Very few people ever read this book.

10. 'The opportunities for solving the Kosovo problem are becoming desperately scarce, so that even the smallest wrong move, however well-intentioned, can have tragic consequences for the Serbs and Montenegrins of Kosovo, for the Serbian people in general and for stability of the whole of Yugoslavia. The kind of changes being proposed in Kosovo, even if their fallibility is acknowledged, is typically characteristic of the pragmatic and bureaucratic politics that today we greet with applause but that will lead us tomorrow into great troubles. The once-open palms of the Serbs and Montenegrins of Kosovo are now closing into fists, a fact that can only worsen the tragic situation already developing there. What must happen before we realize that these guns are being fired on the instigation of uncontrolled and hysterical words, spoken in public and written in newspapers?' (*Olako Obecana Buzina*, Zagreb: Globus, 1989).

Chapter 4: 'Kosovo is the Equator of the Serbian Planet'

1. The editor-in-chief, Stasa Marinkovic, who died two years later, implemented the paper's change of policy. *Borba* courageously persisted in criticizing

Milosevic's regime and became the only vehicle for promoting the views of the opposition. Its readership constantly diminished. Eventually it was banned, but continued to appear illegally under the name *Nasa Borba* (Our Struggle) after the regime took the paper's former title and gave it to one of its own publications. *Borba* appeared as a pro-Milosevic publication with the title letters in red.

2. At this time, an open letter from Milosevic to the media was published in *Politika*. In it he objected to the overuse of his name. 'Politically, I want nothing for myself; above all I do not want my personality to be used in the creation of a new cult. This would stand in direct contradiction to my understanding of a contemporary socialist, democratic society.' His apologists used this letter to refute the arguments of sceptics claiming that it was a perfect sign of his innate modesty. 'Our Sloba has no intention of becoming a dictator.'

3. King Alexander Karadjordjevic reigned from 1921 until he was assassinated in 1934. His son Petar II was declared king in 1941 but was overthrown by the People's Assembly on 29 November 1945.

4. The title of a book by the German historian, Leopold von Ranke (translator's addition).

5. Several years later, an embezzlement court procedure was ordered against him in France. In spring 1998 he was arrested in Paris, where he was staying semi-incognito, protected by a diplomatic passport. Three months later he was released and the whole affair was hushed up. No Western government ever took action against any of Milosevic's friends; his enemies, however, had problems throughout this period, even with procedures as simple as getting visas.

6. Milosevic's ally, the Serb Orthodox Church, actively contributed to the propagation of this myth. Jovan Velimirovic, the bishop of the Sabac-Valjevo region, wrote that, 'Since the time of Prince Lazar and Kosovo, the Serbs have given their lives in the struggle against the oppressor and in so doing have created a CELESTIAL SERBIA. Ours is the greatest celestial state there is. If we but use the example of this last war and remember how many innocent millions of Serb men, women and children were killed, horrifically tortured or thrown into caves by the Ustashe criminals, we may gain an inkling of the greatness of the Serbian kingdom in the heavens.'

7. Greater Serbia, as a geographical construct, would encompass the current Serbia, Macedonia, Montenegro, a large portion of Bosnia, the whole of Slavonia and a greater part of Dalmatia. It would also include Kosovo, which was known as Kosovo and Metohija, or the Old Serbia. Greater Albania would include northern Greece, the greater part of Macedonia and a part of Montenegro. It too would also include Kosovo and a part of central Serbia (to Kraljevo).

8. Because of the battle of Prince Lazar and the ancient monasteries in the area,

Kosovo Polje was always considered the 'cradle of Serbian Orthodoxy'. In his fight for Kosovo, Milosevic linked both Serbian and orthodox passions and tried to present himself as the saviour of both – a new Prince Lazar.

9. If local press reports from that period are to be trusted, in some cities there were more demonstrators than there were citizens. For example, there were 300,000 in Nis, 100,000 in Kraljevo and 200,000 in Kragujevac. The surplus moved by bus between cities.

10. Seselj later wrote: 'After Milosevic's clash with Ivan Stambolic, the Serbian security services took charge of all processes related to the so-called 'people's events', thus the newly instated leaders were no more than operatives who received orders from Belgrade. This explains the flood of communist phrases and Titoist pledges in the chants and slogans of the time. All the demonstrations in Vojvodina were inspired, encouraged and coordinated by the Serbian secret police. I personally witnessed all this, having been involved in organizing the first demonstrations in Novi Sad' (*Velika Srbija* (The Great Serbia), number 21, 1995).

11. Sejdo Bajramovic was the only ex-Yugoslavian leader to send his son to war. The young man was killed somewhere in Herzegovina.

12. In his 1937 memorandum, Cubrilovic recommended the resettlement of Kosovo's Albanian populace to Albania and Turkey. His central premise was that, since all previous efforts to marginalize the Albanians through colonization had proved ineffective, the only way left was mass expulsion. Cubrilovic was also a member of the Serb Academy of Arts and Sciences.

13. Memorandum of 1937.

14. Title of a book by Borislav Jovic, Milosevic's executor.

15. This was on 24 May 1992.

16. Even today one can still find the book entitled *Srbi, narod najstariji* (Serbs, the oldest civilization in the world), which has been through numerous editions. Among other things, it claims that the Serbs are not only the oldest civilization in the world but that they are also the ancestors of the three races: white, yellow and black. It also claims that the Chinese language was enriched by embracing many Serbian words and that the majority of contemporary Germans are of Serbian origin. The author of the book, Dr Olga Lukovic-Pajnovic, ended her days, senile, in a nursing home.

17. Elias Canetti, *Masse und Macht.*.

18. Matija Beckovic, a poet and academic, described the event as follows: 'The Gazimestan celebration [the place of the Kosovo battle – translator's addition] was the culmination of the Serb national revolt, in Kosovo as the equator of the Serb planet. ... On this six hundredth anniversary of the Kosovo battle, we must emphasize that Kosovo is Serbia; and that this is a fundamental reality,

irrespective of Albanian birth rates and Serb mortality rates. There is so much Serb blood and Serb sanctity there that Kosovo will remain Serbian even if there is not a single Serb left there. ... It is almost surprising that all Serbian land is not called by the name of Kosovo.'

Chapter 5: Building a Belgrade Wall

1. Borislav Jovic, *Posljednji dani SFRJ* (The last days of the Socialist Federal Republic of Yugoslavia), Belgrade: Politika, 1995.
2. In modern history, Serbia has been at war on 13 occasions. If this had not been the case, Serbia's population would have numbered between 45 and 50 million citizens. We can assume that the prosperity of the country would have significantly increased during such a long period of peace.
3. Borislav Jovic describes a tête-à-tête he had with Milosevic: 'As far as the unity of the Serb leadership was concerned, I told him (Milosevic) that I did not believe there to be any great threat. I also said that it was important to ensure the support of the intelligentsia so that more writers, artists, academics etc. might sustain us politically. ... Sloba said that almost all academics, writers and artists were with us, and that we make more use of them – within the country as much as abroad. He based his conviction on a number of conversations he had had with individuals amongst the intelligentsia' (Borislav Jovic, *Posljednji dani SFRJ* (The Last Days of the Socialist Federal Republic of Yugoslavia), Belgrade: Politika, 1995).
4. Director, among other films, of *When Father was Away on Business*, *Arizona Dream*, *Underground* and *Black Cat: White Cat*. Kusturica has won several international awards for his films. He is now a close friend of Kostunica.
5. Mladjan Dinkic, *Ekonomija destrukcije: velike pljacka naroda* (The economy of destruction: a great national theft), Belgrade: VIN, 1995.
6. All these terms refer to the various political factions that took part in the Second World War. The Chetniks were the followers of General Dragoljub Mihajlovic and his commanders who were all self-proclaimed 'dukes'. The Ustashe were the armed supporters of the Croatian Nazi Ante Pavelic. The Ljoticevists were the followers of the Serb nationalist Dimitri Ljotic. The Balists were the members of the Bali Kombatar organization that collaborated with the occupiers. The Vemeroists were members of the VMRO (Internal Macedonian Revolutionary Organization – IMRO in English) the organization that represented pro-Bulgarian and Macedonian nationalists. The Domobrans were Slovenian collaborators.
7. His main work is a book entitled *Bespuca povijesne zbiljnosti* (Endless historical reality) in which he shows that the Jews, not the Ustashe, carried out the killings at the Ustashes' Jasenovac camp. Furthermore, he argues that the

partisans (to which he belonged at the time) massacred more than 300,000 Croats near Bleiburg in 1945. One of his quotes is, 'Luckily, my wife is neither Serb nor Jewish.' Speaking to Croatian immigrants in Cleveland, he announced the part of his programme that stated that the Serbs in Croatia should be pronounced Croatian citizens and referred to as 'Croat-orthodox', and that the term 'Serb-orthodox' should be banned. The Serb Orthodox Church in Croatia would also be banned and would be known as the 'Croat Orthodox Church' for use by those who decided not to emigrate to Serbia.

8. Milorad Tomanic, *Srpska crkva u ratu i ratovi u njoj* (The Serbian Church at war and the wars within the Serbian Church), Belgrade: Media Bookshop Krug, 2001.
9. Members included Dragoljub Micunovic, Zoran Djindjic, Vojislav Kostunica, Nikola Milosevic, Vladan Batic all of whom were the future presidents of future parties: the Democratic Centre, the smaller Democratic Party, the Democratic Party of Serbia, the Serb Liberal Party and the Christian-Democratic Party.
10. The best known among them was the archimandrite Dr Justin Popovic, a follower of Bishop Nikolaj Velimirovic. His pupils, called zealots, later became the bishops and extremists of the Serb Church: Amfilohije Radovic, Atanasije Jeftic, Irinej Bulovic, Artemije Radosavljevic and many others. Although anti-communist, the zealots had supported Milosevic's politics for a long time. They turned against him only when they realized that he had abandoned the 'unification of all Serb countries'.

Chapter 6: The Fight Brews

1. Ivan Djuric was a professor of Byzantine history and later a liberal politician. He was the founder of the 'Liberal Forum' that was intended to match the Hungarian 'Democratic Forum'. The new parties did not support him. At the beginning of the war, in the wake of a regime campaign against him, he was forced to emigrate through Macedonia and Turkey to France. As an immigrant, he established the Movement for Democratic Freedoms. Not a single Western administration supported his democratic programme. He died in Paris in 1997 aged 50.
2. Father Justin Popovic wrote, 'Ecumenism is a common name for pseudo-Christianity, for the pseudo-churches of Europe. It represents all the European humanisms, with papistry on top. All those pseudo-Christianities and all those pseudo-churches are nothing but heresies. The common evangelical name is: "absolute heresy".'
3. Confirmed by anonymous sources both in Serbia and Montenegro.
4. The street was later named the Street of Serbian Rulers. If it could not bear Milosevic's name, then it would bear no name at all.

5. According to Mira Markovic, the events were far more dramatic: 'The city has been completely destroyed; there were two deaths; windows were smashed, cars set on fire; concrete flower jardinières were pulled up. It was a complete madhouse! Half the demonstrators were under the influence of alcohol. They were killing police dogs and running over horses. Horrible! It was a terrible sight and the citizens were very shaken by all this.'

6. While he was descending the improvised podium, humiliated, he accidentally passed by me. Shaking with fury he told me, 'You will pay for this.' Several days later I heard that I was on his list of those condemned to death, along with 100 other people. The majority of those on that 'secret and non-existent list' are no longer among the living, or no longer live in Serbia.

7. Borislav Jovic, *Posljednji dani SFRJ* (The last days of the Socialist Federal Republic of Yugoslavia), Belgrade: Politika, 1995.

8. Shortly before that meeting, Milosevic had said, 'We do not think that Yugoslavia will fall apart. I do not think that Slovenia will leave Yugoslavia, despite the secessionists. But, even if this does happen, Serbia will not be the smallest country in Europe.'

9. This was on 25 June 1991. The war only lasted a week and was fully ended by the Brioni Accords of 7 July.

10. M. Glenny, *The fall of Yugoslavia: the third Balkan war*, London: Penguin, 1996.

Chapter 7: The Defence of Serbian Lives and Serbian Borders

1. Bogdan Bogdanovic said, 'Perhaps one beautiful day the new (real) constitution of Yugoslavia will begin with the following words "In our country all memories are equal".'

2. The following is a quote by Patriarch Pavle in *Pravoslavlje* (Orthodoxy), 1 January 1992: 'The current government in Croatia did not want to recognize the Serb cultural autonomy, the written and oral language, even in those areas where the Serbs were a majority, but instead began using political force and weapons. Serbs had to defend themselves from this state violence, and so the war, with all its horrors, began.'

3. This great Serbian patriot was of Croatian origin, from Herzegovina. If his own theories were strictly applied he had no right to claim Serbian nationality. When the nationalists from the opposition enquired about his nationality, Seselj produced a document certifying that he was of Serb origin through second-degree kinship. The father of the self-proclaimed 'Governor' had converted to Orthodoxy during the division of Muslim land that had followed the First

222

World War. The certificate that attested his pure origins was not issued by the registry office but by the Serb Academy of Arts and Sciences.

4. The main aim of Seselj's party in 1991 was 'the revival of a free, independent and democratic Serbian state that will encompass all Serbian people and all Serbian territory.' This meant that (beside the currently imposed Serbian federal unit) its borders would include Serbian Macedonia, Serbian Montenegro, Serbian Bosnia, Serbian Herzegovina, Serbian Dubrovnik, Serbian Dalmatia, Serbian Lika, Serbian Kordun, Serbian Banija, Serbian Slavonia, Serbian western Srem and Serbian Baranja.

5. This started in August 1991.

6. Arkan's private army; the Serb Volunteer Guard (SDG/SSJ) 'Tigers', organized in 1992, responsible for several war crimes.

7. A statement by one of Seselj's 'governors', Branislav Vakic, *Velika Srbija* (Greater Serbia), number 21, December 1996, read as follows: 'The Serb Radical party, a national and patriotic party, had sent over 30,000 volunteers (Serb Chetniks) to war affected zones to fight our century-old enemies, the Croats and the Turks, ... with the knowledge and approval of Slobodan Milosevic. At the time, high ranking officers of the former JNA, later called the JA (*Jugoslovenska Armija* – Yugoslav Army) gladly agreed to train Serb Chetniks in their barracks in Belgrade and in other cities across Serbia and Montenegro in order to send them into war zones to fight. Thousands of volunteer Serb Chetniks also formed a significant part of a series of special force units attached to the Ministry of the Interior.'

8. Armed paramilitary formations equipped by the Serbian Ministry of Internal Affairs during the war in Bosnia were connected to the Serbian Radical Party (SRS).

9. Misha Glenny, *The fall of Yugoslavia the third Balkan war*, London: Penguin, 1996.

10. Stankovic was all over the media and spoke to all the newspapers. 'Serbia is an exceptional nation, better and older than any other. The name comes from the word Sorabi, which shows that they are the descendants of ancient Greeks and Romans.' According to him, they were like the inhabitants of Atlantis who had spent thousands of years locked into glass capsules. His absurd statements were read with great interest. Many patriots, most of whom accumulated wealth during the war, decided to purchase his paintings and he became a wealthy man.

11. Jelica Rocenovic, *Srbi bez krivice krivi* (The guiltless, guilty Serbs), Belgrade: Cigoja, 1997.

12. The need to undergo a medical examination before running for high office was stipulated in the 1974 constitution and in later election laws and procedures.

13. Presently an NGO dealing specifically with publishing activities and education projects.

14. Part of an international NGO started in Jerusalem in 1988.
15. Based more or less fully on the 1974 Yugoslav constitution.
16. It is rumoured that the only reason several EU countries agreed was to get exemptions from the then discussed Social Chapter of the Maastricht Treaty. John Major, among others, is said to have made deals involving the UK.
17. Borislav Jovic, *Posljednji dani SFRJ* (Last days of the SFRJ), Belgrade: Politika, 1995.
18. The project of Greater Croatia encompassed the current state of Croatia, the whole of Bosnia, a part of Montenegro and a part of Vojvodina called Srem. It also included the city of Zemun, a Belgrade municipality that was Seselj's constituency for some time.

Chapter 8: 'I am Interested in 66 Per Cent of Bosnia'

1. Tito created the artificial republic of Bosnia-Herzegovina within Yugoslavia in 1949. The Bosniaks only acquired official status in 1965 when 'Muslim' became an official nationality category. This made the inhabitants of Bosnia-Herzegovina more inclined to call themselves Yugoslav than people from the other republics.
2. The Norwegian peace-plan negotiator, Thorvald Stoltenberg, proposed a similar argument. In 1994, at a lecture in the Norwegian Refugee Council, he stated as follows: 'Basically I cannot understand what all the fighting is about, they are all Serbs; the Bosniaks are Islamified Serbs, and the Croats are Catholicized Serbs.' This quote travelled down to the Balkans and the Owen–Stoltenberg Peace Plan was not accepted.
3. Writer and politician Milan Komnenic said three years earlier that, 'If Serbia does not get what it wants, it will bring the world down into the abyss of a Third World War.' He was not alone in thinking this.
4. Karadzic never went to gaol for embezzling Energo Invest, but Krajisnik had to spend eight months behind bars.
5. The vice-president of Karadzic's government was Dr Nikola Koljevic, an expert on Shakespeare. The minister of foreign affairs was a philosophy professor, Dr Aleksa Buha. The director of the newly established news agency was a poet, Todor Dutina. The minister for information was a novelist, Miroslav Toholj. The man in charge of ethnic cleansing in his native city of Foca was Dr Vojislav Maksimovic, a professor of literature. The vice-president of the parliament was Dr Biljana Plavsic, a biologist. Academic titles clearly did not symbolize greater humanity.
6. Seselj, in *Velika Srbija* (Greater Serbia), number 21, 1995, wrote, 'Milosevic had asked us radicals to intensify the sending of volunteers over the Drina promising his support in terms of armament, uniforms and vehicles. As such,

the cooperation functioned perfectly until September 1993. All police and military stores were at our disposal, and our volunteers regularly joined the units of the JNA, Serbian forces or police detachments of the Serbian Ministry of the Interior. We very quickly established their professional status, leave of absence, length of service, medical care and aid for their families. When one of the volunteers was killed, formal military honours were regularly given: the military band of an authorized garrison and a gun salute would be organized.'

7. The retired army minister and chief of staff, General Veljko Kadijevic wrote the following in his book *Moje vidjenje raspada* (My view of the break-up), Belgrade: Politika, 1994: 'JNA represented the basis out of which three armies were formed – the Army of the Socialist Republic of Yugoslavia, the Army of the Republika Srpska and the Army of the Republic of Srpska Krajina.' The six republics' joint property was given to one nation, which thus lost the right to legitimize its demands. Without the army, not even Milosevic would have opted for war.

8. 27 May 1992.

9. The following is the opinion of an old-school Serbian politician Milos Minic, *Dogovori u Karadjordjevu o podeli Bosne i Hercegovine* (Talks in Karadjordjevo about the division of Bosnia and Herzegovina), Sarajevo: Rabic, 1998: 'Nothing distorts the true face of late twentieth and early twenty-first century nationalism like a war between nations, irrespective of whose or when or where the nationalism is. All the horrific characteristics of nationalism are fully expressed in the preparations of war between nations and during the course of these wars. I think that the wars in Bosnia and Herzegovina and Croatia will go down in world history as examples of the misery that contemporary nationalism can cause to its own people and to all other nations in which people live together.'

10. During 1991, when the war was taking place in Croatia and no one wanted to know that Bosnia was next, a telephone conversation between Slobodan Milosevic and Radovan Karadzic was recorded. Milosevic said, 'Do not worry, you will have everything. We are the strongest. ... With the army, nothing can happen to us.' Karadzic replied: 'That is good. What about some bombing?' Milosevic interrupts: 'Today is not good for aviation. The European Community is in session.'

11. The following is a quote by Brana Crncevic from Slavoljub Djukic's *Izmedju slave i anateme, politicka biografija Slobodana Milosevica* (Between fame and abomination: the political biography of Slobodan Milosevic), who in his own words was 'a professional Serb nationalist': 'Serbs do not kill out of hatred but out of despair. Killing out of despair is a pact between the killer and God, while

killing out of hatred is a pact between the killer and the Devil. God is responsible for Serb crimes, and the Devil is responsible for everyone else's crimes'.

12. Both later claimed that they had long refused the honour of becoming saviours before finally accepting. They also claimed that Milosevic had given both of them, personally and together, his word of honour that he would leave power if that meant that sanctions on Serbia and Montenegro would be lifted. There were no witnesses to this apart from Dusan Mitevic, a friend of the Milosevic family, and no written proof, quite apart from the fact that such a sacrifice would have been totally against Milosevic's nature.

13. The following is a quote by Vojislav Seselj, *Velika Srbija* (Greater Serbia), Belgrade, number 21, 1995: 'Property and personal security were never worth as little as when the Mafia became all-powerful. Only those who could not bribe the judges and prosecutors or those who were hated by the top men of the regime went to prison. According to the new economics, crime had become the essence of successful business. The black market channels for acquiring oil, drugs and weapons were directly controlled by the police and the paramilitary units of Arkan and Captain Dragan.' This vociferous Serb patriot was angry and strongly attacked the monopolists. Some time later he took over a smaller sector of this great business. He was also later reconciled with Arkan, following the disappearance of Captain Dragan.

Chapter 9: Crime, Inflation and Other Games

1. Vojislav Seselj, *Velika Srbija* (Greater Serbia), 21 November 1995, wrote: 'It often seemed to me that Milosevic trusted me more than any of his closest associates. ... He was very worried when he heard that I had to undergo an emergency operation at the neurosurgery clinic on the day of the elections in 1992. At first he did not know that it was a case of lumbar herniated disc. He thought it was something much more serious. He personally ordered a higher-ranking official of the Serbian UDB (secret police) to guard my hospital room for the whole night following my operation. Only two members of the Serb Radical Party were with me at the time, everyone else was a secret policeman.'

2. The products of this factory were exported to Russia and paid for somewhere in the West. In Serbia the shortage of medicine seriously affected the health of the population. According to the regime's propaganda and the satellite channel controlled by Panic, the 'unjust and unprovoked sanctions' were to blame.

3. As Marko Milosevic explained, 'Up to the fifteenth car Dad used to get angry, but afterwards he gave up.'

4. On 13 April 1992 *Borba* (the Struggle) printed the following statement by Mrs Dafina Milanovic: 'In my work, I must admit that I have sometimes mimicked

the president of the Republic of Serbia. At the right moment I descended into the crowd and announced, "no one is allowed to steal from you". I gained the people's trust and now I do not want to betray it.'

5. Jezda's attempt to organize another chess match (this time with Kasparov) was soon followed by his escape from Budapest. He then effectively vanished. Investigations made much later revealed that he donated more than one hundred million Deutschmarks to the Milosevic family. There are rumours in circulation today, however, that claim he is now living on a private island in the South Seas.

6. Mladjan Dinkic, *Ekonomija destrukcije: Velika pljacka naroda* (The economy of destruction: a great national theft), Belgrade: VIN, 1995.

7. Ibid.

8. 'The great Yugoslavian hyperinflation was not provoked by natural causes. It was initiated and encouraged by people who were not afraid to follow their own selfish interests; declaring everything to be in the name of the people, they abused the monetary and political power of the state institutions they governed. Having the power meant having the absolute monopoly over the printing of money. The monopoly over the printing of money meant absolute power.' (Ibid.)

9. Milosevic's tendency to call such people out of retirement to occupy important positions can be explained by the exaggerated greed of his new caste. Older men and women asked for much less and, in case of trouble, they could die of natural causes without arousing general curiosity.

10. Named after the indecisive secretary general of the United Nations, Boutros Ghali.

11. Jelica Rocenovic, *Srbi bez krivice krivi* (The guiltless, guilty Serbs), Belgrade, 1997.

12. On 4 August 1994, the federal government announced: 'By refusing peace, the leadership of Republika Srpska has taken the most severe action against the Federal Republic of Yugoslavia, against the Serb and Montenegrin people and against all the citizens living on this territory. Hence, the federal government has made a decision to halt all political and economic relations with Republika Srpska and to ban the members of Republika Srpska's leadership (parliament, presidency, government) from setting foot on the territory of the Federal Republic of Yugoslavia. Effective from today, the border of Yugoslavia is closed to all transport to Republika Srpska, except for the transport of food, clothes and medicines' (TANJUG).

13. At the 1992 presidential elections he presented himself as Dragan Vasiljkovic. He won just under 80,000 votes. The second presidential candidate was Jezdimir Vasiljevic, who was at the time still known as Boss Jezda. He won

approximately the same number of votes. One of the six candidates was Blazo Perovic, a close friend of 'Comrade Markovic' and her family. The role of these men was to secure between 200,000 and 300,000 votes in order to incapacitate a potential counter-candidate.

14. Propaganda sometimes led to unexpected crimes. Near the town of Uzice, a war returnee with a troubled mind jumped off his tractor and while shouting 'I am Captain Dragan!' slaughtered a girl who was passing by.

15. A journalist asked Arkan 'What is your New Year's message to the enemies?' Arkan's response was: 'I will fuck their mothers and their fathers.' Like Milosevic, Arkan enjoyed using obscene language, especially on official occasions.

16. The following is one of his statements. 'We, the Serbs from Bosnia and Herzegovina, are working very hard to ensure a high quality living area for the Muslims.'

17. Four years later Srebrenica was described in *Le Courrier des Balkans*, 1999, as follows: 'It is the darkest corner on the bloody map of the Balkans. It is a wasteland. Barbed wire and a great wall surround the city; it has become a monument to human savagery. ... It is summer time and in this wasteland there are no rivers, no lakes, no drinking water; there is not even a park in which to rest. The Serb inhabitants of Srebrenica have no desire to stay there and the city's ancient Muslim population wishes never to go back.' Mladic's heaven has all the characteristics of hell.

18. 5 February 1994. As before, Belgrade propaganda claimed that this had nothing to do with the Serbs, the army or General Mladic. However, the following statement by General Milan Celekic, commander of the army of the Republic of Srpska Krajina is proof to the contrary: 'Should the Ustasha aggression begin, we will take the opportunity to attack their weakest points. Those places are well known and it is known what hurts the most. The city squares hurt because they are full of civilians. ... Not only will there be no mercy, but I, as a commander, will ensure that we attack the places where most psychological and physical damage can be done' (*Argument*, Belgrade, March 1995).

19. The following is his statement from February 1995 in *Glas: Srbi Sveta* (The Voice: Serbs of the World), Belgrade: 'Should Croatia decide to start a war against the Republic of Srpska Krajina, it would ignite a full-blown war in the region. ... Therefore, if Croatia decides to begin a new war we shall be prepared and our brothers from Republika Srpska and the Federal Republic of Yugoslavia will come to our aid.' As it happened, these 'brothers' did not come to their aid and Martic made no attempt whatsoever to protect his people.

Chapter 10: Trilateral Encounter at OK Dayton

1. The following is a statement from the commander of the 'Tigers', Zeljko Raznjatovic Arkan. 'As a proud Serb, I would have preferred all of them to have been killed and for us to remember them as heroes.' For his part, he chose the life of a living hero, a rich criminal and a celebrity. He founded the Party for Serbian Unity, was a representative in parliament for a short period and became the owner of the football club Obilic.

2. Slavko from Knin, *Nezavisna Svetlost* (Independent Light), Kragujevac, 18 November 1995, is quoted as saying: 'Refugees are groups of people on whom experiments are carried out. We are those people. The great experiment of making Serbs live in the annexes of the motherland was carried out on us. The experiment failed, however, and we have lost everything. Today we are ashamed of being Serbs and Serbia is ashamed of us. It should be ashamed of itself for tricking us. Today the Serbian state is trying to pretend that we do not exist because we are the living proof of its crimes. It is trying to hide us as one hides a stolen object. Indeed, we are just objects to them.'

3. Even the very lowest estimates are as high as 50,000 dead.

4. In a meeting of the Belgrade Circle, Dr Ivan Ahel, an expert on the theory of government, gave the following data (published in *Nasa Borba* (Our Struggle), taken from Milos Minic, *Dogovori u Karadjordjevu o podeli Bosne i Hercegovine* (Talks in Karadjordjevo about the division of Bosnia and Herzegovina), Sarajevo: Rabic, 1998): 'Killed in war: In this war, around 300,000 people have lost their lives; 90 per cent of these were civilians. ... In practical terms, this was a war of armies and para-armies against unprotected people. ... Refugees: Around three million people have left or been expelled from their homes in towns and villages. ... War crimes: The exact number is vast, but as yet unknown to the public. These crimes are the main reason for revenge and the consequences of this brutality will be felt for generations. ... Torture: The shelling of innocent and unprotected urban populations (Sarajevo, Mostar and others), the deprivation of food, water, electricity, heating, the suffering and the fear of snipers will have serious consequences, particularly on the future of mutual life between ethnic communities. ... Destruction of towns and villages: Many cities have been destroyed (Vukovar, Sarajevo, Mostar, Gorazde, Dubrovnik and others) and thousands of villages have been demolished. ... Disturbed family relations: On the territory of the former Socialist Federal Republic of Yugoslavia, 1,300,000 people live in mixed marriages, their close kin would include up to ten million people. Around three million people have been born from mixed marriages. ... Ethnic cleansing: Several thousand people have been displaced in the most brutal way in many regions where populations of mixed nationality lived. During this 'cleansing'

every trace of the ethnos of the expelled population was destroyed (property, cemeteries, religious and other institutions, cultural monuments and belongings).'

5. According to figures from the London Institute for Strategic Studies, 'the strongest regional force was the Yugoslav Army: 125,000 soldiers, 600 tanks, 1500 artillery weapons, 200 aeroplanes and 100 helicopters. The Army of Republika Srpska had 80,000 soldiers, 330 tanks, 800 artillery weapons, 40 aeroplanes and 30 helicopters. The Republic of Srpska Krajina, before its peaceful surrender, had 50,000 soldiers, 240 tanks, 500 artillery weapons, 12 aeroplanes and 6 helicopters. ... Croatia had 100,000 soldiers, 170 tanks, 900 artillery weapons, 20 aeroplanes and helicopters. Bosnian Croats had 50,000 soldiers, 70 tanks, 20 artillery weapons and 6 helicopters. ... The Muslims had 110,000 soldiers, 40 tanks, 400 artillery weapons. ... The military expenses must have amounted to several tens of billions of dollars.'

6. The regime managed to find a way of punishing them. All lost the right to a passport. They were forbidden to cross any borders. Their own country became a sort of prison. Those who managed to go abroad could not receive political asylum on the grounds that their human rights and lives were not in danger.

7. The official language of former Yugoslavia was Serbo-Croatian. The Croatian writer Miroslav Krleza defined it in the following way: 'Serbo-Croatian is a language called Serbian by the Serbs and called Croatian by the Croats.' By the decision of those in power, new languages were introduced in the new states – Serbian, Croatian and Bosnian. The differences between the languages were minute but all three national intelligentsia unanimously denied that this was the case. The possibility of a Montenegrin language coming into existence was also suggested.

8. At the beginning of 1995 the Republic of Srpska Krajina was offered a peace plan 'Z', which guaranteed to the Serbs in Croatia a wider autonomy under international protection. According to Milan Martic, president at the time, Milosevic advised (ordered) him to refuse that plan. In 1991 in Karadjordjevo, Milosevic had already told Tudjman 'I do not care what happens to the Serbs in Croatia. You can do whatever you like with them, you can impale them if you so desire. I am interested in only 66 per cent of Bosnia and Herzegovina.'

Chapter 11: Peace Explodes in the Balkans

1. At a meeting of the Belgrade Circle in 1996, Dr Ivan Ahel quoted as follows from the book by Milos Minic: 'The effect of war is horrific, and this is not remedied by finding and punishing the guilty parties. ... The reality of the aftermath remains the same, whoever is responsible for the tragic situation. ... Still, people may look at their war ideas in a different light once they

witness war's terrifying cost. ... It is important to realize that politics, economics, society and war are all interdependent. Everything that happened is the result of politics and its manipulation. Without politics, nothing would have happened.'

2. The film director Zilnik tells a story of being at an Italian border. The customs official brusquely picked him out of the queue, sent him to a small room nearby and ordered him to wait. Zilnik was convinced that he was going to be mistreated. The customs official entered the room, closed the door behind him and suddenly smiled and opened his arms. 'Come here, my Serbian brother!' Zilnik was confused 'Why, Sir?' The customs official sympathetically said 'I am also a fascist!'

3. Among the eminent names on this list was a man from a city next to the one I was born in, Kragujevac. This was Slobodan Miljkovic, called Miljko the Forester or Crazy Miljko. He was taken out of prison and sent to Bosnia as part of a unit called the 'Grey Wolves' (a fascist paramilitary organization also linked to Seselj). When he returned, he boasted in cafés about killing 700 Muslims. Idiots had prevented him from reaching his target of thousands. The investigators from The Hague tribunal had great difficulty finding out his whereabouts. A Kragujevac policeman killed him at the beginning of September 1998. That same night, in the Serb part of Sarajevo, Knezevic, the former commander of the 'White Wolves' (an offshoot of the neo-Nazi Combat 18) was also killed.

4. Everyone at the top of the ruling establishment attended Zoran Todorovic's funeral. Slobodan Milosevic, Zoran Lilic, Milan Milutinovic, Mirko Marjanovic, Dragan Tomic, Nikola Sainovic, Gorica Gajevic, Milorad Vucelic, Zorica Brunclik, Dragoljub Milanovic, the director of Radio Television of Serbia, Dragan Haji Antic, director of *Politika* newspaper, Chetnik Duke and Sinisa Vucinic. Ljubisa Ristic and Snezana Aleksic gave speeches, and Mira Markovic's letter was read out. Milosevic's own eyes were filled with tears.

5. A report in *Glas: Srbi Sveta* (The voice: Serbs of the world), February 1996, stated: 'A group of minors who had stolen a BMW in New Belgrade surrendered to the police of their own accord. The reason was not their conscience but the fact that they had discovered a man's body in the boot of the car. The man had been shot with a handgun.' The police never discovered the identity of the victim and were therefore incapable of finding the killers.

6. Much like Europe in 1968, Yugoslavia experienced student revolts. Belgrade's 1968 took a strange turn: the revolts were led by Marxist professors, among them Mihajlo Markovic and Ljuba Tadic, who later became followers of Milosevic. The students demanded more social equality, which in practice meant more communism and, realizing what was going on, Tito sided with the

students and slowed down economic reform. In 1968 in Belgrade many careers began, including those of Ljubisa Ristic, Vuk Draskovic, Zoran Djindjic and many other future nationalists.

7. Comrade Markovic did know who had influenced earlier events. As she put it in her book, *Dekatlon* (Decathlon), Belgrade: Prosveta, 1998: 'Three parties bear responsibility for the break up of Yugoslavia and the war. ... First of all, these are the centres of economic and political power outside Yugoslavia who benefited from the break up of Yugoslavia for many historical, political and geo-strategic reasons, much like they benefited from the break up of the USSR and Czechoslovakia. ... The second party are the interior forces. I refer to nationalist ideologies and their representatives in politics, economics, cultural life, science and, even, in sport, which were present among all the Yugoslavian nations at the end of the 1980s and at the beginning of the 1990s. ... The third party consists of the political emigrants from all Yugoslavian nations who fled after the Second World War. They are anti-communists and nationalists.'

8. When she hated someone, Comrade Markovic forgot this sentimental tone. She wrote of Vuk Draskovic's wife Danica that she was 'an android in the shape of a director of a low readership, tabloid, quisling weekly paper', adding that she was 'an unfinished woman, with the habits of a semi-savage, cattle-breeding road bandit'. Mrs Draskovic did not lack finesse herself. She recognized in Comrade Markovic a president's wife who was in love with herself and had all the attributes of a 'mongoloid with a damaged character and conscience'. She saw her and her husband as two sick people. 'There is not a doctor in Serbia or anywhere in the world who would put his signature to assert that the two of them are sane, given their family and social behaviour.'

9. During the war in Bosnia, a secret staff of para-psychologists, mediums, fortune-tellers, miracle workers and possessors of the inner 'third eye' was formed at the Yugoslav Army headquarters. With their united spiritual powers they were expected to destroy the Pentagon and devastate the USA, then turn against other enemies of the Serbian people. The results of the work carried out by this spiritual paramilitary unit are unknown. Later, some of them complained that the army had not paid them enough and said that they would offer their services to the enemy.

10. From Slavoljub Djukic, *Izmedju slave i anateme, politicka biografija Slobodana Milosevica* (Between fame and abomination: the political biography of Slobodan Milosevic).

Chapter 12: 'I Love You Too'

1. Milosevic's former man, Milan Panic, led the opposition at the 1992 elections and lost. At the 1996 elections a sacked economic miracle-maker, Dragoslav

Avramovic ('Super Grandpa') was to lead the opposition, but – in agreement with Milosevic – he stepped back at the last minute.

2. The following is a statement by socialist representative Radovan Radovic: 'Our opposition reminds me of cats in February: they have small cocks, but they scream a lot!' The vulgarity of the provincial was just an imitation of Milosevic, who used it privately, most often in tête-à-tête meetings. When a visitor asked what he thought of Western democracies, Milosevic answered, 'I'll stick them on my cock.'

3. As Slavoljub Djukic described on Belgrade's Radio B92 programme *On, Ona i Mi* (Him, Her and Us) in 1997: '7.30 p.m., the start of the television news. Windows are open, people are going out on their balconies, throwing fire crackers, making noise with anything available: pots, pans, wooden spoons, stereos, automobile sirens, trumpets, rattles. ... The disturbed dogs join their owners with barking. The hellish noise is everywhere, as though a natural disaster were being announced. This lasts throughout the evening news (including the sporting and weather report) because the people have ceased to believe in anything.'

4. No one in Serbia or anywhere else in the Balkans wanted to publish this diary. It was translated into French.

5. The Dayton agreement divided Bosnia-Herzegovina into two parts encompassing three nations. Republika Srpska, which housed the Serbian nation, became one part and the Republic of Bosnia and Hercegovina, consisting of the Muslim (Bosniak) and Croat nations, became the other. Together these entities make up the Federation of Bosnia and Hercegovina. Both republics have independent parliaments, governments and constitutions. In addition, the federation has a separate government with a three-person presidency. Republika Srpska is closely linked to its 'mother country', Serbia, as is Hercegovina, or Herceg Bosna, with its 'mother country', Croatia. The Bosniak nation has no ties to other countries and is therefore often considered the weakest of the three nations.

6. French in the text.

7. Author's translation.

8. The following is a pre-election written memo by Tomislav Nikolic: 'Vojislav Seselj must win the elections for President of Serbia. A man with three sons, a harmonious marriage and a family, he loves his children, and loves the homeland. Dr Seselj loves all the children, his own and other people's.'

9. Prior to the 'first open elections' in 1990, the opposition vowed that it would not vote unless the election conditions were changed. This was a rational demand and the only possible way forward. Milosevic would have found himself in serious trouble, although he did have numerous reserve parties at his disposal. The opposition suddenly decided to accept the unjust conditions,

without Milosevic taking any action against them, and was defeated. The next election was a repetition of the same scenario. The opposition was defeated on several occasions and afterwards complained about the election conditions, but its complaints were always too late and futile.

10. When Mitsotakis, the president of an EEC member country, was accused in 1992 of violating the sanctions against Serbia, he said 'Greece did violate the sanctions, but we will not do so anymore.' It never stopped.

Chapter 13: The State against the Terrorists

1. At the beginning of twentieth century, the writer Radoje Domanovic described the conditions in Serbia in a satire entitled *Stradija* (Disaster). Even at the end of the century there is nothing to add to that criticism of the mentality of slavery, of political deceit and of the propaganda that always succeeds.

2. Tomislav Nikolic would later be presidential candidate in the elections Milosevic would lose.

3. Seselj trusted those whom he occasionally attacked; he trusted Milosevic and his wife, but he did not trust his representatives, the proven patriots. Before going into parliament, all were obliged to write and sign their resignation. The envelopes were handed to 'Duke Voja' who, if and when necessary, would date and activate them. Therefore, they did not have a responsibility to their people but to their scoutmaster who, in turn, was only accountable to Milosevic.

4. At the start of 1989, Fiat, a co-manufacturer of Zastava, wanted to buy and extend the factory, which at the time was producing more than 250,000 cars a year. Milosevic personally intervened. 'We will not sell off our country's wealth.' The same factory today produces around 5000 cars a year. 'Our country's wealth' has been saved and converted into poverty.

5. Ushtria Clirimtare E Kosova (UCK/OVK). In English, Kosovo Liberation Army or KLA.

6. 24 April 1998.

7. Borislav Milosevic was ambassador to the Kremlin from 1998 until Milosevic was arrested in October 2000.

8. Anti-Americanism had been spreading among the Serbs for a long time. Journalists, the intelligentsia and scientists had all contributed to it. The following statement in *Vojska* (The Army) in Belgrade on 6 May 1993 from Dr Cedomir Popov, an academic and historian, is an example of the growing prejudice: 'America is simply a land without history. Its complete history spans the last three centuries. ... Wherever the Protestants settled there was genocide. Unlike any European nation, American civilization rests on the politics of aggression. ... Such a thing does not exist among the Slavs. ... Siptari (pejorative for 'Albanians', translator's addition) are the sworn enemies of the

Serbs, but there is no extermination. The Serbian people themselves have discarded the idea of destroying them. ... The American factor of aggression and insensibility, never known in Europe, can only be matched by the Nazi extermination of the Jews and anti-Semitism.'

Chapter 14: Between Two Earthquakes

1. The story even goes that, as at the Dayton negotiations, the participants sat in separate rooms, refusing to communicate directly. Negotiators had to run between the rooms with answers to every little detail.
2. 'When it comes to the Balkans, all possible measures must be considered to avert conflict. The horrors will not cease as long as Europe persists in ignoring them. In the end there can be neither salvation nor escape – both for the great as well as the small powers – unless it be through unification and reconciliation. The options are sombre, but they might have been clearer had Europe and the great military powers so desired. Those powers might, despite everything, have been able to resolve the problem had they not decided to remain blind to it.' A French diplomat called Desturnel de Konstan wrote this in 1914. The Carnegie Commission for the Balkans published this opinion in its first (transatlantic) report.
3. The nationalist painter Milic Stankovic said: 'I am a representative of the first civilization on planet Terra, and the chairman of the group of planetary initiators in Serbia. Our main purpose is to make preparations for saving our civilization before the year 2001 (more exactly the year 2021) when the apocalypse will take place. I am also very happy that there will finally be collaboration between the artists and the politicians because that has not happened so far. Until now, we have walked different paths because we Serbs really are the ethno-genetic navels of the world. As such, we are responsible to the citizens of planet Earth and to our ancient mother planet Petnica, who made us and our language and whose inhabitants have already contacted us twice. ... The Germans and the Americans will not survive the apocalypse! But as Serbs, we want to help even our enemies. We are asking the Americans and the West to move with their property into the safe havens of our planet – in Serbia, Russia (Siberia), southern America and Africa and southern Australia. It is better for them to start digging for water in the Sahara than to wage war against the Serbs in the mountainous Balkans. ... Maps are irrelevant and secondary to the important actions that need to be taken before 26 June 2001. This is before the start of the apocalypse whose tectonic quake will begin near Portland and will extend horizontally across the whole of America, the Atlantic and Mediterranean basin to the Near East and back through the Adriatic coast, Austria, Germany and Italy to strike American soil a second time.'

4. 'According to the claims of international organizations, in relation to the degree of freedom of press the only countries that are in a worse state than Serbia are North Korea, Tajikistan, Cuba, Turkmenistan and China' (Slavoljub Djukic, *On, ona i mi* (Him, her and us), Belgrade, 1997, Radio B92).
5. The government, through the agency of the minister of justice, appointed the court presidents, the main judges and the public prosecutors. Made legal by the constitution, lawyers were divided into two categories: those who could win and those who could not. The best-paid lawyers were those who defended the accused war criminals on The Hague tribunal's list.
6. Henry Kissinger claimed that 'Rambouillet was for them (the Albanians) the tactical means of ensuring the unleashing of NATO's aerial arsenal on the hated Serbs.'
7. Madelaine Albright politely said to Serbian President Milutinovic: 'I know you think that I am against the Serbs, but my father used to say that had he not been Czech he would have liked to have been a Serb.' Her comment, however, did nothing to encourage agreement.
8. One of Holbrooke's associates said, 'We gave Milosevic the choice between NATO troops and NATO bombs. He chose the bombs.' He later chose the troops. Had he chosen the opposite (troops first), he would have lost the chance to inflict the damage he wanted on the Albanian people.

Chapter 15: At War with the World

1. The following is one of Milosevic's explanations of what was happening: 'When the bombing started, the refugees showed up. This was of course, a direct result of the bombing. Everyone knows this. ... Everyone is running away from the bombing – Serbs, Turks, Roma, Muslims. Of course, the number of the Albanians is the greatest. They are running away in their thousands. Birds are running away, the beasts are running away.'

Chapter 16: Everyone is a Winner

1. Associates of the Institute for Comparative Law in the Belgian town of Louen wrote that: 'During his time as president of Serbia, Milosevic violated the Constitution of that state on over a hundred occasions. He violated the Yugoslavian Constitution on more than fifty occasions. Had he done this in any other democratic country he would have been automatically stripped of his office.'
2. The 'eternal Henry' was referring to a difference in power between Hitler's Germany and Milosevic's Serbia. He overlooked the main difference between these two men. Hitler had deliberately infiltrated the German subconscious, while Milosevic was actually created by the terrified subconscious of his people.

236

3. Russian reporters from Belgrade, all of them harbouring anti-Western feelings, later confirmed that their colleagues from the state television often called them to bizarre evening meetings in Aberdar Street. The guests would sit for hours in the place of future attacks and wait for their hosts who never appeared. The Russians eventually understood what was going on and refused to come. The television employees did not have that opportunity – they were forbidden to leave their workplace. They were killed instead of those who were guilty.

4. In April 1999 a spy was finally caught in the NATO headquarters outside Brussels. It took the allies three weeks to figure out who he was – three weeks in which he had been sending faxes from the fax machine in his office to, among others, the central committee in Belgrade, outlining NATO's bombing plans. All faxes going out of and coming into the NATO building are monitored. In the period when NATO was on red alert, the translator of this work was smuggled into the building via a side door, to follow some of the press conferences. She had neither security pass nor identity card.

5. Rumour has it that there was a radio station in the basement of the Chinese embassy and that the attack was no accident at all.

6. The following are the thoughts of Comrade Markovic on the subject of bullies: 'Bullies are generally incomplete people. They are unaccomplished, insecure, weak or evil people. However, the evil they have caused to others is none the less because it is clear that it was caused by the consequences of someone's frustration. Behind the blows received by nations and individuals, there have usually been distorted personalities – men of suspicious endocrinology, the children of alcoholics, moderate psychotics, unsuccessful writers, and avengers great and small.' She was writing from experience.

7. The European Union and America later added another 300 of Milosevic's associates and the members of their families to the list of people prohibited from entering democratic countries. These were political sanctions instead of economic ones, a solution that friends of mine had suggested in 1993 and that the same administrations now imposing the sanctions had ridiculed as being an absurd and inconceivable plan. The plan was finally implemented six years too late – and incorrectly. Why did that list contain only 300 names? Why were there not 3000? Increasing the number of the 'punished' by ten times would still only constitute the tip of the iceberg of the regime's corruption, violence and crime. There are no innocents among Milosevic's entourage or at any other level of the family. In a law-abiding state not a single one of his associates, however distant, would have got away with anything less than a twenty-year prison sentence.

8. Milosevic had told Primakov during one of the mediating missions on an earlier

occasion that: 'Not one NATO soldier will set foot on Yugoslav soil for the next hundred – if not thousand – years.' As always, he had succeeded in achieving the exact opposite of what he had claimed.

9. One of Seselj's supporters wrote a short song containing the following words: 'I hate the Americans/They are only a little piece of shit/And they want the Serbs in chains.'

10. Ibrahim Rugova brought a piece of ore from Trepca to his first meeting with Clinton in 1998, the same gift he had presented to John Paul II on a previous occasion. Clinton was delighted: there were exactly the same riches under the soil in his native Arkansas. He did not address the subject of the war that was raging in Kosovo until the end of the meeting. Rugova returned with his job unfinished and Clinton returned to his own obsession – the Lewinsky affair.

Chapter 17: Twelve Years Past Midnight

1. Not a single Serb liberal agreed to cooperate with Milosevic or with any of the opposition parties. The *maspokovci* returned to political life and some of its members such as Drazen Budisa and Vlado Gotovac became leaders of the Croatian opposition. They were opposed to their former fellow fighter, the president Franjo Tudjman.

2. *Socijalisticka Partija Srbije*, Socialist Party of Serbia.

3. While changing direction and turning from warrior to peacemaker in 1995, Milosevic made a few changes at the top of the party of which he was no longer president. He appeared before the main committee, which greeted him with a ten-minute ovation, then took the chair and read out a list of names of people no longer deemed to be members of the party leadership. He gave no explanation for their dismissal. The names included Borislav Jovic, Professor Mihajlo Markovic, and director of state television Milorad Vucelic – these men had not been invited to the meeting. No one complained and no one asked for a right to contest the decisions. The meeting lasted 17 minutes, only marginally longer than Milosevic's ovation. A cocktail followed; no toasts were made.

4. The old dissident Mihajlo Mihajlov said: 'Today it can be said that the world is becoming small, that a global society is being formed. No matter what we call it, globalization or anything else, it is perfectly clear that in such a society it is becoming increasingly difficult to speak of national traitors or of anything similar. This is essentially a war between totalitarianism and democracy, between slavery and freedom. My argument is that a man cannot betray his army or his country. A man can betray only what he has freely opted for. With the development of a world society, only humanity can be betrayed, that is, only freedom can be betrayed by a decision to support enslavement.'

5. The so-called 'great Serbian writer' Milorad Pavic joined in the general climate

of denunciation by announcing that 'Mr Milosevic is not a real democrat.' He had forgotten his previous actions. During the eighth conference the new man had received several hundred false telegrams of support through which 'all layers of society' had given their support and approval. Only one of those telegrams was genuine and that had come from Milorad Pavic. In it he expressed his 'full support for the saviour of the Serbian people'. For this clairvoyant vision he was awarded the most extensive media campaign ever conducted abroad for a Serbian artist.

6. Djordje Dj. Stankovic, *Nikola Pasic i jugoslovensko pitanje* (Nikola Pasic and the Yugoslav question), Belgrade: BIGZ, 1985.

7. There was some justification for their paranoia. A truck loaded with sand crashed into Vuk Draskovic's car, killing his cousin and three of his body-guards. A secretary of Djindjic's party was found dead in his apartment – the conclusion was that he had committed suicide. The police never solved any of the cases. A French collaborator Lucien Rebatet wrote, 'The notion of politics is inseparable from the notion of murder.'

8. The family idyll continued despite the wars. The following is a text from Milosevic's interview in *Politika* addressing the year 2000, written by Comrade Markovic: 'The birth of our grandson Marko on 14 January made this rather hard year much better than it would have been without this joyful event in our family. Little Marko certainly changed our life. Until you have had a grandchild you cannot know how important this little being is to your life. Our little grandson is beautiful, wonderful and really resembles our children, Marija and Marko, when they were his age. When we compare his photographs with the photographs of our son and daughter from the time when they were one year old, we hardly notice any difference other than the fact that little Marko is a little bigger. He is growing surrounded by the great love of his mother's and his father's family and I hope that this will have an effect on the formation of his character.'

9. The second phase would involve the division of Macedonia. The third phase would consist of Albania laying claims to southern Serbia and Montenegro. Regardless of the order of phases, there would be fresh Balkan wars.

10. In an interview with *Politika* to welcome the year 2000, Milosevic said: 'I am convinced that the new century will be better and more just if only the people are capable of distinguishing between justice and injustice, good and evil, and that they are capable of knowing what to do for the former and what to do against the latter. Everyone should make a contribution to a better and more just world in the next century. ... Living together is nice and easy for those who want to live together and it is hard and ugly for those who are forced to live together. Where they are forced to be together, besides life not being nice and

easy, there is simply no future. ... I particularly want to emphasize the great experience of Yugoslavia, and Serbia in particular, in the world of international politics and their openness towards cooperating not only with their closest neighbours but also with the faraway countries of the world. We have always been open to those who wanted to come to us and had positive feelings for all those who wanted to be with us. This is our national trait. It is our historical heritage. ... In Yugoslavia, and Serbia in particular, there is absolute freedom in all areas of information. ... People all over the world are hoping that the criminals will become answerable for their crimes. Those responsible are afraid of this process. We are not living in times of Hunan wars; hence, the slaughter of people and crimes against humanity are not done without a certain fear of eventually being found guilty. In the middle of this century fascism was called to account before humanity. I believe that the monster of neo-fascism will not escape the judgement of its time, and of history. ... We have no intention of becoming isolated, although that is the intention of our enemies who have imposed and are maintaining sanctions against us. On the contrary, we are linking and cooperating with many countries of the free world – with the whole planet.'

11. 15 January 2000.
12. Arkan's three killers were taken to court. They denied committing the murder or having any involvement with it. The witnesses were mainly quiet. The grieving Ceca refused to testify. The three men received long prison sentences despite the absence of any proof of guilt.
13. By this time, rumours were flying in every direction. Theories were put forward that Milosevic's people had killed Arkan and that, in revenge, Arkan's people had killed Bulatovic. In the absence of anyone actually being charged with the murders though, the revenge theory is extended for every new victim.

Chapter 18: 'Save Serbia and Kill Yourself, Slobodan'

1. As far back as 1996 he had been diagnosed with a brain tumour and then, in the autumn of 1998, he was found to have a second brain tumour. Rumour had it that he had actually died long before his death was announced because the authorities wanted to pretend he was alive until after the 1999–2000 elections.
2. He died in November. The parliamentary elections were on 23 December, followed by presidential elections in January and February 2000.
3. Mesic belongs to one of the Liberal parties, namely the Croatian People's Party.
4. This was in a speech in the Croatian Assembly in 1991 when he said: 'I have completed my task. Yugoslavia no longer exists.'
5. None of these could actually be revealed because Tudjman's henchmen destroyed more or less everything in the period of Tudjman's stay in hospital.

240

Some documents and tapes are still held by Tudjman's son, incidentally the former chief of the secret police and now leader of a new right-wing party called Democratic Alliance of Croatia. Tudjman taped every single meeting he attended.

6. Duklja is an ancient name for Montenegro; it was revived to reinforce the sense of 'true' Montenegrin identity (translator's addition).

7. The word *carsija* means the importance paid in a small city to other people's opinions of one's actions (translator's addition).

Chapter 19: A Man with a Village Named After Him

1. Vojislav Kostunica.

2. Vojislav Seselj.

3. Tomislav Nikolic.

4. The academic Matija Beckovic said: 'The saviour of Serbia will be a man whose name incorporates the two most sacred Serbian words: *Sloboda* (freedom) and *Milos* (alluding to Milos Obilic, a national hero who had killed the Ottoman Sultan Murad I following the Battle of Kosovo in 1389).'

5. Stambolic's body was found on 27 March 2003. Mira Markovic, who escaped with her son to Moscow, is wanted for questioning about the case.

6. Comrade Markovic later said: 'Ivan Stambolic was a friend of my husband. However, we did not have a strong family friendship. After the eighth conference, Ivan Stambolic left politics and at his request my husband found him a place as director of the Jumbes Bank. He did not keep in touch with him, personally or politically, since Stambolic was no longer involved in politics. In my family, there was no particular animosity towards the Stambolic family, and we never really spoke of Ivan. New and turbulent times were ahead. Ivan Stambolic remained in the past.'

7. Number 11 Uzice Street is today the official residence of the president of the Federal Republic of Yugoslavia. The Milosevic–Markovic family moved to 11 Uzice Street (an unusual mixture of a residence, museum and kind of fortification) while their private home at 33 Tolstoy Street was undergoing reconstruction. Over the years 11 Uzice Street mysteriously changed owners and purposes: this great white building of modern lines was built at the end of the 1970s as a residence for Josip Broz (Tito) who never moved in. Soon after his death the house became a constituent part of the Josip Broz Tito Memorial Centre. A commemorative collection of numerous domestic and foreign medals Tito had received from all over the world was on display. Also on display were a cavalry sword with a diamond encrusted handle, which had been a gift from J. V. Stalin for 'merits in the fight against fascism', a Corinthian helmet from the end of the seventh century BC presented by the Greek King Paul I, a detail

from an ancient mosaic given by Giovanni Agnelli, the owner of Fiat, and a coffee set made of gold and silver presented by the Russian Patriarch Alexei. The employees of the Josip Broz Tito Memorial Centre made a detailed list of the archaeological collection, which noted 112 authentic displays, 177 displays in the ancient weapons collection, 2075 applied art pieces, 106 medals of J. B. Tito (many of which were made of precious metals and stones), 4774 displays in the ethnological collection and 3886 items in the fine art collection' (*Vreme*, April 2001, Belgrade).

Chapter 20: To Remain the Same We Must Change Everything

1. At that time I received a visit from a journalist from a Canadian television station who wanted to interview me. The first question I was asked was: 'What did Mr Kostunica tell you during your encounter?' I said: 'There was no encounter.'

2. The propaganda referred to the bombing of Serbia as 'NATO aggression'. During the pre-election campaign, the opponents were called the 'NATO opposition' and 'NATO mercenaries'. The accusation 'NATO humanists', which was a reference to representatives of Western democracies and anti-nationalist emigrants, was coined for new uses but with the old template. It was used by the newly recruited propaganda on 'all Serbian meridians'.

3. Dragan Struja, who later changed his name to Dragan Haji Antic, was an intimate friend and perhaps lover of Milosevic's daughter Marija.

4. Dusan Mihajlovic, later minister of police, said: 'Out of the police, Milosevic had already created a service to protect his interests and not the interests of the people. As an award for loyalty, Milosevic gave military ranks to some of his higher-ranking officials in the state and public security. They received ranks of colonel and general as though they had managed to suppress crime and guarantee the safety of Serbian citizens. At a time when all kinds of crimes were proliferating, policemen were forever being given ranks and medals; and this precisely when the influx of criminals and the Mafia into the police was getting greater.'

5. Throughout his presidency, Kostunica has continued to state that Kosovo and Republika Srpska should be parts of Serbia. He continuously states that 'Republika Srpska is the heart of Serbia'. This has of course not made him especially popular either in Bosnia or within the international community.

Chapter 21: A Dry Tree in a Dead Forest

1. He managed to be honest once. In a conversation in 2001, he, Slavoljub Djukic, claimed that: 'History and time have shown that many of my convictions were ideological mistakes as well as social and educational utopias. I am not ashamed of those mistakes and I do not defend myself for having made them; for years these mistakes, based on the difficulty and misery of life in Serbia, gave sense to my life. However, I do think that history and time have confirmed many of my views and predictions. Today, I do not consider myself a sinner who has come to his senses and who now justifies himself and regrets, nor do I consider myself the winner or the prophet who glorifies himself on the rubble of the state and its order. I no longer have any hope. The world I have fought for was not made; the world in which I lived has disappeared; it no longer exists; in the world we find ourselves in today there are very few of my friends left. I am fed up with everything. You, Slaboljub and me, we are people of past times; we are only alive by accident. Everything we longed for has failed.'

2. The Serbian historian and liberal Latinka Perovic wrote: 'I think that the attitude to crimes committed during the wars in Yugoslavia is a very important indicator of a break with earlier politics. It is not only a question of getting rid of the perpetrators of such politics but also and primarily a change of political template. Understandably, this depends on several factors. I think it depends primarily on the political will of the people who have the mandate to lead Serbia in this period. Their political will shall determine whether to begin the gradual preparation of the public towards accepting the condemnation of politically instigated crimes or, as it used to be put then, crimes committed in the name of a greater target, for reasons of state. That question remains open; we cannot go back and the question will be important in shaping the political climate in Serbia in the near future.'

3. In a discussion with Pierre Hazan, Louise Arbour said that, 'all the politicians with whom I spoke, from Madelaine Albright to Hubert Vedrine told me the same thing: it is too complicated, too dangerous.' In an exceptional book on the functioning of The Hague tribunal (*Justice in the face of war: from Nuremberg to The Hague*, Paris: Stock, 2000) she went on to state that, 'this policy of giving the Bosnian-Serb leaders exemption from indictment continued to operate for years, despite it being morally shameful, politically dangerous and in direct conflict with the founding principles of the Tribunal.'

4. Friends from Sarajevo claim that a Serb academic now living in Belgrade, a historian named Milorad Ekmedzic, was the person who hatched the idea of breaking up Bosnia, along with the ethnic cleansing, the systematic destruction of mosques and the genocide against the Muslims. His colleagues from the old academy building in Knez Mihajlova had apparently helped him.

5. The Belgrade paper *Danas* (Today) quoted Milosevic as saying that, 'As far as the political climate is concerned, I think this country is in danger of establishing a one-party system since all the parties, apart from the ruling one, are exposed to media lynching with the material goods they legally possess being seized and their distinguished representatives constantly threatened with arrest. Rigged political processes are currently in operation and a whole series of new ones is announced. This creates an atmosphere of fear among the people; they fear for their lives, for their property and their jobs. … Means of information are exclusively in the hands of the government; they are completely uniform and do not allow any space for opinions different from the official and ruling one. As far as the democracy is concerned, it was just an empty promise. However, violence, falling standards, political one-mindedness and territorial instability are everywhere.'

6. Kostunica's favourite journalist and family friend was M. Glisic. His articles continued where those of Comrade Markovic had left off; they identified the head of state's opponents and stipulated who should be attacked. The Karic Brothers immediately gave him their annual prize of 33,000 Deutschmarks – the equivalent of 330 average annual salaries for protecting the state against foreign influences and against Carla Del Ponte.

7. Slobodan Milosevic had the following to say: 'I have told the Americans several times that under Clinton they are no longer a democratic country. This is because as long as the administration lies and systematically sells lies instead of the truth to its population the democratic institutions and the democratic and free spirit of the people is worth nothing. They have been deceived and manipulated. Without truth, there is no democracy.'

8. Markovic was charged with the murder of Slavko Curuvija and the disappearance of Ivan Stambolic.

9. 'Milosevic was charged with "organizing a group of federal officials: Kertes, Sainovic and Zebic, alongside other individuals in 1994 and 1995, with whom he made an agreement and later gave orders systematically to break federal laws". While these orders were carried out, the country's balance of payments suffered and eventually collapsed, thus creating monetary instability and damage to the Republic of Serbia and Federal Republic of Yugoslavia's budget to the amount of 1.8 billion dinars or almost 200 million marks. The charge for economically ruining the system received out of court attention over the operation of taxing war credits for reconstruction, printing illegal money and import permits. The indictment failed to mention Slobodan Milosevic's direct material gains, but it did mention former chief of secret police Rade Markovic's boat and apartments. The report viewed power as a sort of plunder. These charges usually receive a sentence of five years imprisonment, but this can rise up to fifteen years' (*Vreme*, Belgrade, April 2001).

10. 'In the residential building in Uzicka 11, the police, to their great surprise, discovered a pile of weapons, ammunition and explosive materials alongside two armoured cars that turned out to belong to the Yugoslav Army. The greater part of the ammunition was of domestic origin and was typical armament of the army and police, but the question was how it got to Uzicka 11. The question was answered with an investigation. However, some unusual weapons were also found there – an automated Heckler und Koch MP5K weapon, guns of American and other origin, a 9mm Ruger, a 93R Beretta, a special automated gun that is never used by civilians because it shoots in bursts. It is not known what Marija Milosevic shot with, for she was in possession of three guns. Slobodan Milosevic waved his Sig Sauger 226 with a clip of 20 or 25 bullets, also atypical of commercial sales. The most interesting weapon from this impressive collection was a CZ-99 gun with an engraved image and a signature of General Nebojsa Pavkovic, allegedly a present from the chief of staff to Slobodan Milosevic. General Pavkovic entered the history of firearms as the only man who had his own image engraved onto the guns he gave as presents' (ibid.).

11. Branislav Ivkovic, an official in Milosevic's party, coined the term.

12. The Hague tribunal accidentally gave an opportunity to the new caste to tap into yet another source of income through the defence of war criminals. The selection of lawyers – whose fees would be paid by the tribunal, namely the United Nations – was coordinated in Belgrade: both the tribunal and the accused were tricked, and the money flowed into the pockets of the same old privileged figures. Seselj mocked the law, the courts and the judges; he even attacked his former lawyer Barovic. Various sources in the capital of the Federal Republic of Yugoslavia suspect that the majority of lawyers representing accused Serbs at the tribunal in fact work for the Yugoslavian security police. Sources claim that the lawyers' aim is to prevent the former Yugoslavian president Slobodan Milosevic being named the commander of the crimes. The lawyers' function is not to defend their clients but to ensure that their clients do not point to Milosevic.

Index

Index